ECONOMIC POLICY FOR THE ARTS

ECONOMIC POLICY FOR THE ARTS

Edited by

William S. Hendon
James L. Shanahan
Alice J. MacDonald

Contributing Editors

Mark Blaug
Virginia Lee Owen
Michael J. O'Hare
Alan Peacock
C. Richard Waits

Abt Books

Cambridge, Massachusetts

Library of Congress Cataloging in Publication Data
Main entry under title:

Economic policy for the arts.

 Based on the proceedings of an international con-
ference held in Edinburgh, Scotland, Aug. 8-10, 1979.
 Includes bibliographies and index.
 1. Art patronage—Addresses, essays, lectures.
2. Arts—Economic aspects—Addresses, essays, lectures.
I. Hendon, William Scott, 1933– II. Shanahan,
James L., 1943– III. MacDonald, Alice J., 1940–
NX700.E26 700′.68 80-19830
ISBN 0-89011-548-6

© Abt Associates Inc., 1980

Printed in the United States of America

Contents

Preface

THIS BOOK is the first of its kind: the papers and comments have been culled from the proceedings of the first international forum on arts and economics. Held in Edinburgh, Scotland, August 8-10, 1979, the conference was convened for the purpose of prompting dialogue among economists, planners, arts professionals, and government officials. The book is sponsored by the Association for Cultural Economics and the *Journal of Cultural Economics,* with the support of the Scottish Arts Council, the Charles F. Kettering Foundation, the Department of Urban Studies of The University of Akron, and the Center for Metropolitan Planning and Research of The Johns Hopkins University.

The arts are a new area of study in economics, an area largely ignored by the founding fathers of conventional economic theory, Adam Smith and Alfred Marshall. As a consequence, any treatment of art by economists has been anomalous until recently. Even now, after ten years of heightened awareness, when one looks into bibliographical sources for economic studies of culture, one is not impressed with the volume of literature.

From the viewpoint of contemporary neoclassical economists, the credit for the seminal work would have to be granted to William J. Baumol and William G. Bowen for *Performing Arts—The Economic Dilemma,* even though it was not published until 1966. This work has had a large impact on the developing cultural research community over the decade of the 1970s. Many pieces of work have followed to expand, update, or refute the principal parts of this study. While Baumol and Bowen should doubtless be credited for having spawned new research interests, they are to be blamed for limiting research attention primarily to performing arts and to arts institutions rather than to cultural processes and artistic endeavor.

Other notable books published in the 1960s and early 1970s are Richard Rush's *Art as an Investment* (1961), the U.S. House of Representatives' *Hearings on*

Economic Conditions in the Performing Arts (1962), and Alvin Toffler's *The Culture Consumers* (1973).

Later in the 1970s more economists began to apply their tools to cultural studies, and more books were published. Notable among them are *The Joyless Economy*, in which Tibor Scitovsky discusses the nature of cultural values and market forces that mitigate against arts consumption in the United States, and the first book of readings on the *Economics of Art,* edited by Mark Blaug. Both were published in 1976.

More recently, Thomas Moore has published *The Economics of the American Theatre,* and Dick Netzer has published *The Subsidized Muse: Public Support for the Arts in the United States,* a major study of public support in the arts that will become a standard reference. Other works of interest include *The Economics of the Performing Arts,* by David Throsby and Glen Withers; *Analyzing an Art Museum,* by William S. Hendon; *Indirect Subsidies to the Arts,* by Michael O'Hare, J. Mark Schuster, and Alan Feld; *Theater und Orchester Zwischen Marktkraften und Marktkorrekten,* by Erika Wahl-Zieger; *Economics and Culture,* by J. R. Abbing; and *The Arts in the Economic Life of the City,* by Harvey Perloff et al.

In the United States research in the economics of the arts has taken a sharp upturn, principally through the support of the National Endowment for the Arts (NEA). NEA has awarded contracts for research on the demand for arts, the impact of arts institutions on local and regional economies, and other development issues. Highlights of these studies appear in *Research in the Arts* (1978), the published proceedings of a conference sponsored by NEA and The Johns Hopkins University's Center for Metropolitan Planning and Research. The editor, David Cwi, describes the works as comprising "a major component of current policy research on American artistic and cultural institutions, audiences, and artists and craftsmen."

NEA publications of special interest to economists are David Cwi and Katherine Lyall, *Economic Impacts of Arts and Cultural Institutions: A Model for Assessment and a Case Study in Baltimore,* and the first NEA division report, *Employment and Unemployment of Artists, 1970–1975.*

In October 1978 NEA and the U.S. Departments of Commerce and Housing and Urban Development, among others, sponsored a conference in Minneapolis on "The Role of the Arts in Urban Economic Development."

Two academic institutions committed to cultural policy studies are The University of Akron, through its Center for Urban Studies (Cultural and Leisure Studies Program), and The Johns Hopkins University, through its Center for Metropolitan Planning and Research. Akron's Center for Urban Studies completed the first economic analysis of an art museum, the Akron Art Institute, in 1973. This study developed basic methods for evaluating museum programs, management policy and techniques, and future planning decisions, and produced a general development plan for the Akron Art Institute. The Cultural Policy Unit at The Johns Hopkins Center for Metropolitan Planning and Research, directed by David Cwi, has conducted several major studies. Current activities include re-

search on some forty cultural institutions of all types in six U.S. cities: Columbus; St. Louis; Springfield, Illinois; Salt Lake City; Minneapolis-St. Paul; and San Antonio. This study will result in important data sets on local and non-resident audiences, staff households, and institutional operating and financial characteristics.

Further support for economic studies of the arts comes from the Association for Cultural Economics (ACE), which was formed by twelve economists at the Midwest Economics Association's annual meeting in 1973. With the aim of encouraging academic economists to conduct research on cultural topics, ACE has functioned as an organized network of scholars and practitioners and has sponsored sessions on cultural economics at major annual meetings of economics associations. Since 1973 the organization has grown to a membership of over 200 in the United States and abroad.

In late 1976 several interested scholars moved to provide an outlet for the growing interest in what could be described loosely as cultural economics. The *Journal of Cultural Economics* was the result. Published twice a year, the *Journal* has an institutional affiliation with the Cultural and Leisure Studies Program of The University of Akron's Center for Urban Studies and an overlapping membership with ACE. The range of topics published in the *Journal's* first six issues is considerable, although the arts has been the subject of most articles and they have been written largely by economists. During the spring 1978 meeting of the Eastern Economics Association, ACE sponsored a symposium on "Public Support for the Arts," in which social philosophers and economists debated policy issues. The summer 1978 issue of the *Journal of Behavioral Economics* reports on the proceedings of this meeting.

Seeds for the First International Conference on Cultural Economics and Planning were sown in a hotel bar in the spring of 1978 during the Eastern Economics Association meeting in Washington, D.C. Our thought then was simply impulsive: why not extend an invitation to an international conference on the arts and economics and see who might participate? We wanted to convene a meeting of economists from around the world who have done research in the arts and planning for arts institutions. The conference became rooted firmly during Bill Hendon's lecture tour of the United Kingdom, when Alan Peacock and Kathleen Rennie joined the program committee, and cash grants were forthcoming from the Scottish Arts Council in Scotland and the Charles F. Kettering Foundation in the United States. These monies were supplemented by support services provided by The University of Akron's Department of Urban Studies and the Center for Metropolitan Planning and Research at The Johns Hopkins University.

While most of the participants were academic economists, they were joined by planners, administrators, and researchers involved in national and subregional arts councils and government, and by administrators of arts institutions. Fifteen countries were represented, although the majority of participants were from the United States and the United Kingdom.

The selection of papers and the definition of program sessions were interactive. With a program-planning period of less than ten months, it was not possible

to choose themes and chairpersons—and then invite papers. Rather, we let the submitted paper topics suggest possible sessions.

While the themes that thus evolved worked well for structuring the conference, we have found in publishing the proceedings that they do not suffice as a means for categorizing economic policy issues in the arts. Some of the program themes became difficult to describe—let alone differentiate; they could not be distinguished either as art themes or as economic themes. Moreover, the completed papers often did not comport with our earlier speculation on their content. For these reasons, we have regrouped the papers into categories that reflect related cultural policy issues.

Part One, "Public Support for the Arts," addresses a public policy question concerning the arts that has been widely discussed: the granting and allocating of government support. Part Two discusses markets for the arts with respect to both artists and consumers. Part Three examines some of the economic aspects of careers in the arts. Part Four explores issues in cultural and policy management of artistic institutions. Part Five focuses on the role of the arts in economic development.

For the economist and the arts advocate, the study of the arts almost always can be traced to concern with artistic endeavor as a public good or with the "congenital cost disease" of arts institutions. Essentially, the issue of "the role of arts in economic development" or "cultural policy and managerial economics for arts institutions" cannot be entirely separated from the questions of public support and resource allocation. Consequently, subsidy of the arts is addressed throughout the conference.

Economists' strengths are a mixed blessing in this respect. To practitioners and scholars in the humanities, economists must surely look like rigorous and precise thinkers who nevertheless believe firmly in their premises without fully examining them and without admitting other premises—individuals who exhibit a cold and mean tunnel vision. While to economists the words of social philosophers, aestheticians, arts managers, arts historians, and arts critics often read like those of apologists, advocates, or true believers. Their arguments for public support, when carefully examined, do not appear to stand on firm logic, the premises are not fully articulated, and value judgments overflow the thought. When asked about the role of government relative to the arts, economists argue from a narrow but strong logic, failing to recognize that every society in human history has subsidized art. Social philosophers advocate broad artistic subsidy more on the basis of this strong tradition than from a precise logic.

Part of the problem with the economic viewpoint is that it does not isolate parts of an ongoing complex process. For example, in an economic analysis of education we can place a value on years of schooling, but we cannot place a value on a composition course, a history course, or an art course. Yet most economists would agree that such courses have value for participants. If we consider art appreciation an educational experience as well as an activity to be enjoyed, then we can assume that, with proper preparation, the art experience can have general and widespread value as a primary benefit, even if we cannot satisfactorily analyze it in economic terms.

Our collective perception was that economists might treat cultural studies as a novelty, as Scitovsky describes, for their own intellectual stimulation. Economic applications are often no more realistic than esoteric exercises; examples abound in health and crime studies. Economists need to make a concerted effort to deal with the disciplinary issues mentioned above by finding escape points through which the closed system of economic thinking can be opened to other perspectives. However, we believe that this volume reflects genuine progress toward defining the subject areas and methods of analysis that will provide cultural policy studies with vitally needed economic insight.

Acknowledgments

I N BOTH planning the conference and publishing the proceedings, many persons have been of tremendous assistance. Those who came early into the effort and stayed late include Alan Peacock, Mark Blaug, Dick Waits, Mike O'Hare, and Virginia Owen, the chairpersons of the conference sessions. The program committee included Kathleen Rennie, Alan Peacock, David Cwi, Jim Shanahan, and Bill Hendon. This group conceptualized the conference seminars and assisted in all the arrangements. Both The Johns Hopkins University and The University of Akron supported our early efforts through clerical assistance, mailing, and printing. In particular we wish to thank Dr. Yong Cho and the Department of Urban Studies for what at points appeared to be an unending need for xeroxing, mailing, and typing. Lynn Larke, who assists with the *Journal of Cultural Economics,* handled most of the mail and many details which were absolutely essential to the conference's success.

Our local secretary, Kathleen Rennie of the economics faculty at the University of Edinburgh, managed our affairs at the conference and made the visit of delegates a comfortable and pleasant experience. She did it all, she did it well, and she did it with polish. It should also be mentioned that she provided two delegates with a prime aesthetic experience when she and her husband took these two lads from the colonies fishing in the Firth of Forth.

Our profound thanks to the Scottish Arts Council for financial assistance. We particularly appreciate the time, effort, and interest of Alexander Dunbar, Harry McCann, and Lord Balfour of Burleigh. At the University of Edinburgh the consideration of Ian Stewart and his economics faculty helped make the conference a considerable success. Free drink is always appreciated by academics, and as classic "free riders" we all benefited from the elegant receptions, one provided by the Scottish Arts Council and the other by Professor Stewart.

We are grateful to our friends at the Charles F. Kettering Foundation in the United States, who assisted financially in both planning the conference and editing this volume. We particularly wish to thank James Kunde, director of the Urban Affairs Program.

We wish also to thank Harold Horowitz of the National Endowment for the Arts for making the Endowment's research reports available to delegates. We only hope that in the future overseas travel funds for U.S. federal employees are more generous so that more of them can attend conferences. Perhaps the Dutch Ministry of Recreation, Cultural Affairs, and Social Welfare might serve as a model. We thank the Dutch for being so supportive of the conference.

Many persons assisted in the preparation of the manuscript. The editors appreciate the efforts of authors and discussants in developing fine papers and then kindly working to reduce them to meet our limited space.

Able efforts in typing and corrections were made by the secretarial staff of the Department of Urban Studies and the Center for Urban Studies at The University of Akron. Without the dedicated work of Arlene Lane we could not have completed the volume. Student assistants included Karen Anasson, Debbie Decker, Sue Hoff, Lori House, Lynn Larke, Diane Lyman, Connie Smith, and Tilly Vangroll. The efforts of Judy Sherman at Akron's Center for Urban Studies are also appreciated.

Finally, it should be obvious to all of us that the prime acknowledgment must go to the conference participants. They provided welcome insights into the arts and advanced our knowledge in the effort.

William S. Hendon
James L. Shanahan
Alice J. MacDonald

Opening Gambits

The Creative Artist's View
of the Economist

Alan Peacock

CULTURAL ECONOMICS AND PLANNING make use of economic and related fields of analysis in "unwonted places," and eyebrows are sometimes raised at the very idea of the penetration of the hallowed regions of human endeavor by the cogitations of us "rude mechanicals." This has led me to speculate on the possibility of what would happen if the roles were reversed and the creative artist were to use his intelligence, imagination, and insight to reveal the true essence of the economist. I doubt whether any coterie of artists would think us economists worth a whole conference lasting three days, but there is a little evidence to suggest that they might regard us as a suitable case for treatment.

For example, one might be able to cobble together a session on the "economist in literature." The nineteenth century classical economists were sufficiently influential and radical figures to attract the attention of such a fine minor novelist as my adopted ancestor, Thomas Love Peacock. Peacock pokes fun at James Mill and McCulloch unrolling their manuscripts to reveal the principles of production, consumption, and distribution to a protesting audience, at the Malthusians debating with the anti-Malthusians. One of Peacock's characters may be right in describing political economy as "a hyperbarbarous technology," but then he also pokes fun at other enthusiasts for their disciplines—at Coleridge as a philosopher, at scientists arguing about the descent of man, and even at artists and novelists.

Ignoring amateur economists, such as Mr. Micawber in *David Copperfield* and the languid Russian emigrés debating economics in Turgenev's *Smoke,* one meets a barrage of hostility against the economist in modern literature. The Webbs are pilloried in Wells's *The New Machiavelli*. Nasty allusions to economists at the London School of Economics abound—undeserved, of course. In Nigel Balchin's *Darkness Falls from the Air* the unheroic economist is depicted not only as a pedant but as a drunk. The once fashionable English writer, Charles

Morgan, wrote a play (which I have actually seen) in which a traitor is described as an economist of central European origin: "A fellow at one of our universities—I don't know which."

Is it really as bad as that? Well, not quite. There is a passing reference, which I cannot trace, in Proust's *À La Recherche du Temps Perdu* to young Marcel's enjoyment of the lectures by the French economist Leroy-Beaulieu, a little of whose work has been translated into English. More positive perhaps is the economist who plays a notable part in a little known novel by John Buchan, whose film, *The 39 Steps,* is much better known. In his *Prince of the Captivity,* which is one of the worst novels I have ever read, the hero has to save a brilliant practical economist, once an Oxford don and in the novel an expert financier, whose grasp of financial affairs is so important that a world in depression (we are in the 1930s) will depend for its salvation on his expertise. Obviously Keynes springs to mind as the model.

In the areas of painting and music we economists have provided little inspiration. For example, there is an excellent portrait of David Hume by Allan Ramsay, as well as respectable portraits of Adam Smith. The more famous picture of John Stuart Mill by Holman Hunt shows a rather troubled old man and not the radical young hero caught by the police distributing Francis Place's literature on birth control in the streets of nineteenth century London. The picture of Keynes in the National Portrait Gallery is replete with clever observation of that mercurial figure. With the exception perhaps of Hume, these are all examples of portraiture capturing the likeness of the man but not portraying him as some special symbol of his age or of an idea.

And then with a performing art such as opera, there are plenty of economic men, such as Figaro or Dr. Dulcamara in *L'Elisir d'Amore,* but not an economist, and they are not necessarily the same thing! One might note in passing that there is one famous opera or operetta which exploits a familiar economic dilemma—how to cure the balance of payments problem. Guess which? Why, *The Merry Widow* where the mythical Republic of Pontevedro will face economic collapse if Hanni Glawari is not induced to repatriate her assets. And I suppose at a pinch you could say that Wagner's *Ring* is all about the distribution of gold reserves!

Why do we provide so little inspiration to creative artists? Are our activities so boring and uninspiring? If we are represented at all in literature and the theater, why are we cast as seedy drunks or villains and not as heroes? I suppose that the discovery of a new macroeconomic model which survives rigorous testing is hardly material for some great dramatic work, unless its inventor has other, more glamorous characteristics. One recalls the famous story of Schumpeter, who is reputed to have told his graduate students that he had three ambitions in early life: to be the greatest economist in the world, the greatest lover in Vienna, and the best horseman in Austria. "What a pity," he sighed, "that I never learnt to ride a horse!"

There is another reason why economists are never likely to be heroes to the literati, though they may continue to be villains. Most economists can find some-

thing good to say about the market economy, but most artists regard the market economy with suspicion and hostility. One can hardly blame them. They are rarely trained to face its rigors and many go so far as to claim that they should be immune from all market pressures. Nor can one derive much inspiration from taking a balanced view of the performance of the economy. The vision of an ideal, unselfish world contrasting with the evils of capitalism is much more appealing to the tunesmith, lyric writer, and novelist than an apologia for big business, if only because such a vision sells better in the wicked free market! I have no evidence to suggest that Ezra Pound refused any royalties derived from his attacks on usury.

So my conclusion must be that if we economists want to improve our image through the medium of culture, we must do so ourselves! For those who quail at the thought, think again and take courage from our intellectual forebears and even our contemporaries. Adam Smith wrote delightfully about the Italian sonnet and the music of Pergolesi, and, after all, *The Wealth of Nations* is something of a literary as well as an intellectual tour de force. Enrico Barone managed to combine mathematical economics with concoction of some of the earliest Italian film scripts. Pigou wrote his fellowship dissertation not on the economics of welfare but, believe it or not, on Robert Browning, the poet. My predecessor in Edinburgh, Sir Alexander Gray, wrote some remarkable poetry and translated the poems of Heine used in Schumann's *Dichterliebe* into lowland Scots. Gray's erstwhile assistant, Kenneth Boulding, writes superb doggerel verse. David Throsby, coauthor of *The Economics of the Performing Arts,* is both a playwright and a flautist. Henry Phelps Brown, the well-known labor economist, wrote a novel about the Battle of Dunkirk—long before J. K. Galbraith got round to this art form. Bill Baumol and Richard Goodwin are painters, and Abba Lerner is a sculptor.

Now I realize that our polymathic colleagues do not choose their main profession as artistic subject matter, though their activities, if better known, might excite some sympathetic response among the cultural elites and improve our image in that way. The real masterpiece in which the hero is an economist and the work is written by an economist has yet to be written. This is not such a wild idea. Take composers: Rimsky-Korsakov wrote a one-acter based on the unlikely story that the composer Salieri poisoned Mozart; Flotow wrote an opera about the composer Stradella (who was a very wild lad), and Franz, one about Paganini.

A play or opera written by one of us on the love life of Alfred Marshall would be difficult to conceive, and I am not sure that one really does much better by following Keynes's cavortings in Bloomsbury. However, I do have one positive suggestion. Not far from Edinburgh there was born and lived a remarkable economist who did lead an exciting and interesting—that usually means dissolute—life, and that was John Law of Lauriston. In his early twenties he killed a man in a duel and was forced to flee to Paris. He practically invented paper money and became a friend of princes, a prodigious gambler, and a womanizer. Then he was obliged to leave France for Venice—like Casanova—and died there in penury. It is a veritable Rake's Progress.

Now that operas and plays have all sorts of happenings, perhaps one could throw in the John Law Lecture on the Quantity Theory of Money garnished by electronic music. We have missed a glorious opportunity to sponsor a work of art based on Law's life and times, for 1979 was the 250th anniversary of his death. Perhaps there is some unsuspecting foundation—probably an unsuspecting foundation is a contradiction in terms—even at this stage ready to pour money into this great scheme to elevate the economist to the position of the modern equivalent of Renaissance Man. No, that is too fanciful and too ambitious. We shall first of all have to devote our cultural talents not to the elevation of the economist but to his restoration to the human race, and some mean-minded people might say that that is going to be difficult enough!

The Arts in Economics: Conventional, Institutional, and Neoinstitutional

Roger M. Troub

THE ARTS HAVE PROVIDED conventional economics and institutional economics with almost as much difficulty as has religion. The trouble, however, does not permit rejection, for art obviously falls within the goods and services category and therefore should be encompassed by economics. Still, art seems different. It just doesn't neatly comport with the categories of consumer and producer behavior theory, the national income accounts, or the American Economic Association's topic classification system. The "A" section in the index to the classification schedule of *The Journal of Economic Literature* contains entries for accounting, advertising, agriculture, air transportation, aircraft manufacturing, aluminum industry, atomic energy, and automobile manufacturing—but none for art. Perhaps this treatment, or rather the lack of it, results from too great a diffusion in the activities which might be included within an arts category; perhaps the arts are too patently dissimilar to be considered as an "industry"; perhaps economists just have not known what to do with the arts or have not deemed them important.

Efforts in recent years to establish and sustain economic analysis of matters associated with the arts, as represented by work found in the *Journal of Cultural Economics,* appear largely to follow the lead of Baumol and Bowen by applying conceptual and analytical tools from the inventory provided by conventional economics (Baumol and Bowen 1966). Important insights have been and can continue to be secured from this approach.[1]

Institutional economics can also provide an understanding of cultural phenomena and the circumstances of the arts in the economy, but it too has difficulty addressing the arts satisfactorily.[2] In some of the work of neoinstitutionalists (Kenneth Boulding's revolutionary theory of societal processes, in particular) conceptions of man and society are being redefined and articulated in a manner which suggests different perspectives on the problems encountered in both con-

ventional and institutional economics. The neoinstitutionalists have not adequately addressed the arts either, but the work of Boulding contains ideas which appear promising in their potential for a different, but complementary, approach to gaining insights into the arts in the economy and in the larger context of society.

Here, then, is an illustrative and necessarily incomplete survey of the treatment of the arts in conventional economics, American institutional economics, and neoinstitutional economics and some suggestions for possible associations among them as complementary research programs investigating the arts in the economy.

SOME PRELIMINARY OBSERVATIONS:
ART AND "THE ARTS"

According to Jacques Barzun, ". . . even though art today is a public institution, it is an institution without a theory. No coherent thought exists as to its aim or *raison d'être*" (1974, p. 7). Instead, art is involved in a host of institutions, and there are several contending "theories" about its functions and objectives.

Identification of the nature and functional characteristics of art is not as important for the purposes of conventional economic analysis of the arts as it is for the purposes of institutional and neoinstitutional economic analysis. And granted that art, like equity and liberty, is difficult if not impossible to define satisfactorily for all purposes, for the purposes here it is adequate to note that art is basically a process which generates efforts to reify human ideas about what can and cannot be and what should and should not be. Art entails conceptions in human imaginations, activities undertaken in response to those conceptions, and the experiences associated with both the conception and the subsequent reification activities which may generate a sense of fulfillment of expectations or the surprise of new discovery or both. It is, then, a serial or simultaneous process comprised of human imagination, production of artifacts, and resulting experiences ("consumption") which may involve new understandings (learning) or tend to confirm prior ones. As a multidimensional affair, art can be usefully examined from a number of perspectives: as a consumer good, as a production activity, as a private and/or public capital good, as technology, as concept, as action, as an instrumental approach to metaphysics, as communication, and so on.

CONVENTIONAL PERSPECTIVES

The arts were given scant attention by Adam Smith in *The Wealth of Nations*. He accorded them only limited value as neutral or mildly legitimate factors in political economy and politics, but he did not do so with Plato's strident hostility toward artists.[3] Smith noted that in ancient Greece music was taught to every free citizen, reportedly "to humanize the mind, to soften the temper, and to dispose it for performing all social and moral duties both of public and private life" but observed that "it seems probable that the musical education of the Greeks had no great effect in mending their morals, since, without any such education, those of

the Romans were upon the whole superior."[4] Never did he recognize an important social role for the arts, that of expanding freedom of inquiry and other behavior through "public diversions." He suggested state support for liberty for the arts only to counter the structures imposed on thought and behavior by "all the little [religious] sects into which the country was divided" as a remedy in addition to "the great antidote to the poison of enthusiasm and superstition," knowledge of science.[5]

Alfred Marshall in his *Principles of Economics* mentioned painting and music, but merely to illustrate a point. Also, in discussing education he said that "development of the artistic faculties of people is in itself of the very highest importance, and is becoming a chief factor of industrial efficiency."[6] In explanation, however, he stated that it was the visual arts, "almost exclusively," of which he was speaking, since they made important contributions to industrial design and progress: "For though literature and music contribute as much and more to the fullness of life, yet their development does not directly affect, and does not depend upon, the methods of business, the processes of manufacture and the skill of artisans."

In short, conventional economics has accorded little attention to the arts and has included some rather curious notions about the association between the arts and the economy; but over the past several years conventional economics has focused on the arts industries with growing frequency. In part this has resulted from the arts boom; in part probably from subtle changes in some economists' thoughts about the relative contribution of the arts to well-being in affluent countries;[7] and in part, as Mark Blaug has said, from "the eagerness of economists to apply their tools to hitherto untried areas and the recognition by arts administrators of the increasing economic pressures of the arts" (1976). Indeed, the concepts and analytical approaches of conventional economics have become important in contemporary discussions of public support for the arts, alternative public arts policies, and arts administration. The research of economist Dick Netzer, reported in his *The Subsidized Muse: Public Support for the Arts in the United States* (1978), for example, was initiated and supported by the Twentieth Century Fund in response to his critical review of the arguments for large public subsidies (1974).

What has emerged is an economics *of* the arts (economic analysis of demand and supply characteristics of various arts industries and of associations with other industries and the economy), *in* the arts (analysis of resource allocation decisions in arts administration), and *for* the arts (analysis of the case for public support, the efficiency of various levels and types of support, and so on).[8] The perspectives, analytical tools, and empirical approaches of conventional economics have proved highly useful in providing insight into a number of matters.

Analysts have drawn on consumption, production, industrial organization, and welfare theories, as well as other concepts in the conventional inventory. Difficulties, however, are sometimes encountered. In some important areas the concepts can be applied more neatly and less ambiguously to activities other than the arts. As Netzer noted, "Almost everyone considers the arts something different

from the goods and services that we leave to the mercies of the marketplace" (1978, p. 15).

Problems arise in at least three overlapping areas. First, if the arts are different from other commodities and services, how do they differ and how are they to be appropriately thought of in the context of components and operations in the economic system? Second, there are problems in identifying, measuring, and determining the relationships among important variables. Of course, these are problems inherent in economic analysis, but for the arts less background work and useful data exist than for many other applied areas of analysis. Third, there is an area of problems associated with decision criteria and decision-making arrangements for optimal social welfare. This area includes the well-known problems of welfare theory (such matters as indeterminacy of optimal choice in plausible collective decision situations, public goods, and differences between private benefits and costs and social ones) and problems posed by matters beyond the scope of conventional economics—in particular, taste and preference formation and the possible relevance of the concept of merit goods in the case of the arts.[9] As additional work is undertaken, further progress can be expected from conventional approaches in the first two problem areas. The third, however, seems to require the introduction of unconventional perspectives.

AMERICAN INSTITUTIONALISM

Institutional economics is almost as varied and difficult to define as is art. It is not a school of thought but rather a grouping of scholars identified by some more or less common characteristics. These include greater attention to the formation of configurations of tastes and preferences in the society, the longer term dynamics of the economic system, and the roles of changing "habits and beliefs" (tastes and preferences included) and social organizational structures in explaining economic behavior within societal dynamics.[10]

As was the case until recently with conventional economics, institutional economics has concentrated on matters other than the arts. One of the themes running through much of the frequently disparate thought of the early American institutionalists is that culture and economy are interdependent and more or less simultaneous determinants of each other. Many, though surely not all, would probably not have been uncomfortable with the composite view to be sketched here, a view not uncommon in contemporary social science.

The suffusive arts and styles of a society reflect tastes and functions. In a culture structured in a hierarchical manner, belonging to a rank prescribes tastes largely through emulation among its members and proscribes them through strong or weak sanctions for nonmembers. These arts and styles are appreciated for the desired stimuli associated with belonging (that is, signals of shared emotions, world view, and life experiences). They serve as stabilizers in patterns of societal organization. Moreover, the tastes and views involved determine an important portion of the alternatives considered and the criteria employed by the

various decision makers in the economy and thereby (as posited by conventional analysis) contribute to the determination of responses to the basic allocational questions of what, how, who, where, and when.

Artistic creativity and the workmanship of the artist, however, can be distinguished from each other and from arts and styles in the culture. The workmanship of the artist is technology, but artistic creativity involves inquiry and discovery.

Good workmanship in artistic artifacts of social value contributes crucially to that value, and artistic creativity, along with technological and scientific creativity, contributes to human progress (the dynamic growth of social value). The artifacts resulting from artistic creativity and the qualities of workmanship involved are important inputs into further artistic creativity. The arts, then, as organized sets of institutions, can be evaluated in terms of their workmanship and creativity dimensions for purposes of analyzing their current value productivity and their contribution to economic progress.

These views comport in good measure with those of Thorstein Veblen, the largest figure in early American institutionalist thought and C. E. Ayres (1891-1972), "the leading American institutionalist economist in the post-World War II era."[11] Ayres employs the famous Veblenian dichotomy between technological (progressive and dynamic) and ceremonial (restrictive and ossified) behaviors in human social systems to explain economic circumstances and processes and the general nature of their dynamics (Ayres 1961, 1962).

In contrast to Veblen's populistic orientation toward the arts, Ayres has a "deep appreciation for both music and painting and their place in 'the technological continuum.' "[12] Ayres views artistic development as highly contributory to human progress. The contribution is more than that of a consumer good considered in isolation according to the varying value judgments of individuals. Instead, "we have placed a high valuation on esthetic experience generally. . . . not because particular esthetic experiences are enjoyable, but because we know it to be fact—attested by all and denied by none—that all experience of this kind is beneficial" (Ayres 1961, p. 154). To illustrate, he notes that "we set a low value on the enjoyment of opium and a high value on enjoyment of the arts because we know that one is harmful and the other beneficial—harmful and beneficial for all our other activities."[13]

There are at least three major interrelated problems with the institutionalist approach to the arts. First, how do artistic circumstances and changes interrelate with others in societal dynamics? Identification of such associations is not the same thing as identification of their dynamic linkages. Second, if creativity in the arts has different relationships with economic processes than other areas of creativity, what are they? Third, what identifies human progress, what is social value, and how is it to be estimated for decision-making purposes? Although Ayres provides responses to these questions, there are elements of circularity and seeming incapacity for reduction to quantitative magnitudes which are unsettling for the more limited purposes of conventional economic analysis.

PERSPECTIVES OF NEOINSTITUTIONALISM

Allen Gruchy marks the watershed between institutionalism and neoinstitutionalism as roughly 1939 and includes in the latter category such dissenters from orthodoxy as Ayres, John Kenneth Galbraith, and Gunnar Myrdal (Gruchy 1972). A. W. Coats has doubts about the appropriateness of any meaningful category termed neoinstitutionalist but recognizes Ayres as "manifestly of an intermediate generation" between the American institutionalist "triumvirate" (Veblen, Wesley C. Mitchell, and John R. Commons) and the "dedicated younger adherents of the Association for Evolutionary Economics" (Breit and Culbertson 1976, p. 24). The term neoinstitutionalism has some use, however, if merely to designate a broad category which covers those contemporary economists who share the view that economic analysis should encompass an understanding and explanation of economic circumstances and processes in the context of the societal dynamics in which they arise. As with the term institutionalism, the thinkers and their thoughts vary greatly.

Galbraith, as well as Ayres, may be viewed as an intermediary figure. Both examine the industrial economy of the United States in the middle "half" of the twentieth century. The emerging neoinstitutionalists seem to add to that a concern for economic problems, prospects, and policies in an era of changed perceptions about what the coming years may bring. But in one of his more recent books, *Economics and the Public Purpose* (1973), Galbraith devotes an early chapter to "The Market System and the Arts," partly in recognition of the changed prospects for economic development in the United States.

He argues that the nature of the arts as services provided by independent entrepreneurs restricts their conformity to the organizational type associated with the "planning system," and they are therefore left to the sector of the economy in which market forces have more free play. Noting the growth of general affluence combined with the diminishing benefits relative to the costs of growth in production of consumer products originating from industrial technology, Galbraith predicts that "over a longer period of time the arts and products that reflect artistic accomplishment will . . . be increasingly central to economic development" (Galbraith 1973, pp. 61–70). Because neither the market nor the private planning system of a large corporation will adequately provide for the arts, the public sector should do so as a matter of high priority.[14]

Kenneth Boulding has recently published a work of enormous scope and daring entitled *Ecodynamics: A New Theory of Societal Evolution* (1978). In it he sketches out what he hopes "is at least an approximation of a general system of the universe based on a synthesis of the contributions of many sciences" (p. 18). It is a general system of evolution. What evolves is information structure (knowledge) and evolution itself. Physical evolutionary processes have generated biological evolutionary processes, which have generated human societal evolutionary processes.[15] Although all three types of processes are evolutionary in nature, they differ significantly from one another. Economic processes and the questions of economics are important to Boulding's scheme, but his primary concern is with

the societal system. Moreover, only passing attention is given to the arts (Boulding 1978, pp. 336–337).

Nevertheless, Boulding offers a vision of societal processes which reformulates perceptions of man, society, and the context and nature of economic processes. He views "aesthetic, moral, and religious ideas and experiences as a species, in this case of mental structures or of images, which clearly interacts with other species in the world's great ecosystem" (Boulding 1978, p. 20). Human artifacts, including those produced by the arts, are also species. (Explication of the societal evolutionary processes Boulding identifies is too involved to be meaningfully undertaken here.)

The arts can be interpreted from the Boulding perspective as an important process of transmitting information to individuals and creating new information. The information structure encompasses preferences and "values." Boulding's vision also suggests that human teleological processes acquire greater potential importance through the operation of biological and societal evolutionary processes (that is, by increasing the amount of design relative to choices about adaptation to the apparent automaticity of environmental events). "The capacity for forming images of the future is a necessary prerequisite for behavior directed toward fulfilling them" (Boulding 1978, p. 132). Mutations in the image structure are inherent aspects of creating the future. If the arts involve leading-edge probes of what can and cannot be and what should and should not be, their potential relative importance in the longer-term determination of economic conditions and processes has grown. Boulding describes a progression from folk to literary to scientific knowledge as an ecological succession of sources of knowledge (Boulding 1978, pp. 133–139). If evolution itself evolves, could it be that there is potential for emergence of a process of knowledge generation involving the type of creativity associated with the arts which has long been acknowledged but remained mysterious?

There are several problems with Boulding's evolutionary perspective. First, the vision is not articulated to an adequate extent for many purposes. Second, although the evolutionary pattern of mutation and selection has great interpretive power, it has "remarkably little predictive power" (Boulding 1978, p. 326). Third, knowledge about the evolutionary process itself does not tell us anything about what value is, although it may reduce errors in beliefs about the nature and sources of value.[16]

ECONOMICS AND THE ARTS: COMPLEMENTARY RESEARCH PROGRAMS?

Over the decades economists working primarily from the conventional perspectives of the discipline and the minority group labeled institutionalist have frequently viewed one another with disdain, if not hostility. One of the several sources of conflict is mutual misunderstanding. Although there are significant differences in such matters as initial assumptions, perspectives, and methods, comparative analysis of the two has been structured almost completely in terms

of aspects deemed mutually exclusive for appropriate economics. Little attention has been given to associations of compatibility and complementarity which, I submit, are substantial and important.

Many of the differences which have been the focus of ongoing controversies can be perceived as complementary if it is recognized that the two approaches raise different questions and pursue them in different contexts, that both sets of questions are important, and that both contexts are of fundamental concern to social science. Conventional analysis begins with existing preferences ("values") and institutional structures and inquires into their efficiency through use of relative value theory, in which the subjective values of decision makers become transformed through the choices made into objective evidence of relative value magnitudes. From these indicators of preference structure, alternative changes in institutional arrangements can be evaluated for private or public policy purposes. Many institutional scholars consider an inquiry into how existing values and preferences and institutional structures (beliefs and behavioral patterns) evolved as a prerequisite to understanding contemporary economic arrangements and conditions.

Consequently, a different set of fundamental questions is involved. The larger purposes of both approaches are the same: to gain a better understanding of economic processes and to identify the choices and decision-making process characteristics most likely to lead to increases in human welfare. Since the questions differ, the research programs differ in their contexts, approaches and methods, and foci.

In a sense, it is a matter of each approach beginning at a different point in the circular dynamics of economic processes. If we break into those dynamics at any time, decision makers are confronted with beliefs about alternative changes (an opportunity set of "what could be" perceptions) and beliefs about their relative desirability (a set of preferences or valuation criteria derived from a set of "what should be" beliefs). This can be referred to as phase one. In phase two choices of behaviors are considered and made in pursuit of the best outcome, given expected circumstances. The behaviors generated result in experiences which can reinforce or alter the belief composition of both the opportunity set and the valuation criteria set. This is phase three. Conventional analysis tends to focus on the second phase, while institutional economics has tended to give primary attention to the third. From this perspective both appear incomplete but complementary in their aims.

Boulding's evolutionary vision, with its emphasis on learning and changes in images which generate changed circumstances, calls attention to the importance of the entire process of phases one to three and back to one again. Conventional economics emphasizes the notion that an understanding of individual units and individual actions is the basis for understanding the larger organizational characteristics of the economy. Institutional economics emphasizes the notion that individual actions are to be understood by reference to the nature of the societal structures and circumstances in which they arise. Boulding's evolutionary perspective emphasizes the view that an understanding of either societal dynamics or individual action requires an understanding of the interactive nature of both.

In this sense, the distinguishing analytic concerns of conventional, institutional, and neoinstitutional economics have resulted in complementary research programs designed to gain a better understanding of economic circumstances and processes.[17] Progress in each of the programs can yield insights into the role of the arts—a "something different" category of human behavior of growing importance to human welfare—in those processes. The arts might be better considered, in terms of understanding their nature, as consumption goods, social capital, and technology in human communication and learning. The problems of sources, nature, and measurement of value remain. I suspect, however, that the Ayresian instrumental theory of value gains appropriateness from the eco-dynamics perspective of Boulding and is in part complementary to conventional value theory when viewed from the broader perspective on man and society which seems to be emerging.

Much work remains for each research program. Meanwhile, the conventional one appears to have a great lead. Regardless of the progress since Veblen's time, as he said at the end of the last century, "the economic life processes still in great measure [are] awaiting theoretical formulation" (Veblen 1948, p. 229).

Notes

1. For example, see the collection of works edited by Mark Blaug, *The Economics of the Arts* (1976), and several articles in the *Journal of Cultural Economics*.

2. Institutional economics as a broadly conceived category includes a great variety of thought and thinkers. Here the term is used narrowly to refer to a rather small number of American institutionalists.

 Although some aspects of Marxian thought can be viewed as conventional and some as institutionalist in nature, these will not be addressed here. Marxian analysts might point to the aesthetics and art criticism literature which has developed from a Marxian analysis of culture and the arts in social dynamics as evidence of greater development and less difficulty than that confronted by either conventional or institutional economics.

3. An interesting explanation of Plato's attitudes towards the arts is provided by Iris Murdoch in *The Fire & the Sun—Why Plato Banished the Artists* (1977).

4. In discussing wage differentials, Smith noted that the "pecuniary recompence . . . of painters and sculptors, of lawyers and physicians, ought to be more liberal" as a result of more tedious and expensive educational costs.

5. Smith suggests that "The state, by encouraging that is by giving entire liberty to all those who for their own interest would attempt, without scandal or indecency, to amuse and divert the people by painting, poetry, music, dancing; by all sorts of dramatic representations and exhibitions, would easily dissipate, in the greater part of them, that melancholy and gloomy humor which is almost always the nurse of popular superstition and enthusiasm."

6. Marshall also commented that "Education in art stands on a somewhat different footing from education in hard thinking: for while the latter nearly always strengthens the character, the former not unfrequently fails to do this."

7. Tibor Scitovsky, in *The Joyless Economy: An Inquiry into Human Satisfaction and Consumer Dissatisfaction* (1976), has examined "Our Disdain for Culture" (chapter II, pp. 224-247) in the United States. He argues that narrow individual rationality is a major source of the problem and "that the remedy is to move to a higher or social

rationality. . ." (p. 247). He argues further that the nature of technological advance has been such that the cost of producing "novelty and its stimulus" has grown relative to that of producing comfort (p. 259).

8. Again, for examples see the articles published in the *Journal of Cultural Economics* and in *The Economics of the Arts*.

9. The problem areas are recognized (implicitly and explicitly) if not resolved in several of the writings in *The Economics of the Arts*.

10. David Hamilton devoted the first chapter of his *Evolutionary Economics* (1970, pp. 7-17) to a survey of various opinions over the years as to the core differences between classicism and institutionalism. He concludes that the evidence from the "testimony" indicates "the concept of change to be an important distinguishing mark of institutional economics" (p. 16).

11. Breit and Culbertson (1976, p. 3). Veblen's views on art and style are scattered among his writings but perhaps are most easily introduced through the first nine chapters of his well-known *Theory of the Leisure Class* (1899).

12. Breit and Culbertson (1976, p. 6). As Breit and Culbertson note, Ayres frequently referred to great works of art in his lectures and writings. For examples in explanation of technological progress, see chapter 6 of *The Theory of Economic Progress,* (Ayres 1962, pp. 106-124). A substantial portion of chapter 12, "Reason and Ecstasy," of *Toward a Reasonable Society* (Ayres 1961) is devoted to the arts.

13. Ayres (1961, p. 154). It should be noted that Ayres viewed artistic technology as distinct from other types, and though he considered it highly important for human progress, he seems not to have viewed art as a primary source of "ideals" which identify the direction of human progress.

14. "There should be a special presumption in favor of public support and assistance for the arts" (Galbraith 1973, p. 301).

15. Boulding's societal evolutionary processes differ in type from those of "the new discipline of sociobiology" which "is a product primarily of the biological sciences and extends the Neo-Darwinian theory of evolution to the evolution of animal behavior" (Boulding 1978, p. 20).

16. In his foreword to *The Challenge of Humanistic Economics* (Lutz and Lux 1979, pp. v-vii) Boulding indicated general approval but expressed doubt about specific aspects of a recent effort to formulate a humanistic economics.

17. See Mark Blaug, "Kuhn Versus Lakatos, or Paradigms Versus Research Programs in the History of Economics" (1975, pp. 399-433).

References

Ayres, C. E. 1961. *Toward a Reasonable Society: The Values of Industrial Civilization.* Austin, Texas: Univ. of Texas Press.

_____. 1962. *The Theory of Economic Progress: A Study of the Fundamentals of Economic Development and Cultural Change.* 2nd ed. New York: Schocken Books.

Barzun, Jacques. 1974. *The Use and Abuse of Art.* Princeton, N.J.: Princeton Univ. Press.

Baumol, William J. and Bowen, William G. 1966. *Performing Arts—The Economic Dilemma.* Cambridge, Mass. and New York: M.I.T. Press and Twentieth Century Fund.

Blaug, Mark. 1975. Kuhn Versus Lakatos, or Paradigms Versus Research Programs in the History of Economics. *History of Political Economy* VII, no. 4: 399-433.

_____, ed. 1976. *The Economics of the Arts.* Boulder, Col. and London: Westview Press and Martin Robertson.

Boulding, Kenneth. 1978. *Ecodynamics: A New Theory of Societal Evolution.* Beverly Hills, Calif.: Sage Publications.

_____ 1979. Foreword to *The Challenge of Humanistic Economics*. Mark A. Lutz and Kenneth Lux. Menlo Park, Calif.: Benjamin Cummings Publishing Co.

Breit, William and Culbertson, William P., Jr. 1976. Clarence Edwin Ayres: An Intellectual's Portrait. In *Science and Ceremony: The Institutional Economics of C. E. Ayres*. Breit and Culbertson, eds. Austin, Texas: Univ. of Texas Press.

Coats, A. W. 1976. Clarence Ayres's Place in the History of American Economics: An Interim Assessment. In *Science and Ceremony: The Institutional Economics of C. E. Ayres*. Breit and Culbertson, eds. Austin, Texas: Univ. of Texas Press.

Galbraith, John Kenneth. 1973. *Economics and the Public Purpose*. Boston: Houghton Mifflin.

Gruchy, Allen. 1972. *Contemporary Economic Thought: The Contributions of Neoinstitutional Economics*. Clifton, N.J.: Augustus M. Kelley.

Hamilton, David. 1970. *Evolutionary Economics*. Albuquerque, N.M.: Univ. of New Mexico Press.

Murdoch, Iris. 1977. *The Fire & the Sun—Why Plato Banished the Artists*. Oxford: Clarendon Press.

Netzer, Dick. 1974. Large-Scale Public Support for the Arts. *New York Affairs* 2, no. 1: 76–88.

_____. 1978. *The Subsidized Muse: Public Support for the Arts in the United States*. London: Cambridge Univ. Press.

Scitovsky, Tibor. 1976. *The Joyless Economy: An Inquiry into Human Satisfaction and Consumer Dissatisfaction*. London: Oxford Univ. Press.

Veblen, Thorstein. 1948. Why Is Economics Not an Evolutionary Science? In *The Portable Veblen*. New York: Viking Press. Reprinted from *The Quarterly Journal of Economics* XII (July 1898): 373–397.

PART ONE

Public Support for the Arts

Introduction

THE DEBATE OVER PUBLIC SUPPORT for the arts has as rich a scholarly heritage as can be found anywhere in the arts and economics literature. The recent history of this debate can be traced to Baumol and Bowen, *Performing Arts—The Economic Dilemma* and to "debate" between Lord Robbins and Alan Peacock. Numerous economists have since entered the fray. Attempts to find a rationale for public support can be found in *The Economics of the Arts*, by Mark Blaug (1976), *The Subsidized Muse*, by Dick Netzer (1978), and a symposium on "Public Support for the Arts" published in the *Journal of Behavioral Economics* (1979)—notably the paper presented by David Cwi. Thanks to these efforts, we can draw certain tentative conclusions:

1. At least according to economic theory, art goods themselves are not public goods. In policy terms, the conditions of supply may be made "public," but economic theory is clear on the definition of public good and on the resource allocation problems. Public finance application as an attempt to make an economic argument in support of governmental interference in dollar resource allocation only confuses the definition of public good. Even the presence of externalities does not by definition make a good "public." One might go so far as to say that economists unwittingly have provided credibility to the practices of government as an economic agent.

2. In economic theory a necessary *but not sufficient* condition for a pure public good is that it can be jointly consumed perfectly. The exclusion principle says that the product, though jointly consumed, can be provided in separable units to various consumers. Since admission to an artistic event (or right to use) can be provided in separable units, the exclusion principle is operable in the arts.

3. Economic theory clearly states that inefficient allocation of resources will exist for a jointly consumable good if (1) a free rider (concealed demand) is possible because he or she cannot be excluded, or (2) the suppliers cannot gauge the collective demand sufficiently for the product to be provided in sufficient quantities. Of course, the free rider only compounds the error in predicting demand. However, without the idea of the free rider, the problem of planning production in anticipation of actual use applies equally to national sporting events and the arts.

4. The merit good argument is a political argument, not an economic one, a point that has needed to be made for some time. For public monies to be used for arts subsidies, we must be able to show either that the public interest will be served directly or at least that the special interests served are widely accepted as desirable social objectives.

5. "Market failure" applied to the arts is really a merit good argument one step removed: demand for (certain) arts ought to be greater, or supply ought to be greater or better in certain markets. Actually, in some instances, the market is not failing; rather, it is simply not providing the market solutions desired by those who tout the widespread merit of the arts.

6. The more definitive externalities generated by the arts usually flow to special interest groups, a fact which probably is not generally accepted by the larger public.

The papers in this section follow two themes: David Austen-Smith and Hans Abbing penetrate beyond the points made above in search of a basis for providing public support. Steve Globerman, Bruce Seaman, Robert Hutchison, and John Caff focus on the impacts of established public support policies in Canada, the United States, and the United Kingdom.

David Austen-Smith asks if public support of the arts can be justified on the basis of economic reasoning in "supposedly liberal democratic societies." Perhaps so, he concludes, but justifications must ensure that the values implied in the reasons are compatible with those of society. Austen-Smith constructs a conceptual framework for examining possible rationales to justify the subsidy for policymakers in the absence of stated objective functions.

Justification requires a sufficient set of reasons for providing subsidy to the arts that (1) is consistently applied in all instances in which these reasons prevail, and (2) includes at least value judgments consistent with the tenets of liberal democracy which logically bind others to the decision to subsidize if they find the reasons valid. On this basis, Austen-Smith examines the litany of extrinsic (market failure) arguments and intrinsic (merit good, quasi-economic) arguments for subsidy and concludes that neither group alone suffices. He leaves open the possibility that justification may exist; however, it would have to be some combination of the two.

Hans Abbing establishes a public support rationale for the arts by arguing that, while most art products are marketed in divisible units to buyers, obscured in most cases is the fact that many aspects of artworks can be freely consumed; ergo, they are public goods. Furthermore, public support for the original production is needed because development costs are high and the artist lacks property rights for the spin-offs of his or her creation. This paper also coaxes out the numerous ways in which the artist cannot exclude others from reproducing and translating his or her creation. Comparisons are drawn between art products and industry products and between artistic innovations and scientific innovations.

The papers by Seaman, Globerman, and Hutchison have a common focus in that each addresses some aspect of the impacts that public support for the arts has on the private sector or market role.

Robert Hutchison raises questions about the pricing policies of arts providers—principally in the United Kingdom—as a result of the presence of public support. His concern is that performing arts prices in Britain are lower than needed to attract the numbers and composition of the present audience and that the public subsidies used to make this possible could be better used to support other arts activities.

In a brief note John Caff describes the extent of government support of artistic endeavor in the United Kingdom in terms of stated policy objectives, categories covered, and monies spent.

As a matter of public policy, according to Steve Globerman, we should be able to show the impacts from increased public support of the arts in the United States and Canada. Are there more arts organizations, more arts productions, or increased opportunities for artists to work in the arts? In short, how have arts organizations, artists, and audiences and patrons responded to increased support? Comparisons are made between Canada and the United States, based on the initial work of Dick Netzer reported in *The Subsidized Muse*.

Bruce Seaman investigates the nature of the interaction among the various sources of financial support to community nonprofit arts organizations—in particular, that between local government and local private individuals. At issue here is the potential for an unintended impact of government subsidy, namely, the reduction of private contributions. Findings suggest, however, that local government may see itself as a residual source of support by providing lower subsidies in the presence of higher private contributions.

A POSTSCRIPT

The economic concern in the study of the arts has been either with artistic endeavor as a public good or with the problems faced by nonprofit arts institutions. The importance of this distinction between artistic endeavor as constituting or generating public goods and the economic dilemma of artistic organizations has not been appreciated fully. To the economist, the contemporary outlets for display of current and past artistic endeavor—the arts institutions—are not providing public goods, and in many cases it cannot be assumed that they have the public interest at heart any more than has other private industry. It is this distinction that implicitly separates the perspective of Abbing, in his effort to find public goods which flow from cultural processes and artistic innovation, from that of David Throsby, who senses the need for government to impose cultural policy on arts organizations in the allocation of public support. (See C. D. Throsby's paper, "Multiple-Objective Allocation Procedures in Arts-Funding Decisions" in Part Four of this volume.)

On Justifying Subsidies to the Performing Arts

David Austen-Smith

T HE PROBLEM OF JUSTIFYING subsidies to the arts is an important one in sup-
posedly liberal democratic societies, where any redistribution of resources
solely on grounds of taste is generally considered illegitimate. This is especially
true when the redistribution favors a relatively wealthy and well-educated mi-
nority, as in the case of the arts. Economists have looked for some justification
on the grounds of inefficiency. And, for the performing arts sector at least, mar-
ket failure arguments do entail positive net subsidies. Unfortunately, as Peacock
(1969) recognized, this result alone fails to vindicate the provision of public
monies. The conclusion reached is that the decision to provide such subsidies
must be purely political: it is none of the economist's business qua economist.
Thus, Lord Robbins observes:

> . . . it is a question of ultimate values, a question of what you believe to be
> the purpose and function of the authoritarian element in society, a question
> of political philosophy. . . . Economics comes in only when you want to
> know the implications of your decisions in this respect, implications as re-
> gards the proportions, incentives and machinery. (1971, p. 3)

Drawing a sharp division between the why and how of subsidy, Lord Robbins im-
plies that the economist can legitimately engage in prescriptive subsidy analysis if
and only if the policymakers' preferences are known. Blaug notes: " . . . if we
cannot discover his [the policymaker's] preference function, we can neither eval-
uate his past decisions nor improve his future ones" (Blaug 1976, p. 135); and
Godley remarks, "But if this statement is accepted, that the scale and distribution
of subsidies to the arts is part of a complicated political decision . . . the econo-
mist *qua* economist may not be left with much at all to say" (Godley 1977,
p. 135).

But the Robbins position is unduly restrictive. Its tenability rests on an implicit contention that there is no necessary relationship between the policymakers' preference schedule—whether or not it is explicit—and the reasons underlying the political decision concerning subsidy per se. This contention is false.

A CONCEPT OF JUSTIFICATION

In the sequel the policymaker is referred to as the state and is assumed to be unique and consistent. A case can be made for the first assumption on grounds of "collective responsibility." Despite possible differences in view among members of any policymaking committee, if a decision is reached, there is an official perspective, and this is the relevant issue here. It is clear that the impossibility results of social choice theory are irrelevant. The second assumption is considered a normative requirement of the state.

We wish to show that there exists a necessary relationship between the reasons for the political decision to subsidize (the arts) and the state's objective function. That there is some connection is obvious, given consistency. However, a stronger result can be established—if the state can justify its decision, then the justification essentially implies the relevant objective schedule. Although the detailed argument (based on the philosophy of practical reasoning) is inappropriate here, some elucidation is necessary.

First, note that subsidizing is a consequential act. Given consistency, the state must be capable of offering a set of reasons for the decision to act. Two types of rationale are possible: *explanation*—the rationale explains the decision if the decision is made intelligible to any inquirer who understands the statement of the constituent reasons; and *justification*—the rationale justifies the decision if any inquirer (who understands the statement of the reasons) would also reach that same decision if faced with that set of reasons. In other words, a justification is a sufficient set of reasons for a decision, while an explanation is not. An inquirer might accept an explanation yet contest the correctness of the decision. Acceptance of a justification, however, rationally commits the inquirer to the same decision. The reason for this distinctive feature is that justificatory arguments always contain at least one value judgment carrying practical force, for example, "the state ought to provide work for artists." Assuming the set of reasons is fully coherent and contains such a premise, sufficiency of the argument for the decision is guaranteed. Any dispute an inquirer might have regarding some agent's (justified) decision, therefore, must revolve about either the tenability of the value premise or the empirical truth of the content of the other premises (reasons) of the argument.

We are now in a position to establish the stronger result mentioned earlier. Subsidizing is an act undertaken for its consequences; given consistency, these consequences must be at least implicit in the rationale for the decision to subsidize per se, since (by assumption) this is a justification, a sufficient set of reasons. The (state's) objective function merely describes these consequences, which must be economic in the first instance—subsidy has an overtly economic impact. Therefore, the objective function must be at least implicit in the justification for subsidy.

This result exposes the relationship between the why and how of subsidy. In particular, it asserts that knowledge of the why gives the economic analyst considerable guidance as to the how of subsidy. When the policymakers' objective functions are not readily available (as they rarely are for arts support), finding a justification for state intervention is of practical value to the analyst.

THE ARGUMENTS FOR SUBSIDY

Two types of rationale for subsidizing the performing arts can be identified. Arguments of the first type rest on grounds extrinsic to these arts per se—subsidies to the arts are justified because of something else. The second type of argument attempts to justify subsidies on grounds of the intrinsic merits of the arts. I shall argue that either entirely extrinsic or intrinsic arguments for subsidizing the arts cannot, in general, be justifications. Purely intrinsic arguments embody values which conflict with those of a liberal democracy, while purely extrinsic arguments are usually insufficient for a decision and may also generate inconsistencies.

Extrinsic Arguments

Most extrinsic arguments refer, either explicitly or implicitly, to market failure in the technical (Paretian) sense. It is well known that in general the free market will fail to achieve an efficient allocation of resources when any or all of the following phenomena are present: indivisibility, uncertainty, and inappropriateness. There is good reason to suppose that this is the case in markets for the arts. However, for market failure per se to provide a sufficient reason for the decision to subsidize, either the Pareto criterion has to be accepted as a normative rule, or a relevant social welfare function must entail correction of the germane types of inefficiency.

Consider the first option. The Pareto criterion is accepted as a normative rule if, when it is possible to make at least one person better off (according to that individual's own evaluation) without simultaneously making someone else worse off, then, ceteris paribus, such a policy should be initiated. (I consider only the strong form of the rule for brevity.) I shall call this the Pareto Judgment. Acceptance of the Pareto Judgment is, I think, a weak requirement if the domain of its application includes all possible features and states of the world. It is considerably less acceptable if its domain is restricted to some commodity space only because correction of a market failure might, for example, generate an unacceptable distribution of income. Thus, although inefficiency in markets for the arts can constitute a prima facie reason for public intervention in these markets, it cannot be a sufficient reason unless inefficiency per se is also a necessary condition of state intervention, because market inefficiency is defined in terms of resource allocation only, given a distribution of income (which typically is not "ideal").

At the conceptual level, the demand for market inefficiency to be a necessary condition of state intervention is very strong. In particular, it rules out moves to-

ward achieving any social goal not involving correction of such inefficiency. At the operational level, the demand is untenable. This assertion is adequately supported by observing that the state does act on the basis of criteria other than market failure. Given consistency, therefore, the state cannot claim that inefficiency in markets for the performing arts justifies the decision to intervene in these markets, for making such a claim would entail acceptance of the Pareto Judgment, and the state would then be rationally committed to intervene in all cases of market failure. Since it does not do this, either the state is inconsistent—which is not permissible—or it is employing some additional reason(s) to explain why inefficiency in markets for the arts is subject to the Pareto Judgment, while other cases of market failure are not—which renders the argument, as it stands, insufficient.

That market failure arguments alone cannot justify subsidies to the arts does not, as noted above, mean that inefficiency cannot provide some reason for the decision. This fact relates to the second option mentioned above, that a relevant social welfare function entails correction of inefficiency. For example, the state may be committed to intervention in markets where the extent of increasing returns is greater than some given tolerance level. Indeed, an analysis of market failures commonly encountered in the arts suggests that the expected cost of corrective subsidy is always positive. The state can then assert that the free arts market is inefficient enough to warrant support, given the underlying social welfare function. If (1) the empirical assertion is correct, (2) all other markets known to be at least as inefficient (in the relevant ways) as the arts markets are also being supported, and (3) the underlying social welfare function is legitimate for a liberal democracy, then this argument for subsidizing the arts—which is certainly an extrinsic rationale—is a justification. In this argument the social welfare function works in the same way as the Pareto Judgment in the argument based on the first option discussed above; both supply the required value carrying "practical force." But here it is not market failure alone which motivates the subsidy. The difficulty with this argument is unequivocally establishing the extent of inefficiency in any market. Because this measurement problem is pervasive, the argument, operationally, is not very robust. Consequently, while admitting the validity of employing market failure as a reason in any justification, I conclude that using it to establish the case for subsidy is not a viable strategy.

The only class of extrinsic arguments other than that based on market failure is that based on some particular notion of justice or goodness. Two well-known examples of such notions are (1) Benthamite utilitarianism—act so as to maximize the average level of (cardinal) utility, and (2) Rawls's maximin rule—act so as to maximize the welfare of the worst-off member of society. There are not, as far as I am aware, any conceptions of equity which are not formally compatible with the Pareto Judgment when it is applied to its widest domain. That is, even if some inefficient allocation of resources (E) were preferred by the state to a feasible and efficient allocation according to equity criteria, there could exist some other efficient and potentially feasible allocation which would be preferred to E.

Ideas of equity presuppose some idea of what is just. Therefore, equity considerations can function as value premises in a sufficient set of reasons for the

state's decision to subsidize (for example, X is just; therefore, X ought to be brought about). The question is then whether an extrinsic justification involving equity and market failure reasons can be consistently applied by the state to intervention in the arts markets.

Consider the following statement:

> We generally take it as an article of faith that it is undesirable for anyone to be kept from achieving as much as he can through the abilities with which he is endowed. . . . One may well argue that the extremely narrow audience for the arts is a consequence, not of limited interest, but of the fact that a very large segment of the community has been denied the opportunity to learn to appreciate them (because of having no access to theaters etc.). (Baumol and Bowen 1966, p. 379)

This statement is typical of equity-based arguments and can easily be accommodated with inefficiency reasons. The authors assert that some commodities or activities exist for which personal purchasing power should not be the sole determinant of consumption opportunities. There is also a supposition that people would voluntarily consume the arts if they had the opportunity (which their budget sets do not include).

Thus, the equity argument claims that some tastes are common to all members of the society or "to large numbers of people in all sections of society" (Williams 1962, p. 124) and that individuals should be permitted to gratify such tastes as far as social rather than individual resources allow. Subsidizing the arts, therefore, generates a more equitable—and perhaps efficient—allocation.

However, to assert that some commodities exist for which individuals' wealth should not be the only determinant of consumption opportunities is not to assert that "the performing arts" is one of these commodities. So the underlying equity rationale can be accepted without necessarily accepting that it applies to the arts.

I therefore conclude that this particular type of extrinsic argument is no more viable, per se, than the market failure rationales as a justification. In using it, either the state will be inconsistent or the argument will be insufficient—some other premise being required to explain why the arts are subject to such an equity condition.

Purely extrinsic arguments usually fail as justifications for state subsidy of the arts because they invoke only general value premises. In applying such a general argument to a particular case, such as in the arts, it is always legitimate to ask why the particular case is subject to the argument when other prima facie particular cases are not. Extrinsic arguments, therefore, are rarely viable justifications for subsidizing the arts. (But there is no reason why extrinsic arguments cannot be used in a justification so long as they are consistent with any other reasons advanced.)

There is one possible exception to this conclusion. It might be argued that subsidizing the arts increases the size of individuals' choice sets absolutely; realizable personal opportunities increase overall, which is desirable on libertarian grounds.

But as Bryan Barry points out, " . . . 'widening choice' by subsidy 'narrows choices' . . . by taxation . . . " (1965, p. 221), which is surely undesirable on the same grounds. This argument then reduces either to the equity rationale discussed above, if the incidence of choice set changes over society is considered, or to a Benthamite utilitarian argument, if the incidence is deemed irrelevant. The conclusion reached in the previous paragraph holds for the former case. It is the latter possibility which is the potential exception. The utilitarian argument is that the average level of utility is raised by subsidizing the arts. Waiving difficulties with the measurement of utility for the moment, the truth or falsity of this claim is an empirical issue. And even if it could be demonstrated to be correct, it remains unclear whether or not there exists some alternative policy not involving the arts which would generate a still higher level of average utility. But there is no way (given the present state of knowledge) of empirically establishing a utilitarian claim that arts subsidy is a necessary element of any aggregate utility-maximizing policy. Therefore, use of a cardinal utilitarian value here cannot be sufficient. Hence, this argument is not an exception to the conclusion that extrinsic arguments cannot, in general, constitute justificatory rationales.

Intrinsic Arguments

> The market mechanism is a splendid thing for ministering to wants and satisfactions that can be discretely formulated. But we oversimplify and run the risk of discrediting a fundamental institution if we claim that it can formulate demands for all the *necessary ingredients of the good society*. (Robbins 1963, p. 58; emphasis added)

> Arts will not get the public patronage they need without a fundamental change in public attitude. . . . Action must start with those who recognize *the arts as sheer necessities* and know that arts need money from us all. (Redcliffe-Maud 1976, p. 21; emphasis added)

Both these quotations express the view that the arts are a necessary input for the cultural ambience of a society, that a society having the arts is in some sense qualitatively superior to one not having them, and that such quality is an increasing function of arts supply and consumption. Given necessity and a state responsibility for the quality of life, this argument is clearly sufficient for state intervention in the arts markets (assuming that intervention can increase arts supply and consumption). Although the arts are being considered here as inputs into "the good society," it would be wrong to classify the argument as extrinsic, because the arts are seen as necessary inputs. And they are necessary because of what they are per se: the relevant first-order value is that the arts are intrinsically good.

If there is not a consensus within society on the goodness of a society with a high degree of arts activity—as both statements suggest there is not (if there were a consensus, then presumably there would be little need of justifying subsidies)—then the argument reduces to a claim that some tastes are better than others. The motivation of state support is thus paternalistic and the effect is a re-

distribution of resources among agents on grounds of taste. But it is a tenet of any avowedly liberal democratic society that "the game of pushpin is of equal value with the arts and sciences of music and poetry" (Bentham 1843, p. 253). Paternalism in individual tastes is fundamentally illegitimate—in which case the argument above violates consistency. This is especially true where the tastes relate to prima facie entertainment activities, as they do here. Furthermore, it is incompatible with the Pareto Judgment, since the latter requires the primacy of personal taste. The rationale for subsidy given in the two quotations, therefore, degenerates to a particular belief, the consequences of which are to be imposed upon society.

However, paternalism as a policy is generally predicated upon the belief that individuals do not always know what is good for them (what is in their interests as individuals), implying information deficiency or distortion. If individuals recognized the "true worth" of the particular commodity or activity, they would have no need of paternalism. It is held that individuals will eventually come to appreciate the efficacy of the policy. If this is not so, the policy ceases to be paternal and becomes dictatorial—which is ruled out by assumption. This conception of paternalistic action generates another argument for subsidizing the performing arts:

> . . . if children and adolescents are not exposed to artistic performances during their minority, by the time they become adults it will be too late. The arts must be made available early, while tastes are still being formed and behavior patterns developed. (Baumol and Bowen 1966, p. 380)

This type of argument concerns the education of minors and, by extension, "the satisfaction derived by the present community of economic decision-makers from conferring benefits on future generations. Even those who do not understand and appreciate music and drama may be glad to contribute to those whose tastes are not yet formed" (Peacock 1969, p. 330). The argument can be interpreted strictly within an orthodox welfare economic framework through preference interdependencies. But then the argument is a purely extrinsic one.

The other, not necessarily incompatible, interpretation of this rationale focuses on the well-being of the subjects of the argument rather than on the benefits accruing to donors. But as Baumol and Bowen point out: " . . . the logic of this argument . . . rests also on an allegation of fact which has yet to be tested: the hypothesis is that a taste for the arts is instilled by early experiences. No one seems to have any overpowering evidence that this is so" (1966, p. 380). The "also" in this statement refers to the required acceptance of the value judgment that society has a moral obligation to educate its minors (and/or provide for future generations) with respect to the arts. Some advocates of this rationale certainly hold this view. For example, Lord Redcliffe-Maud writes: "Such support for education in the arts is justified not only on strictly educational grounds but as a means of increasing further adult audiences by introducing young people to the theatre at an impressionable age" (1976, pp. 55–56). And Alan Peacock

writes, with respect to increasing education in the arts, in favor of "the possibility that such support may serve to alter the preference functions of future generations to create receptivity to the benefits of culture" (1969, p. 375). The widely acceptable judgment that the state has a responsibility to educate minors seems to be used here to further the less acceptable aim of altering or forming tastes to suit a particular concept of what tastes ought to be. As the argument stands, therefore, it is inconsistent. It suffers from the same defect as the previous rationale, namely, collapsing into a belief in a hierarchy of tastes which is to be imposed upon society.

The intrinsic arguments typically advanced, then, can be shown to be inconsistent in the context of a liberal democracy. And it has already been seen that purely extrinsic arguments can rarely be sufficient reasons for the decision to subsidize. (No direct attention has been paid to the internal consistency of arguments put forth by given authors [for example, Lord Redcliffe-Maud], but note that this feature is typically absent.) However, there may be some intermediate argument—one containing both extrinsic and intrinsic reasons—which is consistent and sufficient for the basic decision to subsidize the arts. Entirely extrinsic arguments (usually) fail because some rationales apply equally to commodities other than the arts which are not supported by the state, while entirely intrinsic arguments fail because they result in dictatorial assertions on the quality of various tastes (especially for prima facie entertainment). So it seems necessary to try to connect a value on the intrinsic desirability of the arts with some extrinsic reasons to construct a legitimate justification. I have been unable to find such an argument in the literature.

SOME CONCLUSIONS

Accepting the Robbins position—divorcing the why from the how of subsidy—Blaug and King attempt to infer a policymaker's (the Arts Council of Great Britain) preference schedule from past decisions. They conclude that the "Arts Council certainly has objectives—but most of them are too ill-defined to make evaluation possible" (Blaug and King 1973, p. 16). In view of the tight connection between justifying and allocating subsidies noted earlier and the discussion in the previous section, Blaug and King's conclusion is not surprising. However, the approach to analyzing justifications adopted in this paper suggests a constructive way forward. By examining the state's arguments for providing any subsidy at all, the analyst can arrive at the policymaker's (implicit) preference schedule. Where no consistent and sufficient argument is available, it is open to the analyst to construct a justification by ensuring that the values used in the construction are compatible with those of the domestic society. In doing so, it may turn out that there is more than one justification available, but asking policymakers to choose between rationales is less demanding from an informational perspective than trying to get them to provide suitable maximands. Alternatively, it may turn out that the decision to subsidize cannot be justified.

References

Austen-Smith, D. 1978. Skilled Consumption and the Political Economy of the Performing Arts. Unpublished Ph.D. dissertation. Cambridge: Cambridge Univ.

_____ . 1979. An Approach to Prescriptive Public Subsidy Analysis. Unpublished manuscript.

Barry, B. 1965. *Political Argument.* New York: Routledge and Kegan Paul.

Baumol, W. and Bowen, W. 1966. *Performing Arts—The Economic Dilemma.* Cambridge, Mass. and New York: M.I.T. Press and Twentieth Century Fund.

Bentham, J. 1843. The Rationale of Reward. In *The Works of Jeremy Bentham.* vol. II, J. Bowring, ed. Edinburgh: W. Tait.

Blaug, M., ed. 1976. *The Economics of the Arts.* Boulder, Col. and London: Westview Press and Martin Robertson.

Blaug, M. and King, K. 1973. Does the Arts Council Know What It Is Doing? *Encounter* XII, no. 3 (Sept.): 6–16.

Ford Foundation. 1974. *The Finances of the Performing Arts.* New York: Ford Foundation.

Godley, W. 1977. Review of *The Economics of the Arts. Economic Journal* 87 (Sept.): 578–580.

Mann, P. 1967. Surveying a Theatre Audience: Findings. *British Journal of Sociology* XVIII, no. 1 (Mar.): 75–90.

_____ . 1969. *The Provincial Audience for Drama, Ballet and Opera.* London: Arts Council of Great Britain.

_____ . 1975. *The Audience for Orchestral Concerts.* London: Arts Council of Great Britain.

Peacock, A. 1969. Welfare Economics and Public Subsidies to the Arts. *The Manchester School* XXXVII, no. 4 (Dec.): 323–335.

Redcliffe-Maud, Lord. 1976. *Support for the Arts in England and Wales.* London: Calouste Gulbenkian Foundation.

Robbins, L. C. 1963. Art and the State. In *Politics and Economics: Essays in Political Economy,* L. C. Robbins, ed. London: Macmillan.

_____ . 1971. Unsettled Questions in the Political Economy of the Arts. *Three Banks Review* (Sept.): 3–19.

Ruskin, J. 1857. The Political Economy of Art. Reprinted as A Joy For Ever (and Its Price in the Market). In *The Works of John Ruskin,* vol. XVI. London: George Allen, 1880.

Williams, B. 1962. The Idea of Equality. In *Philosophy, Politics and Society, Series 2,* P. Laslett and W. Runciman, eds. Oxford: Oxford Univ. Press.

Comment
Alexander Belinfante

A premise of David Austen-Smith is that a rigorous justification of subsidies for the performing arts cannot be based solely on either intrinsic or extrinsic grounds. But this is expected for almost any good or service that receives public subsidy. In general, justification of government expenditure on a public good re-

quires that there be (1) a public benefit in providing the good, *and* (2) a market failure causing the good not to be provided by the private marketplace. The second of these requires an extrinsic justification, while the first usually (but not necessarily) requires an intrinsic justification. Thus, a subsidy cannot be justified purely on intrinsic grounds and it probably cannot be justified purely on extrinsic grounds. Indeed, it is generally foolish to expect any single argument to provide complete justification for a subsidy.

What is generally done is to provide a collection of arguments, none of which can stand by itself as a justification, but which collectively might be used as such. Because of the collective nature of the arguments, they generally can be used to justify only the existence of a subsidy, not its level. The question of the level is usually, unavoidably, a political one. For example, even for such natural public goods as roads, the number of roads to be built is a political decision dependent on the value judgment by the policymakers of the relative merits of public versus private transportation, transportation versus the environment, and so forth. Thus, the policymaker who looks for a single argument to provide a justification for a subsidy for the performing arts faces an impossible task. Confronted with a set of choices, the policymaker should not choose just one but should pick them all and maybe add a few more.

I agree it is a mistake to completely separate the why and how of subsidy. It is quite likely that some types of subsidy are more easily justified than others; for example, public expenditure on a facility that can be used for the arts is easier to justify than a direct subsidy to the artists. Indeed, it might be possible to construct a purely extrinsic justification for subsidizing such a facility—especially if it is designed for multipurpose uses, including such nonarts activities as lectures and conventions—since then one can focus on the economic benefits to the community of having activities at the facility without being obliged to pass on the intrinsic merits of such activities.

On the Rationale of Public
Support to the Arts:
Externalities in the
Arts Revisited*

Hans Abbing

U P TO NOW economists have justified public subsidies to the arts in one of
two ways; they claim either that people underestimate the importance to
themselves of art consumption, considering that the arts are subsidized in order
to "educate" people, or that the next generations have to be protected against
our barbaric attitudes toward the arts.

Apart from special cases, neither of these two arguments is satisfactory. Both
presuppose an underconsumption of the arts, and this presumption is unrealistic.
Although art consumption has never been very extensive, it is increasing steadily
and is now more extensive than ever, particularly when we take into account the
impact of technical reproductions.

Thus, the arguments are based on an unrealistic assumption about the con-
sumption of art. On the one hand, they explicitly move the arts into a position of
exceptionality, a position contemporary artists want to get rid of, and since the
majority of economists favor as little interference with public preferences as pos-
sible, they resent patronizing motives. So as long as different arguments are lack-
ing, economists will be likely to oppose most public subsidies for the arts.

But what about externalities? Sometimes the second argument (protecting the
next generation) is cast in terms of external effects;[1] that is, people do not
consume art but still wish to preserve it. The "free riders," however, prevent
them from realizing this preference spontaneously, so government intervention is
required. In this way we drop the unattractive argument of meritocracy for one
concerning externalities. My impression is that Peacock thinks this is about the
only valid argument for public support (Peacock 1969). In actual practice we can
find evidence for the existence of such a preference. We observe campaigns for

*This paper, prepared for the First International Conference on Cultural Economics and Planning
(Edinburgh, 1979), has been commissioned by the Dutch Ministry of Culture, Recreation, and Social
Welfare. I have drawn upon chapter five of my book, *Economie en Cultuur* (1978), commissioned by
the same ministry. English and French versions of the book will be published in 1980.

the preservation of one thing or another and we come across legacies left to the community. Sometimes externalities of a more pedestrian nature have been noted, mostly to supplement the previous arguments. Examples include contributions to tourism, national prestige, and local industrial activity. Much could be said about these alleged external effects, but insofar as they are valid, they cannot be more than supplementary.[2] In addition, careful examination will lead one to acknowledge several less pedestrian external effects, which are, however, limited in scope. The performing arts serving as training grounds for the mass media, as mentioned by Baumol and Bowen, is a nice example of this class of externalities (Baumol and Bowen 1966, p. 385, note).

All the foregoing external effects have one thing in common. They bear no relation to the precise characteristics of art products and the way in which they are consumed. They are general and could apply to any product. In this paper I intend to show that there exists a category of externalities which is more or less tied to the art product and which may be very important in a rationale for public support of the arts. I will demonstrate that the salability of most art products is very limited, always has been, and always will be. Therefore, the possibilities of gaining a proper income in the market are also very limited for most artists. The reason is not a shortage in demand but the typical characteristics of the art product. Most art products can be and actually are marketed in a physical sense, but this only tends to obscure the fact that usually many aspects—often the most important aspects—of a work of art can be and are consumed freely. Contrary to their outward appearance, many art products behave like public goods. This implies that they should be financed like public goods: mainly through public funds.

Even if one goes along with the argument, it still does not necessarily imply the necessity of public support. In other spheres of economic activity similar phenomena exist without such a necessity. So I intend to show that there are important differences between art products and other goods, as well as differences in development costs of innovations and in the possibilities of protecting these innovations.

EXACT REPRODUCTION AND
CIRCULATION OF WORKS OF ART

Since works of art or aspects of works of art can be reproduced on a considerable scale, is it not just a problem of normal price exclusion, that is, the selling and buying of property rights? To answer this question, we turn to exact reproduction and circulation of works of art.

It is true that the multiplication or reproduction of books—including plays, photography and art books, posters and other multiples, records, tape recordings, videotapes, and films—cannot be carried out freely. The same applies to public performances or broadcasting of plays, music, and so forth. Depending on the specific provisions of the law, the state of technology, the absence or presence of general agreements, the organizational effectiveness of controlling bodies, and the nature of public morale, the artist or his or her agent can often apply price exclusion to those who wish to reproduce or re-reproduce the artist's works.

Often the state of technology is decisive, as is shown by the increasing, virtually uncontrollable re-reproduction by tape and video recorders and by photocopying. This form of reproduction by private persons does not even presuppose large preliminary sales if we think of the reproductions made from broadcastings and from lendings by public libraries. Besides, public lendings of books, not least of all art books, records, and so forth, already limit the degree of excludability of works of art to a considerable degree, at least in the majority of countries where public-lending rights do not exist. Therefore, we will have to take into account the impact of both external circulation effects and external reproduction effects.[3]

Apart from private reproduction and public lending, the degree of excludability appears to be normal as far as exact reproductions of works of art are concerned. But appearances are deceptive. I think that the absence of unauthorized, so-called white prints, white records, and so forth does not necessarily imply a high degree of excludability. Depending on the above-mentioned circumstances in a certain branch and country (above all, on the state of reproduction techniques), it might just as easily be that, under the continuous and imminent threat of large-scale violation of the law and free reproduction, the reproduction prices are such that unauthorized reproduction is just not worthwhile. I cannot elaborate on this matter here, but a first indication of the point lies in the fact that in most countries copyright hardly ever plays a significant role in the decision to publish a book or to play a specific record on the radio. In a sense, then, the income from exact reproductions is generally more in the nature of a gratuity—although very important for the individual artist—than a price (in the economic sense) as exists for ordinarily marketed commodities. In any event, insofar as exact reproductions are concerned, the degree of excludability of works of art is quite low, if not in letter, at least in spirit.

This aside, we have to realize that although there exists some sort of excludability between the artist and the so-called mass media, often the same cannot be said about the media and their consumers, the general public. Their products are often free; the radio is on in workshops, magazines lie about in waiting rooms, and so forth. All this plays a role in the spreading of the artist's message. From a public policy standpoint, then, the work of the artist is often free to many consumers.

TRANSLATIONS, VARIATIONS, AND OTHER DERIVATIVES OF WORKS OF ART

In some cases reproductions and originals coincide completely, for example, with photographic prints, posters, and graphic art. In other cases, where the work of art makes use of an existing symbolic language system, the differences can be major, such as with prose, poetry, scripts, choreography, and music notation. Perhaps most reproductions imply a real and significant transformation, sometimes to such a degree that in addition to being the reproduction of an original they can claim the status of new artistic originality separate from the original—for instance, the stage performance or screen version of a play. What is important is that the transformation can have all sorts of gradations.

Popularizing Reproductions

We know of works of art which have changed society thoroughly. How did they exert such an influence? Simple enough—people have stayed in contact with the original, or exact reproductions of it, or engravings and prints with descriptions. Often these comments translate the work of art even more, translate it into the language of the specific period or group. The impact of the work is often increased in this way. At the same time, the original remains technically and spiritually irreplaceable. Often, because of continuous use of these reproductions, new segments of the general public find their way to the original.

The spreading of culture in this sense has existed ever since the introduction of printed engravings, but it has become extensive with diminishing illiteracy and the rise of the illustrated weekly, radio, and television. Apart from some rare exceptions, price exclusion by artists is impossible.

The Influence of the Artist upon Other Artists

The impossibility of excluding nonpayers becomes even more general when we think of aspects of particular works of art which are reproduced in yet other works of art; these are external effects, as far as the individual artist is concerned. But the effects are internal when we consider the industry (the company of artists).

In the last resort, the whole of art production exists largely thanks to this form of reproduction. What we call development in this case is nothing more or less than continuous reproduction with continuous slight modification. At times it may look like there is a major breakthrough, but careful examination may show the derivation from several other artists. Often, certain artists play a larger role in the fundamental work, but receive less of the fruits it ultimately bears.

Applications in Commercial Design

Reproduction of aspects of works of art in the products of the so-called popular arts and in other industries is almost unlimited, but often it is obscured. One has to develop a special eye for it. At this very moment I am sitting at a table in the room of a third-rate hotel. The table cloth is made up of alternating squares, naturalistic and abstract. The former are borrowed from the Japanese art of flower painting; the latter remind one of Braque, however vaguely. The design of the plastic curtain in front of the washbasin is an exact copy of a painting by Vasarely. In front of me there are two notepads. The cover of one has a pattern borrowed from Mondrian but filled in with the present-day fashionable colors, green and pink. On the cover of the other is one of those puzzling, infinite chains, inspired, without any doubt, by the Dutch artist Escher. A Coca Cola commercial on my transistor radio fills the room. The background music is from a synthesizer, and it has an undertone reminding one of the recent German musical formation *Kraftwerk*. I could go on: the cup, the bag of tobacco, the form of the ashtray, the lampshade, the package of food I brought in . . .

Perhaps the exact reproduction of existing works of art in some of these objects really reflects the designer's laziness rather than an expression of respect for the artist. The more varied reproductions, however, with adjustments to mate-

rial, form, and function of the object, are in the majority. Moreover, most often the designer borrows consciously or unconsciously from certain directions in the arts rather than from specific works of art. Thus, it is obvious that the work of the artist is free to many producers, as well as to many consumers. Excludability is minimal.

THE REPRODUCTION OF VIEWS
INHERENT IN WORKS OF ART

The unlimited application of works of art demonstrates the "publicness" of the arts in a very convincing way. But we should not forget that only certain aspects of works of art are fit for reproduction. The application makes demands of its own, just like the arts make demands of their own! So finally we must consider the fact that every work of art has one important aspect that is always fit for reproduction, in the broadest possible sense of the word. I am thinking of the "view" inherent in every work of art: literally, the way, the mode, the procedure of perceiving—not just seeing through the eyes—and at the same time the contents of perception, the fact that the one is perceived and the other is not.

The works of Giotto and Rousseau, for instance, changed the face of the world, just as did the works of Marx and Freud. Millions and millions of people were and still are influenced by them even without having the slightest notion of their names. Daily life is imbued with their works.

Contrary to the reproduction discussed above, in this case it is completely useless to look for one or more specific intermediates. A view can be reproduced in too many ways. The reproduction is not limited to one or two specific ways of expression, or one or two media; it is appropriate for translation into all sorts of media. To a degree it is like the pebble cast into the water which reproduces itself in ever-widening circles. The difference, however, is that with the new view the old situation will never be completely restored, and many more elements can carry the movement. A new view can be reproduced not only by written words but also through conversation, by images, different tones, different behavior, a new mentality, and so forth. Matters of consciousness—and that is what it is all about—can be re-expressed and transmitted in every possible way. This is the very reason why this form of reproduction can apply to every work of art. In the last resort the view inherent in the work of art is reproduced in social practice itself.

I mentioned Giotto and Rousseau, but keep in mind that many artists are involved. The work on views is done continuously. Some names become known, others remain obscured. Always there is at least a preparing and supporting collective of artists.

The point I want to make is probably best illustrated by examples of the plastic arts. The introduction of central perspective reforms the image of the world as we perceive it. We begin looking at reality in a different way. Romanticism opens our eyes to nature. With surrealism we start seeing things behind things. Through COBRA and action painting, our most trivial utterances become a matter of significance to us. And through our often retarded and indirect acquaintance with

constructivism and futurism, at last we really dare to face the new forms of our industries and workshops.

The procedure of perceiving and the content of perception can never be distinguished fully. A new procedure will lead to new contents and vice versa. But there can be differences in accent. It may be primarily the procedure which is renewed, or rather expanded through the arts. But it also may be primarily the contents which are expanded, as in the discovery of nature and of modern industrial shapes, although it is possible that the latter presupposes a new way of looking as well.

SOCIAL FUNCTIONS OF THE ARTS:
AN UNNECESSARY EXTRA

The foregoing arguments as to circulation, reproduction, and view are made without resorting to moral standards and judgments. There is no need to plunge into the hazardous subject of the social functions of the arts. We merely observe that the arts are being employed on an enormous scale (be it good or bad). They are employed far beyond the actual art markets and without the artists deriving any income from them. Externalities exist and we can conclude that the degree of excludability is low.

From this follows the very important point that when we discuss the rationale for public support of the arts, we can do so, if we wish, taking into account only pure economic arguments, ignoring all speculations and value judgments on the possible functions of artistic activity.

It also follows that Peacock is unjustified when he dismisses Robbins's argument saying that "one cannot make a case on grounds of externality in absolute terms alone" and (knowing the results in advance) that "it would be interesting to poll the public at large in order to confirm whether they derived an uncovenanted benefit from the attendance at publicly subsidized symphony concerts or modern plays by those whose median income is almost twice that of the employed population" (Peacock 1969). Leaving aside the more specific and difficult question of the rationale of public support in the cases selected by Peacock (not mentioned at all by Robbins), we must generally reject the cheap argument of an overall and abstract poll where complicated and refined concrete mechanisms are at stake. The external effects of the arts are valued, otherwise they would not exist. For unlike polluted air, they are, since the creation of the originals, brought into existence through chains of deliberate human acts which could just as well have been omitted. Making a slight but vital modification, one can say that the "proof of the pudding is in the eating." (What else could an economist educated in the tradition of revealed preferences wish?)[4]

THE RATIONALE OF PUBLIC SUPPORT

Do externalities and a low degree of excludability imply the necessity of public support of the arts? First of all, we have to realize that these characteristics are not unique. They can also be found in such cultural expressions as sports and fashion design; we also find them in industry. And in these other areas there

hardly seems to be a case for public support. Let us examine things more carefully.

A whole culture is founded, as it were, on the phenomenon of varying reproduction, and price exclusion is hardly involved. We learn and reproduce one another's behavior, attitudes, and ways of dressing with or without minor variations. The baker, who reproduces what we know as bread, has to pay royalties to no one. And if, for instance, in industry the exact reproduction is submitted to price exclusion, the more fundamental innovation, which always remains a form of varying reproduction, is free.

Innovations in daily routines are brought about by each of us, but the important thing to realize is that in many cases there are hardly any development costs involved. The same idea applies in varying degrees to innovations in sports, popular arts, fashion design, and so forth.

On the other hand, in industry, as in the arts, there are often major development costs. In both cases the protection by law of the "intellectual" property is quite limited. But again, there is an important difference. In industry the very nature of the newly created product and/or its production process often renders specific innate possibilities for price exclusion, as far as the inherent intellectual property is concerned. As production processes become more complicated, so do the systems for organizing and controlling these processes. None of these, the latter even more so than the former, can be detected from the finished product bought on the market. So the owner who otherwise succeeds in concealing developments can apply price exclusion to the intellectual property and sell it (or hire it out) to anyone who wants to reproduce it and avoid the development costs and risks. With these sales and/or the sales of the newly developed product itself at a price exceeding reproduction costs, the owner can sooner or later cover development costs and make a profit.

A work of art, on the contrary, is like an open book (if it is not a book already). Almost anything we might be interested in reproducing, from technical features to the inherent message, can be conceived just by perceiving it carefully. (And if not completely so, we can even ask the artist, for in the arts, as in pure science, producers are not supposed to keep methods secret.)

But are development costs that high in the arts? Applying a romantic idea, we have developed the false concept of the genius in the arts, and this concept still tends to contaminate our view. Apart from a few rare but quite appealing exceptions, innovations in the arts are a matter of work, tremendously hard work, often not just by one individual artist but by collections of individuals.

It turns out that the proper comparison is not between works of art and industrial products, but between arts and more or less pure science. Even so, some sciences nowadays have even more actual possibilities for exclusion than do the arts if we consider their very complicated languages, which sometimes serve as effective barriers. In addition, while both arts and sciences offer ways to the same object—knowledge in the broadest sense—the arts do so primarily through our senses and emotions, while science does so primarily through reason.[5] Both create externalities.

Nevertheless, there still remains the question of whether the externalities have to be paid for. Is an extra income along with a market income necessary? It is my strong conviction that in the long run—I am thinking in terms of centuries—it is just as necessary to pay for externalities in the arts as it is in the sciences, more so when the development of new artistic and scientific views is involved, and less so when the emphasis is on spreading, multiplication, and popularizing of new artistic or scientific views. There is no value judgment involved here, just a perfectly normal division of labor, a division which has consequences for the possibilities of gaining an income in the market, which in actual practice is not always easy to gain. The greatest artistic development has occurred in those European city-states which were prosperous and which at the same time were marked by a strong and stable sponsorship.

This takes us to a final question: if the externalities ought to be paid for, why public support and not private support or, even better, an extension or refinement of property rights provisions? We need all of these, but the emphasis has to be on public support.

Coverage of the execution of property rights can be improved but will remain very limited, and is even likely to diminish with the further development and popularizing of reproduction machines. Moreover, there is a chance that one will sooner stop reproduction than skim the consumer or producer surplus. And, at least from a social point of view, that could be suboptimal in many respects. Eventually, we should require general payments (involuntary private support) enforced by the government from, among others, the mass media and the producers of reproduction machines to organizations of artists.

As far as voluntary private support is concerned, it should be noted that the tenor of this paper is a proof of the rationale of (and a plea for) support in general, be it public or private. An analysis of the advantages, dangers, and possibilities of voluntary private and other forms of support would require another paper. Nevertheless, I think the word "public" in the title of this paper is justified. It is justified because public support is a policy area that can be manipulated most easily and, in spite of all encouragement, private support is insufficient. The case is no different from national defense, higher education, and so forth.

Moreover—to borrow just one sentence from "the other paper"—I think that for a number of reasons voluntary support from commercial organizations, as well as from organizations of private persons, has a natural tendency to favor those art products which are somewhere in between the popular arts and what we may call "pure" arts. These "in-between" art products still need support and as a result this support is welcome. For other reasons, however, it is also quite limited, particularly in Europe.[6]

I do think that, since the old days of sponsorship by the clergy, nobility, and gentry are definitely gone,[7] local and central governments are their main heirs. Thus, we are left with the need for large-scale and generous public support of the arts. This is not surprising when we remember the nature of the externalities involved. Nor can it possibly be a dirty matter when we look at ourselves and see how all our little "creative" scholarly papers are financed after all.

Notes

1. For instance, see A. Peacock's "Welfare Economics and Public Subsidies to the Arts" (1969, pp. 323–335).
2. See, for instance, Peacock (1969) and Abbing (1978).
3. The reproduction (circulation) is the external effect. External effect and reproduction are the same thing. This is why I have chosen these expressions instead of "the external effect of reproduction (circulation)."
4. Of course, the economist, myself not excluded, will wish more. This is demonstrated also by the other criticism of Peacock. When he tells us "one cannot make a case on grounds of externality in absolute terms alone," it is also an answer to the question of how we compare subsidizing the arts with, say, subsidizing the Concorde or the fares of Leeds United to play Milan. (The particular question is raised with respect to a contribution of the arts to international prestige, but the criticism is general.) Of course we wish—and we will put forth lots of effort in the attempt—to quantify the value of external effects as much as possible, but we just cannot demand quantification as a sine qua non for public support! Often comparisons and quantifications are—and in many cases will always remain—a subjective matter, a matter of politics. To demand objective comparisons, and along with them quantifications, as economists often do these days, is usually erroneous and unjustified. It would come to the same thing as deciding to stop all foreign policy or all big investments in industry, because past results cannot be evaluated unambiguously and future results are not fully predictable. See also Abbing (1978, pp. 106–114 and 171–176).
5. See N. Goodman, *Languages of Art: An Approach to a Theory of Symbols* (1969).
6. I elaborate on the reasons mentioned in this paragraph in an article published in 1979 in *Akt*, the journal of the Institute of Art History of the State University of Groningen (Netherlands).
7. The social and economic reasons underlying this proposition are discussed in Abbing (1978).

References

Abbing, Hans R. 1978. *Economie en Cultuur*. The Hague.
Baumol, W. J. and Bowen, W. G. 1966. *Performing Arts—The Economic Dilemma*. Cambridge, Mass. and New York: M.I.T. Press and Twentieth Century Fund.
Goodman, N. 1969. *Languages of Art: An Approach to a Theory of Symbols*. London: Bobbs-Merrill.
Peacock, A. 1969. Welfare Economics and Public Subsidies to the Arts. *The Manchester School* XXXVII, no. 4 (Dec.): 323–335.

Comment
F. F. Ridley

Abbing provides two arguments against the existing economic rationale for public support of the arts: first, such rationale explicitly moves the arts into exceptionality, an identity contemporary artists prefer not to have; second, such rationale tolerates little public preference.

I find the first argument less than true. Granted, some artists, mainly those in-volved in community arts, want to integrate their activities with the lives of ordi-nary people and dissolve the special status of arts and artists, which is frightening to the working class; however, these same artists often demand special subsidies based on the need for community building among socially disadvantaged groups, notably inner-city populations. From my own experience, furthermore, artists are quite willing to claim exceptionality if it furthers their claim for support.

The second argument bears more truth; economists are in favor of as little interference with public preferences as possible. But the reason lies in the nature of economics—without revealed preferences, it is difficult to construct an eco-nomic science at all. There is no reason for policymakers to let such economists outweigh other advisers. It is true that "shopkeeper liberalism" has suddenly be-come popular, eclipsing traditional conservative beliefs that the elite know best and that socialism recognizes the manipulation by the capitalist system of con-sumer demand. However, even in Thatcherite Britain, many fields of government policy—defense and education, for example—start from other assumptions about what is politically desirable.

While Abbing makes a plausible case for his rationale, it would probably carry little weight with policymakers, even if put forward by establishment economists. Nor, in fact, is there much evidence that the continuous pressure economists are said to exert against public subsidies to the arts has had much influence on those in government responsible for cultural policy.

Of course, Abbing's real purpose is to construct a rationale on the basis of externalities which are special to art products and the way these are consumed. The argument is that art products, though they can be marketed, in most cases can also be consumed freely; contrary to their outward appearance, therefore, they behave like public goods. They should thus be financed like public goods if artists are to obtain fair reward for their labor and, more important, if art pro-duction is to be encouraged.

Why are the arts a special case for subsidy, given that the process of diffusion of art products is not a unique one: "our culture is founded on the phenomenon of reproduction"? The argument is that in the arts, as in industry, there are major development costs; unlike industry, it is virtually impossible in the arts to ensure that these costs are met by consumers. To maintain continuous creativity, artists must be rewarded, but what they can obtain from consumers directly (by the sale of paintings, for example) is not enough. It is "false romanticism" to accept the notion of the starving artist producing works of art in a garret. The arts will not blossom in poverty; they cannot thrive without sponsorship.

Abbing points out that works of art may be reproduced on a considerable scale and that, with modern technology, the creator cannot in practice prevent free re-production by consumers, for example, by videotaping a play and showing it on television. However, neither the televised performance nor the videotape is the same thing as a live performance; enjoyment of theater depends in part on the ambience of the theater itself. Consuming either a script or a screened perfor-mance is different from consuming live theater. This problem of defining the field of art products is not really faced, though Abbing does observe that in

many cases reproduction implies a real transformation; specifically, he notes the change from script to stage to screen.

Most paintings cannot be reproduced without considerable loss of effect. Reproductions do not produce the sensation of the originals, nor do they reward the creator, who is unprotected by copyright. Here, however, we come to the core of Abbing's argument, which centers on a form of consumption that does not actually involve the consumption of art products at all. The consumer sees not the art product itself, even reproduced as we normally understand that term, but only a diffusion of art through industrial design. What is consumed is the influence of artworks on such products as curtains and tablecloths.

Abbing goes further in his argument for the role of art. It is not just a matter of diffused reproduction in consumer products but of the way art permeates the life of society. Artists have influenced our way of seeing the world, and this influence, because it is part of the culture of our time, affects even those unaware of art products. In that sense, the history of art has shaped our ways of seeing and thinking just as the history of science has done: "Though sometimes in inscrutable ways, the arts penetrate all spheres of life."

The implication is not just that artists deserve subsidy because their works will be consumed freely by the public, but that they should be subsidized because the arts perform—though in an invisible way—a vital social function which benefits the public as a whole. The "external" value of the arts, in this sense, can be demonstrated without any need to measure revealed preferences. It is self-evident. The external effects of the arts are valued because diffusion is part of the "chains of deliberate human acts which could just as well have been omitted"—"the proof of the pudding is in the eating."

There are other problems of logic as well, for example, the assumption of rational man ("deliberate human acts") dear to economists. A sociologist or a philosopher might worry about whether the permeation of arts through life involves deliberate choices and what meaning is attached to the word "valued." But even accepting the notion of deliberate acts, one might ask, whose acts: consumers' or producers'? Abbing's argument surely depends on the notion of a consumer-determined market rather than a market manipulated by producers in which preferences are shaped by the fashion industry.

The question is, who controls the diffusion of art into consumer products that may have this impact on ordinary people? Do art products enforce themselves through their own virtue (because they are good art), or do market interests dominate in the reproduction process, "censoring" the world of art, more often than not to keep eyes closed? Can one be sure that subsidizing the arts will greatly enhance the social function of the arts, or must other socioeconomic structures be altered to facilitate this? Though his argument about the influence of art is persuasive, Abbing attaches too great a weight to the independent force of art products.

One might ask, indeed, whether the art products which influence life are more or less independent variables or more or less dependent variables? In other words, is it the work of genius (which in a sense arises "out of the blue") that influences

fashion, or are influential works themselves the products of the environment, the culture of the time, which also shapes fashion? The second explanation does not destroy the case for subsidy, but it somewhat weakens the force of the argument.

How is one to know which artists to subsidize? Not all create public goods through the diffusion of art products, and we cannot tell in advance (often not until after their death) which ones will fill the social function described. Are we to subsidize "good" artists (as defined by those who appreciate the artworks themselves) or influential artists? Reading Abbing, one might think the two coincide, but it is just as likely—to adapt a phrase—that "bad art drives out good art." The most popular reproductions of paintings (in the strict sense, that is, prints), those sold in our popular stores, are not only bad artistically, but do little to enhance the quality of life.

Alternatively, is it the artistic community as a whole that is to be subsidized, on the assumption that one cannot identify where beneficial (or even just popularly desired) influences will come from? This is rather like the argument for promoting research in the sciences generally, rather than by reference to immediate practical needs, on the grounds that something good is bound to spin off, but we cannot identify the research programs that will actually provide such spin-offs. While the costs of scientific creativity are higher than the costs of artistic creativity, those who fund pure scientific research are at least clear in their minds (except at the margins) what the population of the scientific community is and what the field of scientific research is. It is much harder to define the field of the arts that is to be subsidized, in terms of either personnel or activity.

If the arts are to be subsidized in general terms, therefore, one must first define what the arts comprise. Artists include full-time professional painters, professional painters who earn their living as teachers, community artists, amateurs, and crackpots among whom there may be the unrecognized genius. The same applies in other fields. If not people but activities are to be the basis for subsidy, what sort of activities—paintings (that is, by commissioning), exhibitions, art books (to hasten the diffusion process)? Furthermore, how wide is the net to be cast? Does one assume that the real contribution to society in the form of research and development depends on great artists or on the competent popularizers who, inspired by innovators, create the art movements without which diffusion is unlikely?

How is the subsidy to be distributed? This may sound as if it were just a technical question, but the manner of allocating subsidies is likely to bring in rationales for subsidy other than Abbing's general case. Are the creators of art products to be subsidized directly or indirectly through the purchase of their products? If the latter, arguments for subsidy are almost inescapably based on heritage and education. Works cannot really be bought by public authorities just as a way of keeping painters alive; they must be exhibited. The same is true of music. Composers can be awarded scholarships to ensure them time for creativity, but the likelihood that their works will be performed is as important a stimulus as cost-of-living grants. Performances of new works generally need subsidy and this has to be justified by reference to the audience. If full payment is not to be extracted from

them, one probably has to resort, again, to justifications that relate to these direct consumers rather than to diffusion.

The fact that a general rationale for subsidies to the arts can be constructed on the lines Abbing suggests is unlikely to impress policymakers, who want to know not only why a global sum should be allocated to the arts in the budget, but also what it will be spent on. Indeed, this, together with the budgetary situation, will determine the global sum. Public authorities have to justify the spending of public money in more specific terms than the generalized public benefit Abbing rightly discovers in the arts. In explaining why particular sums go to subsidize the arts, they are bound to think in terms of the direct benefits to those who actually consume them.

There are a number of such arguments. The most acceptable in our democratic societies is the educational one. Practical people often use the tourist trade argument, though one suspects that this is a political justification (excuse) rather than the real motive. For my part, I prefer enhancement of the national heritage. Thus, I return to my own opening statement: one needs to define real works of art (and I will not debate with those philosophers or populists who claim there is no way of defining good art; I know it when I see it—*ça suffit*) and subsidize art for its own sake. But that is not the point here; the point is simply that Abbing's rationale will in itself be insufficient to convince policymakers and is, in any case, incapable of implementation.

A Note on Government Spending on the Arts and Heritage

John T. Caff

THE DEMAND FOR SPENDING on the arts is virtually limitless. As with health, expenditure on the arts has tended to increase with income and, over the course of the last decade, with expectations about what should be provided from public funds. The public sector's contribution to this effort is in the form of either direct expenditure or tax concessions. There is growing interest too among the public in the arts. This is reflected in the extent of interest in Parliament, in the press, and in lobby groups. It can also be seen from the fact that the BBC has a daily half-hour program reporting on artistic activity just before the main news in the evening. The government's contribution to sustaining artistic activity in Great Britain is greater than is often believed, and in real terms expenditure by the government on the arts has probably increased faster than in most other areas of government spending. My aim in this paper is to set out, in a way which has not been done before, the extent to which government resources are spent on the arts, artistic endeavor, and our heritage.

THE ARTS AND HERITAGE

First, what are the arts? Given the interdependence, we need to use a fairly broad definition. I include the live arts, which receive grants from the government through the Arts Council and its Scottish and Welsh subcommittees, the offices determining how the money should be spent and how help is to be distributed among large national companies, smaller groups, and individuals; museums and galleries, from the famous national collections to the relatively small local collections throughout the country; historic houses, many of which are owned by the National Trust or are in private hands and supported by grants from the historic buildings councils and by tax concessions in the form of exemption from capital transfer tax on certain heritage property; older castles and pal-

aces (for example, Edinburgh and Caernarvon Castles, Hampton Court); and ancient monuments, such as Stonehenge, looked after by the ancient monuments directorates. Coming back to living art, perhaps land and thus spending by the Countryside Commission and the Nature Conservancy ought to be included.

RESPONSIBLE GOVERNMENT AGENCIES
AND THEIR OBJECTIVES

Within Whitehall the new Office of Arts and Libraries is responsible for the live arts, museums, libraries, and galleries both in central and local government. The Department of the Environment is responsible for historic buildings and ancient monuments. In Scotland and Wales arts and heritage responsibilities are assumed by the Scottish Education and Development Departments and the Welsh Office. The Treasury comes into the picture insofar as public expenditure and tax issues are concerned. The Inland Revenue has an important role as the guardian of tax policy.

The government's objectives in the cultural area are, within established limits of public spending, to help preserve artistic and heritage property and, in the case of live arts, encourage artistic and historic endeavor for general public enjoyment. The emphasis has to be on maintaining what we have and ensuring proper public access to it. Public expenditure aimed at achieving these objectives requires some return for the benefits conferred through tax exemptions or grants, be it for art objects or for historic buildings. In the case of public libraries and museums the public has free access; in the case of privately owned property the various heritage associations have accepted the bargain implicit here. The terms of reasonable public access required are subject to negotiation and take account of the special circumstances of each property.

THE COSTS

How should the government decide how much to spend within the overall budget constraint, and on what? Insofar as civil servants and ministers themselves cannot be experts, advisory or independent bodies have been set up: arts councils in the live arts field and historic buildings councils. It has also been proposed to set up a National Heritage Fund with independent trustees to provide funds for heritage preservation purposes.

Tables 1 through 4 show how much has been spent over the course of the last ten years. Expenditure on the live arts, at constant prices, has almost doubled in real terms in the ten years up to 1979–80. Expenditure on national museums and galleries has almost doubled, and expenditure on historic buildings and ancient monuments has risen by about a half. The grants given annually to the national collections for the purchase of new works of art now total some £10 million a year. (The trustees of the national collections decide how to spend these monies.) Overall, the percentage share of expenditures for the live arts has tended to increase, but for museums, galleries, and heritage it has decreased. Thus, while the

Table 1. *British Public Expenditure on Heritage, Arts, and Libraries*
(million £, 1979 survey prices)

	1968–69	1969–70	1970–71	1971–72	1972–73	1973–74	1974–75	1975–76	1976–77	1977–78	
Heritage Expenditure	32	36	36	37	38	44	54	56	54	53	
Art Expenditure	72	68	80	94	98	107	128	124	129	128	
Libraries Expenditure	166	181	194	210	230	246	255	252	251	246	
TOTAL	270	285	310	341	366	397	437	432	434	427	
Annual Increase/Decrease (%)		+6	+9	+10	+7	+8	+10	–1	0	–2	average annual increase = 5%
Annual Increase/Decrease in Total Public Expenditure (%)		0	+3	+2	+5	+3	+9	+1	–4	–6	average annual increase = 1½%
Annual Increase/Decrease in GDP (%)		+2	+2	+2	+4	+3	–1	–1	+3	+2	average annual increase = 1½%
Expenditure as % of Total Public Expenditure	0.49	0.51	0.54	0.58	0.60	0.63	0.63	0.62	0.65	0.67	

Table 2. *British Public Expenditure on the Heritage*
(million £, 1979 survey prices)

	1968–69	1969–70	1970–71	1971–72	1972–73	1973–74	1974–75	1975–76	1976–77	1977–78
Historic Buildings and Ancient Monuments	16	17	17	17	18	20	21	26	25	23
Royal Parks and Palaces	10	11	11	11	10	12	14	14	13	13
Countryside Commission	2	2	2	2	3	6	12	10	9	9
Nature Conservancy Council	4	6	6	7	7	6	7	6	7	8
TOTAL	32	36	36	37	38	44	54	56	54	53
Annual Increase/Decrease (%)		+12	0	+3	+3	+16	+23	+4	−4	−2

Table 3. *British Public Expenditure on the Arts*
(million £, 1979 survey prices)

	1968–69	1969–70	1970–71	1971–72	1972–73	1973–74	1974–75	1975–76	1976–77	1977–78	1978–79
National Museums and Galleries											
Capital expenditure	7	4	4	8	2	6	7	7	8	6	12
Current expenditure	16	19	22	24	25	24	28	30	30	31	33
TOTAL	23	23	26	32	27	30	35	37	38	37	45
(excludes purchase grants)											
Local Museums and Galleries											
Capital expenditure	1	2	2	4	4	8	7	7	4	4	5
Current expenditure	19	14	16	18	21	22	29	29	29	29	29
TOTAL	20	16	18	22	25	30	36	36	33	33	34
Arts Council and Other Arts											
Capital expenditure	2	2	6	6	8	7	14	6	4	2	2
Current expenditure	27	27	30	34	38	40	44	45	54	56	62
TOTAL	29	29	36	40	46	47	58	51	58	58	64
TOTAL ARTS	72	68	80	94	98	107	128	124	129	128	143
Annual Increase/Decrease (%)		–6	+18	+18	+4	+9	+20	–3	+4	–1	+12
Average Annual Increase											+7

Table 4. British Public Expenditure on Libraries
(million £, 1979 survey prices)

	1968–69	1969–70	1970–71	1971–72	1972–73	1973–74	1974–75	1975–76	1976–77	1977–78	1978–79
British Library and Other National Archives											
Purchase grants						5	5	5	5	6	6
Other current expenditure				15	13	12	19	20	18	22	21
Capital expenditure						6	1	—	8	1	3
Local Public Libraries											
Current expenditure	166	181	194	195	217	188	200	206	204	203	205
Capital expenditure						35	30	21	16	14	14
TOTAL	166	181	194	210	230	246	255	252	251	246	249

precise figures depend on the starting and final year, the general conclusion is that arts spending has grown three to four times faster than gross domestic product or public spending over the last decade.

Clearly, aggregate cost to the public sector borrowing requirement of tax concessions is difficult to calculate, particularly for charities or business spending on the arts. Conditional exemption from the capital transfer tax of heritage property cost the Exchequer some £10 million last year, and expenditure from the National Land Fund on acceptance in lieu cases and special purchases of historic buildings cost something of the order of £3 million. However, these are relatively small amounts when compared with the total. Consequently, fundamental questions remain as to whether more could be achieved by a different allocation of the sums involved. Obviously this note raises questions that it does not answer, but however they are answered, policymakers will certainly ask them.

Comment
Berend J. Langenberg

John Caff's paper, as he himself underlines, is descriptive, not analytic. The main conclusion is that government spending on the arts in Great Britain has increased over the last ten years three to four times faster than gross domestic product, as well as public expenditures.

First of all, the government of Great Britain deserves congratulations that in times of a troublesome economy it maintained a steady growth of expenditures on the arts. The conclusion must be that some people did a good job in the chase for government money during those ten years. A comparison with the money spent by the Dutch central government on the arts over the last fifteen years reveals a rather constant percentage of total public expenditure.

At the end of his paper Mr. Caff raises a typical economic question: could not more be achieved by a different allocation of the sums involved? I am interested in how people in different countries are succeeding in *preparing* answers to this question. I emphasize the verb "preparing" because I think that there is still a lot of preliminary work to be done before a question like this can be answered. The first problem, and perhaps the most important aspect of Caff's question, is: more than what? How can one find out how much has been achieved by looking at the figures in the tables given in his paper? The problem is that of measuring the "productivity" of government money spent on the arts, that is, the quest for meaningful "output" measures.

There is nothing new, not even in the arts, in this search for output measures to quantify productivity. Considerable economic and sociological research concern-

ing certain ideas of productivity has already been done in some countries. For example, Moore (1968) and Baumol and Bowen (1966) in the United States used the number of performances and the size of the audience as a measure of productivity in the performing arts. In general, in the late 1950s and in the 1960s audience or consumer surveys in the arts offered insight into some aspects of the productivity of money spent on the arts.

In many Western European countries, as well as in Canada and the United States, some data are collected on a yearly basis. From such collections we ought to be able to develop insights into changes in productivity. In Holland, for example, the Central Agency for Statistics (CBS) now collects data annually on the number of performances of 24 subsidized theater companies, 47 unsubsidized theater companies, 6 minigroups, 15 symphony orchestras, 5 ballet companies, 3 opera companies, and 149 puppet theaters. The audiences for these companies are broken down into various groups; museum visitation is disaggregated; the size of cinema audiences is broken down in various ways; the number of users of libraries and the frequency of lendings are provided; the number of visitors to archives is recorded; and information on the number and cost of restorations is broken down into the kind of building (for example, house, farm, castle, church), its location, and so on. The Dutch Social and Cultural Planning Office biannually compares several cultural activities of the Dutch population with other activities (especially free-time activities) as part of a general social and cultural "photograph" of our society. This highly documented report, with extensive statistics, is also available in English—the last one was published in 1978 by Staatsuitgeverij, The Hague.

The "boom" in methods initiated by some countries during the 1960s to rationalize public expenditures in one way or another (performance budgets; cost-effectiveness analysis; planning, programming, budgeting, and systems; and so forth) has been used to rationalize government expenditures on the arts. For example, in 1973 Holland started to construct a total program (in terms of planning, programming, budgeting, and systems) of, among other things, the cultural policy of central government. This large job, especially the whole semantic and local fieldwork, entailed a complete and consistent compilation of objectives. The general objectives are (1) development and preservation of cultural values (that is, supply); (2) public accessibility to cultural objects and events (that is, distribution); and (3) participation of the whole population in cultural activities (that is, demand). These objectives are subdivided into more specific, concrete objectives to which one can attach a policy instrument, for example, subsidy or information. This work was finished in 1979, but it is still just the first step.[1]

So far I do not think an answer can be given to Mr. Caff's question, although economists are on their way to developing an answer. Up to now decisions in arts policy have been made mostly on the conviction that one art(ist) is better than another, and many people involved in the arts argue that this kind of decision making is still usually the best. Does this mean that the work of economists, the effort to rationalize government expenditures on the arts, is useless? Not at all. It

proves that economists have not yet provided workable figures and concepts for the decision makers to work with in a language that can be used for day-to-day decisions.

Note

1. For further information on the objectives of the Dutch government's policy on the arts, see *Art and Arts Policy in The Netherlands* (Ministry for Cultural Affairs, Recreation, and Social Welfare 1976a) and *Towards a New Museum Policy* (Ministry for Cultural Affairs, Recreation, and Social Welfare 1976b).

 The Central Bureau voor de Statistiek (Central Agency for Statistics) produces yearly statistics on several art forms. It also publishes statistics on government expenditures for culture and recreation. See *Statistiek van de Uitgaven der Overheid voor Cultuur en Recreatie* (Statistics on Government Expenditures for Culture and Recreation).

 Statistics on public participation are presented in the *Social and Cultural Report 1978*, published by the Sociaal en Cultureel Planbureau (Social and Cultural Planning Office) (1978).

References

Baumol, W. J. and Bowen, W. G. 1966. *Performing Arts—The Economic Dilemma.* Cambridge, Mass. and New York: M.I.T. Press and Twentieth Century Fund.

Centraal Bureau voor de Statistiek (Central Agency for Statistics). *Statistiek van de uitgaven der overheid voor cultuur en recreatie* (*Statistics on government expenditures for culture and recreation*). The Hague: Staatsuitgeverij (yearly).

Ministry for Cultural Affairs, Recreation, and Social Welfare. 1976a. *Art and Arts Policy in The Netherlands.* Memorandum to the Dutch Parliament. The Hague.

———. 1976b. *Towards a New Museum Policy.* The Hague.

Moore, Thomas. 1968. *The Economics of the American Theater.* Durham, N.C.: Duke Univ. Press.

Sociaal en Cultureel Planbureau (Social and Cultural Planning Office). 1978. *Social and Cultural Report 1978*, chapter 8, "Leisure." The Hague: Staatsuitgeverij.

Economic Aspects of Arts
Subsidy in England

Robert Hutchison

"WE ARE ALL CREATIVE, imaginative, artistic, to a certain extent but few of us have been given or have taken the opportunity to discover our talent," writes the author of a recent book on drama in schools (Allen 1979, p. 10). Public subsidy since the Second World War has been essential for the emergence and survival of a great number of arts organizations of all kinds, but one seldom hears any talk of "opportunity cost" in all the discussions of arts subsidy.

Take the underresearched question of pricing policies. The level of subsidy for particular drama organizations is crucially affected by their pricing policies, and the inappropriate application in the second half of the twentieth century of nineteenth century philanthropic notions has considerably increased the subsidy requirement of many theater companies. Some time after 1880, when Emma Cons put the coffee into the Royal Victoria Coffee Music Hall, the Old Vic was constituted as a charity with a charter stating that "admission to performances, lectures, entertainment, and exhibitions shall not be gratuitous, but shall be at such prices as will make them available for artisans and labourers." In practice, Tyrone Guthrie tells us in his autobiography, "this has always been interpreted by the governors as meaning that the cheapest seats shall cost no more than a few cigarettes or a glass of beer, and the expensive seats shall cost considerably less than the current price for similar seats in the West End of London" (1960, p. 101). Similarly, Sadler's Wells, under the terms of its charter, was intended "for the recreation and instruction of the poorer classes" (Haltrecht 1975, p. 58).

But as public subsidy for the performing arts developed after the war, the poorer classes had little inclination toward the recreation and instruction provided for them at subsidized theaters. Yet the pricing policies continued to reflect earlier obligations and the accompanying assumption that lower prices in theaters result in considerably more socially diverse audiences. After a thousand and one

nights of audience surveys, and in A.B.B. (Anno Baumol and Bowen) 13, such an assumption is no longer tenable, and was always somewhat naive: "While low prices do diversify the audience to some extent, they do not metamorphose the performance into 'art for the people'. Even at free performances the audience is relatively well educated, of relatively comfortable means, and is composed primarily of members of the professions" (Baumol and Bowen 1966, p. 284).

It is not being argued that sizable increases in seat prices will solve the problems of the subsidized theater; indeed, it is right to assume when dealing with a commodity which is not an essential that price increases have to be approached with extreme caution. Nor is there any suggestion that for theater managers optimizing pricing policies is not among the most complex and challenging of their tasks, which entail a whole range of both tactical and strategic decisions about how, if at all, the house should be divided; the number of different schedules; sales outlets to be employed; discounts; subscriptions; and so forth. And, of course, VAT has compounded the problems.[1]

What is being argued is that seat prices in Britain have been low on almost any remotely relevant comparison,[2] and that only if one sees no use for public subsidy for other arts activities can one rejoice unequivocally in this fact; that if the theater-going public not only can but will pay more for seats, particularly at the top end of the scale, then these further increases are desirable.

At the end of 1973 the Arts Council published the report of its Committee of Enquiry into Seat Prices. The committee concluded that "in the provinces in particular, the grant is used to keep certain prices below a level at which they could be kept without reducing the size of audiences," and that the policy of low average prices "overlooks the disposition to associate better quality with higher price" (Arts Council 1973, pp. 20–21). Since then—or rather since the spring of 1974—while the Royal Price Index has gone up approximately 100 percent, the great majority of theaters outside London have more than doubled their top seat prices, and some theaters have trebled them. It is perhaps invidious to single out particular examples since circumstances alter cases so markedly, but Nottingham Playhouse provides an example of sharp increases. In the spring of 1974 the range of prices for its weekday performances was 30p to 70p; three years later the range was £1 to £1.85 (it is now £1.35 to £2.65). What happened to the audiences? In 1974–75 average figures for seats in auditoriums with capacities between 649 and 768 was 60 percent; the equivalent figures for 1976–77 and 1977–78 were 61 and 62 percent, respectively.[3]

Price is only one factor, and the study of pricing policies needs to be linked to study of the performance elasticity of demand, that is, the response of the public to what is being performed. The concept of "the evening out" is probably crucial in any such study. Multiplying the parameters even further, R. W. Vickerman has argued that "much greater understanding of the internal organization of decision making within households is necessary before an adequate economic assessment of household leisure decisions can be made" (1978, p. 1.6). But evidence that ticket price is not a particularly weighty factor in a decision as to whether or not to see a play comes from two surveys, one in Clwyd in 1974 (Macbeath 1977) and

one in Newcastle in 1978 (Marketing Consulting Services 1978). In Clwyd respondents gave lack of time, problems with baby-sitters, and lack of availability as the principal reasons for not seeing more drama. Only for those over the age of fifty-five was cost a major constraint. In Newcastle the type of production weighed much more heavily than financial considerations with potential audiences when they were asked about specific factors that would lead them to visit the theater more often. Again, in Birmingham in 1974 a cross-section of the population said that they would expect to spend an average well over £1 for a medium-price seat at the theater, when the medium-price seats at Birmingham's most popular theater, the Alexandra, were priced at 80p (Mass Observation 1974, table on p. 80). In the same year twice as many of those in the audience at the Sadler's Wells Opera than those at the Coliseum said that they would have been prepared to pay more than £2.50 per head (Royal Opera House/Sadler's Wells Opera 1974).

Clearly time and her brother, inflation, have eroded the value of some of this evidence, but we also know that a very high proportion of visitors to the main theaters in Britain during the summer months are from overseas (British Tourist Authority 1977–78), and many of them are accustomed to higher ticket prices. The Royal Shakespeare Company has already adopted a differential pricing system, with more expensive tickets offered during the peak tourist months. Might not other theaters be encouraged to follow suit? And the argument for higher prices at certain theaters is further strengthened by accounts of theater tickets having a real scarcity value.[4]

Given the number of subsidized theaters, the long tradition of low prices, and the evidence mentioned here, there is reason for suggesting that over the last three decades millions of pounds of public money have gone to subsidize sections of audiences who not only could but would pay more for their seats. Indeed, there is hardly an area that calls for more systematic attention—through research and publication—from the Arts Council than that of pricing policies and practices, including the effects of different kinds of concession schemes. And although the argument here has been principally concerned with the better-subsidized theaters, there is also a need for systematic study of pricing policies for performances by subsidized groups at clubs, pubs, halls, and community centers, not only because of the increasing number of professional performances in such venues but also because there is some evidence that the audiences in some of these venues are more socially diverse than those attending performances at theaters (Mass Observation 1978).

The Arts Council already intervenes considerably (often crucially) in the affairs of arts organizations by the very act of giving or withholding guarantees and grants. The council's responsibility for ensuring the best use of scarce resources should logically lead to a more direct interest in the pricing policies of these organizations. But it cannot do this in ignorance, and even now little is known about the price elasticity of demand for theater and concert tickets in Britain.

Emphasis has been put on pricing policies partly because of the peculiar shibboleths of British theater practice, but, more importantly, because the paying

customer should perhaps be the first resort for those interested in economic support for the arts. Toward the end of the war, Keynes expressed his belief that state investment in the arts should primarily be used for building theaters, concert halls, and galleries—"nor will that expenditure be unproductive in financial terms"—and that "if with state aid the material frame can be constructed the public and the artists will do the rest between them" (1943). The Theatre Royal, Bristol, which the Council for the Encouragement of Music and the Arts (CEMA) ran under Keynes's chairmanship, made almost embarrassingly large profits in the three years from 1943 to 1946. It was only opera that Keynes thought would need continuing revenue subsidy, though he could hardly have been expected to conceive how great this would be. In 1945 he returned from America and asked Kenneth Clark, who had been conducting the negotiations with Boosey and Hawkes about the possibility of the newly formed Arts Council taking responsibility for Covent Garden, "How much will it cost? About £25,000 I suppose? . . . I said 'Add a couple of noughts,' but he thought I was joking" (Clark 1977, p. 131).

In addition to ensuring optimal pricing policies for ventures associated with CEMA and the Arts Council, Keynes was also intent on fund raising in the private sector. As chairman of the Opera House as well as of CEMA, he exhorted some of his wealthier friends and acquaintances to give the Opera House deeds of covenant at a time when such deeds could be made from money liable to surtax: "He had had some subscriptions promised, and one of them was going to yield as much as £25,000 a year. Dalton's Bill [the Finance Bill at the beginning of 1946] decreed that people couldn't make a deed of covenant with surtax. £25,000—and more—was lost at a stroke" (Haltrecht 1975, p. 66). It remains to be seen whether the Thatcher government will make any amendments in the law relating to charities to stimulate an increase of private support for the arts.

In the visual arts too some of the best uses of government money might well lie in more direct stimulation of private patronage. In 1978 the team from the Gulbenkian Foundation Enquiry into the Economic Situation of the Visual Artist interviewed 150 artists in Bristol, whose total income from their art work in one year was about £150,000, or approximately £1,000 per head. The total sum was considerably larger than the total amount (£122,000) spent on the visual arts by the Arts Council and South West Arts in the six counties covered by that regional arts association in 1976–77 (Pearson 1979, p. 16). And, of course, a high percentage of the £122,000 went to administrators, buildings, and overheads rather than into the pockets of visual artists. So there already exists—outside the London gallery world—a rather informal and small-scale art market. The workings of the private gallery system, which helps to perpetuate what Walter Benjamin called a "fetishistic, fundamentally antitechnological notion of art" and the complementary reluctance of public agencies to become involved in sordid commerce have resulted in a divorce between the exhibition of new work in publicly funded galleries and the sale and diffusion of that work. The principle that artists should be paid like any other members of the community—that is, for what they do or make rather than for what they are—is a sound one. But if homes, schools,

libraries, offices, and waiting rooms are regarded as among the better places in which to see pictures, photographs, and prints, then, given the experience of the last thirty years and the limited opportunities for exhibition and sale, a strong case could be made for more direct public intervention in the marketing of works of art and in their diffusion, in which loan schemes probably have a much greater part to play.[5]

Mark Blaug has warned against the danger of thinking about the arts in administrative compartments and has pointed out that, given the relatively heavy subsidies to national and local museums, "the consequences of free museums and galleries, therefore, is [sic] almost certainly to reduce the funds that might be devoted to supporting the Performing Arts" (Blaug 1976, p. 145). The two attempts made by Conservative governments to introduce museum and gallery charges—those by Baldwin in 1923 and by Lord Eccles fifty years later—both hit the political rocks, and any mention of such charges is noticeably absent from "The Arts: The Way Forward." But though the issue is shattered, it would be premature to write its obituary, if only because the sardine factor—the number of tourists in the main museums and galleries in the summer months—grows more and more evident. Why not control demand and earn foreign currency simultaneously?

It is, of course, central to the present government's thinking that more money for the arts should come from private rather than public sources. Exceptions readily admitted, given the common pursuit of the prestigious and glamorous by businesses sponsoring entertainment, such sponsorship of the arts is almost bound to favor disproportionately the relatively well-established artists. Nevertheless, business sponsorship is a growing component in the arts and entertainment industry as a whole, and it is in that total context, in their interactions with the commercial world, that the subsidized arts need to be understood. The broadcasting organizations are important here and, once again, with a Conservative government a new set of opportunities exists with the growth of commercial television and the potential development of the Television Fund. The fund, created by the associated commercial television companies and operated under the auspices of the Independent Broadcasting Authority, has provided small but not insignificant grants to arts organizations, particularly those concerned with vocational training. The Annan Committee's report on the future of broadcasting recommended that "the companies' payments to the Television Fund should be increased so that they may be used to provide money for national and regional artistic elements outside broadcasting, and . . . these payments should be taken into account before the companies' levy payments are calculated" (1977, pp. 81–82). In 1977–78 the levy payments to the Exchequer totaled £62 million; 10 percent of this figure, channeled through the Television Fund, would provide a rich source of quasi-private subsidy to organizations whose work is likely to benefit broadcasting.

The big leaps forward in public spending on the arts in real terms came in the middle 1960s and early 1970s as part of a general acceleration in the rate of growth of public spending. (See the tables in John Caff's "Note on Government

Spending on the Arts and Heritage" in this volume.) During those years, to the Arts Council's long-established funding of national companies, regional theaters, the main orchestras, and directly provided exhibitions were added major commitments, including regional arts associations, company touring, and a new "Housing the Arts" capital fund. Individual artists in many media began to be funded in substantial numbers and "poetry" as a funding category metamorphosed into "literature."

The closure of the last five Arts Council regional offices in 1956 badly hurt the small arts organizations at that time. Now there is a much greater number and variety of subsidized arts organizations, but the concentration of heavily subsidized companies in London is still the subject of widespread criticism—criticism that is not assuaged by the fact that the four national companies (the bulk of whose subsidies is needed for work in London) received 33 percent of the total Arts Council expenditure in England in 1977–78, compared with a figure of 43 percent ten years earlier. The cries against centralization have also in part been answered through the encouragement of touring by many excellent companies. But the major investment in touring (approximately £5 million, or 10 percent of the Arts Council expenditure in England in 1979–80) is arguably a short-term measure made at the expense of the more farsighted policy of developing local arts centers. Subsidy of independent arts centers is now largely in the hands of regional arts associations, all twelve of which in England were born between 1956 and 1973.

The pattern of funding of regional arts associations poses worsening policy problems. The Arts Council now provides more than 70 percent of the income of the associations on average, and the local authorities provide less than 20 percent. This is far from the funding formula originally hoped for: one-third Arts Council, one-third local authorities, and one-third other local and national sources. The imbalance is an expression of two facts. First, particularly in hard financial times, local authorities tend to give priority to spending on buildings that they own and activities that they directly manage rather than to grant giving; and though many do contribute generously to theaters and orchestras, the lowest priority for most is to give a grant to a regional organization which, in turn, passes most of it on in grants. Second, in England there is no strong tradition of regional organizations. A hotchpotch has resulted with few clearly defined regional boundaries, and it takes years, if not decades, for new regional organizations without statutory rights or duties to build credibility.

Undoubtedly, it is the relatively small, often innovative organizations that have suffered most from the slow pace of devolution. (To put the matter in economic perspective, the total income of the twelve regional arts associations in 1978–79 was less than two-thirds the total income of the Royal Opera House.) And the regional arts associations are starved of the funds that they need to act as an effective third force of public subsidy.

The system of arts subsidy in England is pluralist, but the flaw in the pluralist heaven is that the heavenly choir sings with a strong, upper-class accent. A decade ago Alan Peacock argued that "the diffusion of benefits might best be brought

about by directing a large part of any increase in funds for the arts through the education system" (1976, pp. 81–82). But that is only likely to come about when there is widespread acceptance of the view that "the arts are not only a way of communicating ideas, but a way of having ideas, a training for creative thinking of all kinds and, therefore, of direct value to the economy" (Brinson 1978, pp. 8–9).

Notes

1. Since VAT is a European Economic Community creation, and since VAT rates for the theater in France, Italy, and West Germany are 6 percent, 6 percent, and nothing, respectively, the theater industry's campaign against VAT has some powerful arguments in its favor.
2. *The Observer* series on London's villages, "The Real London," notes that in the summer of 1977 prices for a good meal at a recommended restaurant were usually three or four times and sometimes six or eight times as much as the cost of a good theater ticket in the same vicinity.
3. These figures were supplied by the Arts Council's research and information section.
4. For the production of "The Lady from the Sea" (with Vanessa Redgrave) at the Round House, £2 gallery seats were changing hands on the black market at eight a time.
5. Since completing this paper I have learned that the Serpentine Summer Show 2 "introduced an excellent new Arts Council scheme for financing private purchases, the artist being paid immediately and the buyer settling in installments over a year" (Spurling 1979).

References

Allen, John. 1979. *Drama in Schools*. London: Heinemann.

Annan Committee. 1977. *Report of the Committee on the Future of Broadcasting*. London: HMSO.

Arts Council. 1973. *Report of the Committee of Enquiry into Seat Prices*.

Baumol, W. J. and Bowen, W. G. 1966. *Performing Arts—The Economic Dilemma*. Cambridge, Mass and New York: M.I.T. Press and Twentieth Century Fund.

Blaug, Mark. 1976. Rationalising Social Expenditure—the Arts. In *The Economics of the Arts*, Mark Blaug, ed. Boulder, Col. and London: Westview Press and Martin Robertson.

Brinson, Peter. 1978. Social, Economic, and Aesthetic Criteria for Grant Aid to the Arts. In *Social and Economic Costs and Benefits of Leisure*. London: Leisure Studies Association, Conference Paper No. 8.

British Tourist Authority. October 1977–September 1978. *Overseas Visitors Survey*.

Clark, Kenneth. 1977. *The Other Half*. London: John Murray.

Guthrie, Tyrone. 1960. *A Life in the Theatre*. London: Hamish Manilton.

Haltrecht, Montaue. 1975. *The Quiet Showman: Sir David Webster and the Royal Opera House*. London: Collins.

Keynes, Lord. 1943. The Arts in Wartime—Widening Scope of CEMA—Reopening of Bristol Theatre Tonight. *The Times* (May 11).

Macbeath, Alan. 1977. Pre-Experiment Leisure Survey in Clwyd (Deeside). In *Leisure and the Quality of Life, A Report on Four Local Experiments*, vol. 2. London: HMSO.

Marketing Consultancy Services. 1978. *Non-Theatre-Going in the North East*. London.

Mass Observation. 1974. *The Potential for the Arts in Birmingham*. London.

_____. 1978. *Survey of Small Scale Drama Groups' Audiences*. London.

Peacock, Alan. 1976. Welfare Economics and Public Subsidies to the Arts. In *The Economics of the Arts*, Mark Blaug, ed. Boulder, Col. and London: Westview Press and Martin Robertson.

Pearson, Nicholas M. 1979. The Bristol Example. *Art Monthly*, no. 23.

Royal Opera House/Sadler's Wells Opera. 1974. Audience Surveys (mimeographed).

Spurling, John. 1979. *New Statesman* (July 27).

Vickerman, R. W. 1978. Economics and Leisure Studies: Themes, Problems, and Policies in the Economics of Leisure. In *Social and Economic Costs and Benefits of Leisure*. London: Leisure Studies Association, Conference Paper No. 8.

Comment
Anthony Field

The first half of this paper, which later becomes quite wide ranging, deals mainly with seat prices and their relation to subsidy. Since Robert Hutchison concedes that "even now little is known about the price elasticity of demand for theater and concert tickets in Britain" and that the question of price policies is "underresearched," we are left with the two difficult facts that (1) there have been "a thousand and one nights of audience surveys" but few surveys of the sections of the population not found in audiences, and (2) it cannot be maintained that there is any more direct link between subsidy and seat prices than between subsidy and all the items which comprise a company's income and expenditure account.

Subsidy is offered toward a company's net deficit, that is, the deficit after all income and all expenditure have been brought to account. It is as impossible to assume that box office income pays the artists' salaries, local authority donations the upkeep of the administration, and commercial sponsorship the cost of sets and costumes as it is to relate Arts Council subsidy to box office prices. Where Arts Council subsidy is large (£297,000 to Bristol Old Vic) it might be said to relate to the local authority's small subsidy for that company (£109,920), whereas a small Arts Council subsidy (£132,000 to the Belgrade Theatre, Coventry) might relate to a high subsidy by a local authority (£315,710). Indeed, subsidy by local authorities to other arts organizations in their local regions might be a vital influence on the Arts Council funding levels. Thus, Arts Council subsidy is assessed on the basis of many criteria, the most important of which must be successful creativity; but there is also the worth of the administration and financial acumen, the quality of service to the region (the catchment area), and many factors I have listed elsewhere (*Arts Council Bulletin* for Lynmer 1971).

I am generally convinced of Baumol and Bowen's statement that "even at free performances, the audience is relatively well educated, of relatively comfortable means and is composed primarily of members of the professions." But I am not

entirely convinced, particularly in view of trends in communication in the 1960s and 1970s. The increasing accessibility of radio, television, and travel has brought new horizons to the lives of large numbers of people, who, certainly fifty years ago, would never have heard of "theater," let alone gone to it. Similarly, people of all classes now collect records—or go pony trekking or mountain climbing or steam-engine rallying—which fifty years ago was impossible.

If it is indeed the "well-educated" who go to the theater (and concert halls and art galleries), few people ask why such a small percentage of them do so. (Professor Sonia Gold's paper, "Determinants of Arts Demand," asks this question in light of the fact that even at free performances "well over 50 percent of the audience is reportedly college graduate, professional, and with a higher median income than the general population.") Dare one suggest that we are moving toward the era when those who are interested will go and will have access to it, whereas the ones who don't go have other interests?

I have talked to people in rural communities and been told, "We want Britain to have a National Theatre just as we wanted Concorde, not because we shall ever want to sit in either, but it is a mark of our national achievement and also it affects our everyday lives in other ways." Better air travel makes air postal service faster and cheaper. The existence of theaters brings the mass audience their products through radio, records, television, and magazines faster and cheaper. There can be no justification for an annual subsidy of £350,000 to the English Stage Company at the Royal Court (a 401-seat theater in London) to present ten new plays a year to an audience averaging 65 percent of seating capacity. But if just one of those plays is John Osborne's "Look Back in Anger," the subsidy may be justified. That play has since been transferred for a long run in the West End of London and to New York, played by nearly every drama company in the world, seen on television, and filmed so that most cinemas have presented it. Few people are unaware of the "angry young man" syndrome as epitomized by John Osborne. So when we talk of the "quality of life," what we mean is that the work achieved by subsidy infiltrates to the darkest corners of everyone's life and lights up their very existence.

The concentration on audiences *within* theaters and the price of tickets perhaps deflects from the main problems. Rough estimates, with little scientific analysis, indicate that 2 to 3 percent of the population of England go to theaters, concert halls, and art galleries. If we doubled this amount it would fill them to overflowing every day of the year; so any talk of bringing the performances to 50 or 60 percent of the population is quite simply impractical.

Does all this lead to the assumption that seat prices are not a very relevant factor when one also takes into account that audiences now prefer to sit in better seats, being more attuned to seeing artists on television and hearing them on radio in closer proximity than in the "old days"? There are many nights at the Coliseum when the people waiting in line for English National Opera tickets turn away because the stalls and circle are sold out even though there is a half-empty gallery.

Young people today seem to have no difficulty paying £5 for a seat at a pop concert and then buying a record for £4 on their way out. Similarly, patrons are frequently seen spending much more at the bar in the interval than they have for their seats, which considerate managements are underpricing.

It is all too easy for an accountant to spill out these personal observations which economists will want to examine statistically. One cannot help but remember the old actor-managers who knew in their hearts that the excuses for empty houses (too wet, too hot, too expensive, too cheap, before Christmas, after Easter, no tourists, too many tourists, and so forth) really were excuses used to avoid admitting that the product was simply not good enough.

One of the statistics I most regret in Robert Hutchison's paper is that whereas Nottingham Playhouse prices were 30p to 70p in 1974, three years later they ranged from £1 to £1.85. This means that the lowest price moved from 40 percent of the top price to 54 percent. This trend is repeated in West End theaters, where the 1946 prices of 1/6d to 15/- have now become £2 to £7. Thus, even if I am wrong about price being a less important factor than is supposed, the comparatively steep rise in the cost of the cheaper seats militates against younger newcomers to the theater.

The second major issue raised in Robert Hutchison's paper is "whether the Thatcher Government will make any amendments in the law relating to charities to stimulate an increase of private support for the arts." For two decades I have attempted to persuade the Treasury to grant tax concessions for registered charities in this respect. However, the legal advisers have maintained that it is impossible to define arts charities as distinct from educational charities, medical charities, and so forth. Enormous losses will be experienced by the Exchequer if such concessions are granted to organizations from the Battersea Dogs' Home to the Society for the Prevention of Cruelty to Children. Certainly, there is every indication that the Exchequer would reduce the Arts Council's grant-in-aid to reflect the losses suffered through tax concessions to the arts. Thus, the burden for supporting the arts would be shifted from central government to private sponsorship, with no indication of new, additional money.

A further matter which concerns the Arts Council is that sponsorship seeks out the successful and prestigious. This is only fair; commerce and industry do not want to be associated with concerts which are only half full, let alone plays which are experimental and attract undesirable publicity. The Arts Council would be left with the less successful and the more experimental, which makes a weaker case for Treasury funds. There is no doubt that over the past thirty years new small-scale work has "ridden in" on the back of the star items in the Council's application to the Treasury—the National Theatre, the Royal Opera, the Royal Ballet, and so on.

Finally, one must note that private sponsorship, vital to support the main regular subsidizers, is fickle—this is part of its worth. But the switching of such sponsorship, at the whim of a chairman's wife, from ballet to opera, cannot be the basis of a logical evolution of arts organizations. Present estimates indicate

that private sponsorship in Great Britain has grown to about £3,000,000, which is approximately 5 percent of the Council's current grant-in-aid of £63,000,000 (1979–80). Thus, if it were feasible to achieve a welcome doubling of such sponsorship next year, it would only just compensate for a cut of 5 percent in the Council's grant.

The last point in Robert Hutchison's paper on which it might be useful to comment is his statistic that "the four national companies received in 1977–78 33 percent of the total Arts Council expenditure in England compared with a figure of 43 percent ten years earlier." I consider it essential to note simply that in those ten years not only has the percentage dropped dramatically (while acknowledging that the total grant-in-aid has increased from £7,200,000 to £41,725,000 over that period), but that during that period the National Theatre Company moved from the Old Vic Theatre (878 seats) into the three auditoria on the South Bank (1,132 seats in the Olivier, 894 in the Lyttleton, and 353 in the Cottesloe), and it also tours. The English National Opera not only occupies the Coliseum and sends a touring company to the regions, it also has a major new company in Leeds (the English National Opera North). The Royal Opera and the Royal Ballet at Covent Garden are supplemented by the Sadler's Wells Royal Ballet Company on tour. And the Royal Shakespeare Company has extended its work in Stratford to "The Other Place," and in London to "The Warehouse"; it tours in large regional cities and maintains a small-scale company for a long season in the Theatre Royal, Newcastle upon Tyne. Thus, what is referred to in our annual reports as four national companies is, in fact, the equivalent of seventeen performing companies.

An Exploratory Analysis of the Effects of Public Funding of the Performing Arts

Steven Globerman

THE DRAMATIC INCREASE in government support of the performing arts is a striking feature of public sector expenditure patterns over the last decade or so. From 1967 to 1976 the substantial increase in arts funding was undertaken by the Canada Council and the National Endowment for the Arts, the major federal funding agencies in Canada and the United States, respectively. In Canada this time period showed nearly a sixfold increase in funding, while at the same time in the United States the increase was nearly eightfold. Since funding of the performing arts at lower levels of government also increased over the period cited, the absolute increase in total direct government funding of the arts was even greater.

In spite of the growth relativity, the absolute dollar value of such funding remains relatively small. Perhaps for this reason, although hypotheses abound, little effort has been made to evaluate the impact of the rapid increase in public funding of the arts over the last decade. For example, it has been suggested that the rapid increase in funding has led to the establishment of a large number of new artistic organizations and to increased productions of new and experimental works, that increased funding has enabled performers to devote greater time to performing and less time to supplementing their incomes, thereby improving the quality of arts performances.

However, skeptics of government funding argue that the ready availability of government funds has accelerated the increase in the costs of producing live arts performances, and that increased government support merely substitutes for private funding or box office revenue. Another concern is that government subsidies permit artists to perform unorthodox presentations more pleasing to the performers than to actual and potential customers. Still another criticism is that government funding favors the established companies at the expense of new companies, making it more difficult for new talent to enter the industry.

67

Some of these arguments involve value judgments that are highly contentious. For example, the impact of public funding on the quality of a nation's performing arts resources may only be discernable in the mind of the individual critic. However, such issues as the impact of government funding on the number of performances, average ticket prices, and payments to artistic performers are potentially tractable through empirical analysis. The possibility of governments reducing the amount of future public funding for the arts is causing understandable concern in performing arts organizations. On the other hand, several politicians have expressed optimism that creation of greater private sector initiatives would more than offset any adverse effects of direct reductions in government funding.[1] Unfortunately, our limited understanding of how the rapid growth of government funding has affected the performing arts implies a symmetrical ignorance about the likely effects of any substantial cutbacks in real levels of public subsidies to the arts.[2]

However, some insight can be gained into the consequences of increasing or decreasing direct government funding of the performing arts by investigating the empirical relationship between funding patterns and various operating characteristics of arts organizations. The following empirical analysis focuses on aggregate data for individual art forms, as well as disaggregated data for samples of Canadian symphony orchestras. The analysis leads to the conclusion that certain cynical assessments of public funding of the arts may have validity, while others may be misplaced. Specifically, there is some basis for concern that government funding substitutes to some extent for other sources of revenue. However, public funding is associated with an increased number of arts performances and increased attendance. While increased expenditures per performance also appears to be a consequence of public funding, there is some indirect evidence which suggests that the composition of expenditures of groups receiving relatively large government subsidies does not differ dramatically from the expenditure pattern for less heavily subsidized groups.

Before I detail the empirical analysis, it is worthwhile considering some theoretical issues related to the presumptive effects of public subsidies to the arts, both to sharpen the focus of our inquiry and to identify some important topics for future study.

SOME THEORETICAL CONSIDERATIONS

To identify theoretically the allocative and distributional implications of government subsidies, one needs some model of how potentially affected institutions behave; for example, what do arts organizations try to maximize or minimize? What outside forces or internal policies constrain their actions? Apropos of these and related questions, Weisbrod asserts that no consensus exists among economists as to how to model—that is, to describe and predict—the behavior of voluntary nonprofit "firms." He further observes that the motivations of those

who contribute to the financing of an organization's activities are difficult to determine (Weisbrod 1977).

A number of writers have developed models of nonprofit institutions which attempt to support and derive implications from different assumed objective functions. These functions include output maximization, budget maximization, maximization of some "mixed" objective function containing quantity and quality of output arguments, and professional income maximization, among others. However, we are still far from a consensus on organizational goals or on the nature of trade-off functions between the most likely multiple goals.[3] The performing arts offer no exception to this assessment.

Baumol and Bowen's model of performing arts organizations has received widespread attention and has been drawn upon extensively for its policy insights;[4] however, their model is largely implicit. They view performing arts organizations as seeking to promote the quality of the services they provide and to distribute their bounty as "widely and as equitably as possible." Consequently, performing arts groups tend to exhibit a bias toward overproducing quality and pricing below the real cost of providing their services. Furthermore, the inability to take advantage of technological change and to demand elasticity constraints on raising prices to cover cost increases necessitates ever larger government subsidies merely to keep the quantity of output in the sector from decreasing. Hence, Baumol and Bowen's model implies that reductions in real output will accompany reductions in real subsidy levels, pari passu.

The Baumol and Bowen model has been criticized on the grounds that it ignores the possibility (suggested by a number of observers) that opportunities for cost reductions do exist for arts organizations. For example, arts organizations may overrehearse and undertake a wider range of productions than is optimal.[5] Excessively elaborate props, costuming, and other capital inputs may be reflections of "artistic indulgence." The critics of large-scale public funding of the arts worry that the availability of such funding blunts the incentive of arts organizations to take advantage of cost-reducing opportunities or to forego granting salary increases to performers, technicians, and managers beyond what is required to encourage the provision of their services.

Obviously, arts managers may rationalize some expenditures as serious efforts to improve the quality of artistic performances, and perhaps attempts to distinguish the promotion of true quality from excesses of artistic and technical indulgence are bound to be inconclusive. Nevertheless, it is important to arts policymakers to know how increased government funds are allocated among competing alternatives. For example, there may be a distinct preference for promoting the development of indigenous cultural resources (local writers, composers, and so forth) rather than hiring guest artists of international repute. Put in broader terms, increased expenditures may be manifested in an increased scope of performance and/or in higher costs per performance for a given scope of performances. Unfortunately, the Baumol and Bowen model provides no a priori insight into how arts organizations are likely to choose among alternative expenditure pat-

terns and, more particularly, how trade-offs will be made between promoting quality and "distributing their bounty widely." Thus, in the absence of compelling theory, the supply-side effects of public subsidies to arts groups appear to be primarily an empirical issue.

Issues related to the demand-side or revenue-related impacts of public funding, while also uncertain, are somewhat more focused. Specifically, critics have argued that government subsidies and private funding (including earned revenue) of arts activities may be substitutes. One source of substitution is the alleged tendency of public support to undermine the willingness of people to contribute to the arts out of their own pockets.[6] Another is the widespread view that government grants are used by arts organizations to keep certain prices below the level at which they could be kept without reducing the size of audiences.

Regarding the first assertion, it is certainly possible that government grants discourage private philanthropic contributions by increasing the perception among potential donors that a minimum level of arts performances will be available even if private donations are scaled down. Alternatively, a plausible case can be made for complementarity between government subsidies and private philanthropic contributions. Specifically, government subsidies may increase the marginal utility of a dollar of private patronage by increasing the expected output of private contributions. The exploitation of this relationship is most clearly seen in the case of matching funds programs, where private contributions are leveraged by some multiple amount of tied government funds. However, even ignoring matching funds programs, complementarity might still exist. For example, base levels of government funding may be seen (by potential patrons) as guaranteeing that acceptable levels of artistic competence will be achieved and therefore that private contributions will not be frittered away on substandard productions. Furthermore, government funding patterns may reduce private information costs; that is, potential private donors may simply follow the lead of major public funding agencies rather than attempt to evaluate relative artistic competence and integrity on their own, thereby encouraging greater private philanthropy. In short, the relationship between public subsidies and private philanthropy is potentially complex and theoretically uncertain.

The relationship between government funding levels and earned revenues in the arts is also somewhat ambiguous. The view that government funds are used to keep admission prices below equilibrium is of particular concern, given available evidence that subsidized attenders are likely to be drawn predominantly from the middle and upper socioeconomic strata.[7] Unfortunately, reliable estimates of price elasticities of demand are not generally available for the various performing arts sectors. It is likely that price elasticities of demand differ significantly across arts performances: while demand might be relatively price inelastic for performances given by the National Ballet of Canada, it could be quite elastic for performances given by experimental theater and dance groups. Furthermore, audiences for small theater and dance performances tend to be younger and less wealthy than audiences for other types of arts performances. Thus, it is not clear that arts groups can in general boost real prices substantially above those charged

without suffering significant reductions in earned income, if, indeed, such a concern about inflexible prices is generally valid for arts organizations.

The foregoing discussion might be summarized as follows: the effects of government subsidies on the supply (or cost) and demand (or revenue) sides of the market for performing arts output are not evident on an a priori basis, although a number of plausible hypotheses can be asserted. Empirical evidence relating government funding to various characteristics of performing arts organizations is clearly warranted if enlightened policymaking is to take place in this important area.

EMPIRICAL EVIDENCE ON THE EFFECTS
OF GOVERNMENT FUNDING

In an earlier attempt to assess the impact of government subsidies to a sample of U.S. theater companies, opera companies, and symphony orchestras, Netzer concludes that while all three types of arts organizations received large increases in government funds during the sample period, public subsidy had quite different effects on each. Specifically, public subsidy for theater companies was associated with wage increases far in excess of wage increases in the rest of the economy. The increase in average ticket prices was quite low relative to the consumer price index, thereby facilitating a sizable increase in attendance. The number of performances increased very modestly. The opera companies in the survey did not make wage increases in excess of those in the economy at large, but the number of performances increased substantially.[8] Ticket price increases were kept low relative to the consumer price index. Major symphony orchestras considerably increased their number of performances per year. Wage costs per performance rose only modestly as did the number of ticketed performances. The number of contracted performances more than doubled, however. For all performing arts organizations, Netzer concludes that there is no evidence to support the notion that increased government support substituted for private contributions and grants that might otherwise have been forthcoming.

Netzer acknowledges several weaknesses of his study. One is the failure to hold constant other factors besides government funding in his analyses.[9] A second is the limited sample size employed. A third is the procedure of averaging variables across all groups in a given performing art form, which could mask significant variance across groups within the form. I have attempted to embellish upon Netzer's results in two ways. First, I have replicated Netzer's analysis for a comparable sample of Canadian performing arts groups. Similarity in results across both U.S. and Canadian samples would impart added confidence to the results cited above for each specific art form. Second, in another exercise I relate government subsidy levels to a variety of financial and performance variables for a sample of Canadian orchestras. This analysis is undertaken, in part, to mitigate concern that conclusions drawn from comparisons across art forms may be modified by investigations carried out at more disaggregated levels.

Table 1. Percent Distribution of Total Operating Income by Source, 1965–66 and 1973–74 for Performing Arts Organizations in the Ford Foundation Surveys

Source of Income	Theater Companies		Metropolitan Opera		Other Operas		Symphonies		Dance Companies	
	1965–66	1973–74	1965–66	1973–74	1965–66	1973–74	1965–66	1973–74	1965–66	1973–74
Government*	4	13	—	5	2	10	5	15	11	20
Ticket Income	68	52	52	44	50	40	38	30	42	27
Other Earned Income	7	9	19	23	8	8	23	16	13	18
Other Unearned Income**	21	26	28	28	39	41	33	40	34	34
Number of Organizations	27	31	1	1	30	28	91	78	17	15

*Includes services income from government sources and government grants.

**Encompasses individual, business, and foundation contributions; grants; and endowment earnings.

Source: Netzer (1978, p. 101). It should be noted that the data in the last column do not correspond precisely to the data cited in the source table. In a private correspondence Netzer suggested to the author that the numbers shown here are probably more appropriate.

Table 1 reports the percent distribution of total operating income by source in the years 1965–66 and 1973–74 for U.S. performing arts organizations in the Ford Foundation surveys. These data provide the basis for Netzer's conclusion that relative increases in government funding have not necessarily come at the expense of private donations. Rather, box office income has (in relative terms) experienced the major compensating decrease. Table 2 reports revenue data for a sample of twenty-nine Canadian performing arts companies that received Canada Council funding over a time period similar to that for Netzer's sample.

A number of interesting observations emerge in comparing Tables 1 and 2. First, the relative share of earned income declined for all arts sectors in both countries. However, decreases in the relative shares of earned income in the Canadian sample are substantially less pronounced than they are in the U.S. sample. Furthermore, there is somewhat more evidence from the Canadian sample that government funding and private philanthropy are net substitutes. Specifically, there was a decrease in the relative shares of private contributions for three of the four art forms in the Canadian sample, although the decrease for opera might well be insignificant. Only in the case of theater groups did the relative income share of private contributions increase in both the Canadian and U.S. samples. Moreover, it is possible to argue that if a weighted average of the sample points for the Metropolitan Opera and other U.S. opera companies were calculated, the change in the relative share of private funding would border on insignificance, as does the change for the Canadian opera sample. Thus, the pattern

Table 2. *Percent Distribution of Total Operating Income by Source, 1966–67 and 1974–75, for Twenty-nine Canadian Performing Arts Companies (thousands of dollars)*

	Theater		Opera		Music		Dance	
1966–67	Total	%	Total	%	Total	%	Total	%
Government	1,406	33	447	29	1,199	31	778	35
Private	160	4	160	11	723	19	431	19
Ticket Income and Other Earned Income	2,698	63	912	60	1,949	50	1,042	46
Total	4,264		1,519		3,871		2,251	
1974–75								
Government	4,182	33	1,243	35	4,593	40	2,678	44
Private	892	7	353	10	1,554	13	685	11
Ticket Income and Other Earned Income	7,757	60	1,925	55	5,479	47	2,777	45
Total	12,831		3,521		11,626		6,140	
Number of Organizations	13		3		10		3	

Source: Calculations based on data provided in Brice and Rosborough (1978).

for private funding appears similar across the Canadian and U.S. samples for at least two of the four art forms (theater and opera).

The data in Tables 1 and 2 suggest that government funding might substitute for earned income and to a lesser extent for private philanthropy. However, the patterns observed are far from definite and are somewhat sector-specific. It is also important to reiterate that failure to control explicitly for all intervening variables potentially affecting the relationships of interest mitigates against drawing strong conclusions from the foregoing analysis.

Our concern that intervening variables may mask the true relationship between changes in government funding and changes in other sources of revenue might be alleviated to some extent by focusing on the relationship for a relatively homogeneous set of arts companies. We were able to obtain data similar to those presented in Table 2 for a sample of thirteen Ontario symphony orchestras. For all thirteen orchestras, the absolute amount of government funding increased substantially over the sample period (1972–73 to 1976–77). It can be shown that if either private philanthropy or earned revenue has a negative (or inverse) relationship with government funding, then absolute increases in government funding will be associated with decreases in the relative share(s) of nongovernment sources of revenue, all other things remaining constant. In fact, in seven of the thirteen cases the share of private contributions in total revenue decreased over the sample period. The relative share of total concert revenue decreased in eight of thirteen cases. Hence, the results obtained from the symphony sample provide very tentative support for the conclusion that funding from the government might substitute for earned income and to a lesser extent for private philanthropy in the revenue-generating activities of arts organizations.

Potential supply-side effects of government funding are to be found in increased expenditures of different types. A preliminary insight into these effects

Table 3. *Percent Increases in Economic Variables, 1965–66 to 1973–74, for Selected Groups of Performing Arts Organizations Included in the Ford Foundation Surveys*

Economic Variable	Theaters	Operas (excluding Metropolitan)	Symphonies
Total Personnel Costs	141.6	160.8	135.1
Performances	11.1	64.0	79.7
Personnel Costs per Performance	91.8	59.0	30.8
Ticket Income	101.4	114.4	80.0
Ticketed Attendance	38.1	48.3	17.8
Average Ticket Price	46.0	43.5	52.8
Income from Government Sources	718.3	1,897.2	534.5

Source: Netzer (1978, p. 104).

can be obtained from Netzer's analysis of the Ford Foundation companies. Table 3 reports the growth rates over the period 1965–66 to 1973–74 for a number of output-related economic variables for selected groups of performing arts organizations. Table 4 reports comparable data over a similar period for the group of twenty-nine Canadian performing arts companies. A slightly more detailed breakdown of personnel costs is available for the Canadian sample and is consequently provided. As was true for Table 1, a breakdown of earned revenue is unavailable; hence, ticket income cannot be reported separately from other earned income.

Comparing the results in Tables 3 and 4 for U.S. and Canadian theaters, it does not appear that Netzer's conclusion that "public subsidy for theater companies was associated with wage increases far in excess of wage increases in the rest of the economy" holds for the Canadian sample. Specifically, the increase in personnel cost per performance (40 percent) was less than the approximate 91 percent increase in average weekly wages and salaries for the industrial sector as a whole over the sample period. Thus, average wages in the theater sector will have increased less than in the economy as a whole, as long as the personnel-to-performance ratio was reasonably constant. The relatively small increase in personnel costs per performance reflects a rather substantial increase in the number of theater performances. An incidental but nonetheless interesting observation is that over the period from 1971 to 1975 the number of theater performances of Canadian works increased by 191 percent, which was well in excess of the growth rate of non-Canadian works. By comparison, theater performances of all types

Table 4. *Percent Increases in Economic Variables, 1967–68 to 1975–76, for "Group of 29"*

Economic Variable	Music	Opera	Dance	Theater
Artistic Salaries	184	126	113	140
Technical Salaries	526	187	259	297
Publicity and Promotion Expenses	336	230	261	136
Administration Expenses	157	211	65	183
Performances	93	66	25	101
Production Personnel Cost per Performance*	52	44	88	40
Earned Revenue	176	119	130	186
Attendance	49	23	26	80
Earned Revenue per Attendee	85	46	83	58
Government Funding	283	178	244	197

*Calculated as artistic plus technical salaries divided by total performances.
Source: Author's calculations from data in Brice and Rosborough (1978).

increased by 30 percent over the same period. Thus, it appears that managers of Canadian theater groups intensified their efforts to promote Canadian content in their performances. This objective is consistent with broad public policy goals at the national level. Earned revenue per attendee increased by 58 percent for Canadian theaters over the sample period. This was greater than the 39 percent increase in the consumer price index for Canada. On the surface it would therefore appear that theater groups on average increased real ticket prices, if in fact the ratio of box office income to other earned income remained fairly constant over the sample period.

Opera companies in the Canadian sample also appear to have granted smaller wage increases than those in industry at large, presuming that the personnel-to-performance ratio did not decrease significantly over the sample period. The number of performances increased substantially, and earned revenue per attendee increased by somewhat more than the consumer price index. Very similar observations might be made for symphony orchestras. Although no Canadian opera productions were performed before 1971, performances of classical music composed by Canadians from 1971 to 1975 increased by 57 percent, compared with an increase in total performances of 110 percent over the same period. Given the small number of Canadian composers compared to playwrights, the relatively smaller increase in Canadian content for classical music is not surprising.

The increase in production personnel costs per performance was greatest in the case of dance companies. Although still slightly below the increase in average weekly industrial wages and salaries, it was above the increase in average weekly wages and salaries in the service sector. The increase in performances was relatively modest in the dance sector. However, the increase in earned revenue was substantial and well above the percentage increase in the consumer price index. The percentage increase in Canadian performances (17 percent) from 1971 to 1975 was about equal to the percentage increase in all dance performances.

What can one make of the data presented in Tables 3 and 4? First, simple generalizations about the output and pricing decisions of arts groups are bound to be tenuous. Thus, while Netzer finds some evidence (specifically, for theaters and operas) that increased government funding was associated with above-average wage increases and below-average price increases, this pattern is not clearly evident in the Canadian sample of theater and opera companies. Nor is the pattern apparent in either the Ford Foundation or the Canadian samples of symphony orchestras. A second observation worth making is that the relationship between government funding and expenditure and pricing decisions by arts groups may vary across art forms. This can be seen directly in the nature of expenditure increases (for example, artistic versus technical versus administrative) and in the differences in performance increases relative to increases in expenditures per performance.

The obvious question left begging is what factors determine the observed differences? Again, a fully specified model might identify the sources of these observed differences and reveal a significant impact of government funding levels. However, our cursory examination suggests that such an analysis is unlikely to support such simple propositions as the statement that government funding

merely inflates artistic salaries (or keeps prices unreasonably low). Indeed, the data presented in Table 4 imply that increased performances may well have been the major impact of increased public funding of the arts.

SUMMARY AND CONCLUSIONS

This study has considered the impact of government funding on arts organizations using a variety of fragmentary data. The limited data combined with the failure to perform multivariate analysis seriously circumscribe any conclusions that might be drawn. Nevertheless, several suggestive observations seem permissible. One is that government funding for the arts might well result in some offsetting declines in private philanthropy and earned revenue. If this is so, estimates of the likely contraction of the arts sector resulting from real cutbacks in government funding may be overstated.[10] Another is that increased expenditures per performance are associated with increased government funding; however, these increased expenditures largely follow the pattern observed for smaller, less heavily subsidized symphonies. A relatively greater emphasis on artistic salaries characterizes the larger symphonies, but a more detailed analysis not reported in this paper suggests that these added expenditures are presumably reflective of a striving for "professionalism" rather than excessive rehearsing or other forms of artistic indulgence.

Notes

1. The cultural affairs coordinator for Canada's recently elected Progressive Conservative Party has called for changes in tax laws to encourage performers, artists, and producers of films, books, magazines, and recordings to increase output.
2. For an exploratory impact analysis of radical reductions in public funding, see James H. Gapinski, "What Price Patronage Lost? A View from the Input Side" (1979). A more extended consideration of the impact of government funding can be found in Dick Netzer, *The Subsidized Muse* (1978).
3. This is the conclusion of Weisbrod (1977, p. 15), based on his extensive review of the nonprofit literature.
4. A summary of this model can be found in W. J. Baumol and W. G. Bowen, "On the Performing Arts: The Anatomy of Their Economic Problems" (1965).
5. On these points as applied to symphony orchestras, see R. Weiss, "The Supply of the Performing Arts" (1976).
6. See, for example, David Alexander, "Business and the Arts—The Case Against Business Support" (1975) and David Alexander, *Business and the Arts* (1976). A fuller discussion of the theoretical relationship between public and private arts philanthropy can be found in Bruce A. Seaman's paper, "Economic Models and Support for the Arts," in this volume.
7. For a summary of the evidence on this point, see S. H. Book and S. Globerman, *The Audience for the Performing Arts* (1975).
8. Since the number of artists increased very little, however, average annual earnings per artist in opera companies increased substantially more than average annual earnings elsewhere in the economy.
9. In this regard, Seaman's fuller econometric study of the relationship between public and private philanthropy comes to different conclusions from Netzer's study.
10. One such estimate can be found in Gapinski (1979).

References

Alexander, David P. 1975. Business and the Arts—The Case Against Business Support. In *Business and the Arts*, Eric Moonman, MP, ed. London: Foundation for Business Responsibilities.

———. 1976. *Business and the Arts*. London: Foundation for Business Responsibilities.

Baumol, W. J. and Bowen, W. G. 1965. On the Performing Arts: The Anatomy of Their Economic Problems. *American Economic Review* 4 (May): 1495–1502.

Book, S. H. and Globerman, S. 1975. *The Audience for the Performing Arts*. Toronto: Ontario Arts Council.

Brice, Max and Rosborough, Daniel. 1978. *The Group of Twenty-Nine Revisited* (mimeographed). Research and Statistics Directorate, Arts and Culture Branch, Secretary of State for Canada.

Gapinski, James H. 1979. What Price Patronage Lost? A View from the Input Side. *Journal of Cultural Economics* 3 (June): 62–72.

Netzer, Dick. 1978. *The Subsidized Muse*. Cambridge: Cambridge Univ. Press.

Weisbrod, Burton A. 1977. *The Voluntary Nonprofit Sector: An Economic Analysis*. Lexington, Mass.: D. C. Heath.

Weiss, R. 1976. The Supply of the Performing Arts. In *The Economics of the Arts*, Mark Blaug, ed. Boulder, Col. and London: Westview Press and Martin Robertson.

Comment
William S. Hendon

In taking up some of the issues arising from the substitution of public dollars for private ones in the arts, earlier addressed by Dick Netzer, Bruce Seaman, and Roger McCain, Globerman tentatively finds evidence to support the contention that "the patronal motive," as Seaman calls it, has weakened with increased public funding. Globerman is the first to admit, given the rather scarce data he has at hand, that there is nothing conclusive in his findings. But his analysis gives further weight to the possibility and does so thoughtfully and carefully.

One question, however, immediately comes to mind: who do we mean by private donors? Are we referring to individual patrons, corporate givers, or foundation grantors? Identity is important, and some insight into just who they are, if they have changed, and if their behavior has changed would be very useful.

For example, if donors are local individuals, they may have passed away, in which case the donors in 1975 are not even the same people who were giving in 1966.

If they are corporate givers, we may see a general decline in their giving as a group, not because they are shifting this role to the public sector, but because they may have what they deem better uses for their advertising and promotion monies. They may have found more effective ways to achieve good will and to do "good works."

If they are foundation grantors, they may simply have moved away from that kind of interest. Do the foundations give money to the same kinds of recipients in 1974–75 as they did in 1966–67? Perhaps they have simply changed their emphasis in what they wish to support. Or perhaps, just as in the case of business corporations, they have had a change in top management, and the new managers, unlike their predecessors, do not wish to contribute to the arts but would rather support a public television series, or a boys' program, or whatever.

While I have no real quarrel with the work done thus far, questions about these shifts seem central to the research. I suggest, then, that a profitable line of inquiry at this point would be to ask donors about their giving in order to answer these questions.

Economic Models and Support for the Arts*

~~~~~~~~~~~~~~~~~~~~~~~~~~~~~~~~~~~~~~~~~~~~~~~~~~~~~~~

## Bruce A. Seaman

INCREASED GOVERNMENT support for the arts in the United States in the last decade has caused some concern that private support is being "crowded out," that public support is substituting to some degree for private funding that would have been forthcoming.[1] This possibility is particularly interesting in the United States because of the great variety and importance of private funding in contrast to that found in most other countries. In addition to private box office payments ("earned" income for art groups), individual voluntary contributions and grants from corporations and from nonprofit foundations contribute significantly to the support of both museums and performing arts organizations.[2]

Here a theoretical foundation is suggested to evaluate the degree of substitutability between local government subsidies and local individual contributions. A simultaneous system of arts funding equations is also tested. Cross-section data on funding sources for the major performing art groups and museums in forty-seven standard metropolitan statistical areas (SMSAs) are used in the empirical analysis.[3] While the model is used to investigate the relationship between individual contributions and government subsidies, it could conceivably be expanded to investigate the relationships among other sources of income for the arts.

## A SUGGESTED FRAMEWORK

One way to characterize a community's arts funding for a single time period is with the following three-equation system:

*This paper is an extension of work begun with the author's dissertation, "A Positive Analysis of Government Cultural Subsidies" (unpublished, University of Chicago, 1978). Gratitude, without implication, is expressed to Jorge Marinez for helpful comments on parts of this paper. Special thanks also to Rita K. Roosevelt and to Michael Edison for invaluable assistance in obtaining the data.

(1) $C = f(D, X, S, B, F, S_{t-1}, C_{t-1})$

(2) $S = f(D, X, C, B, F, S_{t-1}, C_{t-1})$

(3) $B = f(C, S, F, S_{t-1}, C_{t-1}, X)$

where $C$ is total community contributions from individual households; $S$ is total local government subsidies; $B$ is total combined arts organization expenditures, or arts budget size; $F$ is a vector of all other sources of arts income, including earned receipts from ticket sales, business contributions, other private grants, and state and federal grants; $S_{t-1}$ and $C_{t-1}$ are earlier time period subsidies and contributions; $D$ is a vector of individual consumer demand variables, such as household income, the prices individuals must pay for additional contributions and subsidies, and taste variables (for example, education and age); and $X$ is a vector of community characteristics that affect either individual willingness to fund the arts, such as population size and density, the degree of income inequality, and the number of arts organizations, or variables added for empirical testing purposes, such as regional dummies. The funding variables may be usefully expressed in per-capita terms. A more general and much more complex formulation would attempt to specify separate equations for all of the funding variables.

The interpretation of arts expenditures, $B$, can be simply stated. Since, in general, income received by arts groups will be spent in the current time period, expenditures are an obvious function of the various sources of income.[4] A certain amount of earned and unearned income will be given to museums and performing arts groups regardless of fund-raising and promotional efforts. On the other hand, various descriptions of these organizations suggest that managers set spending targets for the year based on artistic and attendance goals and then embark upon fund-raising efforts to generate target income. Therefore, observed expenditures are also a function of desired expenditures, and observed contributions, subsidies, and other support are in part a function of the fund-raising efforts or needs of the organizations. People may be willing to pay more when these needs are more serious, and more expenditures become feasible as people finance more support. Thus, $B$ is the dependent variable in equation (3) and an independent variable in equations (1) and (2).[5]

## The Relationship Between Contributions and Subsidies

Community decisions to contribute privately and to subsidize publicly are related at two levels: first, in the initial political decision to devote tax funds to the arts, and second, in the reactions of contributors to the subsidizing decision once it is made and, conversely, in the reaction of voters/constituents to private contributing decisions once they are made.

The relationship cited in equation (1) reflects the fact that contributions and subsidies are to some extent jointly determined by individuals having different preferred amounts of contributions and subsidies that they are willing to finance. Observed community contributions are the sum of the individual contributions of utility-maximizing consumers choosing an optimal mix of goods, contributions, and publicly financed subsidies. Observed government subsidies are the result of an aggregation through the local political system of constituent demands based

on this utility maximization. Elected officials must be responsive, to some extent, to the intensity of political demands for arts subsidies as measured either by the lobbying and letter-writing costs that constituents are willing to bear or by the probability that one's vote in the next election will be influenced by this particular public policy. The greater the expected utility loss to any constituent from being forced to "consume" a nonpreferred amount of arts subsidies, the greater will be the intensity of political demand expressed.[6]

The relationship cited in equation (2) extends this interaction one step further by recognizing that once the political decision is made, the amount of subsidies given to arts groups becomes an exogenous shock to actual and potential contributors, who in turn react in a utility-maximizing way. For complete accuracy, further reactions by constituents/voters to the contributing decisions of households would also have to be considered in the next decision-making period, since such contributions might change voters' willingness to finance subsidies through their taxes.

An individual's $i$ "demand" functions for government subsidies and personal contributions can be written as follows:

$$(4)\quad S^i = f(Y^i/P_z, P_c^i/P_z, P_s^i/P_z, X, F, \sum_{i=1}^{n} C^i, B)$$

$$(5)\quad C^i = f(Y^i/P_z, P_c^i/P_z, P_s^i/P_z, X, F, \sum_{i=1}^{n-1} C^i, B)$$

where, in addition to those terms already defined, $S^i$ and $C^i$ are the utility-maximizing quantities of subsidies and personal contributions, $Y^i/P_z$ is disposable real income, $P_z$ is the price of a composite private good, $P_c^i/P_z$ is the relative price of contributions, $P_s^i/P_z$ is the relative price of subsidies, and the summation of $C^i$ over $n$ or $n-1$ represents either all private contributions or all contributions by people other than $i$.

The only difference between these and normal demand functions is that the $S^i$ function is what Breton (1974) calls a "technocratic" demand function, since it will generally not be observed due to the nature of collective decision making. Also, the $C^i$ function might as easily be called a supply function, reserving the term demand for the recipient arts organizations which most directly benefit from the support. But this is only a semantic distinction, because contributors can be viewed as demanders of the "services" of contributions (suggested below), which they obtain by simply making contributions.

### Substitution Versus Complementarity

There are three basic ways for a person to receive utility from contributing privately to the arts. There may be a samaritan effect based on the act of giving. Specifically, contributors often receive preferential treatment in the form of better seating at concerts, invitations to private showings, less waiting time at special exhibitions, and so forth. Encouraging contributions with such rewards may in fact be an effective way for arts organizations to price discriminate by offering

all-or-nothing tie-in sales to consumers who are willing to buy preferential seating for a contribution of $100 or pre-access to visiting exhibits for a membership fee of $50 per year. Finally, there is likely to be a utility interdependence effect, through which an individual receives utility from the increased art consumption of others that is made possible by contributions. The additional income allows managers to reduce admission fees, increase the number of arts events, provide more varied and accessible facilities, or increase the quality of arts events—all of which reduces the effective "price of art" and stimulates attendance. Contributions, therefore, provide "public" benefits to others who happen to share the concern for expanded arts consumption.

It is clear that an individual paying indirectly for arts support through the local tax system can only benefit through the utility interdependence effect (and of course from any reduction in the price of art the individual consumes). Thus, publicly financed support cannot be a perfect substitute for privately financed support since the marginal utility to the donor of a dollar of contributions exceeds that of a dollar of subsidies. On the other hand, the use of public funding spreads the cost of supporting the arts around the taxpaying community, and will make an individual's per-dollar price of subsidies (equal to the individual's local tax share) lower than the dollar price of contributions (equal to one minus the individual's marginal federal tax rate). Therefore, an individual favoring support for the arts is likely to prefer some mix of private and public financing.

If arts support is a normal good, the effect of income in equation (4) on both $S^i$ and $C^i$ will be positive. The relative price terms will reflect the "own" and cross-price elasticities for contributions and subsidies and will depend on the degree of substitutability between the two forms of support in the individual's utility function.[7] These price variables will interact with income to complicate the "pure" income effect cited. As personal income increases, the private price of giving drops because the marginal tax rate increases, and the local tax share is likely to increase with income and raise the price of subsidies. Finally, the value to a contributor of the rewards accompanying contributions will tend to increase with the value of time, and, thus, with income. When combined, these effects can shift one's utility-maximizing mix of support toward contributions and away from subsidies as one's income increases.

While the strength of the substitution relationship between contributions and subsidies will be reflected in these price and income terms, it will also appear in the "reaction" effect represented by the total contributions and subsidy terms (and also to some extent the all-other-funding term, $F$) on the right side of equation (4). There is a strong substitution effect among these funding sources due to utility interdependence. As funding increases from one source, it reduces the marginal utility of an additional dollar of funding from another source.[8] This negative reaction is only partially weakened by the fact that contributions and subsidies are not perfect substitutes.

This substitution effect competes with a possible complementary relationship between subsidies and contributions (and all other funding) due essentially to a taste change that may be induced by an increase in funding that leads to an im-

provement in arts quality or induces consumer experimentation in response to lower ticket prices. It is sometimes called a "threshold" effect because a critical level of arts support may be necessary to generate enough interest to induce greater support from other sources, or in other words, increase the marginal utility of arts funding for given quantities, prices, and income. Complementarity may dominate when overall arts support is low but yield to the substitution relationship once the community has an arts industry of an acceptable size.

### Efficiency Versus Patronal Motives
### for Demanding Public Funding[9]

A final consideration useful in interpreting the empirical results is the distinction between two underlying motives for people to demand government financing of unearned income. Both are broadly consistent with a negative correlation between observed private individual and public support and also maintain the relationship among income, prices, and desired quantities of support expressed in equation (4).

The effect of increased other individual contributions on any one person's willingness to contribute is, of course, similar to that of the effect of increased subsidies. Unless the complementary effect is strong, the marginal utility of additional personal contributions declines due to the interdependent utility effect, and fewer contributions are made. It is a standard conclusion that as population size increases, total private contributions (to all types of recipients) increase but per-capita contributions decline.[10] To the extent that per-capita measures of support are better reflections of the "effective" arts services provided to the community from increased funding, the free-riding behavior that leads to this result can be "inefficient."[11] Efficiency will not actually result as long as some people who are not interested in additional arts support are coerced into paying for such support through taxation. But in a more limited sense, for those who *are* demanders of additional support and would be willing to pay more themselves if more equitable cost sharing among arts supporters could be achieved, utilizing the coercive cost-sharing arrangement implicit in government funding would tend to reduce free riding and increase total arts transfers.

Of course, the general reliance on property taxes to finance local spending means that some cost shifting to those not favoring arts support is inevitable. One can identify a patronal motive for demanding subsidies based on the idea that contributors and potential contributors can reduce their own cost of arts support by substituting relatively cheap public funding (with costs shared) for relatively expensive personal contributions. Since this motive is based on a desire to reduce one's own cost of supporting the arts, the reduction in contributions in response to increased subsidies will be greater than if the efficiency motive were dominant, perhaps even reducing *total* support.[12] With the efficiency motive, the relatively small amount of per-capita contributions due to free riding will stimulate demand for public financing but will not lead individuals to reduce their own contributions further as subsidies increase. People are willing to *increase* their costs of supporting the arts according to the efficiency motive. However, according to the

patronal motive, people are trying to *reduce* their costs of supporting the arts and are expressing demands for public funding in order to be able to reduce their own private support as subsidies increase.

## EMPIRICAL TESTING

In order to test the relative strength of the substitution and complementarity relationships between public and private household support, and the interaction between arts budgetary expenditures and these two forms of financing, equations (1), (2), and (3) must be accurately specified, and corrections must be made for the effect of simultaneity bias. All funding variables are measured in per-capita terms, and all but the dummy variables are in logarithmic form.

The variables included in vectors $D$ and $X$ of equations (1) and (2) are based on the individual demand functions in (4), the performance of optional variables in preliminary testing, and the need to assure equation identification. Income, price, and demographic data are taken directly from standard sources, such as the Statistical Abstracts of the U.S. Census (1970 or 1972) and the 1970 Census of Population, or are constructed from Census or Internal Revenue Service data (see Table 1).

Four separate variables are used to capture the effect of the income and price determinants of demand in equation (4). Mean family real income, Ymean, is used instead of per-capita or median income in the contribution equation since it is more reflective of the upper-income groups that are expected to be contributors. Ymean is also used in the subsidy equation, although "percent of the population with income above $15,000" was tried with similar results. Either of these measures of income is more appropriate than median income when a nonmedian voter—essentially a lobbying model of collective choice—is used. They are more sensitive than median income to the strength of the upper income, "pro-arts" segment of the population.[13]

Cross-sectional variations in prices are accounted for by the variables Tax Share and Con. Price. Tax Share is constructed as an estimate of the relative price to the average high-income (above $15,000 in 1969) taxpayer of an additional dollar of government subsidies, taking into account value of housing owned, effective local tax rates, total property tax revenue, and local price index of private goods.[14] Similarly, Con. Price is constructed as the relative price to the average high-income person of an additional dollar of tax-deductible contributions, taking into account marginal tax rates, the difference between adjusted gross and taxable income, and the price of "all other goods" as measured by the index of local prices.[15]

Finally, the variable Upper Income is included to test further the hypothesis that people will be more willing to make private contributions than to support public subsidies politically as personal income increases. This reflects the lower contribution price, the higher local tax share, and the increased value of the private advantages given to contributors as any one person's income rises. The variable is defined as the percent of households with income exceeding $25,000

**Table 1.** SMSA Arts Funding*

| Independent Variables | (1) Gov OLS | (1) Gov Two Stage | (2) Gov OLS | (2) Gov Two-Stage | (3) Con OLS | (3) Con Two Stage | (4) Con OLS | (4) Con Two Stage | Exp. OLS | (5) Expend. Two Stage |
|---|---|---|---|---|---|---|---|---|---|---|
| Constant | -94.7 | -91.1 | -94.2 | -89.3 | -47.9 | -48.9 | -34.4 | -7.41 | 5.43 | 5.49 |
| Ymean | 7.01 (1.44) | 6.42 (1.27) | 6.9 (1.51) | 5.7 (1.17) | 3.87 (1.84) | 3.95 (1.78) | 3.12 (1.57) | 1.55 (.55) | | |
| Tax Share | 1.71 (1.39) | 1.85 (1.45) | 1.34 (1.13) | 1.47 (1.18) | .011 (.02) | .03 (.05) | -.06 (-.13) | -.64 (-.86) | | |
| Con. Price | 1.92 (.33) | 2.09 (.36) | 2.69 (.49) | 3.57 (.63) | -.91 (-.38) | -.89 (-.37) | .22 (.09) | .146 (.05) | | |
| Upper Income | -.30 (-.07) | -.64 (-.16) | -.03 (-.008) | -.60 (-.15) | -.42 (-.24) | -.42 (-.24) | .84 (.49) | 1.87 (.82) | | |
| Density | .07 (.09) | .23 (.29) | .031 (.14) | -.09 (-.12) | -.51 (-1.75) | -.49 (-1.62) | -.37 (-1.35) | -.41 (-1.14) | | |
| Orgs. | -2.41 (-2.31) | -2.39 (-2.27) | -1.47 (-1.35) | -1.18 (-1.03) | -.29 (-.64) | -.32 (-.58) | -.21 (-.48) | .42 (.58) | | |
| Pop. | 2.86 (1.97) | 2.99 (2.00) | 2.29 (1.64) | 2.51 (1.72) | .16 (.25) | .19 (.25) | -.068 (-.114) | -1.02 (-.99) | | |
| Age | — | — | — | — | 3.28 (1.93) | 3.27 (1.92) | 1.75 (1.03) | .99 (.44) | | |
| Expend. | 2.53 (4.22) | 2.34 (3.02) | 3.43 (4.85) | 4.17 (3.89) | 1.02 (3.95) | 1.02 (2.62) | .85 (3.43) | .217 (.37) | | |
| Gov. | — | — | — | — | — | — | — | — | .08 (3.25) | .06 (1.71) |
| Con. | -.96 (-2.52) | -.63 (-.98) | -1.04 (-2.87) | -.88 (-1.4) | -.175 (-2.5) | -.187 (-1.29) | -.129 (-1.97) | .14 (.64) | .28 (4.46) | .36 (3.75) |
| $Gov._{t-1}$ | .16 (1.2) | .13 (.94) | .18 (1.37) | .69 (1.19) | .10 (1.89) | .10 (1.87) | .092 (1.8) | .092 (1.8) | -.03 (-1.47) | -.035 (-1.57) |

| | (1) | (2) | (3) | (4) | (5) | (6) | (7) | (8) | (9) | (10) |
|---|---|---|---|---|---|---|---|---|---|---|
| $Con_{t-1}$ | .29 (.99) | .16 (.43) | .31 (1.10) | .27 (.76) | .35 (3.31) | .35 (3.26) | .349 (3.51) | .349 (3.51) | -.08 (-1.56) | -.122 (-1.91) |
| Earned Y | — | — | — | — | — | — | — | — | .043 (1.67) | .043 (1.51) |
| Other Priv. | — | — | -.44 (-2.14) | -.59 (-2.38) | — | — | — | — | .171 (6.16) | .159 (5.34) |
| Business | — | — | — | — | — | — | .26 (2.42) | .41 (2.33) | -.07 (-1.59) | -.106 (-1.88) |
| Fed. | — | — | — | — | — | — | — | -.003 (-.10) | -.003 (-.10) | -.006 (-.15) |
| State | — | — | — | — | — | — | — | — | .151 (1.73) | .153 (1.69) |
| West | -.40 (-.42) | -.37 (.39) | -.25 (-.27) | -.23 (-.25) | -.22 (-.56) | -.22 (-.56) | .26 (.63) | .59 (1.03) | — | — |
| Midwest | -1.49 (-1.61) | -1.53 (-1.62) | -1.3 (-1.47) | -1.3 (-1.42) | -.35 (-.87) | -.37 (-.81) | .057 (.13) | .67 (.96) | — | — |
| Northeast | -.69 (-.53) | -.91 (-.66) | -.42 (-.34) | -.44 (-.33) | .12 (.22) | .11 (.18) | .63 (1.14) | 1.22 (1.47) | — | — |
| Southeast | -.0006 (-.0006) | .11 (.12) | .35 (.38) | .72 (.72) | -.43 (-1.09) | -.43 (-1.07) | .038 (.09) | .176 (.32) | — | — |
| $R^2$ | .5680 | — | .6253 | — | .7601 | — | .8003 | — | .7824 | — |
| F | 2.717 | — | 3.130 | — | 5.940 | — | 6.838 | — | 14.783 | — |
| Mean Square Error | 2.21 | 2.26 | 1.98 | 2.11 | .373 | .374 | .321 | .512 | .078 | .083 |

*All dollar funding variables are in per-capita terms. All variables are in natural logarithms, except for the regional dummies and the state grants dummy. The number of SMSA observations is 47. t statistics are in parentheses. t statistics greater than 1.67 in absolute value indicate statistical significance at at least the .10 level.

divided by the percent of households with income exceeding $15,000, and therefore it represents the proportion of the upper-income group that has the especially high income of $25,000 or more. We expect this variable to have higher positive coefficients in the contribution equation than in the subsidy equation.[16]

Population density may serve as a proxy for the cost of commuting to arts events—greater density might imply lower commuting costs and more interest in the arts. The number of arts organizations may influence the efficiency with which funds are raised; that is, economies of scale may exist in fund raising or political lobbying, or diseconomies of scale may arise from confusing and competing claims upon potential contributors. (Note the continual discussion surrounding United Arts Fund drives.) Median SMSA age is included only in the contribution equations because it never performed well in other equations.[17]

SMSA population (Pop.) enters the subsidy and contribution equations in two ways. Even if it were omitted as a separate variable, it is negatively correlated with Tax Share, since this share drops for any taxpayer as the tax base in the community increases. However, the population variable has the independent effect of increasing free-rider incentives and lowering per-capita contributions. Since the efficiency motive for demanding public funding is based on the attempt to minimize free riding, it is of interest to see if per-capita subsidies are larger and per-capita contributions smaller as population size increases.

Regional dummy variables are included because of their successful use by Withers (1979) and because regional differences are likely in U.S. arts funding. The other forms of earned and unearned income are generally omitted from the subsidy and contribution equations to ensure equation identification.[18] But equations are reported in which the single strongest of these other sources is included (federal and state grants were not strong and are not included). Finally, the predetermined lagged terms $Gov._{t-1}$ and $Con._{t-1}$ are included to capture simple trends, even if these trends are not understood. Their interpretation may also be related to lags in reactions of contributors to subsidy increases and vice versa. They are measured using only performing arts data (museum data were only available for one year) and are measured as the average per-capita amounts over the previous *five* years, not just one year.

Table 1 reports five pairs of equations, each pair including an OLS estimate and the identical equation estimated using two-stage least squares. There are two pairs each for 1971 per-capita local government subsidies (Gov.), and for 1971 per-capita local individual contributions (Con.). There is one pair of equations for 1971 per-capita arts organizations budgetary expenditures (Expend.).[19] There are nineteen exogenous or predetermined variables in the reduced-form equations in the first stage of the two-stage estimation, and all structural equations are over-identified.

The justification for using two-stage estimation is not just to increase "goodness of fit."[20] It is required by the theoretical process of community decision making that has been postulated. Funding totals are determined jointly, both by the political and contributing decisions of households trying to achieve their optimal consumption mix of private goods, arts subsidies, and arts contributions and by a process of action and reaction of the funding sources as these decisions are

made. The equations are treated as a simultaneous system, even though the process just described is partly recursive. Funding equations might be estimated using OLS if we knew the exact sequence of decision making and the proper time lags for reactions.[21] Lacking this information, the actions and reactions occurring in the process of determining any one period's pattern of financing are best treated in a simultaneous model.[22]

The income and price variables in Table 1 are weak and in some cases opposite in sign to what was expected based on the theory and past experience in a related study (Seaman 1979).[23] In equations (1), (2), and (3) the signs on Con. Price are consistent with a positive cross-price elasticity for substitutes and negative own price elasticity. But the statistics are low and the coefficients are larger than one would expect, even though by construction these coefficients cannot be interpreted as the price elasticities of any one individual. This last point also applies to the large coefficients for Ymean. They merely represent the percent change in per-capita community funding as mean family income increases by 1 percent—not the income elasticity of demand or supply for funding of any one household.

Regarding Tax Share, when the population variable is removed from the equations, Tax Share becomes negative in the Gov. equations, with a $t$ statistic of about $-1.6$. In the Con. equations removal of the population variable causes little change in the behavior of Tax Share. It is difficult to measure the effect of this variable when it partly depends on the size of the tax base, which in turn is partly dependent on population size. The population variable is retained in the equation in order to test for the free-rider effect discussed above. Furthermore, Tax Share may be picking up the effect of larger local revenues, which would provide government agencies with a greater ability to finance subsidies. This is plausible since Tax Share is constructed using property value data and effective tax rates. Also, the coefficient of this variable is much larger in the subsidy equations than in the contribution equations, which is consistent with the revenue explanation.

There is also only weak confirmation of the increased preference of upper-income people for contributions over public support as income increases. A comparison of Gov. equation (2) and Con. equation (4) indicates that a higher proportion of upper-income people with income above $25,000 actually reduces per-capita subsidies while increasing per-capita contributions, with these effects reinforced in the second-stage estimates. However, in contrast to earlier findings these results are not significant. Also, the performance of Ymean in the two equations is not consistent with an increasing proportion of contributions to subsidies as income increases.

Briefly, population density has a weak positive effect on Gov. and a moderately strong negative effect on Con. It may be that density is a poor proxy for commuting costs to arts events in SMSAs with generally poor inner cities where wealthy families are willing to pay the cost of commuting long distances. Increases in median age exert fairly strong positive effects on contributions, but this effect is weakened when per-capita business grants are included in the equation. Population size has a strong positive effect upon per-capita subsidies, which is consistent with an efficiency motive for households to demand public support.

But there is only a weak confirmation of this effect in the contribution equation. In equation (4) population coefficients are negative but insignificant. This is one case in which performing arts data and museum data yield different results when separated. Population size exerts a strong negative effect upon per-capita museum contributions, but this effect is diluted when performing arts contributions are added. Finally, the regional dummies are surprisingly weak, although there is evidence that government support is lower in the Midwest, ceteris paribus, and private support is higher in the Northeast, ceteris paribus.

The important results for the funding variables can be interpreted as follows. If simultaneity is ignored, one would conclude that a 1 percent increase in per-capita private support, holding constant all income, price, taste, and arts budget size variables, would reduce public support by .96 percent or 1.04 percent, according to OLS equations (1) and (2). Conversely, the independent effect of a 1 percent increase in per-capita subsidies is to reduce per-capita contributions by .175 percent or .129 percent, according to equations (3) and (4). These "one-way" crowding-out or substitution effects will be overestimated, however, if simultaneity is present. Part of the negative effect of contributions upon subsidies is being incorrectly attributed to the effect of subsidies on contributions in equation (4). Therefore, the −.129 estimate of the effect of subsidies on contributions should become less negative when the reverse causality is eliminated in the second-stage equations (it actually becomes weakly positive in this case). This effect is widely observed in the funding equations. And in equation (3), where the coefficient of Gov. goes from −.175 to −.187 in the second stage, it still drops greatly in statistical significance. In fact, in seven of eight Gov. equations, the coefficient of Con. became less negative in the second-stage estimates, and in six of eight Con. equations the coefficient of Gov. became less negative. This confirms the existence of simultaneity and indicates that the extent of the one-way substitution effect of any funding variable on the other will be overestimated in OLS equations. On the other hand, it suggests that the substitution effects are reinforcing to some extent, although the magnitude of the effects is not necessarily large.

There is another interesting interpretation of the magnitudes of the coefficients. In both OLS and two-stage equations the negative effect of increases in contributions on subsidies is much greater than the negative effect of subsidies on contributions. This provides support for the view that government officials, or their constituents, are less willing to support the arts when contributions are high or perhaps when such support is not as desperately needed as a residual to meet funding shortfalls. Evidence of a more traditional crowding-out effect, by which government support reduces private contributions due to some combination of a utility interdependence effect and any reductions in household disposable income as tax financing increases, is present but in magnitudes that are moderate (−.187 at most). There is certainly no evidence of the patronal motive for households to support public financing. In fact, the interpretation given to the effect of population size on per-capita subsidies and contributions is consistent with the so-called efficiency motive.

The possibility that the government acts as a residual source of funding is also supported by an examination of the expenditure variable. In the OLS estimates larger arts expenditures are strong positive determinants of both contributions and subsidies. Since these sources of funding also help determine expenditures, unbiased estimates are only possible after the reverse causality has been purged. However, in equations (1) and (2) the second stage Expend. coefficients are either moderately reduced (from 2.53 to 2.34) or actually increased (from 3.43 to 4.17), with the *t* statistics remaining high. On the other hand, the coefficients of Expend. in the Con. equations either stay the same or are greatly reduced. In fact, the effect of arts expenditures on contributions is much less, regardless of estimation technique, when viewed in terms of coefficient size alone. This suggests that increases in need, as captured in the expenditure variable, are responded to much more by governments than by individual contributors. This is also confirmed by the fact that the highest Expend. coefficient in a Gov. equation is in the equation where the variable for other private support (primarily foundation grants) is held constant. In fact, subsidies are strongly reduced as this other private support increases—a coefficient of −.59 in the second-stage estimates. On the other hand, the presence of the strongest other-funding variable affecting contributions, that is, business grants, does not increase the Expend. coefficients, and in fact business and individual contributions are positively correlated. Furthermore, the effect of Gov. on Expend. in equation (5) is only .08, and this drops to .06 when the reverse causal effect of expenditures on subsidies is eliminated. Meanwhile, a 1 percent increase in contributions increases expenditures by .28 percent, and this effect becomes .36 percent (with a high *t* statistic) when two-stage estimation is used.

Finally, it is clear that previous period contributions are strong predictors of present period contributions, with a 1 percent increase in past contributions leading to a .35 percent increase in present contributions, ceteris paribus. This positive relationship also holds between past and present subsidies, but it is not as strong. On the other hand, the effect of past contributions on present subsidies is weak but positive, and does not suggest any longer lagged negative reaction of government decision makers to increased contributions. Similarly, the coefficient of past subsidies in the contribution equations is only about .1, suggesting at best a weak long-run complementary relationship and the absence of any longer lagged crowding-out effect.

CONCLUSION

Using the theoretical framework described in this paper to test various hypotheses about U.S. metropolitan area arts funding leads to several conclusions:

1. Estimates of the one-way effects of public support on private support and vice versa cannot accurately be made using single-equation OLS techniques because of the presence of simultaneity bias.

2. There is some evidence that increases in local government support cause reductions in private individual contributions, but these reductions are very small and provide no evidence in favor of the patronal motive for households to favor public funding.

3. There is stronger evidence that constituents/voters or government officials acting independently react in a negative way to increases in private contributions either due to a utility interdependence effect or because they react to perceptions of arts organization needs and see themselves as a residual source of support.

4. The latter interpretation is bolstered by the strong independent effect of arts expenditure size on per-capita government support, in contrast to a weaker effect of this budget size on contributions and a very small reverse causal effect of government subsidies on expenditures.

5. The income, price, taste, and community demographic variables, which performed fairly well in an earlier study of the museum subsidy/no subsidy decisions of local governments, did not do well in determining per-capita variations in combined museum and performing arts contributions and subsidies. In particular, only very weak support was obtained for the hypothesis that upper-income people will choose to finance the arts privately rather than publicly as their personal income increases.

The findings regarding the crowding-out effect are broadly consistent with those of Netzer (1978) and Globerman (in this volume). To date, even when accounting for the importance of other variables and simultaneity, the crowding out of private contributions by increased government subsidies has been relatively insignificant.

## Notes

1. Netzer concluded from a nonregression analysis of Ford Foundation data on performing arts financing that there was no evidence of such crowding out in the period 1965-1974, because "both unearned income from private sources and income from government sources simultaneously increased as proportions of total operating income" (1978, p. 102). Instead, he argues earned revenues may have declined. Globerman, in a similar analysis of Canadian data in this volume, argues that there is some evidence that government funding "might substitute for earned income and, to a lesser extent, for private philanthropy."

2. Based on the Ford Foundation survey of performing arts groups and the National Research Center of the Arts survey of museums, household contributions represented about 25 percent of local museum unearned income and about 65 percent of local performing arts unearned income. Corporate grants are about 3 percent of local unearned support for museums and 22 percent for the performing arts.

3. These data were specially compiled from the widely used Ford study of 166 nonprofit performing arts organizations (symphony orchestras, theater and opera companies, and dance units) for fiscal years 1965-1971, and the National Center of the Arts survey of museums for fiscal year 1971-72. Aggregates of the income received by the various arts organizations, classified by SMSA location, were provided so that SMSA totals were available for private contributions, local government subsidies, corporate

contributions, "other" private contributions, admission revenues for museums only, and state and federal grants. Combining the two sources of data, there are forty-seven SMSAs for which comparable funding totals are available for both performing arts groups and museums (after eliminating a few obvious outliers and special cases). To assure comparability, the fiscal year 1970–71 was stressed from the Ford data, since the museum data were only for 1971–72.

4. Equation (3) is not tautological since expenditures are not strictly identical to income in any year. Temporary surpluses are used mainly to cover past or expected deficits, or they are placed in an endowment fund.

5. A fuller analysis would attempt to explain the determination of any budget targets and the possible preference managers may have among sources of support. Also, tic-ket-pricing policies are not examined. It is merely assumed that, given some amount of earned income, organizations are interested in attracting additional income from all possible sources, and managers are aware of the costs involved in encouraging such additional support. For reasons of both artistic independence and rising marginal costs of attracting support from any one source, organizations are likely to want a mix of funding sources.

6. This description of collective decision-making generally follows Breton (1974). This is basically a donor rather than a recipient political demand model, although it is recog-nized that other interest groups may have an impact on the ultimate political decision.

7. This refers to the concept of net substitutes, since any effect of a reduction in the price of, say, subsidies on a person's real income, and consequently his "purchase" of con-tributions, is likely to be minimal.

8. While this should hold for *all* funding sources to some extent, the relationship be-tween contributions and, say, corporate grants should be weaker than that between contributions and subsidies. An increase in subsidies will have a more direct negative effect on household disposable income than will an increase in corporate grants. This standard disposable income effect is not emphasized here, and may not be large in magnitude. It is indirectly captured, however, by the tax price term in the function de-termining optimal private contributions.

9. The word "patronal" was originally used in a slightly different context by Garvey (1969).

10. See Chamberlin (1974) and Becker (1974).

11. To the extent that the impact of a dollar of support diminishes as the population (or the affected potential audience) increases, the reduction in the price of effective sub-sidies (as measured by an individual's tax share) that accompanies a larger taxpaying population is diminished but not eliminated. This is a type of "crowding" in the Berg-strom-Goodman sense (1973), applied not to the direct consumption of arts services but to the impact of money transfers on individuals exhibiting utility interdependence.

12. Actually, the likelihood of more than a dollar-for-dollar reduction in private support as public support increases is small, since subsidies are not perfect substitutes for con-tributions. Also, Becker (1974) argues that when someone else contributes to a cause that interests you, your own utility increase represents a "full-income" effect, which for normal goods will partly offset the incentive to reduce your own contributions. However, if subsidies and contributions are viewed as nearly perfect substitutes, and if this full income effect is outweighed by any money income reduction accompanying increased tax liability to finance subsidies, contribution reductions could exceed the subsidy increase.

13. Tests using median income showed it to be generally less statistically significant and smaller in coefficient size than mean income.

14. Specifically, the average housing value of the "high" income families (taken from the 1972 Census of Housing) was multiplied by the effective local tax rate (from Part 2 of the 1972 Census of Government), with this product then divided by the total property

tax revenue for the SMSA (from Vol. 5 of the Census of Government). The price index data are from Ben-Chieh Liu, *Quality of Life Indicators in U.S. Metropolitan Areas, 1970.*

15. Specifically, the average taxable incomes for households with adjusted gross income ranges above $15,000 in the 1969 Internal Revenue Service annual report were calculated. These average incomes were then translated into contributing prices by subtracting the marginal tax rate (using Schedule Y—married taxpayers filing jointly) associated with each average income level from one. An overall city average price was then computed by weighting these prices by the proportion of the above-$15,000 population they represented.

16. An alternative way to test this hypothesis is by including the two separate variables, "percent of population between $15,000 and $24,999" and "percent of population above $25,000," and examining the differences in the coefficients. The variable used in Table 1 has the merit of emphasizing the composition of the upper-income group and is not closely correlated with Ymean. Withers (1979) also included an upper-income variable, although he defined it differently.

17. Other variables that were dropped include the community gini coefficient and various measures of community educational level. These variables were not strong or were negative and insignificant.

18. Even the inclusion of all the funding variables, along with the budget size, in an equation estimating contributions or subsidies does not become an identity or cause spurious substitution relationships among funding variables. The one variable that must be included to avoid spuriousness is budget size, because without it there is no cross-sectional arts budget constraint and all funding sources tend to become positively correlated.

19. For almost all types of funding, there are zero observations. These are not bizarre observations since it is plausible that some cities may not use all the types of funding available. To reduce estimating bias that might result from any clustering of data into zero and nonzero observations, the relatively few zero observations were given positive log values equal to 80 percent of the log of the lowest positive observation. The only effect of this procedure was a reduction of some of the coefficients, which were being biased upward by the clustering. State grants, however, were treated as a dummy variable because the absence of accurate data on state performing arts grants forced the use of only museum grants, and twenty-six of the forty-seven cities had no museum arts grants from the state. In Seaman (1979) sixty cities were examined using museum funding data only and not making any adjustments for zero observations. Thus profit analysis was used since the dependent variable was a (0,1) subsidize/not subsidize dummy.

20. In fact, due to measurement errors in computing the second-stage estimates, $t$ statistics are generally lower and mean square errors higher in two-stage compared to OLS.

21. For example, if we knew that contributors waited until some deadline in budget allocation decisions of the local government (and that these decisions were binding) before deciding on what contributions to give, the process would be strictly recursive. OLS could then be used to estimate contributions, with subsidies as an independent variable free of simultaneity bias. Of course, any single equation estimating the original government decision regarding subsidies would have to include variables reflecting any influence potential contributors have on that political decision, such as Upper Income, Tax Share, and Con. Price.

22. Trial runs using Zellner three-stage least squares showed only moderate covariance across equations and therefore similar coefficients for the third-stage and second-stage estimates. Also, since 3SLS is very sensitive to the full system specification, 3SLS estimates may be more biased than 2SLS, even though 3SLS is more efficient than 2SLS when there is cross-equation correlation. See Pindyck and Rubinfeld (1976, chapter 9).

23. However, when Ymean, Tax Share, and Con. Price were run as the only independent variables, they performed well in the contribution equation. Ymean was positive, Con. Price yielded a negative own price elasticity, and Tax Share yielded a positive cross-price elasticity. All were significant at .01.

### References

Becker, Gary. 1974. A Theory of Social Interactions. *Journal of Political Economy* 82 (Nov./Dec.): 1063–1093.

Bergstrom, T. C. and Goodman, R. P. 1973. Private Demands for Public Goods. *American Economic Review* 63, no. 3 (June): 280–296.

Breton, Albert. 1974. *The Economic Theory of Representative Government*. Chicago: Aldine.

Chamberlin, John. 1974. The Provision of Collective Goods as a Function of Group Size. *American Political Science Review* 68 (June): 707–716.

Ford Foundation. 1974. *The Finances of the Performing Arts*. New York: Ford Foundation.

Garvey, Gerald. 1969. The Political Economy of Patronal Groups. *Public Choice* 7 (Fall): 35–45.

National Research Center of the Arts. 1975. *Museums U.S.A.: A Survey Report*. Prepared for the National Endowment for the Arts. Washington, D.C.: U.S. Government Printing Office.

Netzer, Dick. 1978. *The Subsidized Muse: Public Support for the Arts in the United States*. London: Cambridge Univ. Press.

Pindyck, Robert S. and Rubinfeld, Daniel L. 1976. *Econometric Models and Economic Forecasts*. New York: McGraw-Hill.

Seaman, Bruce A. 1979. Local Subsidization of Culture: A Public Choice Model Based on Household Utility Maximization. *Journal of Behavioral Economics* 8, no. 1 (Summer): 93–132.

Withers, Glenn. 1979. Private Demand for Public Subsidies: An Econometric Study of Cultural Support in Australia. *Journal of Cultural Economics* 3, no. 1 (June): 53–61.

# Comment
## James L. Shanahan

Seaman recognized that opening the public purse may close the private philanthropic purse and that patronage may attempt to shift its efforts to the public sector. The likelihood is real since investigation of the fundability of public dollars in other fields reveals that public effort simply replaces private efforts.

And what of the implications beyond this possibility; will some communities have a local patronage mix that discourages the receipt of public support because of the implied loss of control over the institutions? Will other communities seize

the opportunity to substitute public money for their own, leaving the arts organizations no better off financially?

Following Seaman's theoretical model, contributions and subsidies can be partial substitutes or complements. Rational consumers will determine the optimal mix of private donations and public monies according to their income, relative prices, and relative tastes for the two sources of unearned income.

At a symposium on public subsidy to the arts (published in the *Journal of Behavioral Economics*, volume 8, Summer 1979) Seaman presented a consumer-maximizing model for predicting local private individual demand for public subsidy. The same conceptual thinking seems rooted in this paper. The empirical model tested is an improvement. In the earlier paper this regression analysis of museum data for sixty SMSAs in the United States was structured to explain why some urban areas provide museums with public subsidies and others do not on the basis of the aggregate consumer demand for subsidy. The empirical test has its usual specification problems and, many caveats later, Seaman could only conclude that there are "dangers involved in discussing future increases in government support as the salvation of the arts." Seaman now specifies a three-equation model, one which determines local government subsidy, one which determines private individual contributors (patrons), and one for arts organization expenditures.

As mentioned in the introduction to this volume, economists often can be accused of treating the arts—using Scitovsky's terms—as a piece of novelty for their own intellectual stimulation; that is, they are more interested in applying their tools than in formulating policy-related questions about the arts. In my view Seaman does a yeoman's job at dividing his talents evenly. The conceptual construction of possibilities for motives by individuals and government for supporting local arts institutions is thoughtful and reflective of the astute kind of close thinking attributed to economists. Furthermore, his econometric modeling is fascinating.

Cross-sectional analysis of aggregate data is never satisfying when what the researcher really wants to know is how behaviors would change in a (typical) community should alternative determining factors prevail. While Seaman, no doubt, knows this, like all economic scholars who feel compelled to test the empirical propositions posed by their models, he proceeds with "the only game in town." Yet one could raise these very basic questions: Can this model detect different individual tastes across communities for public philanthropy to the arts and what are essentially private, nonarts pursuits, such as country clubs and private golf courses? Can this model detect different degrees of a "sense of community"? Such questions force the researcher into utter speculation about the community processes which influence actual behaviors. While Seaman's analysis is an excellent start, what is now needed is an interdisciplinary research design capable of capturing processes, as well as impacts, and capable of capturing attitudes and perceptions, as well as observed behaviors.

# PART TWO

~~~~~~~~~~~~~~~~~~~~~~~~~~~~~~~~~~~~~~~~

Markets for the Arts:
Artists and Consumers

Introduction

ALTHOUGH RESEARCHERS trained in neoclassical microeconomic theory bring their market analysis techniques to the study of art objects, little, except for audience studies, has been done in the way of modeling or analysis of markets for alternative art forms.

The papers contained in this section fill in some of these gaps by examining the market for artistic innovation, the market for new (additional) music, the hypothesis that the market for "good" art may "fail" because of the threat to buyers of "bad" art, the importance of the art collector to artists, and the state of the art of literature on consumption demand for art.

Virginia and Philip Owen investigate one market aspect of artists' "freedom to pursue artistic endeavor": the opportunities for artistic innovation. Their concern is with the limitations under which artists function—constraints which dampen innovative output. The authors note the severity of social restraints on medieval oil painters; the church and patrons defined sanctioned art so narrowly that only the familiar, astute eye could differentiate among works by different artists, because they "all looked alike." In a secular world, where an infinity of subject matter and expression abound and in which technological innovations—in painting techniques, materials, and so forth—occur, the production choices of individual artists become more important. Even so, artistic recognition and financial reward, conferred in markets for finished art objects, may well act as brakes on artists' innovative instincts.

What Owen and Owen want to know is if information theory can be used to formulate a predictive model that can relate observed patterns of artistic innovations over extended historic time periods to market demand and supply for experimental art forms. They model the quantitative possibilities for innovations for both art consumers and artists. The solution sought is a market mix, according to supply and demand for "innovative," "transitional," and "traditional" art objects. Market equilibrium is based on public "tastes" for each art type and the artist's capacity to respond creatively when a constraint that previously prevented artistic expression in some defined way is removed.

Another market aspect of the arts arises when, as Michael O'Hare says, there is little demand for new pieces of music when compared to the potential for contemporary composers to create it. The reproductive and transferable characteristics of music are such that millions of listeners over hundreds of years can satisfy a major part of the demand by a single composition. O'Hare examines the particulars of this market problem and reaches the conclusion that matters can only get worse for the composer in the future. He offers several reasons why private patrons may choose to support contemporary composers even though their efforts may never be marketed; none of these reasons, according to O'Hare, suffice as economic grounds for government support of contemporary music.

Yet another aspect of markets for art (objects mostly) is discussed by Roger McCain: do sellers of art know more about the quality of the art supplied than do buyers? If so, can art be considered a "market of lemons," that is, a market in

which buyers are apprehensive about the representations the artists make, about their innovative forms, or when first introduced to existing forms? McCain attempts to pin down how quality might be judged. Pattern complexity is linked to the capacity of the art object to provide enjoyment by capturing and holding our attention. The consumer needs to learn particular artistic codes, ones progressively more complex as enjoyment increases.

McCain argues that when new art publics are first introduced to existing complex-pattern art or established art publics to innovative art forms, only the artist knows the "quality" involved. For whatever reasons, the particular art public may be concerned that the seller will misrepresent patternless art, or "bad" art, as a new form of complex-pattern art. Drawing from economic theory, McCain observes that such markets for lemons can lead to less than full economic value prevailing in the market for good art, if not destruction of the market altogether.

Montias discusses the nature of purchases of local artists' works by community collectors in mid-seventeenth-century Delft, Holland. He concludes that collectors bought from local artists because they knew their work well, and perhaps because their works captured local tastes better than the work of "foreign" artists. Despite previous historical opinion, Dutch households were no more prone than those in other countries to have art collections—although middle- and upper-income households had substantial collections. Of approximately 50,000 paintings produced by Dutch painters during this time, probably no more than 100 have survived to today.

To advance our understanding of policy research questions concerning the consumption demand for art, Sonia Gold (1) contemplates the usefulness to demand theory of the separate contributions made by Tibor Scitovsky's *The Joyless Economy* and Staffen Burenstan Linder's *The Harried Leisure Class;* (2) identifies the deficiencies in audience studies for measuring latent demand and for understanding how tastes are formed and market choices made; and (3) adopting the perspective of Khakee and Nilsson, considers how the spatial constriction of arts supply creates a situation in which demand remains latent in the absence of a market for expressing it.

Scitovsky and Linder draw implications for the demand for arts as a spin-off of the central thrust of their respective books. Relative to Scitovsky's work, suggesting that the Puritan ethic and the stimulus/comfort dichotomy influence human behavior in ways that result in a relatively low demand for art, Gold argues that we must better understand how these concepts influence demand before trying to predict actual choices. In addition, she sees the need for other attributes of consumption experience (for example, active-passive, mental-physical) to be included, because they potentially influence individual choices between art and other commodities.

Gold questions the operational validity of Linder's categories of time: working time, personal time, consumption time, cultural time, and free time. Since recreation and entertainment activities can be categorized only in an arbitrary manner, this greatly impairs any attempt to understand choices between arts and nonart commodities.

Regarding the measurement of demand, Gold observes that knowing the identity of those most likely to attend arts events is not the same thing as knowing what explains their behavior (choice). We need to understand the reasoning behind attendance and nonattendance. Gold suggests ways to expand the demand study to include nonattendees; specifically, consumer demand research should become more interdisciplinary because we must understand underlying attitudes and values and how they affect consumer choice.

Finally, Gold concludes that arts institutions are maldistributed across the United States on the basis of population, income, and so forth—the characteristics thought to be indicative of demand—and that decentralization of the quantity of original works quickly exceeds its limits.

An Economic Approach to Art Innovations

Virginia Lee Owen
Philip James Owen

THE DEVELOPMENT OF ART since medieval times can be viewed as a gradual enlarging of the available choices confronting the artist. As the contemporary artist prepares for a new creation, several choice variables appear. Let us consider a painter. He may choose from a variety of media, subject matters, colors, forms, and physical properties. Some of these choices are restricted technologically. If, for example, he decides to do a fresco, choice of materials and other physical properties is probably restricted because of limited mobility. If one decides to paint in oil, very little restriction is placed on most of the other choices. The painter working in 979 instead of 1979, however, would have been even more restricted: church and custom prescribed subject matter (religious), form (non-realistic and ethereal), color (symbolic uses of color), and style (groupings determined by numerology and attitudes determined by religious symbolism). Technology prescribed nearly all the rest—medium (fresco) and materials (plaster or gold and precious stones). It is not surprising that only a connoisseur can detect the nuances of individual artists and that for the general public medieval art "all looks alike."

The Renaissance brought with it an enlarging of choices for the painter. Subject matter could be secular, as well as religious. Mobile paintings as decorations supplemented frescoes and altarpieces. Perspective and the concern for reproducing reality became an alternative to the "other world" style. In short, the artist had more choice variables with more alternatives for each. The art produced was more individualistic, and greater variety was thus offered to the art-buying public. This same enlargement of choice variables for the artist has continued—cubism brought choices in form, fauvism brought choices in color, and contemporary movements have freed the process and even the definition of art. Through the use of information theory, our purpose here is to model mathematically the production choices of the artist and to discuss the economic factors determining these choices insofar as they lead to innovations in art.

102

INFORMATION THEORY AS A MEASURE
OF ARTISTIC INNOVATION

The hierarchical mathematics of information theory applied to the analysis of artistic innovation has several uses. From an epistemological viewpoint, the hierarchical information model clarifies the limits inherent in any effort to discuss art in a vigorous format; that is, it specifies what can be said with respect to art that is verifiable. Clearly such epistemological questions become as much questions of language as questions of art. Elsewhere, P. Owen has discussed the hierarchical model in connection with language (Owen 1973). This analysis seems applicable to art history and therefore warrants a brief summary.

It can be argued that the quantity of meaning in an utterance, or for that matter the ability of language to convey any meaning whatsoever, is dependent not on what is said but on the alternatives from which the particular utterance is taken. Applied to language, the model takes the form of a tree diagram, the nodes of the tree representing grammatical categories. For example, assume the following simple generative grammar:

Sentence $-$ S
$S \rightarrow NP + VP$
$VP \rightarrow V + OP$
$NP \rightarrow T + N$
$OP \rightarrow A + O$
$V \rightarrow$ hit
$T \rightarrow$ a, the
$N \rightarrow$ boy, girl, ball
$A \rightarrow$ that, their
$O \rightarrow$ bicycle, fence, dog

If we assume that this grammar completely specifies the language, then there are thirty-six indicative statements of five words each constructed from eleven total words. A sentence is clearly the product of choices of words at one level of analysis and the hierarchically created structure of the grammar at higher levels of analysis. The corresponding tree diagram giving the grammar and the hierarchical information quantities associated with it is depicted in Figure 1. The technique of using language requires that participants who share the grammar make selections from the vocabulary in accord with the rules of the grammar.

If we listened to a conversation involving a shared grammar and vocabulary, then we would be willing to make rigorous statements about the participants who were using the language correctly. We could even develop a satisfactory test to determine whether one participant received correctly or incorrectly the grammatical message sent by the other. The effects of the language on the participants' feelings or behaviors, on the other hand, are not easily accessible to rigorous analysis. Consequently, should an ungrammatical utterance occur, we are not in a position to assess a priori whether such a deviation from the rules indicates a lack of social grace or a stroke of poetic genius.

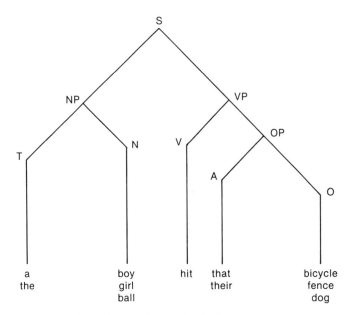

Figure 1. *Tree Diagram for a Simple Grammar*

The argument here is that a work of art, from the epistemological viewpoint, is like a piece of language. The clearest examples are the performing arts, particularly music. Beethoven's Ninth Symphony has an independent existence as a set of directions or a score. The integrity of musical notation, or language, if you will, is illustrated in the fact that a deaf Beethoven could write such a score with confidence that his directions were rigorous representations of the music his soul was hearing. Such musical factors as key signature, time, tempo, and harmony are the grammar of the art. Thanks to these factors, permanent musical works can be created, pupils can learn how to interpret them, and critics can tell us about their value or quality. And as with language, there is nothing in the grammar of a musical score which will rigorously specify whether we will be moved by hearing the music performed.

The idea of art as a set of directions applies equally well to museum arts or art objects, if we think of the art object as a set of directions to the senses. The grammatical classes of such art are form, color, medium, texture, perspective, and the like. The artist chooses among the several alternatives in each grammatical class to present our senses with an object to interpret. However, if we don't share the artist's grammar, then we cannot understand the object as art. Our eyes may be delighted by the luminosity of a Seurat painting, but only if we know about "chromoluminarianism" as the alternative in the grammatical class of color which Seurat chose, can we discuss the painting as an object (Blunden and Blunden 1972). The extent of our shared grammar for art sets the limit for our discussion of innovation, then, since we can verify only what we know about art.

Once we obtain a shared grammar for an art, hierarchical information theory can be applied quite rigorously to determine the quantitative differences among the grammatical structures of art objects. Consider an example. Suppose the artist begins with a simple grammar expressed in the two alternatives x_1 and x_2. This grammar can be represented by the simple tree diagram in Figure 2. When the artist frees the second variable, y_1, y_2, and y_3, the diagram expands (see Figure 3). The information associated with Figure 2 expressed in bits is 1.0000.[1] The information associated with Figure 3 is 2.5849. Here we see the appropriateness of information as the measure of artistic structure. Although three times as many painting types are possible, given the innovation of Figure 3, it does not require three times as much cognitive structure to conceive them. To achieve any particular painting type, $x_1 y$, for example, the artist makes two cognitive decisions: first, between two alternatives, x_1 or x_2, and then among three, y_1, y_2, or y_3. Since in information theory,

(1) $H(2) + H(3) = H(6)$,

we have an appropriate mathematical representation of the cognitive activity required.

The information model reinforces the idea that, for the painter, innovation lies not in creating a painting that hasn't been produced before but in articulating an artistic grammatical structure that hasn't been recognized before. A clear example of this conclusion can be seen in the public response to an exhibit of paintings by Seurat, Signor, Camille Pissarro, and Lucien Pissarro, which was given shortly after the latter three had taken up Seurat's pointillist technique. The exhibit failed because no one could tell one man's paintings from another's (Blunden and Blunden 1972, p. 176). In this instance, the technique was so overwhelming to the painters' individual creativity in manipulating other grammatical factors that no value could be perceived in having more than one interpretation of the technique. Innovation is valuable, then, because it expands the number of

Figure 2. *Simple Painting as a Tree Diagram*

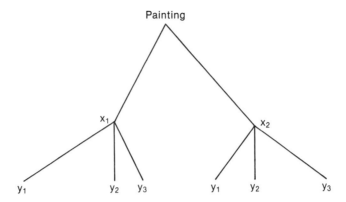

Figure 3. *More Complex Choice Variables in Painting*

unique artistic grammatical structures that can be produced, not because the number of art objects themselves can be increased.

A MODEL OF DIFFUSION
OF ART INNOVATIONS

Let us consider the "life history" of an artistic innovation, which can be defined as the freeing of some heretofore fixed variable, thereby enlarging the potential types of painting available. As indicated earlier, the measure of creativity is attributable to this act whether or not all the implied types of painting are displayed. In fact, demonstration of the freeing of a variable is most likely to appear in only one or two experimental works—Monet's *Impression Sunrise,* for example. Such an innovation may be alien to the art-buying public. Few may find it acceptable; most may deride it. As artists explore the ramification of this innovation, however, more and more potential painting types resulting from this development are displayed. The meaning of the development becomes clearer to the buyers. The paintings seem more familiar. Again using Monet as an example, viewing only one of the series of *Haystacks* or *Rouen Cathedral Facades* does not provide the viewer with the knowledge that Monet is exploring light. Several versions must be seen to comprehend that study, to provide a reference for comparison.

Traditional works are easily accepted because their reference of comparison is well defined by previous works and generally acknowledged by the art-buying public. When some critical mass of buyers finds the new approach legitimate, that general art type is no longer innovative but rather in an intermediate state called transitional. As more and more painting types are displayed through artists' explorations of the innovation and as greater numbers of art buyers become familiar with the approach, the transitional stage becomes part of the traditional. The innovation has been assimilated into the mainstream of acceptable artworks. Also, later innovations make earlier innovations more acceptable and speed their transition by seeming more familiar than the strange new creations.

Case 1

Let us postulate a simple model of art buyers' adjustment to innovations. Assume the extreme limitation on artistic choice depicted in Figure 2. All variables except one are fixed by tradition. Let us further assume that the one choice variable has only two states, x_1 and x_2. These painting types have been thoroughly explored and displayed and are completely within current artistic tradition. This does not mean that only two paintings are possible. Different artists with different skills will produce different paintings, but each of the paintings produced can be classed in one of two categories based on the use of either x_1 or x_2. Thus, only two painting types are possible. Now let an artist free another variable, y, which can take on three states, y_1, y_2, y_3. There are now six possible painting types $(x_1y_1, x_2y_1, x_1y_2, x_2y_2, x_1y_3, x_2y_3)$ described by the tree diagram in Figure 3. After all, y always existed. It is just that its state was prescribed by tradition before. If this prescription was y_1, then x_1y_1 and x_2y_1 are the traditional painting types formerly described by x_1 and x_2 alone. The other four combinations are new potential painting types created by the innovation and classed as innovative during this time period.

Suppose that another variable is freed and that this variable has two states, z_1 and z_2. Twelve painting types are now possible:

| A | B | C |
|---|---|---|
| $x_1y_1z_1$ | $x_1y_2z_1$ | $x_1y_1z_2$ |
| $x_2y_1z_1$ | $x_2y_2z_1$ | $x_2y_1z_2$ |
| | $x_1y_3z_1$ | $x_1y_3z_2$ |
| | $x_2y_3z_1$ | $x_2y_3z_2$ |
| | | $x_1y_2z_2$ |
| | | $x_2y_2z_2$ |

If z_1 is the traditional state prescribed for z, then $x_1y_1z_1$ and $x_2y_1z_1$ are the traditional painting types defined by x_1 and x_2 in the original model. (See column A above.) The former innovations using y_2 and y_3 are listed in column B. They no longer seem as avant-garde as the new painting types represented by combinations including z_2, listed in column C. As a result, what was formerly innovative (column B) has been supplanted by something even more innovative (column C). Column B combinations are now transitional. As innovations occur, the formerly innovative combinations become transitional and then fully acceptable in the artistic tradition.

Using difference equations to express this simplistic model, we have the following:

(2) Traditional$_t$ = Traditional$_{t-1}$ + Transitional$_{t-1}$
(3) Transitional$_t$ = Innovative$_{t-1}$
(4) ∴ Traditional$_t$ = Traditional$_{t-1}$ + Innovative$_{t-2}$

where Traditional, Transitional, and Innovative refer to the number of painting types as defined by combinations of choice variable states, and t refers to the time period. This time period may refer to centuries, decades, or perhaps even years.

The unit chosen will have to reflect the state of the arts under consideration. These equations and those developed subsequently can be refined and solved for specific art forms.

Case 2

One problem with the Case 1 example is that artistic innovations are totally exogenous. It seems logical, however, that the search for new problems to solve, and therefore new variables to free, could be related to the state of artistic tradition. If large numbers of potential painting types have not yet been displayed, artists may well be content to investigate within the confines of existing free variables. As more and more of these painting types are presented, however, the ease of discovery is reduced. The novelty is reduced. Those who wish to be on the frontiers will begin to look for alternative means of expression. Ultimately, a new variable will be freed for exploration. Using this approach, innovative painting types are related to the proportion of potential painting types actually displayed as follows:

$$(5) \quad \text{Innovative}_t = f \frac{\text{Transitional}^*_{t-1} + \text{Innovative}^*_{t-1}}{\text{Transitional}_{t-1} + \text{Innovative}_{t-1}} = f(P_{t-1})$$

where $\text{Innovative}^*_{t-1}$ represents transitional types actually displayed. The closer P is to 1, the more likely artists are to free a variable, thereby increasing the number of possible innovative types in the current period. Substituting equation (5) in equation (4), a new definition of traditional is developed:

$$(6) \quad \text{Traditional}_t = \text{Traditional}_{t-1} + f(P_{t-3})$$

Case 3

The model developed in Case 2 places full emphasis on the artist's innovation. Each passing period mechanistically moves previous innovations to transitional and traditional states. This ignores the possibility that innovations may come so rapidly that the art-buying public cannot assimilate them. If this occurs, additional innovations simply swell the innovative classification without altering the other classifications.

To accommodate this possibility, let us define $_{t-n}D^j_t$ as the percentage of art buyers who find the j-th innovation acceptable art at time t. Note that D refers to the art-buying public rather than the general public. In some historic periods there might be very few art buyers.

$$(7) \quad {}_{t-n}D^j_t = d^j_{t-1} + d^j_{t-2} + d^j_{t-3} \ldots + d^j_{t-n} = \sum_{i=1}^{n} d^j_{t-1}$$

where d^j_{t-1} is the percent of art buyers who decide that art using the j-th innovation is acceptable during the $(t-i)$-th period. The j-th innovation is assumed to have been created in the $(t-n)$-th period. One could expect that immediately after an innovation is introduced the d^j_i's would be small; they might increase significantly if the art innovation caught on; they would tail off at the end, as most art buyers would have already committed themselves. The time period here is

measured in calendar units. This general approach is a simple version of models of diffusion of innovations in technology throughout the firms of an industry.[2] When some critical minimum value is achieved, an innovation moves into the transitional stage. Finally, when an even higher critical value is achieved, that innovation moves into the traditional stage:

(8) $V_{t-n}D_t^j \geq K < k, j$ is transitional

$\quad\quad V_{t-n}D_t^j \geq k, j$ is traditional

The values of K and k are purely speculative. A reasonable range for K might be 10 to 25 percent; for k, it might be 75 to 90 percent.

D is a function of a complex array of variables, many of which may not be readily identifiable. Attitudes toward the role of art and artists in society and toward change in general will be involved and will vary from one time period to another. Other variables may always be present and affect the value of $_{t-n}D_t^j$ in a consistent manner across time periods. One such variable is the percent of art buyers who already find the j-th innovation acceptable, $_{t-n}D_t^j$. A second is the absolute number of innovative painting types created by the j-th innovation and innovations in the subsequent time periods up to the present, $\sum_{i=0}^{n}$ Innovations$_{t-i}$.

A third is the rate of change of innovation painting types from $t-n$ to t,

$$\frac{\text{Innovative}_{t-i} - \text{Innovative}_{t-i-1}}{\text{Innovative}_{t-i-1}} \text{ for all } i = 1, n.$$

The rationale for each of these is straightforward. The percent of art buyers who already accept an innovation captures the "bandwagon" effect and peer pressure. The absolute number of innovative painting types is based on the assumption that human capacity for assimilation is limited. The greater the number of new painting types to review, the slower the process of accepting a particular innovation. The problem is compounded if innovations come rapidly. Even though actually separated in time, they are likely to be viewed as simultaneous developments. This was the case in the first years of the twentieth century, when one innovation followed another in rapid succession. The rate-of-change variable captures this reaction:

$$(9) \quad _{t-n}D_t^j = g\left(_{t-n}D_{t-1}^j, \sum_{i=1}^{n} \text{Innovative}_{t-i}, \frac{\text{Innovative}_{t-i} - \text{Innovative}_{t-i-1}}{\text{Innovative}_{t-i-1}}\right)$$

In the model set out above the transformation of a painting type from innovative to traditional is expressed by equation (6), subject to conditions (8) and (9). The model implies that if innovations are slow enough in development, a new artistic innovation makes previous innovations seem more familiar and speeds their transformation to transitional and traditional states. If, however, no new innovations are forthcoming for a prolonged period, the transformation still takes place on the basis of the art-buying public's acceptance, which follows a

diffusion path implied by equation (9). In the event that new innovations come too rapidly, they exceed the assimilation capacity of the art-buying public and appear to that audience as innovations taking place almost simultaneously. Thus, the innovations of last week do not automatically become transitional this week when a new innovation appears. Instead, both innovations, with all their implied painting types, are included in this period's innovative classification.

SUMMARY, CONCLUSIONS, AND IMPLICATIONS

Here, then, is a prototype for modeling the economic history of art. Obviously each period examined will have unique peculiarities. Nevertheless, by approaching artistic development as a freeing of variables for exploration and by looking for factors affecting acceptance of innovations, a structure is developed for organizing the myriad of historical details available for interpretation. The examples have been in the field of painting. They could have come from music composition, sculpture, dance, or any of the other arts.

Some tenuous implications and avenues for further research can be stated. The implication for patronage support of the arts or commissioning is nearly always a narrowing of the range of choices or elimination entirely of some choice variable for the artist. A commission for a wall painting or a public sculpture determines medium, size, and often subject matter. A patron might place an artist in a room and say, "Do as you please," but this is rare. The Florentine Renaissance patrons did this perhaps more than any others. A mass market, on the other hand, provides the greatest freedom from a priori restrictions on artistic endeavors, but at the same time it provides the least security in both monetary and nonmonetary terms. A commission by a Medici or Louis XIV gave both artistic recognition and financial reward. The mass market confers neither until after the fact and perhaps never. Modern government grants may provide financial security on a temporary basis, but artistic validation of the work comes afterward on the basis of actual production. An examination of these rather intuitive implications might prove fruitful.

Another implied avenue of research is a model of collections based on information theory. It was noted earlier that an innovation requires more than one example of that kind of work to convey the meaning. Several Monet *Haystacks* clarify that the artist is studying light. Hence, the information content of numerous works by the same artist may be greater than the same number of works by different artists in the movement. The implication is that artist specialization by galleries, museums, and private collectors is artistically preferable to alternative strategies. This provides an alternative or perhaps complementary explanation to one already posited in the literature—that the collector seeks to monopolize an artist's work to maximize profits (White and White 1965).

A final implication for research concerns the role of the art critic. If artists work simultaneously on diverse innovations, their connections may seem remote.

In terms of the information trees depicted in Figures 2 and 3, they are expanding nodes which are far apart. The role of the art critic is to bridge these gaps. This serves both the artistic function of explaining the information content of the art and the economic function of providing customer information in the art market. Credence is lent to this view of the critic by the fact that full-time critics did not exist until 1850. Their numbers and influence grew in proportion to the new art movements of the late-nineteenth and twentieth centuries.

Notes

1. For the reader who is unfamiliar with the mathematics of information theory, the following are recommended: W. Ross Ashley, *An Introduction to Cybernetics* (1963); Claude E. Shannon and Warren Weaver, *The Mathematical Theory of Communication* (1963); and Philip James Owen, "A Hierarchical Information Analysis of the Order of Words" (1973).
2. See further, Edwin Mansfield, *Industrial Research and Technological Innovation* (1968), especially chapter 8.

References

Ashley, W. Ross. 1963. *An Introduction to Cybernetics*, Science Editions. New York: John Wiley and Sons.

Blunden, Maria and Blunden, Godfrey. 1972. *Impressionists and Impressionism*. Trans. by James Emmons. Geneva: Skira.

Mansfield, Edwin. 1968. *Industrial Research and Technological Innovation*. New York: W. W. Norton.

Owen, Philip James. 1973. A Hierarchical Information Analysis of the Order of Words. In *Advances in Cybernetics and Systems Research*, vol. 1, F. Pichler and R. Trappel, eds. London: Transcripta Books.

Shannon, Claude E. and Weaver, Warren. 1963. *The Mathematical Theory of Communication*. Urbana, Ill.: Univ. of Illinois Press.

White, Cynthia and White, Harrison. 1965. *Canvasses and Careers*. New York: John Wiley and Sons.

Comment
Stroud Cornock

There has been a fundamental shift of attention in art since medieval times, when the ostensibly religious concerns of private and institutional patrons were expressed through stereotypical images and structures. Thereafter, the quality of the expression came to rival the purpose of a work. Later still, during the Italian

Renaissance, responsibility for authorship passed from the patron to the circle of individual painters and sculptors whom he commissioned, establishing the conditions for the emergence of the generalized status of "artist."[1] An extreme example of this shift is an increase in the exchange value of those U.S. dollar bills that carry the signature of the American artist Andy Warhol next to the U.S. Treasury Secretary's signature. The shift is from some object of purposeful communication to celebration of authenticity itself.

In reminding us of this shift, the Owens' paper also indicates and goes some way to illuminate the ramifications of change and development in what we now refer to as the arts. It does so by using modes of analysis which to art specialists will seem alien, but which are specific neither to the *Naturwissenschaften* nor to the *Geisteswissenschaften*.[2] Cultural studies are conditioned by the capacity of people and groups to ascribe different and often conflicting meanings to phenomena, which has led Sir Geoffrey Vickers to characterize systems studies as locating "the nature of facts in a world of values" (1977). In assessing the Owens' information theory model, our criterion should therefore be its heuristic value rather than either the authenticity of its descriptions of art or the validity of any predictions made using it.

What then is the heuristic significance of the concept of art as a "shared grammar"? First, the approach requires a suspension of our affective responses and asks for concentration on describable and verifiable elements of experience. This can be an excellent discipline, particularly where, as in the arts, we have come habitually to evaluation as a first step in analysis. Second, it encourages us to look beyond the foreground of received and subjective evaluations to an often unnoticed pattern of conditioning upon choices made by members of the art world. A consequence of this approach is a tantalizing glimpse of the modern movement as a crisis precipitated by an excess of innovative types whose practitioners are not so much avant-garde as cut off from the cycle of transition and tradition described by the Owens.

The strategy employed is to cleave a body of articulate knowledge aside from the "tacit" knowledge which may cloud constructive analysis. This expedient enables us to re-examine such topics as the diffusion of ideas through painting together with the economic consequences of that diffusion. It is, however, necessary to remind ourselves that the gain in rigor is achieved only by adopting a number of simplifying assumptions. A relevant case is provided by the concept of tradition.[3] One view of tradition sees it as an embodiment of a set of knowledge in both tacit and articulate forms; thus, the understanding (*Verstehen*) of a musical composition can be viewed as rooted in the tacit elements of a tradition of musical sensibility. Those who find themselves separated from direct access to that tacit knowledge may find that a musical score helps as little in the re-creation of the musical experience as, by analogy, a physicist's written description of the relevant principles helps an otherwise unaided novice to make use of a bicycle.[4] Hence, if our simplifying assumptions necessitate the exclusion of tacit considerations from one part of our model, certain general concepts and conclusions to which those considerations are essential may have to be treated with special care.

Notes

1. See P. O. Kristeller's "The Modern System of the Arts" (1960); and Ernst Gombrich's "A Tribute to the Late Cecilia M. Ady" (1960).
2. *Naturwissenschaften* refers to the natural sciences, resting on objective knowledge, and *Geisteswissenschaften* refers to the sciences of the mind, based on understandings (*Verstehen*).
3. The concepts of tacit and articulate knowledge and that of tradition are discussed by Michael Polanyi in *Personal Knowledge* (1958).
4. The composer Wittold Lutoslawski, remarking on the failure of the musical tradition, declares his consequent reliance upon *non*musical shared understandings with the modern audience.

References

Gombrich, Ernst. 1960. A Tribute to the Late Cecilia M. Ady. In *Italian Renaissance Studies*, E. F. Jacob, ed. London: Faber & Faber.

Kristeller, P. O. 1960. The Modern System of the Arts: A Study in the History of Aesthetics. In *Journal of the History of Ideas* 12, no. 4: 496–527 and 13, no. 1: 17–46.

Polanyi, Michael. 1958. *Personal Knowledge*. London: Routledge.

Vickers, Geoffrey. 1977. Artistry in Physical and Social Space. In *Aesthetics in Science*, Wechsler, ed. Cambridge, Mass.: M.I.T. Press.

A Malthusian Nightmare
for the Composer
and His Audience*

Michael O'Hare

IN 1974, when I first considered Marianne Felton's survey of American compos-
ers, I regretted that most of the 434 compositions for that year alone
would wait in line to be premiered, perhaps for years. In 1975 it occurred to me
that *another* four to five hundred works awaited performance, yet there were still
fewer than sixty orchestras to perform them. The next time I thought about it
after that was around mid-April, a date significant to Americans as marking a
national ceremony of sacrifice on the altar of public goods. How many of those
unperformed works did I pay for? I wondered. How many will I ever hear? How
many will ever be heard by any audience? What the heck is going on here?

The mismatch between the supply of and demand for performable art is not a
new perception. Felton notes that the likelihood of any new piece being per-
formed is almost nil; she points to the number of performance groups as evi-
dence. But the problem is deeper than that. The oversupply of compositions and
low pay for composing are commonly dismissed by asserting that the "psychic
income" received by composers or writers is partial compensation and that the
best of the work produced is filtered through the critical marketplace. These
observations amount to a facile assumption that some equilibrium is reached.
They may be all the attention the problem deserves, except that about 40 percent
of the compensation received by the composers that Felton surveyed was in the
form of commissions or prizes. I know of no commercial commissions of serious
music; this support is mostly philanthropic. Philanthropy for the arts, at least in
the United States, is nearly half government money (Vandell and O'Hare 1979).
Commissions provided directly by government agencies or funneled from them
through orchestras are, of course, entirely public funds. So it appears that the

*The contents of this paper do not represent the position of the Executive Office of Environmental
Affairs of the Commonwealth of Massachusetts.

government is paying people to write music that will never be heard. This is only marginally more rational than paying farmers not to grow food or to grow food no one wants to eat (two American agricultural policy traditions of long standing). The supply of performing arts source material and the demand that might be developed for it deserve attention as inputs to policy formation.

We characterize the latent supply of music, $S(t)$, as the total that could be created in a given year, t, at any given level of quality. It is limited by the pool of talent—the fraction, f, of the population, p, that can create in a given medium. Thus,

(1) $S(t) = K_1 f p(t)$

where K_1 is constant, and f is probably constant, though the invention of new media might cause it to increase occasionally (a genius in holography would have had no outlet in 1900); p is roughly constant (in developed countries) or growing, often exponentially. The latent stock of art, $A(t)$, grows—or could grow if encouraged—over time as:

(2) $A = \int_0^t S(x)dx = K_1 f \int_0^t p(x)dx$

Demand is a little more complicated to model. The consumption of *art experiences* is a function of leisure time for art, a, and p: a hundred people spend ten times as much time listening to music as ten people do; if prosperity increases so they have twice as much time to spare, they listen to twice as much music. The consumption of *art being experienced* is not so simple. Since performing art (not performances) has the nonrival property, two performances of Jones's third symphony do not consume two symphonies—in fact, they don't consume any. One symphony and enough musicians or record players could supply all of society with symphonic music by this simple measure. Luckily for composers, people exhibit satiety: after they hear Jones's symphony, they want to hear Smith's and then Green's. Unluckily for composers, this satiety is limited; after a while they want to hear Jones's again. (Another limit to satiety is the death of a consumer; his replacement can start all over again with the pieces his predecessor "used up.")

For each listener, some maximum number of pieces of music can be enjoyed in a lifetime. The reason there is a maximum is that there are only 24 hours in a day and about 600,000 hours in a lifetime. How great can the demand for music be? If each experience were the first, drawn at random from the unheard items in A, the consumption of compositions would be:

(3) $C(t) = K_2 a p(t)$

where K_2 is constant, a is music-listening time and is ultimately constant, and p is population.

The ratio of C to A describes the probability, $P(t)$, that the next composition added to the stock of A will be heard in the year of composition:

(4) $P(t) = \dfrac{C}{A} = K_3 \dfrac{ap(t)}{f\int_0^t p(x)dx}$

For constant population, this is just:

$$(5) \quad P(t) = K_3 \frac{a_p}{f_{pt}} = K_4 \frac{1}{t}$$

The probability that the piece will be heard within any given number of years T is:

$$(6) \quad P_T = \int_t^{T+t} K_4 \frac{1}{t} \, dt = K_4 \ln \frac{T+t}{t}$$

which goes to zero as t increases.

For exponential population growth P is constant in t; for any other rate (any power law, for example, such as $p(t) = Kt^a$) decreasing $P(t)$ obtains. Since exponential growth is not a steady state and has come to a halt in Western nations already, we ignore that special case.

This result means that if we increase the consumption of music compositions to the maximum possible rate—effectively, everyone listening to as much unheard music as possible—and add to the stock of music the same proportion of the possible products of musical talent each year, the probability that anyone will hear a new piece becomes smaller and smaller without limit. Alternatively, it means that the probability that a new piece will be heard can be held constant only by adding to the stock each year a decreasing proportion of the music that the talented population could produce—in particular, f must decrease as $1/t$.

Unfortunately, a more realistic approach to the social use of music and its real patterns of consumption makes matters worse (for the composer). First, to the extent that art is a defining element of a culture, it is essential that each music listener not listen to different pieces of music. It is not surprising that nearly all musical Germans listen to Schubert's songs rather than each listening to different songs; to whistle *Die Forelle* is in part what it means to be German. Music is also an important medium with which to cement different cultures into larger units. Thus, the existence of 50 million French persons does not double the consumption of symphonies accounted for by 50 million Germans: if able to exchange music, the French and the Germans listen to about the same number of symphonies (by composers of both countries) as either would (to the work of its own natives) alone.

On an individual basis there is benefit not only in listening to the music others listen to, but in listening to the same piece repeatedly. Differences in performance and interpretation can only be appreciated by hearing different performances, and a piece of music does not yield what it has to offer on a first hearing; it usually takes a few performances to appreciate its subtleties. Familiarity itself is sometimes an important part of the aesthetic experience. These considerations reduce K_2, K_4, and thus P_T, the probability of performance of a new piece of music, below the figure suggested by the best-case model above.

We have established that the probability of performance of a new piece of music, assuming that the fraction of talent allowed or induced to compose remains constant, will be constant only in a time of exponential population growth;

otherwise, it will decline with time. It is interesting to look back at the last couple of centuries to see what this model claims to represent.

Until early in the nineteenth century music did not have the nonrival property it has today. A composer was an author of work for hire, employed by an aristocrat who, for reasons of convention and fashion, was obliged to present new music to his guests at social occasions. A new ball meant not only a new costume but also a new divertimento or suite. Furthermore, the only music performed at such occasions was contemporaneous music. The effect of this market structure was to remove the integral sign from the denominator of equation (4); the consumption of music was roughly proportional to the fraction of the population that was talented, and no serious disequilibrium obtained.

In 1830 a significant event occurred: Mendelssohn organized a performance of music a hundred years old (Bach's *St. Matthew's Passion*) and started a trend that still obtains, paralleling a rather rapid shift in the composing business from the work-for-hire model to a publication/royalties model. The result of these developments, which advanced rapidly with the romantic approach to historical periods and styles as conventions among which one might choose for consumption, was to put composers from that time onward into competition not only with each other, selling quasi-public goods, but in competition with the growing number of past composers.

For a while population growth, nearly exponential, suppressed the effect described in equation (7); in the 1870s it was possible to provoke riots in the streets of Vienna over the merits of two contemporaneous composers. In the twentieth century, however, the latent supply of music and its realizable demand have diverged so rapidly that a composer who earns his living at composition is the rare exception to the rule. The divergence has been accelerated by rapid expansion of the stock of serious music not only through new compositions but through increasingly aggressive mining of the past; it is not extraordinary for the record collection of a cultured Westerner to contain music ranging from Bach and even earlier (including Renaissance and sometimes medieval music) to the present. Moreover, the market now includes not only Western music from Russia to California but also non-Western music (including African and Asiatic works); it encompasses not only the compositions of an educated aristocracy but also jazz and popular music. Indeed, the jazz composer/performer of the present time, even within the devoted jazz-listening market, faces a problem akin to that of his long-hair colleague: recordings have preserved jazz performances from the past seventy years, and an art form which used to be consumed exclusively in its contemporaneous works is now available as an accumulation over time. Paul Whiteman can still compete, long after his death, with living musicians.

The continued technical development of music reproduction has maintained a market for contemporaneous performers, but critical discographies can now recommend as preferred performances records that are fifteen and twenty years old. It will be interesting to see whether performers start to feel the pressure familiar to modern jazzmen and to composers.

Some back-of-the-envelope calculations will illustrate approximately where we stand now. Suppose American composers have only been composing since 1945, but at a rate of 400 compositions per year (this accounts roughly for the preexisting stock of music). If 100 of these pieces are performed each year (a rate of about 2 per orchestra per season), by 1975 ($t = 3C$) 12,000 works had accumulated. The probability that a new one added to this group was performed was about 100/12,000 or 1/120. Since $1/t$ is 1/30, K_4 is about 1/4. The likelihood of performance within the next ten years is then:

$$P_{10} = \frac{1}{4} \, 1n(\frac{30 + 10}{10}) = .072$$

By 1995, P_{10} will have fallen to .046, and P_{20} will only be about 1/12. In fact, in 1995 P_{50} will be less than .02!

A program of encouraging new composition might increase the production rate to 450 per year. If it had been in effect since 1945, P_{10} in 1975 would have been only .064 unless performances were increased. Would performances be increased? Instead of 9,000 unperformed works to choose from, the program director could select from 10,500—not much of an incentive for increasing performances. Thus, if things are bad for serious music composers right now, they will get worse before they get worse. The prospects of providing, as a performance, a piece of music composed today (let alone selling it for money!) are poor and getting poorer.

The patron considering commissioning some contemporary music will simply be adding a piece to a stock enormously greater than will ever be played or heard. What would be the reasons for so doing? (1) The patron might cleverly identify an unwritten piece (perhaps by reference to the composer) as being so much better than its contemporaries that it would be performed despite the odds. (2) The patron might commission a piece for an orchestra and fund its performance as well as its composition. (3) Perhaps the patron thinks that increasing the supply of unperformed music will increase the quality of that which is eventually selected from the pool. (4) Composers have to practice, like other artists: the next piece commissioned might not have to be performed in order to contribute to the production of an eventual masterpiece that will be. (5) Composition, like any art, exists in a tradition. If composition isn't maintained as an ongoing practice, masterpieces of the future will never be written. (6) The patron might feel that artists have a "right" to be supported at their craft.

In the light of our analysis, none of these reasons seems to have much force, especially for a government patron. It's hard to see that reason (1) would mean more than the support of successful composers who already have the best (if poor) markets. Reason (2) simply substitutes the piece commissioned for what the orchestra would play instead, and subsidizing an orchestra to play a new piece is about as likely to result in performance of a good work as if the work were written for the occasion: why not just draw from the existing pool of unpremiered work? The pool already contains excellent work that hasn't been made available for consumption. Making it even larger, as per reason (3), makes the search even more difficult and less likely to be exhaustive. Reason (4) has some force but sim-

ply delays the crunch: the stock of excellent late works will as surely exceed the capabilities of the audience later as the stock of pretty good pieces does now. Reason (5) entails the same problem: the future for which the tradition is maintained is less promising as a market for composition than the present. Reason (6) is outside the scope of arts policy; do we want to establish a principle that people should be supported to do *whatever* they are good at, even if there is no demand at any price for it?

I am deeply discouraged about the implications of this small exercise. I think I can easily say that there is no reason from a public policy point of view to operate a supply-side subsidy for the performing arts unless it is strictly rationed as intensive support for a small and shrinking number of artists. But it is a matter of great distress to recognize that we can expect to enjoy a decreasing fraction of the great music of the future no matter how we raise the standards and that the prospects of a composer being of any use to society by composing music are already bad and getting worse.

What can be done about the problem of composer and audience? The possible strategies are two: we can educate the public to devalue old music relative to recent work and thereby flatten out the curve depicted in Figure 1, creating a market like that in the popular music business; or we can increase the time listeners devote to music listening, but this is only a stopgap, for eventually a limit is reached.

Finally, a comparison with other art markets makes the point. The limiting factor on consumption is not the expense of the product but something much

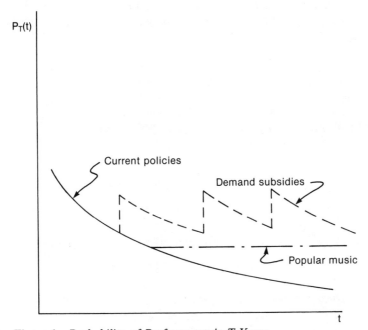

Figure 1. *Probability of Performance in T Years*

more fundamental: the time available to an individual for consuming the product. Also intrinsic to the problem statement is the nonrival quality of musical composition and its endurance. For example, literature and drama exhibit the same formal properties as music, but there are many more writers making a living from their work than composers. Why? One difference is that literature has a shorter life span than music: the music of the eighteenth century is commonly performed and widely appreciated, while the literature of that period—with a few exceptions—is a specialized taste. Perhaps music lacks the explicit reference to circumstance that dates narrative; it is an interesting question in aesthetics why the language of prose is less accessible with age, while the opposite seems to apply to music.

Another factor is the restriction of literature to a particular language: if one population keeps twenty novels and twenty symphonies in use, two populations speaking different languages will support forty-odd novels—but only a few more than twenty symphonies; the authors will have a market twice as rewarding as that for the composers.

The rapid senescence of popular music keeps its market operating like the serious music market of the eighteenth century; for the most part, popular music does not accumulate, so each generation will support its proportional share of composers.

Visual artists enjoy two happy circumstances that outweigh their product's durability. First, it is possible for an individual to consume an entire painting even without looking at it full time: if it's on my wall, you can't have it on yours. Second, the technical level of reproduction is so primitive by comparison to musical recording that a slide or print of a painting does not even enter the market in which the original is traded. Not surprisingly, we find many visual artists who can support themselves at their craft.

References

Felton, M. V. 1978. The Economics of the Creative Arts: The Case of the Composer. *Journal of Cultural Economics* 2, no. 1: 41–62.

Vandell, K. and O'Hare, M. 1979. Indirect government aid to the arts: the tax expenditure in charitable contribution. *Public Finance Quarterly* 7, no. 2: 162–181.

Comment
William S. Hendon

As detailed by Michael O'Hare, the Malthusian nightmare for a composer is the reduced probability that a particular piece of music will be performed as the number of pieces of music increases. For the consumer the nightmare appears to

be the reduced likelihood of being able to hear pieces of music relative to the total stock of music being composed. O'Hare carefully details this hypothesis and argues, among other things, that there will be little justification for the public to subsidize composers or performers.

O'Hare suggests that music up until the nineteenth century was in effect commissioned and consumed on a one-time basis, and economists today might find (given other conditions of the market being acceptable) that this is an efficient and, hence, presumably desirable arrangement. But wouldn't it be unfortunate if this kind of efficient market were the case? Who really would want to go back to such a limited but somewhat competitive market? O'Hare, of course, would not and rightly so, especially when we have so many opportunities to consume music.

O'Hare may be correct in his analysis. The nightmare may be upon us as we find ourselves with reduced probabilities of having a given composition performed, but it may be merely a modest bad dream, since more music is composed, performed, and enjoyed by many people now than at any other time. Thus, while his analysis may be correct, O'Hare is perhaps too closely arguing one point among several, insofar as the implications of his analysis are concerned.

O'Hare understands the extension of the market but really emphasizes the limits to growth in the total number of listeners, not the fact that listeners are increasing, a fact that may be the important one over any reasonable time frame. Also, the reduced probability of performance may be sufficiently small that it will not inhibit composers to compose or to reduce their numbers. Consumers may not feel the pinch of the reduced probability; on the contrary, they may be more likely to take the optimistic view that it is wonderful to have such a wide choice, such excellent compositions, and such an increase in the quality and number of performances over time.

In short, O'Hare's argument raises solid points, but his view may be an extreme one. Its value certainly lies in questioning the arguments made by arts advocates in pursuing public subsidy of the arts. If oversupply is obvious, then subsidy may need to address issues of access, location, and other relevant demand-side questions to keep the number of listeners increasing until we reach O'Hare's stationary state.

Markets for Works of Art and "Markets for Lemons"

Roger A. McCain

ECONOMISTS AND OTHERS interested in the economics of the arts often find themselves talking at cross-purposes. To the noneconomist it seems to be self-evident that the arts are a "special case," meriting special treatment and special encouragement from the government. By contrast, the economist is hard put to say what there is that makes them more special than any other goods, for example, potatoes. Thus, the economist falls back on the assumption that there is, in fact, nothing special about artwork, with the result that each scholar seems to be missing the other's point.

To most economists, the best-known category of "exceptions" is the category which encompasses public goods and externalities, in which government action may be merited on efficiency grounds as a means of overcoming the "free rider" problem. There is, however, a large literature on markets with imperfect information,[1] which includes some interesting hypothetical pathologies or "special cases." In particular, Akerlof's "market for lemons" attracts consideration as a category of exceptions or possible exceptions. This paper explores the possibility that the "lemon" model may be a means of bridging the gap between the humanist and the economist in arts policy, that is, a key to posing hypotheses of arts exceptionalism in terms that are mutually comprehensible and that may lead ultimately to empirical tests. This paper will attempt not to prove any hypotheses but rather to pose some hypotheses about the economics of art. The purpose is to establish that the lemon model is of interest for the economics of the arts and to stimulate its further study.

LEMONS

When information is incomplete or costly that fact is likely to have implications for market equilibria. Suppose, for example, that the quality of goods is

known to sellers but not to buyers. Then the sellers who have better quality goods may be reluctant to offer them for sale, knowing that they may not get full value.

One example is the market for used automobiles. Everyone knows that cars vary in their quality, even within a product line. Some are lemons and some are not. The buyer of a new car can only guess whether it is a lemon or not. However, after having driven the car for a few months, the buyer knows whether it is a lemon or not. Now, a person is much more likely to sell a lemon than a "cream puff" as a used car. Potential buyers know this. According to the old saying, "When you buy a used car, you buy somebody else's trouble." But the buyer of a used car cannot tell (until it is too late) whether that car is a lemon or a cream puff. "An asymmetry of available information has developed: for the sellers now have more knowledge about the quality of a car than the buyers. But good cars and bad cars must still sell at the same price—since it often is impossible for a buyer to tell the difference between a good car and a bad car. Thus, the owner of a good machine must be locked in . . . he cannot receive the true value of his car. . . ." (Akerlof 1970, p. 489). Most of the cars traded on the used car market will be lemons.

The lemon model also reveals the costs of dishonesty and the usefulness of trust. The discussion of the market for used cars offers an example. If I own a cream puff, I shall not be able to sell it to a stranger for what it is worth. However, I may be able to sell it to my brother or my friend for a price approximating its worth, if my brother and my friend trust me not to deceive them.

The problem is that the market for trustworthy people is itself a market for lemons. The potential trustee knows whether he or she is trustworthy or not, but the potential truster does not necessarily know.

When goods can be misrepresented by the seller, the lemon problem arises. The buyer must allow for the possibility of misrepresentation and so will not pay the value of a good of assured quality. This in turn forces some honest dealers out of the market and may leave the market to the lemons or destroy it entirely.

To see how dishonesty and the lemon problem can destroy the market, consider the following numerical example. There are just two kinds of goods: shoddy goods, which consumers value at $5 each, and fine goods, which consumers value at $20 each. The industry marginal cost curves for both goods are shown in Figure 1. The marginal cost curve for shoddy goods is right-angle curve *abc*; that is, at a price below $10 the output of shoddy goods is 0, while above $10 the output of shoddy goods is 100 per period. The marginal cost curve of fine goods is *dec*; that is, the output of fine goods is 0 at prices below $15 and is 100 per period at prices above $15. The assumed demand curve for shoddy goods is shown by D_s, and for fine goods by D_f. (Following Akerlof, we are ignoring the law of demand for simplicity and thus avoiding the complication of risk aversion.) Thus, if shoddy and fine goods were sold separately, no shoddy goods would be sold, while 100 units per period of fine goods would be sold at a price of $20, yielding a profit of $500 per period.

Because of dishonesty, however, the market for fine goods is a market for lemons. From the marginal cost curves in Figure 1, we can derive a curve of the

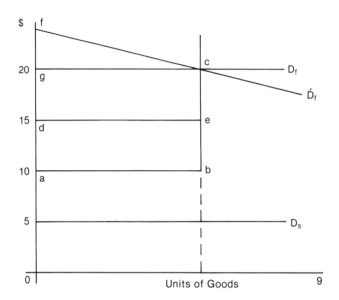

Figure 1. *Marginal Cost Curves for Fine and Shoddy Goods*

proportion of goods offered which are bona-fide fine goods. This is shown by broken line *abcd* in Figure 2. At prices between $10 and $15 only shoddy goods will be offered, so the goods are zero percent fine. At prices above $15 100 units each of shoddy and fine goods are offered, so the goods on the market are 50 percent fine. The expected value of a good, depending on the proportion of goods

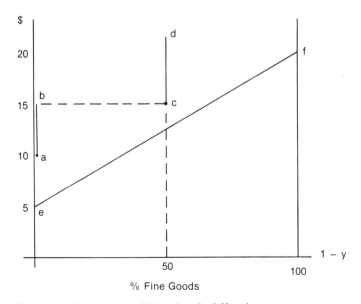

Figure 2. *Proportion of Fine Goods Offered*

which are fine, is shown by line *ef*. Observe that there is no equilibrium in this case. Point *a* is not an equilibrium, since at point *a* the cost of shoddy goods is more than the consumers are willing to pay, and so none are offered. Indeed there is no attainable proportion of fine and shoddy goods which will induce consumers to pay the cost.

Because of dishonesty and misrepresentation, then, the market for fine goods is wholly suppressed. The cost of dishonesty in this case is the profit which might otherwise be made by selling fine goods: $500 per period. If the demand curve for fine goods were downward sloping there would be, in addition, a consumers' surplus on fine goods lost due to dishonesty. Suppose that in Figure 1 line D_f is the demand for fine goods. In that case, if fine goods are sold separately, the consumers' surplus of fine goods will be measured by the area of triangle *fcg*. Thus, dishonesty and misrepresentation cause suppression of the market for fine goods and loss of the potential profit, area *gcde*, and the potential consumers' surplus, area *fcg*, in this example. (But that would bring further complications with risk aversion.)

EVASIVE TACTICS

This dishonesty may be more or less evaded in several ways. One possibility is monopolization of the market for fine and shoddy goods. If there is a single seller of fine and shoddy goods, the proportion of the two can be adjusted to maximize profits, and in such a case at least some fine goods are likely to be offered. Since the price the monopoly can get is:

(1) $\quad p = 5\dfrac{q_s}{q} + 20\dfrac{q_f}{q}$

the monopoly's profit is:

(2) $\quad q\left(5\dfrac{q_s}{q} + 20\dfrac{q_f}{q}\right) - 10q_s - 15q_f$

subject to the constraints that:

(3) $\quad q_s \le 100 \; ; \; q_f \le 100$

Here, of course, q_f is the quantity of fine goods, q_s is the quantity of shoddy, $q = q_s + q_f$, and fixed costs are ignored. Equation (2) is the same as:

(4) $\quad 5q_s + 20q_f - 10q_s - 15q_f = (-5)q_s + 5q_f$

Clearly, the monopoly will offer only fine goods in this case.

The lemon problem can also be more or less evaded by using signals (Spence 1974). In a world of markets for lemons, buyers naturally search for some sign that the good is high in quality or that the seller is trustworthy. To take a ridiculous extreme, suppose that every honest person wears a green hat. Knowing this, buyers only buy from sellers who wear green hats. Knowing that they do, every sharpie puts on a green hat, thus destroying the usefulness of the green hat sign. The problem is to find a sign that dependably distinguishes between good and

bad quality in a world in which sharpies are well informed and maximize their profits.

The sharpies will imitate a sign of quality if it is profitable for them to do so. Therefore, a sign may be trustworthy if the seller of shoddy goods finds it more costly to display the sign than does the seller of fine goods. A sign which has this property is called a *signal*.

Guarantees, service contracts, and similar arrangements are examples of signals and their role in lemon markets. A guarantee is a promise to repair or replace the item or compensate the buyer if it proves to be of low quality. A guarantee is more costly to a seller of low-quality goods than to a seller of high-quality goods, so the guarantee may be a signal of quality. A service contract is also a promise to repair, replace, or compensate for poor-quality goods, but the promise is sold separately from the commodity, so that an individual buyer can choose whether or not to buy the service contract along with the item. A cheap service contract is also costly to the purveyor of shoddy goods, and so it may be a signal of quality. However, customers who know that may find that their best strategy is to buy only from firms that offer service contracts but not to buy a service contract. But that strategy, in turn, reduces the cost for the sellers of shoddy goods offering service contracts.

In our numerical example no market could exist because of misrepresentation. Now suppose that guarantees can be offered at an administrative cost of $1 per item. A seller of fine goods can get $20, total, for a good which costs $15 and a guarantee which costs $1. The profit is $4 per item. However, the seller of shoddy goods would have to replace the shoddy goods with fine ones under the terms of the guarantee, so that shoddy goods cannot be profitably offered under the guarantee. Customers treat the guarantee as a signal of quality and buy only guaranteed goods. Guarantees make a market possible where it had not been possible before, and no shoddy goods are sold.

But a guarantee seems rather arbitrary, since it forces the person to buy one thing (the guarantee) in order to buy the other thing (the good guaranteed). Some people might prefer to buy the good without paying the $1 administrative cost of the guarantee. Thus, a service contract might seem to be a better arrangement.

Suppose, then, that service contracts are offered in place of guarantees at the same $1 administrative cost, which the customer may pay separately. Suppose that the probability of getting a shoddy item is y. If one is uninsured, the loss from getting a shoddy item is $20 - $5, or $15, the difference between the price paid and the value of the shoddy item. Thus, the expected loss on an uninsured purchase is $15y$. Consumers will buy the service contract if $15y > 1$, that is, if $y > 1/15$ or 0.067. This is shown in Figure 3 by right-angle curve abc, which represents the proportion of consumers who buy the contract, x, on the horizontal axis. Thus, x is 0 when $y < 0.067$ and is 1 when $y > 0.067$. If $y = 0.067$ then consumers are indifferent about buying the contract, so any proportion between 0 and 1 may buy it.

Suppose that the proportion of consumers who buy the contract is x. Then a seller of shoddy goods who offers a service contract will have to replace x propor-

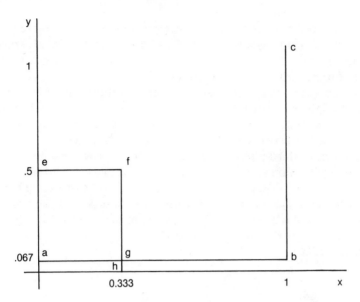

Figure 3. *Proportion of Consumers Who Buy When Service Contracts Are Available*

tion of all that is sold with fine goods at an additional cost of $15 each. Thus, the expected replacement cost per sale is $15x$. The profit from selling shoddy rather than fine goods is the difference in cost between $15 and $10, or $5. It will be profitable to sell shoddy goods if $15x < 5$, that is, if $x < 1/3$, and not otherwise. Suppose, as before, that when it is profitable to sell shoddy goods, 50 percent of all goods sold are shoddy. Then the proportion of shoddy goods, y, will be 0 when $x > 1/3$, 50 percent when $x < 1/3$, and any value between 0 and 50 percent when $x = 1/3$. This is shown by right-angle curve *efh* in Figure 3.

As usual, the equilibrium is the intersection of the two curves, that is, point g, so that the proportion of shoddy goods is 0.067 and the proportion of service-contract buyers is 1/3. With 0.067 of shoddy goods, the demand price of a unit of goods (net of service contract) is $(0.067) (5) + (0.933) (20)$, or $19, and the price of the item plus the service contract is $20, as assumed. Thus, the market can exist with service contracts as it can with guarantees, but with service contracts some shoddy goods are sold.

In this example 7.5 units of shoddy goods are sold (as an annual average, perhaps) and 36 service contracts are bought at $1 of administrative cost each. Thus, the net social benefit from the market is:

$$(5) \quad 7.5(5 - 10) + 100(20 - 15) - 36 = 500 - 37.5 - 36 = 426.5$$

With guarantees the net gain is 400. Thus, in this case, the service contracts are preferable from a strict cost-benefit viewpoint, though some fakery does occur.

If some of the sellers have a reputation for honesty or quality or both,[2] this may allow the market to function despite the potential lemon problem. Since a

reputation cannot be separated from the item sold by a well-reputed seller, the reputation will function as a guarantee does, insofar as it is equally trustworthy. There is no analytically useful distinction to be made between guarantees and a reputation for trustworthiness in these simple models.

Another possible buyer response to the lemon problem is to seek third-party certification of the quality of the goods offered. Let us see what effect this has in the numerical example of fine and shoddy goods. Suppose that certification costs $4 and is perfectly trustworthy. (Thus, we exclude the rather plausible possibility that the market for third-party certification is itself a market for lemons.) If some buyers seek certification and others do not, then the market is bifurcated, and the noncertifying buyers' demand may differ from that of the certifying buyers. (For brevity let us call them n-buyers and c-buyers.) Suppose that the proportion of c-buyers to the total is z. Then c-buyers take zq of the supply of fine goods, since c-buyers take fine goods only. Consequently, the proportion of fine goods available to n-buyers is:

$$(6) \quad \frac{1 - y - z}{1 - z}$$

and the proportion of shoddy goods is:

$$(7) \quad \frac{y}{1 - z}$$

Thus, the maximum price the n-buyers will pay is:

$$(8) \quad p_n = \left(\frac{y}{1 - z}\right)5 + \left(\frac{1 - y - z}{1 - y}\right)20 = 20 - 15\left(\frac{y}{1 - z}\right)$$

The c-buyers face a somewhat different risk. They must pay for certification even if the items are shoddy, though in that case they do not buy the goods. Thus, it pays to certify, or it does not, accordingly as:

$$(9) \quad (16 - p)(1 - y) - 4y \gtrless 0$$

and there will be both certifiers and noncertifiers in the market if equation (8) is an equality. (In equation [9] the first term is the consumers' surplus from a unit of fine goods weighted by the probability that fine will be drawn, and the second term is the cost of certification weighted by the probability that shoddy will be drawn.) That is, both noncertifiers and certifiers will be in the market simultaneously only if:

$$(10) \quad p = \frac{16 - 20y}{1 - y}$$

Equations (8) and (10) together imply that if $p_n = p$, then:

$$(11) \quad y = \frac{1 \pm \sqrt{1 - 1.067(1 - z)}}{2}$$

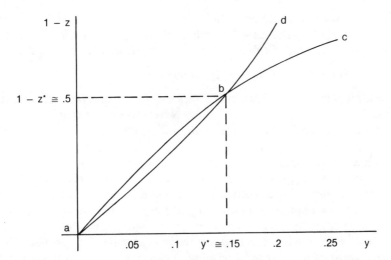

Figure 4. *Proportion of Consumers Who Buy When Third-Party Certification Is Possible*

This parabola is shown in Figure 4 by curve *abc*. We may also require that the price cover the cost:

(12) $20 - \dfrac{15y}{1-z} 10y + 15(1-y) = 15 - 5y$

that is:

(13) $1 - z \quad 3\dfrac{y}{1-y}$

Equation (12) is shown in Figure 4 by curve *abd*. Evidently both (10) and (12) can be satisfied anywhere to the left of y^* ($\cong .15$) and below $1 - z^*$ ($\cong .5$). If the sellers increase the proportion of shoddy goods whenever they can sell them, then y will increase to y^* (about .15), and in equilibrium 100 units of fine goods and 18 units of shoddy will be sold for a proportion of shoddy goods, y, of .15. In equilibrium .5 of the buyers certify, so that 59 certifications take place and $236 is spent on certification. The market exists with third-party certification, but the net gain from the market's existence is:

(14) $18(5 - 10) + 100(20 - 15) - 236 =$
$-90 + 500 - 236 = 174$

Most of the potential net gain of 500 is thus dissipated in production of shoddy goods and in the real resource costs of protection against buying shoddy goods (that is, the administrative costs of certification). Of course this result depends on the numbers chosen for the example and in particular on the assumed high cost of third-party certification. If third-party certification were as cheap as $1, the mere

threat of certification would be sufficient to keep the rate of fakery to 7 percent, an equilibrium rate. In that case 7.5 units of shoddy goods would be sold in equilibrium, and the net benefit due to the existence of the market would be:

$$(15) \quad 7.5(5 - 10) + 100(20 - 15) = 462$$

Note that this is better than both guarantees and service contracts, as indicated by equation (5) above and those that follow. Nevertheless, the monopoly does still better, producing no shoddy goods at all and yielding a net benefit of 500, the maximum possible in this example.

Of course, these examples do not establish any general proposition about markets for lemons. What they do establish is that the characteristics of market equilibria with qualitative uncertainty are often quite counterintuitive. Mechanisms which appear to eliminate qualitative uncertainty (such as service contracts and third-party certification) may not do so at all. Monopolization, which at first blush might seem to make the problem worse, can have the opposite effect. In short, the world of qualitative uncertainty is a new world in economics, and the performance of these markets according to conventional theory cannot be taken for granted. It is necessary that the lemon phenomenon be taken explicitly into account.

THE STARVING ARTIST THEOREM

Is there any reason to think that buyers of artwork are less able to judge quality, on the average, than the producers are? The answer is maybe, and it depends somewhat on what we mean by quality. Lest that be regarded as a trivially obvious point, recall that none of our examples to date have depended on any specific definition of "quality." We have simply assumed that "better quality" means "more costly," and that the producers know the quality because they have borne the cost or (in the example of used merchandise) that the seller knows the quality of the item by long and intimate experience, which the buyer necessarily lacks ex ante. Neither of these cases is self-evidently applicable to art.

We might, however, borrow an idea or two from Scitovsky (1976, especially pp. 52-56), who alerts us to the importance of a particular qualitative dimension of art: pattern complexity. According to Scitovsky, relatively simple art soon loses its interest, since the mind forms *supersigns* as a means of classifying familiar patterns. This process of pattern recognition and supersign formation is a source of enjoyment of art in Scitovsky's view; but with simple art the process (and so the enjoyment) is soon over. With more complex art there are new levels of pattern recognition to enjoy once the first layer of supersigns has been formed—patterns of patterns, as it were. Thus, the more complex art is capable of holding our attention even when it is familiar, but for the same reason it is likely also to be more "difficult" and "demanding," in that a person who has not formed the first layer of supersigns may recognize little if any pattern. This may also underlie the phenomenon known as cultivation of taste,[3] in that

some exposure to a genre is required before one forms the supersigns necessary to recognize its patterns, and so appreciate its charms and express a mature demand for it.

Let us tentatively identify pattern complexity with quality in markets for art. Is there any reason why a (modal) artist might be better able to recognize quality than a (modal) buyer when quality is interpreted in this way? Perhaps there is. There is no danger of mistaking pattern-complex art for pattern-simple art. By definition, the pattern of the latter is immediately accessible. Thus, it is hardly likely that pattern-simple art will be misrepresented as pattern-complex art. Instead, pattern-simple art and pattern-complex art are merely distinct and nonsubstitutable goods. It is more specifically the market for pattern-complex artworks in which we may find the lemon phenomenon.

Consider, then, the market for pattern-complex art as a distinct commodity. Suppose that many potential buyers, who are not cognoscenti, are aware of the significance of pattern complexity. These aware but naive buyers expect to be somewhat baffled by their purchases, at least at first. A piece of work may be baffling because it is complex or because it is bad. In other words, for the naive buyer it is possible that patternless art may be misrepresented as pattern-complex art, and so the market for pattern-complex art could well be a market for lemons.

There seems to be some popular consciousness of the possibility that art which is merely bad could be passed off as "advanced" and complex, as witness the undying joke about a canvas done by a chimpanzee, or splashed with buckets of paint, being sold for a fabulous sum as "modern art." There are also many tales from the annals of music about the poor reception given to the first performances of pieces now recognized as great and as historically important. These tales probably illustrate the importance of supersign formation, but also secondarily they seem to suggest that the paying public is quite suspicious. This suspicion is consistent with full rationality and full information and a demand for pattern-complex art, though I would not assert that the fractious audiences necessarily have had those characteristics.

In brief, the inability of some buyers to perceive the higher-order patterns of pattern-complex art opens the possibility of misrepresentation of patternless art as pattern-complex art, and so makes the market for pattern-complex art a possible market for lemons. As the examples of the previous sections show, this may lead to total suppression of the market for pattern-complex art, despite a positive demand for such art of *assured quality* at a cost-sufficient price. However, there is no reason to expect similar difficulties in the market for pattern-simple art.

If this is correct it supplies us with an immediate rationale for the subsidy of pattern-complex art by the government or by philanthropic agencies and trusts. The lemon phenomenon could imply an inefficiently small output of pattern-complex art, and the subsidies would then be aimed at bringing forth a more nearly efficient and larger output. We also have an answer to the "vulgar economist's" or cynic's question: why should not pushpin be subsidized along with poetry, and the Grand Ole Opry along with grand opera? The answer is that the

lemon problem occurs only in the case of pattern-complex art, not in the case of pattern-simple art. But we are left with a difficult question all the same: why should the subsidizing authority be better able than potential buyers to distinguish obscure advanced art from obscure bad art?

There are, however, further complications in art markets, two in particular. First, the producers of artwork may have preferences as to the sort of work that they wish to produce. Specifically, artists may get some "psychic income" from the production of bona fide pattern-complex art.

Let us illustrate the implications of this point with a numerical example which is a modification of the fine and shoddy goods example. Suppose that a maximum of 50 units of fine goods can be produced at a price as low as $8, because the producers get $7 worth of psychic income from producing each unit. Then, at a price between $8 and $10 the output is 100 percent fine, from $10 to $15, 1/3 fine, and from $15 up, 50 percent fine, as shown in Figure 5. The equilibrium is at *b* with a price of $10 when fine and shoddy goods are valued as before. (Remember, in the absence of psychic income there was no equilibrium and no trading.) Suppose, however, that the value which consumers set on fine goods is reduced below $20 per unit. Then—perversely—the proportion of fine goods will increase! If fine goods are valued at $10, the locus of expected values is at *d*, and the equilibrium is at *d*, with output 100 percent fine.

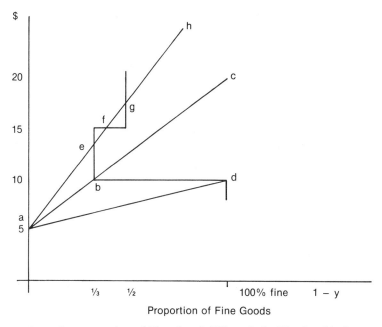

Figure 5. *Proportion of Fine Goods When Artist Has Psychic Income*

It is worthwhile to linger a bit over the perverse response of quality to demand here. What is happening is this: at prices between $8 and $10, no one can profitably offer any goods except sellers who derive psychic income from doing so, and as shoddy goods are not a source of psychic income, there is no lemon problem, and the output, though small, is of uniformly high quality. When the demand price rises above the alternative cost of shoddy ($10) then further increases only increase the quantity and proportion of shoddy goods. In this model such an increase in quantity produced is entirely regrettable: each unit of shoddy goods entails a social net loss of $5. It is only when the demand price of fine goods rises quite high (that is, above $25) that additional supplies of fine goods produced without aid of psychic income are brought forth. (With fine goods valued at 30, we have an expected value locus of *aefgh* and local stable equilibria at *e* and *g*.)

This tale may apply to some activities other than the arts. The sorting phenomenon on which the example rests is general, and it may be common to find that an activity which can be carried out on a small scale by highly motivated, poorly paid labor cannot be very much expanded without extreme degradation of quality, due to the small and inflexible supply of intrinsically motivated labor. Exploration of the evolution of the crafts of medicine and education, carried out along these lines, might prove rewarding. In any case, we are reminded of the postromantic stereotype of the artist starving in a garret in order to produce great art.

The first complication does provide us with one possible answer to the dilemma of how to subsidize art without subsidizing fakers, however. As Solo suggests in another context,[4] let the subsidizing authorities find individuals who seem to want to do artwork, and offer such persons a modest stipend on the condition that they do this work and that they have no income besides the stipend. If the stipend is modest enough, the sharpies will be cut out of the subsidy. Academic tenure in the humanities seems to approximate this program. (But can subsidy improve upon the market in this case?)

The second complication has to do with the resale market for artworks. The question of quality, in this case, is the question of whether the work continues to engage our attention after it has become familiar. Presumably this will be known in time as a matter of experience. Thus, in markets for artwork fine goods may command their full value in the resale market, even if not in the market for newly produced goods. Notice that this is precisely opposite to the case of automobiles in the lemon hypothesis. What we are suggesting here is that an artwork which continues to attract comment over a number of years is not prima facie shoddy and may be purchased with confidence that it is not.

Now take the two complications together, and consider the picture that they paint. We have our artist starving in a garret, selling artwork for a pittance, and the work later being resold for a great deal. Thus, the bohemian stereotype is complete. Perhaps one ought to hasten to add that such agreement between a hypothesis and a popular stereotype—common sense or common prejudice, as the case may be—is not evidence. No evidence has been presented. Our purpose has been rather to demonstrate that the lemon approach can generate a wider

range of hypotheses of interest for understanding the position of the arts in society than can the kind of economics which ignores information asymmetry.[5]

Before leaving our two complications, though, let us consider a policy implication which may help to establish the interesting character of the hypothesis. It has been proposed to revise property rights in graphic artwork in such a way as to give the artist a share in capital gains from resale of the work. The second complication offers a rationale for such a revision of property rights. Suppose that the seller has a 50 percent share in capital gains, if they are positive, and that fine goods are resold, after some lapse of time, for the $20 consumer value. (Perhaps they are sold to settle the original purchaser's estate.) At an original purchase price of $10, the capital gain is $10, and the sum, $15, is enough to bring forth a supply of fine goods. Thus, we have the equilibrium at point *e* in Figure 6. In this equilibrium one-third of the output is fine (genuinely pattern-complex) goods, and so the revision of property rights brings forth some fine goods in a situation which would otherwise yield none.

It should be stressed that this discussion does not demonstrate that such a revision of property rights is desirable, nor that the market for pattern-complex artworks is a market for lemons. Rather it admits these cases as possibilities. Thus it would permit us to submit these policy proposals and hypotheses to analysis and test within economic theory. This seems to be a step forward.

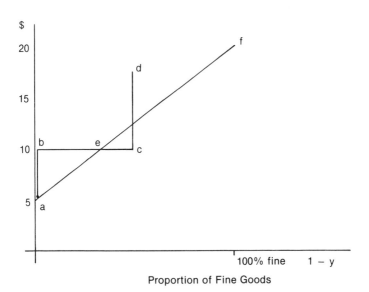

Figure 6. *Proportion of Fine Goods When Artist Shares in Capital Gain*

CONCLUSION

The literature on markets for lemons admits of a wide range of hypotheses which have no place in other, more conventional forms of economic theory. These hypotheses have to do especially with the economic determinants of quality, a matter of some interest for the economics of art. Pursuing this thought, we find that there are some grounds for suspecting that the market for pattern-complex art may be a market for lemons. This hypothesis in turn suggests a possible rationale for the subsidy of pattern-complex art, suggests some reasons why art which is notably unremunerative to its producers may later be very valuable, and suggests a rationale for some proposed revisions of property rights aimed at remedying this problem. In short, the lemon model seems to speak to issues of interest in the economics of art.

Notes

1. For example, see G. A. Akerlof, "The Market for 'Lemons': Quality Uncertainty and the Market Mechanism" (1970); J. Salop and S. Salop, "Self-Selection and Turnover in the Labor Market" (1976); S. Salop and J. Stiglitz, "Bargains and Ripoffs" (1977); and M. Spence, *Market Signaling* (1974).
2. I have dealt with this at more length in "Comment on Lancaster" (1978).
3. See R. A. McCain, "Reflections on the Cultivation of Taste" (1979).
4. See "Economic Organizations and Social Systems" (1967). Solo's proposal is for subsidy to basic research which, in addition to the lemon problem, is a public good. Thus, there is no possibility of market provision in Solo's case. Here again we come across a contrary strain in Galbraith's thought: in his list of ways in which an organization can mobilize individual efforts, he neglects to mention the possibility that an organization might subsidize people in order to free them to follow their own inclinations. It is not as if this were a novel possibility: the church has used it for hundreds of years. See Galbraith, *The New Industrial State* (1971, pp. 138–9). What seems to be missing in Galbraith's thought on this topic is any realization that work can be a source of satisfaction in itself.
5. My colleague, W. Lynn Holmes, suggests that this is a disadvantage rather than an advantage. A more general theory is only to be preferred if the less general theory is wrong, and there is, as yet, no evidence on the point. In the light of this quite valid argument, it seems best to indicate my methodological grounds for wanting a more general theory. First, the absence of evidence does not warrant any assumption that the less general (textbook) theory is correct. Second, experience teaches us that rival theories are not tested against one another until they are resolved as special cases of a single overriding (general) theory. In the terms of econometrics, the hypotheses to be tested must be nested ones. The merit of the lemon hypothesis, as I see it, is that it nests textbook theory along with many other hypotheses, some of which have never been formalized but express only someone's "common sense."

References

Akerlof, G. A. 1970. The Market for "Lemons": Quality, Uncertainty, and the Market Mechanism. *Quarterly Journal of Economics* 84 (Aug.): 488–500.

Galbraith, J. K. 1971. *The New Industrial State*. 2nd. ed. New York: Mentor.

McCain, R. A. 1978. Comment on Lancaster. In *The Economics of Information*, Leiter and Galatin, eds. New York: Cyrco Press.

———. 1979. Reflections on the Cultivation of Taste. *Journal of Cultural Economics* 3, no. 1 (Spring): 30–50.

Salop J. and Salop, S. 1976. Self-Selection and Turnover in the Labor Market. *Quarterly Journal of Economics* 90, no. 4 (Nov.): 619–627.

Salop, S. and Stiglitz, J. 1977. Bargains and Ripoffs. *Review of Economic Studies* 44, no. 138 (Oct.): 493–510.

Spence, M. 1974. *Market Signaling*. Cambridge, Mass.: Harvard Univ. Press.

Scitovsky, T. 1976. *The Joyless Economy*. New York: Oxford Univ. Press.

Solo, R. A. 1967. *Economic Organizations and Social Systems*. Indianapolis: Bobbs-Merrill.

Comment
Adrian Kendry

Professor McCain's paper constitutes an interesting attempt to escape from the modes of analysis that are customarily employed in the economic analysis of the arts. By focusing upon the literature of the last decade that deals with asymmetric, imperfect information, McCain wishes to demonstrate that various pathological cases have a relevance for the understanding of the economic condition of the arts. Furthermore, he argues that such cases may provide a foundation for the mutual comprehension (among investigators and practitioners) of the problems of the arts, particularly the need to treat the market for art as a "special case." A substantial body of literature examines the special case arguments for art in terms of market failure and the public goods and/or merit goods characteristic of artworks. McCain is clearly aware of these arguments, but, perhaps disappointed by their lack of forcefulness or concerned about their efficacy in times of public sector retreat, he prefers to advance various propositions about another type of failure in the market for art—information failure.

The major theme of the paper is that the market for artworks suffers from information failure and (in no sense an automatic conclusion) some agency intervention is required to correct the deficiency in the output of "fine" goods (that which McCain refers to as pattern-complex art). Although there are other issues which are considered by the author, this is the crux of the paper and it needs to be scrutinized carefully.

As the author points out, Scitovsky draws upon pattern complexity as *one* of the dimensions of art. To relate art quality to pattern complexity is to skim rather adroitly over the muddy waters of aesthetics and the philosophy of the arts. Most economists (the present writer included) stay well clear of these intricacies, but it

would be naive to pretend that the formal, structural (supersign formation) approach to art appreciation is uniquely valid. Art may be valued because it is a medium of emotional communication, a vehicle for stimulating the senses. Appreciation of a work of art may require contextual information (for example, a knowledge of the limitations of scoring for brass in the composition of symphonies in the eighteenth century). Thus, it is not clear that quality in markets for artwork is necessarily to be associated with pattern complexity alone.

Supposing that we accept pattern complexity as a means of distinguishing the spectrum of art quality, why should the market exhibit information failure? McCain contends that naive buyers may be unable to differentiate between pattern-complex and bad art. Now in an economy where a direct transaction takes place between the artist and the buyer, this may indeed be a problem. But in a system where exchange of this kind is likely to be in the market for comparatively pattern-simple art (for example, buying a seascape on holiday) or is repeated through commissioning, the problem does not seem a serious one. Pattern-complex art is more likely to be traded through some intermediary (such as an art dealer), who will presumably employ various screening procedures before deciding whether to accept a piece of work for potential sale. One might acknowledge the sinister possibility that a dealer would elevate a "bad" work in order to share in the short-term (or even long-term) benefits arising from its sale, but the screening mechanisms that exist at various levels of control (for example, licensing, gallery expertise, critical reviews) should discourage such practice. Since cultivation of taste for pattern-complex art will reside in the hands of the media and experts, it is equally conceivable that "good" pattern-complex art will be misrepresented as "bad." As the author remarks, there are many examples in the history of the performing arts illustrating the inability of consumers to appreciate and understand a composition initially. Perhaps more important is the fact that on many of these occasions the cognoscenti's distaste (and sometimes disgust) was even greater. I conclude that, notwithstanding the examples posed by the author, it is not self-evident that signaling and screening procedures will be unable to prevent misrepresentation; a more serious problem might be underrepresentation of artworks.

Even if these arguments are ignored, the intervention of some agency to correct "failure" in the market for complex art raises the question posed by the author: "why should the subsidizing authority be better able than potential buyers to distinguish obscure advanced art from obscure bad art?" No answer is offered to this question, and perhaps none can be forthcoming. (It would be easier to answer this question if "ideologically" were inserted after "obscure.")

Comment
V. N. Krishnan

Professor McCain's attempt to use the "lemon" phenomenon case as a spring-board for exploring further hypotheses for testing behavior in the art market is commendable and interesting. He stresses that imperfect information would influence sellers' attempts to suppress quality and buyers' preferences to seek protection, with the lemon phenomenon enacting a kind of Gresham's law.

The particular case cited deals with measuring costs of dishonesty in business. For the purchaser the cost is the amount by which he is cheated. The author's numerical examples showing this are not very clear. The problem with the competitive case is to know where the marginal cost for art originates. What will be the lowest point of the average variable cost curve to trace the rising marginal cost curve as supply? If shoddy goods are priced at $5, how can we know that the supply is zero below a price of $10 without examining the average variable cost? In the possible monopoly case, while the cost to business is considered, the treatment of cost to the purchaser needs to be further explained. What role would guarantees, service contracts, and certification play in art? Can an artwork be repaired, replaced, or otherwise serviced? It seems to me that the case of lemons was meant to apply initially, at least, to the specific types of market transactions mentioned above, and the author has not fully addressed himself to this problem. To rely on Scitovsky's pattern of complex art is to oversimplify the problem of identification of a demand curve in the art market. To begin with, a distinction has to be made among art schools, art styles, and art objects. This is not to say that the lemon phenomenon cannot be taken seriously, as the author has tried to show that it can. But it may well lead to an identification of some special cases in art.

Art Collections in
Seventeenth Century Delft*

J. M. Montias

I N MID-SEVENTEENTH CENTURY DELFT, perhaps two-thirds of the population, estimated at 30,000 inhabitants,[1] lived in households possessing paintings.[2] All in all, as many as 40,000 to 50,000 paintings hung in the city's 4,000-odd houses at the time. I doubt whether 100 of the paintings are left in Delft today. Some found their way into museums and private collections outside of Delft. Almost all the cheap ones, which cost a few *stuivers* when they were first bought, have disappeared, burnt in fires or thrown away with the rubbish when they were no longer worth keeping, before they had acquired the value of age and scarcity conferred on even the poorest daubs.

DELFT INVENTORIES

The inventories preserved in notarial archives and in the estate papers of the Orphan Chamber are the only records left of these tens of thousands of pictures. Even though only a minority of inventories and estate papers have survived, there are still enough of them left to form a fairly good impression of the range and contents of contemporary collections. More importantly, there is enough evidence to trace changes in the makeup of collections in the seven decades spanning the period 1610 to 1680 that mark the rise, the apogee (in the 1650s and early 1660s), and the decline of the Delft school of painting.[3]

The analysis of 1,191 inventories from 1610 to 1679 forms the core of my paper. I have classified all paintings itemized in these sources by artist and subject to the extent that they were attributed and their subject was described. In addition, for all inventories based on auction sale records or on assessments, I have

*The complete manuscript from which this paper is excerpted will be published in the author's forth-coming monograph, *Artists and Artisans in Delft in the Seventeenth Century: A Socio-Economic Analysis.*

noted the price of all artworks, including prints and sculptures, and have computed their share in the total value of movable goods sold, assessed, or appraised. This close study of a relatively large sample of inventories yielded, as a by-product, some observations on contemporary connoisseurship and on the changing character of collections through time. A summary of these results is contained in the next section.

Unfortunately, I cannot claim that my sample of nearly 1,200 inventories is either exhaustive of all the inventories that have come down to us in the protocols of notaries or in the estate records of the Orphan Chamber or even that they represent an unbiased sample of the entire population of these inventories. My "data base" for all decades except the 1640s is perhaps best described as a 20 to 25 percent sample of all extant *contracedullen* and inventories significantly biased toward the upper end of the wealth distribution. The data overrepresent inventories with attributed paintings, since I systematically recorded all inventories that I came across containing attributions. For the decade of the 1640s, I initially sampled 97 inventories (as I did, more or less, for the other decades) and then combed through all surviving notarial records for inventories of movable possessions, whether or not they contained works of art. As a result of this search, I was able to add 345 inventories to my original list of 97.

The supplementary list increased the number of paintings in my original sample two-and-a-half-fold but only contributed 80 percent more "titled" paintings (those whose subject was in any way described) and less than one-fifth as many attributions as the original; 20 percent of all inventories in the new sample contained no paintings at all.

The low incidence of titles and especially of attributions in the second sample is, of course, a reflection of the bias toward richer inventories in my first sample. I would venture to guess that my samples for the decades of the 1620s, 1630s, 1650s, and 1660s covered between a quarter and a half of all titled paintings and 70 to 80 percent of all attributions in extant inventories. These samples, ranging from 119 to 187 inventories per decade, give an adequate representation, in my view, of the attributions in inventories that have survived.[4] With regard to subject matter, the samples for these decades are satisfactory only for the study of broad trends in major categories. My samples for the years from 1610 to 1619 and for the 1670s are even less adequate: the first, because few inventories are left dating from this period, due in part to the Town House fire of 1618, which destroyed most Orphan Chamber estate papers; the second, because I did not exploit all the notarial records of the late 1670s.

The samples I collected may be biased because of two types of nonrandom gaps in coverage. First, it is likely that many of the original collections—particularly those of the poorer strata of citizens—were never notarized in the period covered by this study. Second, many inventories described in contemporary notarial records have disappeared. Data on death rates and number of households, as well as the names of contributors to the Chamber of Charity (*Camer van Charitate*), can provide insight into the extent of these biases.

All these statistics confirm the serious bias in my original sample of inventories dated in the 1640s in the direction of individuals with above-average wealth,

which was largely but not fully corrected by the additional sample. The bias for the other decades was probably roughly comparable to that in the original sample for the 1640s. Extrapolating these comparisons to the 1620s, 1630s, 1650s, and 1660s, I would venture to guess that the individuals whose inventories I noted may have been about twice as wealthy as the average inhabitant of Delft with a separate household. What this implies for my analysis of paintings by subject and by artist is that I collected far too few inventories with no paintings at all and far too many with attributed paintings, as compared to a truly representative sample. These defects notwithstanding, a sample containing perhaps 70 to 80 percent of all the attributed paintings in extant inventories should still have considerable value for the study of artworks collected in Delft.

Table 1 summarizes the information available in the inventories. Price data, consisting chiefly of the records of auctions, sales, and estate appraisals, together with a few transfers, sales, and records of possessions held as collateral for debt, were available for a little over half of the total sample collected in all decades.

If we do not take into account, for the moment, the additional sample of inventories collected for the 1640s, we find that the percentage of the total number of inventories containing attributed paintings and the percentage of attributed paintings in the total number of paintings listed in the 1640s and 1650s increased dramatically compared to the 1620s and 1630s. These percentages seem to decline moderately in the 1660s and 1670s.

I am confident, despite the varying size and the biased character of the samples in each decade, that the increase in the relative importance of attributed paintings in the 1640s and 1650s represents a real phenomenon. My argument for the plausibility of this increase rests on my earlier claim that these samples probably covered some 70 to 80 percent of all extant inventories with attributed paintings. (Recall the small percentage of attributed paintings in the additional sample for the 1640s.) The decline in the 1660s and 1670s, however, may be due to sampling fluctuation.

If my surmise is correct that notaries and their clerks became distinctly more conscious of the importance of appending an artist's name to a painting in the 1640s and 1650s, this represents a significant change in attitude toward the painted objects described in inventories. There is no greater step in the metamorphosis of craft into art than the recognition that an object is the unique creation of an individual and that its worth to potential amateurs will depend, at least in part, on the information they have about its maker. It is remarkable that makers of furniture and silverware, with no known exceptions in the case of Delft-based artisans, remained anonymous in inventories during the period, apparently unable to gain recognition as artists transcending their craft.[5]

RESULTS OF THE ANALYSIS OF INVENTORIES

Paintings represented by far the most numerous and valuable works of art in Delft inventories; yet sculptures, pen drawings, prints, needlework and embroidery pictures, and other types of decoration at the limit between art and craft were by no means rare. Sculptures are almost never attributed. Coats of arms (*wapen*)

Table 1. *Summary of Information Available in the Sample of Delft Inventories*

| | Number of Inventories in Sample | Number of Inventories with Price Data | Number of Inventories Containing any Attributed Paintings* | Total Number of Paintings* | Number of Paintings Itemized by Subject* | Number of Paintings Attributed** |
|---|---|---|---|---|---|---|
| 1610–1619 | 49 | 30 | 1 | 536 | 473 | 110 |
| 1620–1629 | 147 | 93 | 10 | 2,016 | 1,225 | 178 |
| 1630–1639 | 140 | 98 | 21 | 2,290 | 1,338 | 159 |
| 1640–49 Original sample | 97 | 61 | 42 | 2,155 | 1,226 | 392 |
| Additional 1640–49 sample | 345 | 77 | 10 | 2,905 | 968 | 68 |
| Total, 1640–49 | 442 | 138 | 52 | 5,060 | 2,194 | 460 |
| 1650–1659 | 185 | 106 | 58 | 3,612 | 1,802 | 487 |
| 1660–1669 | 119 | 70 | 48 | 2,509 | 1,566 | 362 |
| 1670–1679 | 109 | 68 | 30 | 2,304 | 1,025 | 225 |
| Total, 1610–1679 | 1,191 | 603 | 220 | 18,327 | 9,623 | 1,981 |

*Including pen drawings

**Including monogrammed paintings

Source: Delft Municipal Archives, notarial protocols and estate papers of the Orphan Chamber.

are common objects in inventories. Some of them were sculpted, others painted; but they are usually not described in sufficient detail to tell which were painted and which sculpted. Similarly, most alabaster boards or slabs were probably painted—some of them with only a losange (*ruytgewys*) design—but others were probably incised in low relief. Again there is no way to tell which was which. All armories and alabaster boards are included in the total value of works of art in my statistical analysis (but not in the breakdown by subject).

If we can judge from the contents of inventories of the 1610s and 1620s, almost all the better-off households had at least one or two sculptures. Later their number seemed to decline. In any case, they were never appraised or sold for more than two to three *guilders*, and they represent only a very small fraction of the value of works of art in collections, either at the beginning or end of the period.

Pen drawings, especially of ships (a genre made popular by Willem van de Velde the Elder, but also frequently practiced by Delft artists), are listed fairly often in inventories. Red chalk drawings are less frequently cited. Prints are found in all types of households, from the humblest to the richest. They may have served as decoration, as religious symbols, or even as a source of subject matter for certain draftsmen. A few wealthy, artistically inclined individuals collected them, often together with drawings, in portfolio volumes for their own sake; in such rare cases they are identified by the artists who created them.[6]

In auction sales anonymous prints were rarely valued above a few *stuivers* apiece (for example, "14 prints for 30 *stuivers*" in the van der Lande inventory). The most valuable prints were actually maps that were hung on walls either in frames or on rollers. These maps, which are never attributed, typically cost 15 *stuivers* to 2 *guilders*. I have included prints and maps in the value of works of art contained in inventories sold or estimated but not in my sample of paintings classified by subject and artist.

At the limit between craft and art we find an occasional paper cutout or a framed leather pattern (for example, "2 *gelyste goude leeren*") (Orphan Chamber 1624). We also encounter in many inventories "written panels" (*geschreven borts*), some of them with the Ten Commandments or with Salomon's prayer.[7] It is often impossible to tell whether a "Ten Commandments" (*een tien gebode*) is a painting representing Moses with the Commandments or a written board or possibly both—that is, a list of the Commandments inscribed in a picture of the story of Moses. Specimens of fine calligraphy (many made by the Delft schoolmaster Felix van Sambix) are also to be found, normally hanging on the wall and framed. All these written boards and decorative writings are included in the value of the artworks contained in inventories but not in my breakdown by subject (unless they are suspected to be actual paintings). Decorated clavecins are sometimes recorded in the possessions of wealthier individuals. In a rare instance where the clavecin was decorated with a specific subject ("a naked scene of Venus and Adonis") (Orphan Chamber 1638), I have chosen to include it in the breakdown of paintings by subject; however, musical instruments such as these are normally omitted from the value of artworks, as well as from the subject breakdown.

A SUMMING UP

The relatively large sample of inventories I have sifted through in preparing this paper is biased toward the upper end of the distribution of household wealth (though much less so than the inventories of paintings that have been published by Abraham Bredius and other specialists in Dutch art of the period). Despite this upward bias, I was still able to draw certain conclusions grounded on the following line of reasoning. Inventories below the median of the sample distribution of inventories of movable goods—531 *guilders*—contained mainly "work-by-the-dozen," paintings costing a *guilder* or two apiece. If the median price of the entire population of Delft inventories was, say, 250 *guilders*—a reasonable figure[8]—this would imply that the vast majority—perhaps two-thirds—of all inventories consisted more or less exclusively of such products by artisans. The bulk of works by master painters would be found in the top third of the (unbiased) wealth distribution (say, above 500 *guilders*). But even inventories of movable possessions worth 500 to 1,000 *guilders*—the range in which we would find the estates of most handicraft masters, from builders to weavers—would normally contain very few paintings costing more than 5 to 10 *guilders* apiece, for which one could buy a Vroomans, a small Bramer, or a Nicolaes Vosmaer, corresponding to the lower range of paintings by guild masters. Most of the paintings that hang in museums today—the van Goyens, the Vermeers, the Rembrandts, the Fabritiuses—would have been owned by merchants, book printers, successful innkeepers, notaries, and patrician rentiers with inventories starting at 1,000 *guilders* but most frequently in the range of 3,000 to 10,000 *guilders*. The fact that the "wealth elasticity of works of art" was above unity only in the class of citizens whose wealth was above the sample median also suggests that serious collectors were in the upper range of this group.

These inferences allow me to speculate on two contemporary stereotypes about the market for Dutch art in the seventeenth century, the first claiming that most Dutch houses were "full of paintings" and the second that "most of Holland's painters no longer worked for a few patrons but were dependent on shopkeepers, bakers, butchers, and even peasants, roughly the same stratum of society into which most painters were themselves born" (Swart 1975, p. 47).

The first assumption, sometimes based on a broad interpretation of an entry in John Evelyn's diary in which he marveled at the abundance of paintings in the houses of Dutch people and particularly of peasants (cited in Floerke 1905, p. 20), has limited validity, at least for Delft. Most poor households—the houses of the apprentices and the journeymen who made up a majority of the population's wage earners—possessed few if any paintings. Inventories in the 50 to 150 *guilders* range contained anywhere from one to ten small boards of very little value. At least a third contained no paintings at all. French and English visitors to Holland (for example, B. de Monconys, René Descartes, Sir William Temple, and Evelyn), who themselves were from the nobility or from the high bourgeoisie, had little opportunity to visit poorer houses. Their impression of the relative

abundance of paintings in Holland—compared to their own country—was probably correct, but it was exaggerated due to the bias in their observations.[9]

The second stereotype, which places artists in the same lower-middle-class stratum as most of their clients, is also misleading, if not totally false. I argue in another paper that the fathers and wards of artist-painters in Delft were either of upper-middle-class background (notaries, merchants, and so forth) or, if they were artists, artisans, or tradesmen, they were all guild masters in their craft and hence belonged to the upper half of the wealth distribution (Montias forthcoming). I would conjecture that the inventories of movable possessions of virtually every such father or ward living in the period from 1620 to 1680 would have been valued in excess of 800 *guilders*. As I have tried to show, the buyers of these artist-painters' works were mainly in the top third of the wealth distribution. A few clients, doubtless, were (master) "bakers and butchers,"[10] but the majority belonged to higher-status occupations.

Concerning the contents of inventories themselves, I found that the subject matter of the paintings collected underwent a gradual but profound change in the course of the century. Religious and mythological "histories," as well as allegories, receded in importance; landscapes, which gained most of the ground the histories had lost, were gradually shorn of their earlier religious or otherwise symbolic significance.[11] I take these trends to be evidence of the secularization of Dutch, or at least of Delft, society after it had recovered from the religious turmoil of the half century preceding the Synod of Dordrecht (1618), but also of a turning away from the humanistic preoccupations of the previous century. A landscape, a still life (without manifest symbols), or a "society piece" may well have been more interesting to look at and easier to live with by 1660 than an "Esther Before Assuerus," an "Allegory of the Broad and the Narrow Way," or a "Diogenes."

Finally we come to the apparent provincialism of Delft collectors who concentrated their purchases on paintings by Delft-based artists, the most popular of whom are now judged to have been inferior to their best out-of-town competitors (for example, in the painting of woods and streams, Pieter van Asch from Delft compared to Salomon or Jacob Ruysdael from Haarlem). Was Delft more inward turning than other cities? Only a systematic comparison of attributed artworks in inventories in Delft and in other cities of more or less the same magnitude (Rotterdam, The Hague, Utrecht, Haarlem) might be expected to supply an answer to this question. My preliminary guess, based on published inventories in these other cities, is that Delft was not atypical in this regard. Most collectors in Holland were inclined to buy works from local artists because they knew them personally, because they had seen their works in public places or in their fellow citizens' collections, or simply because these artists were better able to adapt their products to the town's tastes and fashions. To some extent also, the Guild of St. Luke placed restrictions on sales by out-of-town painters that added to the cost and trouble of securing their works. Last but not least, civic pride—at a time when the cities of the United Provinces were largely autonomous—helped steer local demand toward the artists who spread abroad the fame of their city.[12]

Notes

1. Estimated from the population count of 1622 (22,765 inhabitants) on the assumption that the population increased in proportion to the number of deaths from the early 1620s to the 1640s.
2. In my sample of 443 Delft inventories of household possessions dated in the 1640s, 80 percent of the households contained one or more paintings. I have made an approximate adjustment to take into consideration the underrepresentation of the poorest households in the sample.
3. In my article "Painters in Delft, 1613 to 1680" (forthcoming) I have sought to give a statistical overview of this evolution.
4. The slightly larger percentage of attributions in these decades than in my original sample for the 1640s is due to the fact that I made a second search for inventories with attributions in these other decades—less systematic however than for the 1640s—which enlarged my original samples by 20 to 30 percent in the different decades.
5. In a few inventories the mark or the initials of the silver- or goldsmith are reproduced. But this seems to be more a matter of authenticating the object as having been made by *some* registered silver- or goldsmith than of throwing into relief the name of a particular maker.
6. For example, the inventory of Dr. Johan Hogenhouck includes portfolios of prints and drawings by Goltzius, Claes Moyaert, Esias van de Velde, "Bolonge" (Belange?), Francois Perier, and other artists. Orphan Chamber (1648).
7. "*Een borritge daerinne geschreven 't gebedt Salomonis*" (Orphan Chamber 1641). Such a board may be seen in the background of Jan Steen's "Portrait of a Boy Writing."
8. I suggested earlier that the average wealth of households in my entire sample of inventories might be about twice the average wealth of all households in Delft.
9. John Evelyn is also frequently quoted to the effect that the Dutch were given to speculating in artworks on a broad scale in the first half of the seventeenth century. Unfortunately, I have found nothing in my analysis of inventories and of notarial depositions regarding purchases and sales of works of art either to substantiate or to impugn the validity of this observation.
10. It is well known that the baker Hendrick van Buyten bought a number of Vermeer's paintings at high prices. But it is only recently that information has come to light showing not only that he was at one time a headman of the bakers' guild (most of whom were fairly well off) but that he had inherited considerable amounts of money which he lent out at interest. He died a rich man.
11. It might be added on the basis of visual rather than archival evidence that in the course of the century still lifes were gradually emptied of their spiritual content (cf. the vanitas paintings of Pieter Claesz. versus the displays of finery—"pronk" still lifes—of Willem Kalf).
12. Pride in the painters of Delft is a conspicuous feature of Dirck Evertsz. van Bleiswijck's *Beschryvinge der Stadt Delft* (1667, especially pp. 850-857).

References

Evertsz. van Bleiswijck, Dirck. 1667. *Beschryvinge der Stadt Delft*. Delft.
Floerke, H. 1905. *Studien zur Nederlandischen Kunst- und Kulturgeschichte; Die Formen des Kunsthandels, der Atelier und die Sammler in den Nederlanden vom 15–18 Jahrhundert*. Munich and Leipzig: BlutWurst Press.
Montias, J. M. forthcoming. Painters in Delft, 1613 to 1618. *Simiolus*.
Orphan Chamber. 1624. *Boedel* no. 1526 III. Dec. 13.

_____ . 1638. *Boedel* of Lieven Pieckius. No. 1313. Apr. 27.

_____ . 1641. *Boedel* of Jan Brouwers. No. 214. Jan. 30.

_____ . 1647, 1648. *Boedel* no. 810 I. Apr. 3, 1647 and May 16, 1648.

Swart, K. M. 1975. Holland's Bourgeoisie and the Retarded Industrialization of The Netherlands. In *Failed Transitions to Modern Industrial Society: Renaissance Italy and Seventeenth Century Holland*, F. Kraut and P. M. Hobenberg, eds. Montreal: Inter-University Center for European Studies, Concordia Univ. and Univ. du Quebec à Montreal.

Comment
Ina Stegen

To provide insight into the nature of Delft art collections in the seventeenth century—when it can be estimated that as many as 40,000 to 50,000 paintings hung in the city's 4,000-odd houses, of which probably not even 100 paintings are left in Delft today—and to classify these pictures according to subject matter and value would seem a nearly impossible task. Montias has approached it by a systematic examination of notarial archives and estate papers, never leaving us in doubt that even the 1,191 inventories from 1610 to 1679 which he has investigated are only a 20 to 25 percent sample of the existent records and that, furthermore, they constitute only a fraction of those that once existed. He is careful to point out that his sample tends to overrepresent the wealthier households, and he takes this fact into consideration in his conclusions. Since classification according to subject matter is an important part of his paper, Montias has also pointed out his difficulties here, which were often due to ambiguous descriptions.

It is true, as Montias states, that only similar research undertaken in other Dutch cities could conclusively determine whether the Delft situation was typical of all of Holland. Still, his conclusions in terms of the distribution of pictures at different income levels, the preferred subject matters, the value of artworks in terms of skill rather than ingenuity, and the appreciation or lack of appreciation of the artist as an individual genius all confirm generally accepted conclusions about Dutch seventeenth century painting which art historians have made on the basis of extant pictures. This is to suggest that Montias's findings on Delft are likely not to reflect particular local circumstances but clearly relate to the Dutch situation in general.

Although Montias does not mention anything about public patronage in Delft, he investigated this question in another paper and found that it was negligible. This corresponds to the Dutch situation in general. Neither the Princes of Orange nor the *stadtholders* are art patrons of any consequence in the democratic Nether-

lands. The other important public sponsor, the church, disappears with the dominance of the iconoclastic austerity of Calvinism. As a result, in the midst of the court culture of absolutist and Roman Catholic Europe we find in the Northern Provinces an island of bourgeois art in which the small easel painting that easily relates to one's own personal sphere of life becomes the preferred artwork.

Is this development of a "private art," in which for the first time the most private sphere of all, the home life and work of the woman, becomes a central theme, a sign of a new democratic consciousness, of self-realization of the individual, a kind of prerevolution egalitarianism? This would hardly be in correspondence with the motivation for the insurrection against Philip II, as a result of which a republican and Protestant society was established in the Northern Provinces. It has been pointed out that this was rather "a revolution of conservatives" who were defending a medieval concept of regional self-government against a progressive, centralized, and absolutist concept. Their middle-class outlook was inherited from the late Middle Ages and certain aspects of their artistic preferences may well originate in the same period.

If we examine, for example, the origin of those subjects whose increasing popularity Montias has observed, we can, in fact, find them in the paintings of the fifteenth century Flemish masters. The artists of that period had reflected their middle-class outlook (or that of their patrons) by placing traditional religious subject matter in a familiar setting, such as Joseph in the local carpenter's shop; the Baptism in a familiar landscape; the Annunciation in a Flemish living room filled with meticulously rendered inanimate objects, flowers, and, again, a view into a recognizable landscape.

Certainly another characteristic of Flemish fifteenth century paintings (like those of the seventeenth century) was the fact that they were "well painted," that is, reality was rendered as meticulously as possible. As we know, the employment of oil painting by van Eyck and his contemporaries had an important share in this development of detailed realism which seems to have delighted their patrons in finding the reality they knew so perfectly represented.

Given these similarities between the late medieval period and the seventeenth century situation and the way they seem to parallel political attitudes, I suggest that both the preference for familiar subject matter and the concern with the realistic picture are less a conscious advance of democratic thought than a result of isolation and conservatism. Montias points to such attitudes in Delft society as characteristic of Dutch society of that period in general.

While the results of Montias's paper are to me most interesting viewed in terms of the historical context and the connection between sociopolitical structures and the attitudes to the arts to which they point, a number of other observations can be made. One is the apparent parallel between seventeenth century Delft and contemporary middle-class Western society in the distribution of pictures of different value—by-the-dozen work, unattributed and attributed paintings—according to the different income groups. Today the place of Delft copies and by-the-dozen work might well be assigned to photographic reproductions and decorative objects of little artistic merit (I avoid the word "kitsch," although I am tempted

to use it) which, as we know, tend to be most frequent in lower-income homes. At the middle-class income level we might still find some of these, but we would also find more originals, which more often than not are chosen because of their subject matter (still lifes, flower pieces, and landscapes have remained favorites) and their relatively realistic rendering, not because of the artist.

Finally, if we try to draw parallels between seventeenth-century Dutch and contemporary patterns of art patronage, wouldn't it be interesting to take a sample of Delft household inventories today and see if any similarities could be found in terms of the percentage of artworks among the total of movable property and the value and authorship of artwork at different income levels? I wouldn't be surprised if such similarities existed.

Determinants of Arts Demand: Some Hypotheses, Evidence, and Policy Implications

〜〜〜〜〜〜〜〜〜〜〜〜〜〜〜〜〜〜〜〜〜〜〜〜〜〜〜

Sonia S. Gold

T HE INADEQUATE ANALYTICAL and data foundations of arts policy affect a wide range of policy issues, but they seem to be especially severe with respect to demand. The unwelcome reality is that our understanding of the factors which function as *determinants* of arts demand is still severely limited. Recognition of this problem does not seem to be widespread nor is its correction regarded as urgent.

The ideas to be examined herein are organized on the basis of a four-way classification: (1) those which involve broad generalizations about the impact of the culture and the economy on arts demand, specifically, the work of Scitovsky (1972, 1976) and Linder (1970); (2) those which find a link (however tentative) between arts demand and personal attributes, such as age, income, education, occupation, and ethnic and racial affiliation, the work of Baumol and Bowen (1966) serving as prototype; (3) those which stress supply influences on arts demand such as previous exposure and continuing access, availability of substitutes, and so forth; and (4) those which emphasize the highly specific nature of the product—character of programming, exhibitions, and so forth.

CULTURE AND VALUES AS DETERMINANTS OF DEMAND: THE SCITOVSKY THESIS

Scitovsky presents two explanations for underinvolvement in the arts in the United States: (1) the Puritan ethic, which, because of its prowork, antipleasure bias, regards the arts as trivial or pernicious or both; and (2) a psychophysiological mechanism which requires each individual to find a balance between comfort and stimulus-seeking behavior, with the result that, unless offset by powerful cultural influences, the choice is biased in favor of psychological or physical ease rather than the stimulus of the arts, which demands intellectual, emotional, or other effort. These two central propositions yield a very pessimistic outlook for arts

demand in the short run, since the fundamental cultural and value changes are likely to be achieved only over longer time periods.

How can we reconcile Scitovsky's emphasis on the lingering effects of Puritan attitudes with the views of others who see contemporary society as increasingly hedonistic and biased in favor of leisure activities? Also, how can we determine what activities are "pleasurable," "comforting," or "stimulating" except in terms of subjective valuations? Can we automatically assume that individuals not involved with the arts are averse either to pleasure or stimulus without knowing more about the entire array of options considered and choices made?

Some may have chosen an activity which is to them more stimulating and challenging than arts activity—for example, skiing. The choice could represent a preference for "doing" versus "listening or looking," or for outdoor activity to offset sedentary work. For those who indulge their arts preferences, what activities were foregone? Was attendance at a concert chosen in lieu of reading? Only cross-sectional studies, which include subjective valuations and specific choices within the context of total leisure–nonleisure choices can provide answers. Moreover, since subjective valuations are likely to change over the individual's life cycle, longitudinal studies are necessary. In the interim it seems risky to impute valuations, even as a matter of expert judgment.

Do per-capita or aggregate expenditure data on the arts reveal cultural values in the country as a whole? Given the centralizing tendencies in the location of arts activities, much of the U.S. population is bereft of opportunities to patronize the arts and, hence, cannot spend on them. Per-capita expenditures may therefore be seriously misleading as a gauge of values. Moreover, can we ignore the possibility that some nonarts expenditures might yield aesthetic pleasure, as well as utilitarian satisfaction? The automobile and housing exercise strong claims on consumer income in competition with the arts. We do not have empirical information on how individuals and population subgroups view rival claims on personal income, nor which are viewed as serving utilitarian, aesthetic, or recreational needs, or some mixture of such needs. Approximately 6 percent of disposable income is allocated to recreational expenditure. Are we prepared to say what would constitute a more desirable allocation of consumer income to this category by various income groups over the whole range of consumer choices? Within the recreational category, what would be an optimal allocation among various leisure activities? To conduct research that would address this question, it would seem wise not to concentrate on spending in one area—the arts—but to view it within the context of other recreational and nonrecreational choices.

Also, should we not take account of the fact that some cultural activities do not require expenditure? For example, most museums in the United States do not charge admission (except in the case of special exhibits), yet they report soaring increases in visitors. How do we reconcile this enthusiasm with either the Puritan ethic or the preference for comfort over stimulus? Moreover, amateur cultural activity looms large and is a growing sector in the United States. At any rate, we need much more information to decide whether the Scitovsky thesis is a valid generalization.

ECONOMIC GROWTH, SCARCITY OF TIME,
AND CULTURAL ACTIVITY:
THE LINDER THESIS

Linder links economic growth to a pessimistic future for cultural activity because, as economic growth increases incomes and the array of consumption goods, it causes the economic value of time, measured in terms of income and goods yielded per unit of working time, to increase while time to consume this plethora does not increase commensurately. The relative scarcity of time induces increasing "goods intensity" (higher-value consumption per unit of time) and also coerces reallocation of time among five categories—working time, personal work (sleep, self-maintenance, and so forth), consumption time, cultural time (devoted to activities, including the arts, which "cultivate the mind and spirit"), and free time. Except under special circumstances, such as the emergence of anti-growth, proleisure values, Linder forecasts that the likely outcome is encroachment of work and consumption time on cultural and free time.[1]

The Linder thesis assumes a direct causal link between economic factors and time allocations *in the short run*, the economic factor swamping all other influences on time allocations. Is it not possible to conceive of time allocations as the result of a more complex web of reciprocal, interacting influences among a number of factors, rather than the result of a single, direct line of causation? To echo Linder in another context, discovery of the mesh of causal factors influencing time allocations would seem to be best treated as an empirical problem. Cultural activities do compete with other activities for time and expenditure and the critical decision criterion may include "goods intensity," but we do not know that it is the only or most powerful factor affecting the outcome. And it seems unwise to assume so on a priori grounds. Unfortunately, we do not have reliable evidence to establish trends with respect to cultural time and its allocation; therefore, it is not possible to state whether it has increased, decreased, or remained the same. If the question of trend is to be taken seriously, we need some research data on current time allocations as a base from which to track changes in time allocations in the future. The empirical answer, when data are gathered, will depend on the definition of cultural time, and such definition needs to be cast in objective behavioral terms.

Is it not possible to conceive of economic growth combined with increased cultural activity even if work time remains close to present norms and even if material standards of living continue to increase? Economic growth can have a displacing as well as expanding effect on consumption; for example, air instead of train travel is a displacement which saves time and even opens up cultural opportunities not otherwise available. Since an innovation can have a desired time-saving or product-displacing effect, new products which add to the burden of choice are not the only possible outcome of economic growth. Should we foreclose the possibility that working time can be reduced in the future even though it has not changed much in recent decades? Continued growth and productivity increases can be directed to reducing work time and maintaining or even increasing stan-

dards of consumption. Hence, a value revolution which opposes economic growth and consumption is not the only channel for making possible an increase in cultural time.

With respect to Linder's five categories, it is questionable whether they are definitionally consistent with the subjective perceptions of the individual making the time allocations. For example, Linder defines cultural time as that which is devoted to "cultivation of mind and spirit." This austere definition leaves us in doubt about the assignment of purely recreational or entertainment activities—unless some such activities are assumed to have a positive impact on mind and spirit under certain conditions while others are automatically assigned to consumption time. Would not such assignment be inherently unsound, requiring the investigator to judge both the motives of and effects on persons engaged in these activities? Moreover, both motive and effect could differ among individuals and vary for the same individual over time. In addition, many activities involve a mixture of recreational, entertainment, and cultural values, and it may not be possible to separate the strands into dominant and incidental aspects, as Linder suggests.

Should we not also consider the possible emergence of "cultural intensity" (along with the predicted goods intensity) as a factor which heightens cultural experience without requiring increased cultural time? Improvement in urban buildings and public monuments would provide an important source of enhanced aesthetic values which could affect daily life without requiring significant time allocations. Certainly, an interest in enhancing the work environment suggests that boundaries between work time and cultural time can overlap to some extent.

Finally, technology, as part of the engine of growth, can encompass aesthetic values. For example, the great inverted arches in Wells Cathedral in England, now regarded as intrinsic to the beauty of the cathedral, were designed to correct building flaws discovered in the fourteenth century. Should we not extend similar appreciation where warranted to technological performance in contemporary society? For example, in fulfilling a utilitarian purpose, bridge design may also introduce artistic values into the workaday world.

THE EMPIRICAL APPROACH:
THE BAUMOL–BOWEN STUDY

Empirical research to date has provided useful data. Nonetheless, many questions concerning the determinants of arts demand remain unanswered. Using the Baumol-Bowen audience surveys as a prototype, researchers are beginning to collect data.[2] Does this mode of inquiry offer an effective strategy for probing the determinants of demand? The composite profile of the audience is summed up by Baumol and Bowen: "In the main, it consists of persons who are extraordinarily well educated, whose incomes are very high, who are predominately in the professions and who are in their late youth or early middle age" (1966, p. 96). For people who attend live performances frequently these attributes are described as even more pronounced. Moreover, even at free performances well over 50 percent of

the members of the audience are reportedly college graduates who are professionals with a higher median income than the general population (Baumol and Bowen 1966, pp. 96, 93–94). Such a narrow audience profile is undoubtedly disturbing for those arts organizations looking for a broader base of private and public support.

Fifteen years later the profile remains unchanged in its major features. It is astonishing that no continuing (or even periodic) effort to monitor demand has been made, since this kind of information is so patently critical for both private and public arts organizations. Baumol and Bowen argue persuasively that audience studies are needed for several reasons, and their arguments apply not only to marketing policy and other operating decisions, but to the broader concept of demand research: "where merit goods are concerned, we need to know who is deprived; where private and public support is requested, the size and composition of the participating constituency is relevant" (Baumol and Bowen 1966, pp. 71–72). Marketing specialists would insist that effective marketing (and other planning) activities intended to enlarge or reshape the market require information about those who are not responding and about why attendees and nonattendees made their choices.[3] In short, what is needed is a study of the *determinants* of demand, a need which audience survey data cannot serve.

Baumol and Bowen clearly indicate that their audience survey data are primarily descriptive and do not suggest the factors which determine attendance (1966, p. 72). This explicit caveat against converting descriptive findings into explanatory instruments is often unheeded. The temptation to ignore the warning that correlates of behavior are not necessarily causes of that behavior becomes very powerful in situations where policy has to be made and action taken by arts organizations in the absence of knowledge about determinants of arts demand. The temptation will be even stronger for those decision makers who do not understand the analytic limitations of audience surveys. The assumption that audience surveys reveal the determinants of demand may well account, in part, for the neglect of needed research.

EXPANDED RESEARCH FOCUS

The Nonaudience

Audience surveys miss the nub of the arts demand problem, namely, the nonaudience. The identity of present audiences is useful information, but it is completely overshadowed by the fact that a majority of the population with the specified attributes belongs to the nonaudience. Until this can be adequately explained, it must be admitted that the statistical data uncovered in audience surveys merely heighten the mystery.

The blue-collar, lower income, less well-educated attendees are an especially interesting group: they are a minority not only in their own socioeconomic group, but in the arts audience as well. What factors account for their divergent behavior? If less education, lower income, and blue-collar occupations are barriers to

arts participation, what has reduced those barriers for this group? Furthermore, we need to find out if broadening the base of the arts audience is a serious objective of private and public arts organizations. To stress this issue is not to dismiss the possible role of education, income, or other factors in forming a cultural divide, but simply to note the need to study the small group which has exhibited the interest and capacity to cross that divide on occasion, and to assess whether their experience is relevant for the larger blue-collar group.

An experimental arts program sponsored by the National Endowment for the Humanities, state cultural agencies, and the National Union of Hospital and Health Care Employees reflects a pessimistic judgment about the possibility of attracting blue-collar nonattendees to regular arts performances in their normal settings. The program is avowedly based on the premise that the arts have to be brought to this group "where they work and where they live."[4]

Total Work and Leisure Patterns; Subjective Valuations

Most audience surveys are restricted to a questionnaire containing a small number of questions that can be answered quickly. A more complicated instrument is needed to discover and detail the factors determining attendance and nonattendance. Beyond the statistical analysis of patterns of time and expenditure choices, which may allow for inferences about implicit attitudes and values, we need to study directly the personal attitudes and values shaping the choice configuration. Whatever the preference for confining demand research to "objective" phenomena, such as actual expenditure allocations, the subjective-psychological realm lies at the heart of the problem. While the economist's tools have not been designed for this purpose, other social science specialists have developed the necessary skills and experience.

Intensive Analysis of Special Groups

The aggregative statistical results of audience surveys have turned up some interesting but unexplained findings. For example, Baumol and Bowen report that "relative to total population the arts audience is greatest in the interval 20 to 24 years of age" (1966, p. 78). Using a measure of relative frequency (the proportion of the audience in a given age category divided by the proportion of the total population in the same category), they report that "the older the age group, the smaller is its relative representation in a typical audience . . . older people (those over 60) are the scarcest members of the audience in relation to their numbers in the urban population" (1966, p. 79). Here is an empirical finding which needs further research. Are we confronted with an iron law of declining proportionate audience representation for each successively older age group? Why should the relative frequency of representation in the United States fall from 2 in the age group 20–24 and in each age interval thereafter, to 1.55 in the group 45–59, to 0.69 for those 60 and over? The descent in Great Britain is reported to be even steeper—from a relative frequency of 3.45 (20–24), to .93 (45–59), to .32 (60 and over) (Baumol and Bowen 1966, Table IV-D, p. 453). How does one reconcile the findings on the relationship between age and audience with those on the relation-

ship between income and audience? It seems reasonable to assume a positive relationship between increasing age and increasing income.

Several reasons for the sharp drop in audience representation among those 60 and over can be conjectured: geographic relocation to areas without arts availability, physical disabilities, reduced income, changing tastes, and psychological saturation,[5] or combinations of these and other factors. It would be of interest to study behavioral differences between the over-60 attendees and nonattendees (assuming equal access and availability) and to compare their behavior with attendees and nonattendees in other age groups.

Baumol and Bowen, in speculating about why students are infrequent attendees, suggest that it may be due either to the fact that "their studies or their social activities keep them too busy or because they cannot afford to attend very often, though the availability of reduced rate student tickets may cast doubts on the latter explanation."[6] The finding that students are infrequent attendees suggests the need to probe specific findings further: what factors differentiate student attendees from nonattendees and frequent student attendees (if any) from infrequent? We have no reason to expect the determinants of demand to be identical in all subgroups; however, we can define such subgroups in terms of age or any other factor.

THE IMPACT OF SUPPLY ON DEMAND

Supply has to be included among the factors considered as potential determinants of demand. Although the impact of price on demand has received more analytic attention in studies of supply, there are other important aspects of the supply-demand interrelationship.

It is assumed that a potential arts constituency exists which merely requires access to the arts in order to become arts consumers.[7] Reports that some arts organizations are finding a ready response have to be balanced against reports of partial or complete failure to attract audiences. A full and accurate assessment is needed. However, the condition of undersupply (both the absence of opportunity in some communities and the extremely limited supply in others) continues to prevail in much of the United States. If the objective of increasing the availability of the arts throughout the country were earnestly pursued, it is clear that significant supply difficulties and bottlenecks would thwart that objective. The possibility of bottlenecks leads to two questions: (1) what is the potential demand which could be activated by the existing supply, and (2) what proportion of latent demand could be met by supply expansion? Answers to these questions address the issue of whether a condition of under- or over-supply relative to demand (nationally or in particular localities) will be a problem in the future. Since supply problems are not identical for all the art forms, separate analysis of each is necessary.

Illustratively, major museums in the United States are concentrated in a few cities. The addition of smaller, specialized museums and some university galleries improves the geographic spread but does not alter the basic condition. Limited exhibition space does not constitute the critical barrier to the increased supply of

museums, rather, the problem is that museum-worthy art is in inelastic supply. Creation of new museums or an increase in the acquisitions resources of existing museums merely intensifies the competition for the inelastic supply. It is understandable, therefore, that the new Getty museum with its immense resources is reported to have created ripples of anxiety in the museum community. The situation is somewhat eased for museums specializing in contemporary art, since they can augment their collections from the output of living artists or offer temporary exhibits. Cooperative arrangements for traveling exhibits have extended the geographic reach of museum collections, but this arrangement offers limited contact with original work.

If the art of the past is to be made broadly available outside of the major cities, surrogate forms of visual experience should be considered. Despite prevailing attitudes within the arts community, which range from bare tolerance to disdain, good reproductions at reasonable prices are a "second-best" alternative deserving further attention. They provide for the repeated exposure necessary to forming taste. They can create the desire to see the original or provide a means for recalling an earlier visit. Museums could insist on high standards in the reproduction of paintings and casts of sculpture in their own collections. But a denial of the need for reproductions and a refusal to permit reproductions is hard to justify as social policy. A reproduction should be to the visual arts what a recording is to music, an experience which does not duplicate that of a live performance, but provides an extension of the artwork nationwide and facilitates an understanding of it. The interests of orchestras, soloists, and the musical audience have meshed with a progressively improved technical and economic response to provide the surrogate experience in music. A similar cooperative effort is needed in the visual arts.

Although in the case of the performing arts the supply potential to meet a presumed latent demand is less limited than it is for museums, supply constraints do exist. It is not realistic to conceive of the whole country served by a network of performing companies. Surrogate experiences, therefore, appear to be the only means of improving access to opera, ballet, music, and theater. For the performing arts, television (public, network, and cable) appears to offer the second-best opportunity and the only instrument now available for reaching and building a large national audience. Doubts about technical feasibility and artistic value have delayed full-scale ventures, but further technical improvement and growth in the use of the medium are prospective. Therefore, evaluation of the medium should not be based solely on what has been possible to date. The need to resort to surrogate experiences is evidenced by the Baumol-Bowen estimate that only 4 percent of the arts population 18 years and over had some contact with the live performing arts in 1963–64. In response to those who feel that the values of live performance will be destroyed, it does not seem too farfetched to point out the cultural loss to society if contact with Homer's epic had been limited through the ages to those fortunate enough to hear it recited by a Homeric bard.

If latent demand is to become actual demand, is a differentiated supply required to meet the differentiated needs, interests, capacities, and experience of

the audience? To answer this question, we must clarify and resolve the debate over "high" versus "popular" art, consistent with the protection of artistic autonomy and the professional integrity of arts organizations. It is unclear whether a program mixing high and popular art and social activities is based on a necessary, permanent cultural dualism or whether it is intended as a bridge leading gradually to participation in communitywide arts events. The advantages and dangers of dualism, as well as the probable success of a bridging strategy, certainly deserve more study.

As for education, which is viewed by some as the primary instrument in effecting a permanent increase in arts demand, a cautious approach seems wise. Until we learn more about the determinants of arts demand, it is not clear whether education can fulfill such expectations and, if so, for whom. An educational system which is not performing adequately in many respects may not be able to take on another task and handle it with finesse. Before we launch an ambitious educational arts program, it would seem prudent to research the question of why so small a proportion of the highly educated cohort in the population is responsive to the arts. In using education as the deus ex machina, we would be converting a correlate (educational level) of arts participation into a causative factor. But we do not yet know how, or if, it functions as a causative factor. Thus, there is much to be learned about the determinants of arts demand and the use of education as an effective instrument in behalf of the arts.

Notes

1. In the absence of empirical data, however, Linder concludes on the basis of impressionistic observation, "There is a great risk that culture is a pursuit with negative income elasticity. The cultivation of mind and spirit is quite simply an inferior good." He also raises the question as to "whether the rich countries are already in a phase in which cultural progress has not merely slowed down but actually given way to a decline, as expressed in people devoting increasingly less time [to] the development of mind and spirit." Linder (1970, pp. 95, 103).
2. See Baumol and Bowen (1966, chapter IV, "The Audience," pp. 71–97). Published thirteen years ago, it is widely acknowledged as the "best single study of cultural audiences to date" (DiMaggio, Unseem, and Brown, 1978, p. 1). For a valuable and comprehensive survey of audience studies (covering 270 studies sponsored by a variety of organizations), see DiMaggio, Unseem, and Brown, *Audience Studies of the Performing Arts and Museums* (1978).
3. See, in this connection, DiMaggio, Unseem, and Brown (1978, p. 1.)
4. See "A Union Crusades for Rank and File Culture," *Business Week* (1979, p. 108).
5. See E. H. Phelps, "The Harried Leisure Class" (1973, p. 642).
6. See Baumol and Bowen for discussion of two alternative hypotheses—one pessimistic in its implication for the age composition of the future arts audience, the other optimistic. They point out that "we cannot be sure which of these alternatives applies," since we lack the required data (1966, p. 94).
7. See Blaug's critical reference to the "blithe" optimism of the Arts Council of Great Britain in this regard (Blaug 1976, p. 138).

References

Baumol, William J. and Bowen, William G. 1966. *Performing Arts—The Economic Dilemma*. Cambridge, Mass. and New York: M.I.T. Press and Twentieth Century Fund.

Blaug, Mark. 1976. Rationalizing Social Expenditure—The Arts. In *The Economics of the Arts*, Mark Blaug, ed. Boulder, Col. and London: Westview Press and Martin Robertson.

Business Week. 1979. A Union Crusades for Rank and File Culture. January 15: 108.

DiMaggio, Paul, Unseem, Michael, and Brown, Paula. 1978. *Audience Studies of the Performing Arts and Museums*. Research Division Report Number 9, National Endowment for the Arts (November).

Linder, Staffen Burenstam. 1970. *The Harried Leisure Class*. New York: Columbia Univ. Press.

Phelps, E. H. 1973. The Harried Leisure Class: A Demurrer. *Quarterly Journal of Economics* LXXVIII, no. 4 (November).

Scitovsky, Tibor. 1972. What Is Wrong with the Arts Is What's Wrong with Society. *American Economic Review* XXII, no. 2 (May).

———. 1976. *The Joyless Economy*. New York: Oxford Univ. Press.

Comment
Gregory B. Christainsen

As the title of her paper suggests, most of Gold's comments pertain to the demand side of the market for the arts. Supply issues are inextricably entwined with many of the topics she discusses, and the state of our knowledge regarding these issues is in many instances even more limited than it is on the demand side. Curiously, however, it is with respect to one such issue that Gold takes sides—that of "surrogate experiences."

Barring unforeseen technological advances, the originals of the masterpieces of the past must forever be in perfectly inelastic supply, except to the extent that privately owned art is offered for sale or donated to museums. The issue, then, is the extent to which the production of substitutes (surrogate experiences) should be encouraged. Gold argues that if the percentage of the population exposed to the arts is to increase, surrogate experiences will have to play a significant role.

I admit to being sympathetic to this position, and it would appear that in some instances technological advance can be so extraordinary as to permit the emergence of surrogates which are in some ways superior to a live performance or exhibition. The danger is that, before we really understand the determinants of demand for the arts, we will encourage surrogates for which there is no demand or which satisfy the demand for diversion.

At least some of the following are needed to tutor intellects and sensibilities so that the aesthetic and intellectual values of artistic endeavors are apprehended as meaningful: time (and patience), inclination, discipline, focus, guidance, and an environment in which style can be experienced. High and folk cultural works, even when they are not physically altered, change their function if they are absorbed into the stream of popular culture. They become diversions which attempt to displace and disguise our fears and produce illusionary reassurances. One major function of art, however, is precisely to see through disguises and reveal to our consciousness the true nature of our wishes and fears.

Gold rightly cautions against launching an ambitious educational arts program because, again, we know so little; among the highly educated, only a small proportion is responsive to the arts.

PART THREE

Economic Aspects of Careers
in the Arts

Introduction

CERTAIN ECONOMIC ASPECTS of the artist's work milieu distinguish the arts from other occupations. Three aspects addressed by the papers in this section are (1) high development costs for the artist; (2) inordinate career risks relative to income, status, and lack of employment stability given the nature of demand for individual artists; and (3) the presumed special importance of psychic income.

Cyril Ehrlich begins by tracing the history of contemporary musicians' unions in Great Britain during the Industrial Revolution. With "modern" city life came new demands for live music and new notions of the ensemble. A market for "rank-and-file" musicians was emerging, and in this era the first musicians' union was formed. Ehrlich is interested in the power that unions eventually came to possess in professionalizing an explosive market and thereby avoiding another "Malthusian nightmare" while attempting to prevent a cluttered labor market. What is important about Ehrlich's paper is the suggestion that the development of musicians' unions in nineteenth century England provides a model for the grouping or collectivization of an art profession—a model which is modern and which has probably assisted the economic status of the modern musician.

James Richardson provides an historical overview of the career patterns of American opera singers. Their careers are affected by particularly rigorous development costs in acquiring artistic skills, beginning at a rather early age but not paying off until adulthood; the fickleness of opera companies, critics, and audiences; and the presence of a "star system," in which all can aspire but few can succeed. Opera singers are judged by their voice range and stamina, acting skills, personality, and physical appearance. In attempting to reach the top in professional opera, aspiring opera singers may not become mature in voice and acting until their late thirties or early forties, yet they may well be passed by or turned out when aging is evident. These dilemmas for the aspiring professional opera singer are somewhat offset by accelerated growth in productions, houses, and audience demand over the past decades in the United States. Unlike musicians, who have unionized, opera singers are more involved in individual competition, making them vulnerable to exploitation by opera producers, except for the few "stars" who turn the tables on employers and exploit their positions as stars.

Muriel Cantor and Anne Peters analyze employment and unemployment figures for U.S. screen artists and find them lacking. In addition, they observe that the Screen Actors' Guild has grown considerably during a period of declining demand for actors. They speculate as to why the star system is a beacon for new talent and evaluate the usefulness (or lack of it) of guild data on membership for regular reporting of job statistics for actors.

Richard Waits and Edward McNertney search for evidence that artists on the average earn less income than do others in occupations with similar development costs, and that they face a greater risk of earning an income considerably less or more than those in other occupations. This feature of arts "labor" markets may lead to artistic careers being the choice of those who (1) have a source of unearned

income, (2) place a high value (in terms of psychic income) on the arts as the preferred occupation, or (3) subscribe to the star system. Short of giving up altogether, artists may pursue artistic activities part-time.

Victoria Felton asks what determines the amount of time composers allocate to composing, and how the time allotted to expected income from composing compares to the time allotted for suitable work other than as an artist and to leisure time. Felton constructs a conventional household utility maximization model for empirical study of questionnaire results obtained from individuals who define themselves as composers. She utilizes her findings to find the least costly approach to increasing the time spent composing through public subsidy. Felton is interested in explicating subsidy of composers so that they will allot more time to composing, while O'Hare (in the preceding section) sees no economic rationale for doing so since the odds are overwhelmingly against a new composition ever being heard, let alone evolving to the status of a classic.

The papers in this section clearly reveal the fact that low income, lack of job stability, and the part-time nature of artistic employment make the arts, even in their commercial aspects, a dicey occupation for the individual seeking economic rewards. Lack of collectivization, lack of common interests among artists, and an indifferent society create a kind of stoop labor market. From a policy standpoint, one cannot begin to see any real changes in the labor market conditions of artists, or perhaps even know where to begin. Obviously, many artists do well enough economically by teaching in arts institutions, but few full-time artists outside of institutions can expect to do well.

Profession or Job?
Musicians in Late
Nineteenth Century Britain

Cyril Ehrlich

The exorbitant rewards of players, opera-singers, opera-dancers, etc., are founded upon those two principles; the rarity and beauty of the talents, and the discredit of employing them in this manner. . . . Should the public opinion or prejudice ever alter with regard to such occupations, their pecuniary recompence would quickly diminish. More people would apply to them, and the competition would quickly reduce the price of their labour. Such talents, though far from being common, are by no means so rare as is imagined. Many people possess them in great perfection, who disdain to make this use of them; and many more are capable of acquiring them, if anything could be made honourably by them. (Adam Smith 1776)

The peculiarity of the Musician's Union . . . does not reside in the fact that disciplinary powers are used for protective ends, but in the fact that they are used only or mainly for those ends. (Carr-Saunders and Wilson 1933)

THE most obvious feature of the market for musicians in nineteenth century Britain was its remarkable growth. There are familiar but intractable problems of classification and analysis which preclude a simple statistical presentation. At various times musicians were grouped in the census as "musicians and organists," "musicians, not teachers," "musicians and music masters," "musicians, music masters, and singers." Before 1881 and after 1911 "music teachers" and "musicians" are recorded separately, but for the crucial intervening period they are amalgamated. Reliable figures are therefore elusive and it is difficult to quantify even major changes with much precision, while the vital transitions from amateur to professional and from part-time to full-time employment defy count-

ing. Nevertheless, two general trends are clear: a rapid increase in total employment between the 1840s and 1890s, and an important change in sex distribution. By the 1860s music teaching had become predominantly an occupation for women—a significant fact in an age which offered few respectable alternative occupations. The proportion of female musicians (performers) never became as large, though their numbers increased considerably. A similar development occurred in the United States after 1880: by 1910 39,000 out of 55,000 musicians were men; 69,000 out of 84,000 music teachers were women (Harris 1915).

Tables 1 and 2 present figures which are approximate and should be read with caution. They are tentative, representing a preliminary report at an early stage of research and inviting criticism.[1] But their general purport is clear enough: musicians were one of the fastest growing professional groups of the period. To use the word "professional" is to beg several questions to be considered below. The expansion was a response to transformed opportunities of employment. In earlier times musicians had entered a market which, particularly outside London, was small, comparatively static, and dispersed. Seasons were short; tours infrequent, slow, and arduous; and incomes modest, save for a few celebrities. Full-time employment was therefore rare, and most people pieced together a living from performance, "benefits," teaching, patronage, perhaps a little trade, and a variety of quasi-musical activities. Then came a revolution. Urbanization, improved transport, growing incomes, more leisure time, and the commercialization of entertainment created unprecedented opportunities for players in new, enlarged symphony and opera orchestras, seaside bands, theaters, music halls, and restaurants and for teachers in a hierarchy which ranged from the sixpence-a-lesson "professor" to the coveted status of a university chair (Briggs 1960; Ehrlich 1976/77).

How did the supply of musicians respond to this pronounced shift in demand? "Too well" was the virtually unanimous view of participants and observers. Thus, in 1880 C. K. Salaman, pianist, teacher, and critic, addressing the Royal Musical Association "On Music as a Profession in England," was already disturbed by the ravages of "increasing and increasing competition." He concluded with an "unsatisfactory estimate" of the profession's "financial status" in comparison with the recent past. His audience deepened the gloom. Even the cathedral organist, Salaman's "beau ideal of a musical professor's existence . . . relieved from pecuniary anxiety by an assured stipend; a gentleman respected and admired, in and out of his profession; visiting on equal terms his most worthy neighbours" received, according to the chairman, such "miserable payments" that it was a "matter of astonishment that so many estimable men and first-rate musicians were willing to occupy these posts" (Salaman 1880).

A decade later there was a prevailing sense of glut, of incomes continuously depressed by a flood of players and teachers that could not be dammed. We must distinguish, as the Victorians did more profoundly and rigidly than their predecessors, between soloists and "rank-and-file" players. This process of differentiation, a logical concomitant of the market's growth, was articulated and entrenched by a virtually new species of middleman, the concert agent, who by the

Table 1. *Percentage Rates of Increase or Decrease (−) in Selected Professional Occupations, 1841–1911*

| Year* | Musicians | Accountants | Actors | Architects | Barristers | Physicians and Surgeons | Solicitors | Surveyors | Teachers |
|---|---|---|---|---|---|---|---|---|---|
| 1841 | | | | | | | | | |
| 1851 | 17 | 50 | 60 | 100 | 49 | 0 | 13 | −29 | 61 |
| 1861 | 125 | −6 | 8 | 29 | −1 | −18 | −14 | 63 | 32 |
| 1871 | 97 | 58 | 63 | 48 | 17 | 2 | 8 | 2 | 15 |
| 1881 | 37 | 18 | 27 | 21 | 12 | 3 | 9 | 18 | 33 |
| 1891 | 51 | −31 | 60 | 14 | 22 | 26 | 13 | 18 | 15 |
| 1901 | 12 | 13 | 71 | 37 | −14 | 19 | 6 | 10 | 36 |
| 1911 | 9 | 5 | 46 | −17 | −2 | 3 | 8 | −21 | 9 |

*Percentage rates refer to intercensal rates of growth; e.g., the number of musicians increased 17 percent between 1841 and 1851.
Source: Based on Appendix I, Table 1 in W. J. Reader, *Professional Men* (1966).

Table 2. *Musicians and Music Teachers in England and Wales*

| | 1841 | 1851 | 1861 | 1871 | 1881 | 1891 | 1901 | 1911 |
| -- | ----- | ------ | ------ | ------ | ------ | ------ | ------ | ------ |
| Musicians | 3,000 | 6,000 | 11,000 | — | — | — | — | — |
| Teachers | 3,000 | 5,000 | 6,000 | — | — | — | — | — |
| Total | 6,000 | 11,000 | 17,000 | 19,000 | 26,000 | 39,000 | 43,000 | 47,000 |
| Female Teachers as % of Total Teachers | 24 | 44 | 56 | — | — | — | — | — |
| Female Musicians and Teachers as % of Total Musicians and Teachers | — | — | — | 37 | 42 | 49 | 53 | 51 |

Source: U.K. Census Reports.

1890s was shrewdly assessing and marketing artists in terms of their "drawing power"—the phrase probably dates from this period. Since, with due respect to Adam Smith, there is never a surfeit of great talents, a buoyant market merely served to boost the earning power of celebrities to unprecedented heights. Nor, as yet, were there clear indications of an excess of first-class instrumentalists capable of playing, for example, the difficult new scores of Richard Strauss, though some national conservatories and a few prominent teachers were increasing the flow. The real flood, more than even the porous British market could absorb, was in the supply of merely competent players and above all, though they were sometimes the same people, of teachers.

In an open market there are several reasons why the supply of musicians should be highly elastic. Neither language, except perhaps for elementary teachers, nor youth, nor gender is a serious impediment. The familiar route from amateur to professional via part-time work is easy and reversible. The "fiduciary element" (Carr-Saunders and Wilson 1933) tends to be strong—an undiscriminating public takes much on trust—allowing opportunities for modest levels of competence. Aptitude, access to an instrument, and tuition are the limiting factors.

In Victorian Britain circumstances were uniquely favorable for massive expansion. The market was wide open to native and foreign practitioners. The latter had indeed been welcomed for centuries, but a long-established migration was now reinforced by the "pull" of comparatively high remuneration (fees, particularly in London, were higher than anywhere outside America); the "push" of frequent political upheaval on the continent; and fast, reliable communication: railway timetables were a significant new element in the lives of many players. Foreign musicians therefore moved freely in and out of the British market. In 1894, for example, George Henschel's Scottish orchestra imported about thirty instrumentalists from Germany and Holland for the season (*Orchestral Association Gazette* December 1894). Young players encountered fewer barriers than hitherto from legislation or traditional vested interests. Women dominated teaching, were firmly established as soloists—Lady Halle and Clara Schumann are

familiar examples—and were beginning to occupy orchestral positions. Most consumers (audiences and buyers of music lessons) were new and inexperienced, so the fiduciary element was powerful. Instruments were increasingly accessible and cheap.[2] Above all there was a constantly growing range of training opportunities to supplement older patterns of musical education through family and apprenticeship. In addition to the new national conservatories, colleges and private teachers proliferated, including recently trained penurious instrumentalists cumulatively swelling the tide. Another potent breeding ground was the Military School of Music, which opened at Kneller Hall in 1857. By 1890 it was estimated that 450 bandsmen were leaving the army to seek civilian employment every year.

A fundamental revolution was taking place in the supply of musicians seeking to earn a living by their craft, and it was inevitable that existing practitioners would attempt to impose constraints upon newcomers. Their predecessors had sought protection, sometimes achieving a precarious balance, through guild organizations and appeals to authority. In a highly commercialized society such institutions and procedures were inadequate or inappropriate, though they were sometimes invoked. More in tune with the times were initiatives which focused upon two interconnected but incompatible forms of organization: the professional association and the trade union. Their incompatibility may not be self-evident to the modern observer. As Eliot Freidson has noted, "so far as the terms of work go, professions differ from trade unions only in their sanctimoniousness" (1972, p. 367). In nineteenth century Britain it can scarcely be doubted: "The very Victorians who condemned trade unions as vicious, restrictive, futile, and as unwarrantable interferences with individual liberty, flocked to join professional combinations" (Thompson 1968, p. 149).

The Amalgamated Musicians' Union (AMU) was, from its inception in 1893, a tough, single-minded trade union. It represented orchestral players, mostly those in provincial theaters and music halls, who worked four hours a night for miserable wages in conditions which would have scandalized a hardened factory inspector. Their leader, Joseph Williams, was a young Manchester cellist with prodigious energy and organizing ability, whose strategy was to enforce minimum wages and standards upon individual employers. Within a year membership exceeded 2,000, with branches in Wales, Scotland, and throughout the provinces, most of which were affiliated with local trade councils. By 1896 there were more than 3,000 members in 38 branches. Membership was open to "any person following the profession of music or cultivating the art as an amateur" over the age of 16 (*Orchestral Association Gazette* November 1900). Williams recognized the need to accept part-timers, in contrast to AMU's London rival, the Orchestral Association, which admitted only those of "legitimate standing as a bona-fide professional man." While this difference probably originated in a pragmatic recognition of contrasting provincial and metropolitan standards and market forces, it remained for many years a source of acrimonious dispute between the two organizations.

It would be inappropriate here, and premature in terms of continuing research, to attempt a detailed account of AMU's campaigns: its protests against

competition from the military; its "blacking" of recalcitrant theaters (for example, in Bradford, Leeds and Hull, during the summer of 1895); its aggressive national and even international publicity. The essential point is that, within the scope of its limited objectives, the AMU was successful, most notably during the great London music hall strike of 1907, when a "National Alliance" of musicians, stage operatives, and variety artists enforced national arbitration upon reluctant managements, culminating in the "Askwith Award," generally recognized as an "historic charter for theatre musicians."[3]

To describe the AMU's objectives as limited is to imply broader perspectives. Both the Incorporated Society of Musicians (ISM) (founded in 1882, incorporated in 1892) and the Orchestral Association (founded in 1893) were self-consciously "professional" in outlook and aspiration, avowedly seeking a status akin to that of doctors, lawyers, and surveyors. Complete success would have required the following steps: (1) clear emergence as a separate full-time occupation with specific skills; (2) organization to boost morale, arrange publicity, and exclude the unqualified; (3) specialized training, assessment, and validation; (4) an enforced code of practice both for self-justification and to protect the public; (5) recognized monopoly of title through a charter; and (6) legalized monopoly of practice (Perkin 1978). The sequence is taxonomic, of course, not obligatory, but it follows the evolution of several professions in the nineteenth century fairly closely.[4]

What of the musicians? The ISM was essentially a teachers' organization. Despite modest provincial origins it expanded rapidly in membership and, rather bewilderingly, in geographical spread: a meeting of the North West section at Liverpool in June 1892 resolved "that subject to their own approval the Irish members of this section may be transferred to the proposed Welsh section" (*ISM Monthly Journal* 1892). By 1898 there were few urban centers without a branch, and the membership of some 2,000 included several hundred musicians with reputable degrees or certificates. On occasion the society's preoccupation with formal training, examinations, and diplomas approached caricature. Thus, delegates at a prize-giving occasion in Bristol were assured that many of Schubert's works "betrayed want of training" (*ISM Monthly Journal* 1889). Metropolitan critics tilted at a philistinism which "merely deals in music lessons as a grocer deals in tea and sugar" (*Saturday Review* 1898), and a leading academician suggested that "many musicians might as well put the whole alphabet after their names, and leave the admiring reader to sort out the letters according to fancy" (*Saturday Review* 1899). Nevertheless, the society did much to raise morale among its isolated, widely scattered members through publicity, regular local meetings, and annual conferences supported by leading academic musicians and civic dignitaries. It even made a modest contribution to the raising of standards among teachers and pupils by attacking fake qualifications and supporting the Associated Board system of coordinated local examinations, which was introduced in 1890 at forty-six centers. What the ISM manifestly, perhaps inevitably, failed to get for its members was a score in our six-step program (noted above) sufficient to reach the full professional status to which they aspired.

Registration was the crucial target. A campaign was sustained for twenty years, culminating in attempts to get a Teachers of Music Registration bill through Parliament, but it came to nothing. The reasons are not hard to find. One problem was the clash between existing interests and future aspirations. Who was to be excluded from the proposed register? To include everyone would be to give "a legal status to the very class it wishes to wipe out" thereby failing to protect the public, which was the alleged purpose of registration (*ISM Monthly Journal* 1894). Several other professions had overcome this difficulty, but among music teachers the minimum standard was so low and numbers, both actual and potential, so large, that effective registration was a hopeless task. The society tried to be all things to all people, including a representative of the Tonic-Sol-Fa movement on its registration council, to choruses of disdain from "properly trained musicians."[5] Paradoxically, a larger franchise might have helped if it could have embraced the orchestral world and remained united. But the society's attempt to represent "the musical profession in the same manner as the Incorporated Law Society, the Institute of Chartered Accountants, and similar bodies represent their respective professions" (*ISM Register of Members* 1898) failed during this period to attract much interest from instrumentalists: "the orchestral and band world [is] conspicuously absent in the list of members. The truth is the elder and successful performers do not feel the need of joining any such corporation, the unsuccessful either fear that they might not pass the necessary examination or fail to see that it would help them in any way" (*The British Musician* 1896). In later years the ISM was to consolidate and strengthen its membership, including some performers, sustaining morale, most remarkably during the 1930s when sound films, radio, and recording imposed enormous strains. But in nineteenth-century Britain it was too weak to control and elevate a profession which it described in 1898 as "a no-man's land without definition or limits" (*ISM Register of Members* 1898).

Definition was less of a problem for the Orchestral Association, but limitation proved equally difficult, insofar as it was seriously contemplated. Essentially based in London, the association was open to "professional orchestral players resident in the United Kingdom and of good character." Foreigners were therefore welcome, except for the "deliberate importation of whole orchestras" (*Orchestral Association Gazette* July 1895). But extremes of inverted patriotism were publicized in such advertisements as "*Wanted*—first violinist for hotel in town. Must be first class performer and foreigner" (*Orchestral Association Gazette* November 1900). The prevailing cult of exotic light music (frequently provided by masquerading Cockneys pledged to avoid exposure by conversation) was ridiculed: the "Red Viennese Band" at Margate, "Herr Moritz Wurm's Blue Viennese Band" at Folkestone. Women were discouraged with the common excuses of the time: except for a very few instruments their playing lacked strength of tone; they offered unfair competition to family breadwinners; unavoidably late nights were morally dangerous. Women fought doughtily, at least in the correspondence columns: actresses had to change and remove makeup after performances, leaving the theater even later than would otherwise be necessary,

yet they remained unscathed. Several Ladies' Orchestras were successful, even loud; one female had actually led "the men's orchestra of one of our largest touring Grand Opera Companies (*Orchestral Association Gazette* March 1894).

Male rather than political chauvinism was accompanied by a profound conviction that respectability was the essential prerequisite to professional status. The association sought to exclude or reform that "class of performers, now happily diminishing, who never considered their duty to their employer, drank deeply, and dressed badly, and who were at all times by their action and language ready to prove that they were anything but gentlemen" (*The British Musician* 1895). It shrank from association with trade unions with a squeamishness akin to that of its American contemporary, the National League of Musicians (Mueller 1958, p. 342), deploring "picketing and parading the streets" as activities "undoubtedly degrading to professional men" which "cannot fail to disgust the public" (*Orchestral Association Gazette* April 1896). We have already noted its fundamental disagreement with the AMU over part-time musicians ("carpenter and cobbler players who infest the provincial orchestras"), which reflected both a desire to raise standards and alarm at the plight of an "overcrowded profession" (*Orchestral Association Gazette* December 1897). Thus, it attacked the training colleges, which "still go on turning out hundreds more to reap the same crop of bitter disappointment." Much of this concern was focused upon theater orchestras, "the foundation upon which all orchestral musicians have to take their stand, whatever their position" (*Orchestral Association Gazette* May 1898). Apart from their quantitative importance as sources of employment, these London theaters usually offered recent graduates from the academies their first chance of a job and for talented musicians, such as Aubrey Brain and the Barbirollis, provided stepping stones to the major orchestras.

The *Orchestral Association Gazette* did valuable work in publicizing scandalous working conditions: unpaid rehearsals, swingeing "fines," sudden cancellations without recompense, fetid band rooms, even "sweating conductors," an allusion to pecuniary rather than physical activity. Yet in the last analysis, like the ISM, the Orchestral Association was unable to give effective force to its worthy aspirations. Its original intention to establish "a register of duly qualified orchestral musicians" (*Orchestral Association Gazette* May 1894) degenerated into a jobs requirements column in the association's journal: a worthy service, to be sure, but far removed from professional registration. Unlike the AMU, it apparently did little to enforce better working conditions and nothing to stem the flood of newcomers. Certainly it failed to grow as rapidly as its rival, which by 1900 was three times as big. Nor did it retain a hold on London musicians, leaving the 1907 struggle to its rival (*London Times* 1907). In 1896 a London player contrasted the "robust and stalwart brethren of the Provinces" with "our own timorous mode of procedure" and forecast a more general "recourse to trade unionist tactics" (*Orchestral Association Gazette* April 1896). *Rapprochement* between the two organizations came in 1915 through a joint committee and in 1921 when the Musicians' Union was finally established. Perhaps the "peculiarity" of that union's "protective" orientation, noted by Carr-Saunders and

Wilson (1933), lay primarily in the fact that it took so long to emerge. More generally, it is arguable that awareness of Malthusian pressures stimulated the idea but did not provide the means of limitation, without which professional status was a chimera. The mere sketching of boundary lines could not establish territorial rights.

Notes

1. Grateful acknowledgment is made to the Social Science Research Council for a grant in aid of research.
2. Ehrlich (1960, pp. 106–107). Note the great contrast in recent years, when good instruments have become prohibitively expensive.
3. See various numbers of the *London Times* between January 23 and January 28, 1907.
4. See B. Kaye, *The Development of the Architectural Profession in Britain* (1960); N. and J. Parry, *The Rise of the Medical Profession: A Study of Collective Social Mobility* (1976); and F. M. L. Thompson, *Chartered Surveyors: The Growth of a Profession* (1968).
5. For a discussion of the Tonic-Sol-Fa movement, see E. D. Mackerness, *A Social History of English Music* (1964, pp. 157–164).

References

Briggs, Asa. 1960. Mass Entertainment: The Origins of a Modern Industry. 29th Joseph Fisher lecture in commerce. Adelaide Univ. (Australia).

The British Musician. March 1895, June 1896.

Carr-Saunders, A. M. and Wilson, P. A. 1933. *The Professions.* Oxford.

Ehrlich, Cyril. 1976. *The Piano: A History.* London: Dent.

_____ . 1976/77. Economic History and Music. *Proceedings of the Royal Musical Association* 103:188–199.

Friedson, Eliot. 1972. *Profession of Medicine.* New York: Dodd, Mead and Co.

Harris, H. J. 1915. The Occupation of Musician in the United States. *The Musical Quarterly* 1:299–311.

ISM Monthly Journal. December 1889, June 1892, May 1894.

ISM Register of Members. 1898.

Kaye, B. 1960. *The Development of the Architectural Profession in Britain.* London: Allen and Unwin.

London Times. 1907. June 28.

Mackerness, E. D. 1964. *A Social History of English Music.* London: Routledge and Kegan Paul.

Mueller, J. H. 1958. *The American Symphony Orchestra.* London: Calder.

Orchestral Association Gazette. March 1894, May 1894, December 1894, July 1895, March 1896, April 1896, December 1897, May 1898, November 1900.

Parry, N. and Parry J. 1976. *The Rise of the Medical Profession: A Study of Collective Social Mobility.* London: Croom Helm.

Perkin, H. 1978. The Professions in History. *Social History Society Newsletter* 3, no. 1.

Reader, W. J. 1966. *Professional Men.* Weidenfeld and Nicholson.

Salaman, C. K. 1880. On Music as a Profession in England. *Proceedings of the Royal Musical Association* 6.

Saturday Review. January 22, 1898; October 14, 1899.

Thompson, F. M. L. 1968. *Chartered Surveyors: The Growth of a Profession.* London: Routledge and Kegan Paul.

Comment
Dorothy Lee

The broader social context of the music profession in nineteenth century England is intriguing to a sociologist who finds little to criticize in Ehrlich's analysis but wishes to raise a few questions.

One socioeconomic consideration has to do with social class. The French and Industrial Revolutions shook the traditional class systems throughout Europe but with different implications, depending on the culture of the society. On the continent the old elite kept control of the arts, although increasingly, due to the breakup of old inherited fortunes and prince-bishoprics, supported them with public funds (Raynor 1976). In England, where the nobility left politics to the elites, who left pursuit of the arts to the nobility, the pattern was somewhat different.

In both England and on the continent the result was democratization. In no aspect of life was this more true than in music. The new bourgeoisie could afford a standard of living no longer so different from that of an elite losing its fortune, and they could mingle comfortably in the musical realm without interacting at more intimate, enduring levels, such as politics or kinship (Weber 1975). Since the elite still controlled many of the money sources which affected the progress of the new music entrepreneurs (managers, agents, and so forth), the upper class could also mingle with increasing comfort with a growing middle-middle class.

In England democratization extended to the growth of a music of the people. Singing in the churches was fostered by John Wesley; the 1860 publication of *Hymns Ancient and Modern* included hymns known to all the English. And singing became part of the workday in many factories (Raynor 1976). Not only the rich, but also the working classes sought music instruction. The new institutes set up to teach the illiterate masses were increasingly called upon to provide such instruction. Some factories paid for lessons and bought instruments. Choral groups, town or tavern choirs, music halls, and the brass band movement all flourished. "The music halls invented a style of popular song developed from the tastes, habits and manners of the industrial working class" (Raynor 1976, p. 152). Contrary to the notion that it is industrialization which creates demands, the demand for musical instruments led to their mass production (Weber 1975).

These changes increased the demand for and supply of musicians. They also directed the role of the nineteenth century musicians toward professionalism, professionalism in this case meaning an occupation with a theoretical base, relevance to basic social values, a long training period leading to development of a subculture, motivation to service rather than self-interest, autonomy, a sense of commitment, a sense of community, and a code of ethics (Pavalko 1971; Montagna 1977). Thus, musicians underwent professionalization and for the first time could participate in the development of the music industry and in the development of tastes. For the first time also they were not certain of reaching the

audience for which they wrote, but when the public came to hear their music, to some extent, they exercised control over the musical environment (Weber 1975).

There are insecurities inherent in such democratization and in the subsequent public exposure, including bookings, salaries, travel, working conditions, treatment at the hands of all levels of entrepreneurs, and the lack of responsibility of employers for any other aspects of the musicians' lives. These uncertainties and difficulties led to union organization, all of which led to role conflict. What was the musician? Artist? Craftsman? (Some sociologists attempt to distinguish between art and craft, as well as between occupation and profession; for example, Becker [1978] and Fethe [1977].) Was the musician a worker, a professional, a trade unionist?

Ehrlich has not answered the question of whether music performance/composing is a profession or a job. However, he has raised the issues and recognized the conflicts. Perhaps the broader perspective will allow us to consider additional questions, such as whether the industrial model depresses talent, whether talent flourishes when recompense is more equitable and dependable, whether values and self-concepts change with changed behavior. I suggest that the world of the musician reflects the culture of its time, that it affects and is affected by that culture, and that the conflicts of the nineteenth century musician have been recapitulated.

References
Becker, Howard S. 1978. Arts and Crafts. *American Journal of Sociology* 83 (January): 862–889.
Fethe, C. B. 1977. Craft and Art: A Phenomenological Distinction. *British Journal of Aesthetics* 17, no. 2 (Spring): 129–137.
Montagna, Paul D. 1977. *Occupations and Society: Toward a Sociology of One Labor Market.* New York: John Wiley and Sons.
Pavalko, Ronald M. 1971. *Sociology of Occupations and Professions.* Itasca, Ill.: Peacock Publishers.
Raynor, Henry. 1976. *Music and Society Since 1815.* New York: Schocken Books.

Career Patterns of
American Opera Singers

James F. Richardson

MOST DISCUSSIONS OF THE ECONOMICS of the arts focus on the ravages of inflation and the need for greater corporate and government support of the institutions that sponsor symphony orchestras and produce ballets and operas. However, a different tack can be taken by looking at the career prospects and patterns of opera singers and the way in which these have changed over time. The focus will then be on the artist rather than the company or institution. Only a few Americans have been important on the international scene as instrumentalists; yet Americans have long made successful international careers as opera singers, despite the fact that until recently opera has not been an integral part of the nation's cultural life (Lipman 1979). Most of the names to be mentioned are those who made such careers, although one must always keep in mind that the successful are only a fraction of those who aspire to operatic greatness.

All would-be professional musicians face severe obstacles, including long and demanding training and intense competition. Still, it does seem that singers face many requirements that are exceptional in their range and difficulty.

Like dancers but unlike other musicians, the singer's instrument is his or her own body, and the instrument cannot be bought—it must be built. Unlike dancers, singers often cannot begin to build their instruments until their late teens or twenties. Indeed, it may not be until the early twenties that one can tell the potential is there, although a surprising number of major singers did begin in early childhood (Sargeant 1973, pp. 9–16). In the opinion of the great critic and student of the art of singing, W. J. Henderson, most singers need a minimum of five years of study before they are ready to face the public (Henderson 1938, pp. 231, 268–272). The operatic performer must develop a sound vocal technique and the stamina to perform complete operas; learn repertory; be able to act; and maintain a youthful, attractive appearance. Only people who can sing like Montserratt Caballé or Luciano Pavarotti can be as large as they are (Central Opera Service

1978). And there is the sad fact of age. One's ability to play the violin may decline with age, but the violin itself is unlikely to deteriorate; not so the human voice. Only a fortunate few among opera singers can perform satisfactorily past their early or mid-fifties (Sargeant 1973, p. 10).

The teaching of singing is a complex and controversial art; it in no way resembles a science. Operatic folklore is filled with horror stories of inept teachers ruining promising talents and of singers finding themselves only when they switched teachers (Wechsberg 1972, pp. 136–137). A special problem for Americans is language. Some European artists have made great careers singing primarily or even exclusively in their native language—Italian soprano Renata Tebaldi is a case in point—but no American could sing in a major house without mastering two or three languages other than English (Central Opera Service 1978, pp. 66–67).

Even after launching professional careers, singers must continue to work with teachers and coaches to develop their technique, prevent and correct vocal problems, and prepare roles. Singers usually need help if only because they can't hear themselves properly, although the tape recorder is a useful device in this respect. Incidentally, such training and coaching, unless tied to a specific engagement, is not a tax-deductible expense (Central Opera Service 1978, p. 20; Henderson 1938, p. 388).

Singers may be in their thirties before they have all the high notes called for in their voice category. Sometimes these high notes come at the expense of the lower register, but singers soon learn that it's the high C's that bring cheers from the audience and lucrative contracts from impresarios. Also, many roles demand a range and stamina that singers are unlikely to achieve before the middle thirties or beyond. Giovanni Marinelli would not touch *Otello* until he was in his fifties. One of the major problems facing aspiring young singers is being offered roles that they are not yet ready for or are simply not suited for. Managers are more interested in getting the curtain up and "saving the performance" than they are in the long-range interests of singers, and young singers, needing money and hungering for recognition, too often sing roles they should not, or sing too much. The results can be disastrous (Central Opera Service 1978, p. 45).

With all these obstacles and pitfalls, one sometimes wonders why anyone would even consider such a career; but opera, like other art forms, would have collapsed long ago if its practitioners behaved like Adam Smith's economic man. Fortunately for those of us who love singing, many gifted young people have taken the risks, although only a minuscule percentage of aspirants have made professional careers in opera.

Many nineteenth century American cities and towns had a building called an "opera house" in which opera was rarely, if ever, performed. Perhaps the name connoted dignity—class, in the colloquial American sense—but few Americans outside of New York and one or two other cities ever saw an opera. Many Americans liked to sing, but what they sang was not Mozart, Rossini, or Verdi; still, some Americans did build notable operatic careers in the nineteenth and early twentieth centuries. With only a few exceptions, singers in this era had to go to

Europe for their training and early experience. Sometimes a change of name helped. Thus, Lillian Norton of Farmington, Maine, achieved international fame as Lillian Nordica; baritone Richard Bonelli was born Richard Bunn; tenor Mario Chamlee changed his name from Archer Cholmondeley; and baritone Frank Valentino began life in Denver, Colorado, as Francis Dinhaupt. When Valentino sang in Italy early in his career he was Francesco, just as the great Irish tenor, John McCormack, sang in Italian theaters under the name Giovanni Foli. (Foley was his wife's maiden name.) (Kutsch and Rieman 1969)

Bessie Abbott, Geraldine Farrar, and Louise Homer kept their names, but all were trained in Europe and sang there during the early years of their careers. Contralto Homer made her Metropolitan debut in 1900 and sang with the company as late as 1929, when her six children and a number of grandchildren were in the audience. One of her colleagues that last season was Rose Ponselle, born Rosa Ponzillo in Meriden, Connecticut, of Italian immigrant parents (Homer 1974).

Ponselle's career was altogether extraordinary. She had no European training and no European experience; indeed, her professional experience prior to her Met debut opposite Enrico Caruso in 1918 at the age of twenty-one was singing in cafés and movie houses and touring in vaudeville with her sister Carmela. They were good enough to play the Palace, the mecca for vaudeville performers in New York. Rosa became *the* Italian dramatic soprano of her era and arguably the finest female voice the twentieth century has yet produced. She retired at the early age of forty, although some private recordings show that she kept her voice in magnificent condition until at least her mid-fifties.[1]

Ponselle thus avoided the sad fate of Marion Talley of Kansas City, who made a much ballyhooed Met debut as Gilda in *Rigoletto* in 1926. Talley, only twenty at the time, parlayed her publicized Met appearances into a concert tour that took in almost $350,000. After that it was all downhill (Henderson 1938, pp. 340–346, 352–353; Kolodin 1966, pp. 327–328). Not to be outdone in the youth department, the Chicago company once cast a local schoolgirl, fifteen-year-old Betty Jaynes, as Mimi opposite Martinelli's Rodolfo. I don't know whether she ever sang in another operatic performance (Davis 1966, p. 211).

Other young Americans promoted by the Met in the 1920s became solid performers for many seasons. Grace Moore had some European training, but her early professional experience was on Broadway in musical comedy, while Lawrence Tibbett of Bakersfield, California, was a totally American product. Tibbett was not the first American opera star, but no one before him had seemed so American. Both Moore and Tibbett made successful films and introduced a strong element of glamor into the opera house, as had Geraldine Farrar and Mary Garden before them. These American singers, along with such major imported artists as tenor Beniamino Gigli, soprano Maria Jeritza, and bass Ezio Pinza, made music at the box office as well as on stage. Incredible as it now seems, the Metropolitan made money during the 1920s, the profit in a good year exceeding $100,000 (Kolodin 1966, pp. 340, 395–396, 324, 406, 345).

The 1930s were another matter: the Depression cut box office receipts and made deficits a chronic problem. The Metropolitan continued to engage Ameri-

can artists, although in many instances only after they had been recognized abroad. Tenor Richard Crooks was trained in the United States but found opportunities in his homeland only after singing in Europe for a number of years (Steane 1974, p. 280). World War II prevented European artists from coming to the United States, which enhanced the opportunities for American performers. During the 1941–42 season about half of the listed principal artists at the Metropolitan were Americans, and Americans gave an even larger proportion of total performances. Also, the performers' union, the American Guild of Musical Artists, took advantage of market conditions to insist on a ratio of American to foreign performers of three to one (Kolodin 1966, p. 449).

Black American artists did not share in the expanding opportunities. It was not until 1954 that Marian Anderson appeared at the Met as Ulrica in *Un Ballo in Maschera*—unfortunately, several years after her prime. In subsequent years such black American singers as Leontyne Price, Martina Arroyo, Grace Bumbry, and Shirley Verrett have become international favorites. They were trained in the United States, went to Europe for experience and to build their reputations, and returned triumphant. Note that this list is all female; the opportunities for the black male singer have been much more restricted (Kolodin 1966, pp. 547–548; Rich 1976). For many years tenor George Shirley was the only black male principal singer on the Metropolitan roster. Nor are the opportunities necessarily greater for black male singers in other countries; throughout his entire career Shirley was not invited to sing in Germany (Central Opera Service 1978, pp. 47–48).

Shirley's career illustrates another fact of opera in America. In European theaters when a particular singer is unable to perform and must "cancel" in the trade's jargon, it is often possible to get a replacement from a nearby house. In the United States the distance from Europe and between major cities precludes such arrangements, so managers must provide "covers," artists able to perform roles of singers who must cancel. During one season Shirley had the responsibility of performing or covering fourteen operas, which meant that he had to be ready at a moment's notice to sing fourteen different roles. He realized that this was an enormous burden but was unwilling or afraid to say no. He did have the advantage, unlike Joan Sutherland, of having a good memory and being able to learn roles quickly (Central Opera Service 1978, pp. 47–48).

Singers do not like to cover; it injures their pride, precludes them from accepting other engagements, and does not keep them before the public. Lucine Amara is an American singer who made her Metropolitan debut in 1950. In his memoirs Rudolf Bing, former general manager of the Metropolitan, describes her as "a well-trained artist with an accurate flexible voice," who "could be counted on to manage at least acceptably most of the soprano roles in the Italian repertory—but somehow she had never acquired the projection of a star" (Bing 1972, p. 201). She did have great value as a cover, and for ten years or so the Met used her for this purpose, paying her more than $50,000 per year for being prepared to sing. She rebelled when James Levine, the Met's current music director, brought in other singers to substitute for principals who had to cancel, even when she was

the cover artist. Amara filed an age-discrimination suit against the Met and Levine, asserting in her complaint that Levine had told a colleague: "If Lucine Amara would go away, change the color of her hair, have a facelift, change her name and come back within a month singing as she does now, she would be the hottest new soprano around." The New York State Division of Human Rights ordered the Met to conciliate its dispute with her, but I don't know what the outcome has been (*New York Times,* May 12, 1978).

The Met did let her perform on its national tour; we in the provinces do not always get the first team. I saw her name on the program as the Countess in *Figaro* during the Met's stay in Cleveland a few years ago and groaned. I hadn't heard of her in years and thought she must be well past her prime. She sang better than anyone else in the production, but she is low-key and does not project on stage. Her story shows that good singing may not be enough to build and sustain a satisfactory career; one must also have youth and glamor or the projection of a star.

Beyond the small cadre of artists with great international reputations and matching drawing power at the box office, managers and audiences tend to want new faces and new voices. Catching a major new talent on the eve of a great career brings with it the thrill of discovery and the boast that I heard him or her way back when and just *knew* that he or she was destined for greatness.

The story of Birgit Nilsson's three Tristans illustrates both that thrill of discovery and the importance of covers to an opera company. In 1959 Nilsson made a sensational debut at the Met. Not since Flagstad had there been a voice of such power, range, and beauty. Her next performance was to be Isolde. Unfortunately for the Met, both the tenor scheduled for Tristan and his cover were indisposed. The Met did have a third singer able to perform the role, American Albert Da Costa, but he too became ill. The management did not want to have to cancel the performance or substitute another opera and thus disappoint the full house waiting to hear Nilsson. (The management does not provide refunds for changes in the cast but does for a change of opera.) Bing's solution was to ask each man if he could get through one act, and so Nilsson sang Isolde to three different Tristans (Bing 1972, pp. 260–263).

Many years before, in the 1930s, the tenor scheduled to sing Des Grieux in *Manon* could not go on. A young singer from Oklahoma, Joe Benton (known professionally as Giuseppe Bentonelli) came to the Met looking for an audition. He was asked whether he knew the role and when he said yes was immediately engaged. Such stopgaps may have saved performances, but they did not help singers build careers or endear the management to a public paying for and expecting to see established artists.[2]

In those years before the Second World War, and indeed after, there were not many places in the United States for young artists to grow and develop in their crafts. Chicago and San Francisco had opera seasons using well-known international artists. Such great European singers as Jussi Björling, Elisabeth Schwarzkopf, and Renata Tebaldi made their American operatic debuts in Chicago or San Francisco. Established Americans such as Moore and Tibbett

also sang in these houses, but they provided only limited opportunities for beginners (Davis 1966).

From its founding in the 1940s the New York City Opera has had a policy of featuring young American artists, and many aspiring singers have benefited from its activities and the New York exposure. Moreover, the City Opera engaged black artists before the Metropolitan did. A small number of touring companies also helped provide stage experience but under rigorous conditions. Early in her career Beverly Sills did sixty-three one-night stands in a bus with the Charles Wagner Opera Company singing Micaela in *Carmen.* Baritone Sherrill Milnes, who once did singing commercials for television, toured with the Goldovsky Opera Theater and has publicly expressed his gratitude for the experience. Dorothy Kirsten, whom Grace Moore sent to Italy to study, performed with the San Carlo Company. All three artists then sang for the New York City Opera and later went on to major careers with the Met and other international houses. Like her mentor Grace Moore, the equally blonde and beautiful Kirsten managed to combine success in popular music on radio and film with the rigorous demands of opera. She was one of the few artists who sang with the Met for more than twenty-five seasons. When she did Minnie in *Fanciulla,* the vigorously athletic Kirsten literally rode in on horseback to save the tenor from hanging; it was a great show. Beverly Sills will soon retire from singing and has taken over as manager of the New York City Opera. She has pledged to continue the policy of spotlighting young Americans; she has also received commitments from City Opera alumni and current international stars, such as Milnes and tenor Placido Domingo, to do some performances for the company, presumably at much lower fees than they normally command (Central Opera Service 1978, pp. 59, 54).

The New York City Opera experience is not always positive. Carol Neblett is an American soprano, now in her mid-thirties, who has a big voice. Big voices are always in demand for the heavier dramatic roles in large houses. Neblett's manager has expressed concern about her future: "She had to spend ten years at the New York City Opera working constantly on new repertoire with no rehearsal or very little rehearsal. This could not have been good for her psychologically or vocally. And I do not know whether she will be able to go further in her mid-thirties and forties, into the repertoire which she could do in her forties without scars of that first ten years" (Central Opera Service 1978, p. 64).

The small companies, including the New York City Opera, could not accommodate all the aspiring young Americans. The combination of a large number of well-trained Americans, dislocations accompanying the Second World War, and postwar economic troubles opened many opportunities in European theaters. German managers, especially, found the United States a good source of talent, and hundreds of young Americans found positions in German houses. The pattern continues, although there is some indication that opportunities for Americans in Germany may diminish with an increasing supply of homegrown talent and nationalistic sentiments. Thea Dispecker, an artist's representative who has placed many Americans in European houses, tells aspiring young performers that they should be prepared to spend up to seven years in Europe, that they could not

hope to develop repertoire and reputations in a year or two (Central Opera Service 1978, p. 42).

In the meantime there has been a tremendous increase in the number of operatic companies and performances in the United States. The Central Opera Service Annual Opera Survey reports that in 1954–55 there were about 3,200 operatic performances in the United States, in 1974–75 the number had doubled to more than 6,400, and in 1977–78 it exceeded 7,800. The audiences in the last season totaled almost 10 million (Central Opera Service 1978).

Clearly, opera in America is a growth industry, and there are more opportunities for American singers than ever before. But it is still a fiercely competitive business; only a handful will reach the peak of stardom, where singers can command $6,000 to $10,000 per performance and bargain effectively with management on repertory and other conditions. Most singers still have to find other ways of making a living. One respected voice teacher with fourteen years experience has had only two students make professional careers, but they were not the two who seemed the most obviously gifted at the outset (Central Opera Service 1978, p. 24).

There are hundreds of colleges, universities, and conservatories offering vocal training, and the Central Opera Service Bulletin, *Career Guide for the Young American Singer* (1978), lists the apprenticeship and performance opportunities available for those artists who have finished bachelors or masters degrees but who have not yet established themselves professionally. Aspiring performers can find many more people ready to teach than to hire, and only a few will have the combination of talent, good training, stamina, and fortitude to make it. Thus, opera remains a career where many are called but few are chosen. The lure of being a star—or superstar in today's hype—with the attendant rewards in money and fame, as well as the love of music and performing, keeps drawing many more young people to the field than can find places within it. On one level, this is a tragic waste of time and talent; on another it may be a necessary precondition for developing those few artists who can keep the "grand tradition" alive and well.[3]

Notes

1. See Henry Pleasants, *The Great Singers: From the Dawn of Opera to Our Own Time* (1966, pp. 297–300); Joe Laurie, Jr., *Vaudeville: From the Honky Tonks to the Palace* (1972, p. 150); and Henderson, *The Art of Singing* (1938, pp. 385–389). Henderson, who was not easily pleased and who had heard all the great singers of the golden age of the 1890s, greatly admired Ponselle's determination to learn how to sing *after* she came to the Metropolitan. He spoke of "the clouds of glory which she now trails." He thought that her recitatives could use some improvement, but he acknowledged that the public doesn't care as long as she "can sing her arias with all the opulence of that gorgeous voice. . . ." See J. B. Steane, *The Grand Tradition: Seventy Years of Singing on Record* (1974, pp. 289–294) for evaluations of Ponselle's commercial and private records.

2. See Kolodin (1966, p. 392). Kolodin gives his first name as Joseph. Davis (1966, p. 207) mentions the Oklahoma background and uses the name Giuseppe.

3. W. J. Henderson's essay on "The Rarity of Singing Talent," written in 1930, still holds true, although now people can be trained at home rather than going to Paris. Henderson (1938, pp. 390–398).

References

Bing, Sir Rudolph. 1972. *5000 Nights at the Opera*. Garden City, N.J.: Doubleday.

Central Opera Service. 1978. *The Training and Career Development of the Young Professional American Singer*. Proceedings of the sixteenth national conference. New York: Central Opera Service.

Davis, Ronald L. 1966. *Opera in Chicago*. New York: Appleton-Century.

Henderson, W. J. 1938. *The Art of Singing*. New York: The Dial Press.

Homer, Anne. 1974. *Louise Homer and the Golden Age of Opera*. New York: William Morrow & Co.

Kolodin, Irving. 1966. *The Metropolitan Opera, 1883–1966*. New York: Alfred Knopf.

Kutsch, H. J. and Riemen, Leo. 1969. *A Concise Biographical Dictionary of Singers: From the Beginning of Recorded Sound to the Present*. Trans. by Harry Earl Jones. New York: Chilton Book Co.

Laurie, Joe, Jr. 1972. *Vaudeville: From the Honky Tonks to the Palace*. Port Washington, N.Y.: Kennikat.

Lipman, Samuel. 1979. Music: The State of the Art. *Commentary* 67 (May): 68–74.

New York Times. May 12, 1978, p. C28, column 1.

Pleasants, Henry. 1966. *The Great Singers: From the Dawn of Opera to Our Own Time*. New York: Simon and Schuster.

Sargeant, Winthrop. 1973. *Divas*. New York: Coward, McCann & Geoghegan.

Steane, J. B. 1974. *The Grand Tradition: Seventy Years of Singing on Record*. London: Duckworth.

Wechsberg, Joseph. 1972. *The Opera*. New York: Macmillan.

Comment
David E. Ault

The primary purpose of Richardson's paper is to describe the career patterns of selected American opera singers in order to isolate a set or alternative sets of elements that have led to successful careers. Such an analysis could be used to identify the critical paths that will lead potential singers to successful careers. There are two principal problems that must be addressed if this approach is used: (1) a successful career must be defined, and (2) a clearly defined market for the services of opera singers must be specified.

Defining a successful career is of necessity somewhat arbitrary. Must one become a "professional" singer to have a successful career? If so, what percentage

of income must be earned from singing before one becomes a professional? If amateurs can have successful careers, what is the appropriate measure of success?

With respect to the market for opera singers, one must be careful to specify the market structure prior to analyzing the effects of an increase in supply or demand on the employment of singers. It seems that this is an imperfectly competitive market with product differentiation, that is, the market structure commonly referred to as monopolistic competition. The demand for opera singers is derived from the demand for the staging of operas. The demand depends, therefore, upon the opera to be performed, which, in turn, determines the characteristics of each singer employed by the producer. In Lancastrian terms, in each singer is embodied a bundle of characteristics. Among the more important characteristics are:

experience;
voice quality (including tone, volume, and range);
repertoire;
acting ability; and
physical appearance.

Few singers, relative to demand, have the values of these characteristics preferred and, therefore, demanded by producers. The singers who do command the highest prices by acting as monopolists in the sale of their services in a classical bilateral or, perhaps, multilateral bargaining situation.

For those singers whose characteristics are not equal to the preferred values of the producers, salaries will be smaller as producers attempt to maximize the quality of their productions by selecting the combination nearest the preferred combination. Trade-offs are made between experience and youth, between repertoire and voice quality, and so on. Because the possible trade-offs are so many, the supply of singers with fewer than the preferred number of combinations of characteristics exceeds demand, especially in the United States, creating a gap between the salaries of those with preferred combinations and those with less desirable combinations. Apparently in Europe demand is more nearly equal to supply for different combinations of characteristics, because European producers employ fewer experienced singers than U.S. producers do.

The supply of singers is the result of investment by individuals in the quality of their voices and the other characteristics necessary for entry into the market for opera singers. The amount that the individual will invest in the development of characteristics depends on the expected benefits of such investments versus the expected costs. The expected benefits may be more apparent to the potential singer than the expected costs of achieving a specific level of development, because, as Richardson states, there is no standard method for training young singers. The different techniques and philosophies for training singers create a problem for those who have been told or believe they have some talent. Knowledge of the costs of a potential singer's development is not easily obtained. The prospective singer must rely on those who will provide training for advice as to

how much will be necessary to achieve the desired values of characteristics. The potential for abuse is obvious when information is disseminated by those with a vested interest in prolonging the training period or by agents seeking singers to fulfill their agreements with producers or companies.

As Professor Richardson indicates, investment decisions are complex. Should the singer invest in repertoire, voice range, or travel in Europe? The sources of information are not likely to provide the unbiased information the potential singer needs to make sound decisions with respect to the development of voice and other characteristics. For example, what makes European experience a sound investment? Richardson's examples do not provide an explanation for the hypothesized value of European experience. It is apparent that potentially talented singers require more reliable information to avoid mistreatment or neglect.

Richardson's paper is a first attempt to define the market for opera singers. More case histories will have to be obtained in order to test the hypotheses suggested by his work and to determine if the application of the Lancastrian framework suggested in these comments is relevant.

Policy Implications of a Composer Labor Supply Function

Marianne V. Felton

I T IS WELL KNOWN that fewer than a dozen composers make a living from composing alone. The others must find full-time employment, the majority being employed at institutions of higher learning. Part of their income from this activity is in turn used to subsidize the production of music. Because composers are required to spend most of their time in pursuit of a living, their musical output is curtailed and these unique musical resources are wasted.

THE LABOR SUPPLY FUNCTION

To assess the influence of patronage on the output of compositions, one might test the hypothesis that a relatively modest improvement in the economic reward of composing will result in a relatively large additional investment of time in composing. What is needed is a labor supply model which explains the amount of time composers spend composing, as well as their income from such activity.

The General Model

The composer faces three options in deciding how to spend his time: (1) working in the labor market other than composing, (2) composing, or (3) pursuing leisure or other non-wage-generating activities. Other members of the household are assumed not to be composers and, consequently, to have only two options: (1) working in the labor market, and (2) pursuing leisure or other non-wage-generating activities. All activities other than composing which do not produce money income will be considered leisure activities, even though we recognize that home production is a major source of social and private income.

The household is assumed to act in such a way as to maximize its utility:

$$(1) \quad U = U(G, C, L_c, L_s)$$

where G stands for market goods and services, C for time spent composing, L_c for the composer's leisure, and L_s for the leisure of other members of the household.[1] For simplicity, it will be assumed that the household consists of no more than two members, so that L_s becomes the spouse's leisure.

This utility function is subject to a budget constraint:

(2) $\ pG = w(T - C - L_c) + c(C) + o(T - L_s) + Y_n$

where p stands for the price of goods and services, w is the composer's wage rate from work other than composing, c is the composer's wage rate from composing, o is the wage rate of other household members, Y_n is nonwage income, and T^n is total time available to each individual in the period.

The budget constraint may be rewritten as:

(3) $\ wL_c + (w - c)C + oL_s + pG = (w + o)T + Y_n \equiv Y_f$

where Y_f is the imputed potential value of time available, à la Becker.

This simply states that the sum of the household members' expenditures on leisure time, composing time, and goods and services must equal the income they would earn if they were to work during the total time available plus nonwage income or full income, Y_f. The full-income concept provides us with a single resource constraint combining both goods and time, based on the fact that time can be converted into goods through money income. It is assumed that $w \geq c$ so that second-order conditions may be met.

To maximize utility subject to the budget constraint, we use the Lagrangian multiplier and write the augmented objective function as:

(4) $\ Z = U(G, C, L_c, L_s) + \lambda(wL_c + (w - c)C + oL_s + pG)$

Taking the partial derivative of Z with respect to each argument of the utility function and setting it equal to zero yields a set of simultaneous equations which may be written as:

(5) $\ \dfrac{U_{L_c}}{w} = \dfrac{U_c}{w - c} = \dfrac{U_{L_s}}{o} = \dfrac{U_G}{p} = \lambda$

where λ is the marginal utility of full income.[2] This states the proposition that in order to maximize utility, assuming second-order conditions are met, the consumer must allocate his budget so that the ratio of marginal utility to price is equal for every commodity, including time. At equilibrium, w can be interpreted as the composer's psychic income from leisure.

The utility theory of demand implies that the amount of time the composer is willing to spend not working at earning a living depends on the various wage rates and on nonwage income,[3] or:

(6) $\ L_c + C = f(w, c, o, p, Y_n)$

If we let goods be the numeraire, we can write equation (6) as:

(7) $\ L_c + C = f(w, c, o, Y_n)$

Formulation for Empirical Testing

We now wish to assess the influence of a change in the independent variables on the dependent variables. If we specify a linear relationship and assume that the taste for leisure is normally distributed among composers and uncorrelated with the other independent variables so that it may be caught in the error terms, we arrive at an empirical model:

(8) $C = a_0 + a_1 w + a_2 c + a_3 o + a_4 Y_n + u$

Before proceeding with estimation, modifications are necessary. One difficulty in estimating the equation in this form is that we have no data for the spouse's wage rate. Since the spouses in our sample vary with respect to sex, age, education, and occupation, no meaningful average can be used as a surrogate for the missing data. There is no alternative but to drop the term $a_3 o$ from the equation and substitute the spouse's income, Y_s, thereby omitting the estimation of the cross-substitution effect. The result of this omission is probably not serious. Kosters made a similar assumption and found that his estimates were not substantially altered by using plausible alternative assumptions. Since this term is expected to have a positive effect on C, the result of its omission would be to understate the change in C.

The second difficulty in estimating equation (8) concerns the wage rate from composing. What is really needed here is the discounted expected hourly return over the future of the composer's life.[4] The expected value is needed because composers are presumed to base their actions on these expectations. The discounted value is appropriate because income received in any one year may result from composing activity that took place many years ago. To discount present income, a detailed breakdown would be needed as to how much income is derived from each composition, when it was composed, how long it took to compose it, and the appropriate discount rate. Unfortunately, no such information is available. What is available is income from composing received during calendar year 1974–75, broken down by source, such as performing rights income, royalties, and income from commissions. This income is a mixture of a number of different kinds of payments. First, it may represent a wage for composing in the sense of a payment for the opportunity cost of the composing activity. As a rule, however, unless directly employed by a publisher or receiving a commission, the composer receives no such wage. Second, once a composition is completed and assumes a life of its own, the stream of services it provides may generate payments, part of which accrue to the composer, who retains some interest in the copyright through contracts with the publisher and others. Third, the "income" may incorporate a real or pecuniary capital gain, either because of an increase in demand for a composer's work or simply because of inflation. In view of the remoteness of the available information concerning the discounted expected hourly rate of return over the lifetime of the composer, we are forced to replace the wage rate from composition, $a_2 c$, of equation (8) by income from composing, Y_c.

A third alteration in equation (8) follows from the realization that not all income from composing conforms to the normal or permanent concept of income

that applies to long-run behavior. According to ideas introduced by Friedman, Duesenberry, Modigliani, and others, consumer behavior is determined primarily by the amount of income a household expects to receive over its life cycle or, at least, over a long period of years. In the case of composers, such income as commissions, foundation grants, and prizes is sporadic at best and may be a once-in-a-lifetime occurrence. It is desirable, therefore, following Mincer, to separate income into a permanent component, Y_p, and a transitory one, Y_t. Income from commissions, grants, and prizes will be considered transitory income; performing rights, royalties, license fees, and rental income are permanent.

Given these qualifications, we can rewrite equation (8) in a form capable of estimation with the data at hand:

(9) $C = b_0 + b_1 w + b_2 Y_n + b_3 Y_p + b_4 Y_t + b_5 Y_s + u$ where

C = the number of hours per month spent composing
w = the wage rate from noncomposing work
Y_n = nonwage income
Y_p = permanent income from composing
Y_t = transitory income from composing
Y_s = spouse's income

Variations on this basic model can be made, of course, by including such additional variables as age, sex, race, years of education, and type of employment.[5]

THE TOTAL REVENUE FUNCTION

Just as we wished to identify the main influences on the number of hours spent composing, we also want to assess the incremental contributions of the various factors thought to be associated with income from composing. Here we will consider income from composing as total revenue, such that $R = \Sigma P_i Q_i$ where R is total revenue, P_i is the return per composition in the i-th market, and Q_i is the number of compositions which have entered that market. The i's represent the various types of market such as publication or recording. What we wish to determine is the addition to total revenue resulting from the marketing of one additional composition, or its marginal revenue, $\delta R/\delta Q_i$. The partial regression coefficients obtained by estimating the total revenue function will be estimates of marginal revenue. Variables other than compositions marketed are added to account for revenue-influencing factors we wish to hold constant.

We can express income from composing as a function of the following:

(10) $Y_i = f(NC, CP, CR, CC, C, St_j, M_j, MM_j, S, A, R, Sch, E_j, Y_s)$

where

Y_i = income from composing from various sources
NC = the number of compositions completed
CP = the number of compositions published
CR = the number of compositions recorded

CC = the number of compositions commissioned
 C = the number of hours per month spent composing
St_j = a vector of different styles of composition
 M_j = a vector of the number of compositions for various mediums
MM_j = a vector of different marketing methods
 S = sex
 A = age
 R = race
Sch = number of years of formal schooling
 E_j = a vector of various types of employment
 Y_s = spouse's income

The principal object is to discover if and how income from composing is influenced by each of these variables when viewed together.

The numbers of compositions completed, published, recorded, and commissioned are all expected to have a positive influence on income from composing, as is the number of hours spent composing.

Different styles of composition may have different effects on income, depending on their appeal. The more accessible the style, the more positive is the effect one would anticipate. The actual sign of the partial regression coefficient would, of course, depend on which style is chosen as the reference dummy. For example, if the most austere style were picked, all the other regression coefficients would be expected to be positive. Similarly, the various composing mediums would also tend to have varying effects on income, depending upon their popularity.

In the vector of marketing methods one would expect the fact of dealing with a particular publisher to have the greatest positive effect on income, and the fact of shunning all marketing activity the least effect.

If the comments of female composers are to be believed, being male would be expected to result in greater income from composing than being female. Likewise, if the complaints of some black respondents are correct, white composers would anticipate greater incomes than black.

Age is considered to be positively related to income, since the older a composer becomes, the greater his pool of compositions which can generate income.

If it could be assumed that all composers are alike with respect to native ability and motivation, increased years of schooling might be expected to have a positive effect on income from composing. Since we cannot make such an assumption, however, the effect of more years of education may turn out to be negative, particularly if formal schooling is used as an imperfect substitute for creative talent.

Different kinds of employment would tend to have varying effects on income, depending on how much time the work leaves for composing and marketing activities, opportunities for marketing, salary, incentive to compose, and so forth.

An increase in the spouse's income is expected to have a positive income effect on the number of hours a composer spends composing and so, indirectly, on income from composing. The composer may, however, spend less effort on marketing, since the need for additional income has been reduced, so that the ultimate outcome of the change in spouse's income is not unambiguous.

When this model is considered in conjunction with the previous one, there is a problem with simultaneity.[6] What we have here are three endogenous variables: the number of hours spent composing, income from composing, and the number of compositions completed. When any of these endogenous variables is used as an explanatory variable, it will be correlated with the error term, yielding biased estimates of the regression coefficients when ordinary least squares methods are used.

One way to overcome this difficulty is to use the two-stage least squares approach. The objective is to purge the explanatory variable of the stochastic component associated with the disturbance term. The method employed in two-stage least squares is to compute estimates of the endogenous variables by regressing them seriatim on the predetermined variables in the model and replacing the actual observations for these endogenous variables with the estimated regression values. In the second stage the ordinary least squares operation is performed on the reformulated models.

The Two-Stage Least Squares Model

In the first equation estimated, the number of hours spent composing was expressed as a function of the composer's wage from noncomposing work, permanent and transitory income from composing, nonwage income, spouse's income, and a number of sociodemographic variables. In the second equation estimated, income from composing was a function of the number of compositions completed, the number of compositions marketed in the various markets, the number of hours spent composing, the various marketing methods, and the same sociodemographic variables. Clearly, stating the number of hours spent composing as partially dependent on income from composing in the first equation and reversing the causal arrow in the second equation lead to the simultaneity problem discussed above. Furthermore, the number of compositions completed may be regarded as depending upon the amount of time spent composing, the number of years of formal schooling, and age, using a production function approach.

Consequently, the following simultaneous equation model can be written, consisting of a labor supply function, a total revenue function, a production function, and two identities. The identities are needed to relate permanent and transitory income from composing to gross income from composing. This model is just identified with five endogenous variables and five relations:

(9) $C = b_0 + b_1 w + b_2 Y_n + b_3 Y_p + b_4 Y_t + b_5 Y_s + u$

(10) $Y_c = c_0 + c_1 NC + c_2 CP + c_3 CR + c_4 CC + c_5 C + c_6 MM + u$

(11) $\log NC = d_0 + d_1 \log C + d_2 \log Sch + d_3 \log A$

(12) $Y_t \equiv Y_c - Y_p$

(13) $Y_p \equiv Y_c - Y_t$

The Labor Supply Function

Table 1 shows the results of the two-stage least squares estimation. The fourth column represents the labor supply function. We can use some of the variables in this column to illustrate how the results can be interpreted. For each $1 per hour

Table 1. *Results of Two-Stage Least Squares Estimation*

| Independent Variable | Unit of Measure | Means (Standard Deviations) | Labor Supply Function[a,d] | Total Revenue Function[b,d] | Production Function[c,e] |
|---|---|---|---|---|---|
| Wage Rate | $ per hour | 12.98 (15.23) | .48[f] (.93)[g] | | |
| Nonwage Income | $ per year | 671 (2862) | −.001 (−.49) | | |
| Permanent Income | $ per year | 702 (2072) | −.004 (−.54) | | |
| Temporary Income | $ per year | 837 (2425) | .025** (3.76) | | |
| Spouse's Income | $ per year | 3036 (5225) | .0008 (1.04) | −.07 (−1.54) | |
| Age | Years | 43.73 (10.95) | .44 (.86) | 5 (.19) | .99** (4.37) |
| Number of Years of Formal Schooling | Academic Years | 19.36 (2.20) | 5.46* (2.05) | −67 (−.59) | −1.08* (−2.34) |
| Sex | Dummy[h] | .90 | .14 (.01) | 1192 (1.50) | |
| Race | Dummy[i] | .03 | −59.43 (−1.92) | 2719* (2.05) | |
| No Employment | Dummy[j] | .01 | 42.84 (1.22) | −1211 (−.60) | |
| Self-Employed | Dummy[j] | .07 | 48.77 (1.64) | 3098** (2.81) | |
| Employed by Musical Organization | Dummy[j] | .01 | 14.34 (.25) | −72 (−.02) | |
| Nonmusical Employment | Dummy[j] | .03 | 28.92 (1.06) | 403 (.29) | |
| Combination of Jobs | Dummy[j] | .22 | −2.20 (−.22) | 160 (.30) | |
| Number of Hours Spent Composing | Hours per Month | 33.41 (34.40) | | 35** (3.44) | .04 (1.00) |
| Number of Compositions Completed | Units | 68.82 (81.19) | | −2 (−.80) | |

Table 1. *Cont.*

| Independent Variable | Unit of Measure | Means (Standard Deviations) | Labor Supply Function[a,d] | Total Revenue Function[b,d] | Production Function[c,e] |
|---|---|---|---|---|---|
| Number of Compositions Published | Units | 13.75 (20.87) | | 19 (1.26) | |
| Number of Compositions Recorded | Units | 3.53 (6.24) | | 48 (1.24) | |
| Number of Compositions Commissioned | Units | 4.63 (6.41) | | 122** (2.86) | |
| Market with Particular Publisher | Dummy[k] | .27 | | 796 (.94) | |
| Shop Around among Publishers | Dummy[k] | .25 | | −771 (−.95) | |
| Other Marketing Methods | Dummy[k] | .17 | | −52 (−.06) | |
| Combination of Methods | Dummy[k] | .19 | | −607 (−.68) | |
| Constant | — | — | −123.87 | −269 | 23 |
| Number of Cases | — | — | 208 | 208 | 208 |

[a]Dependent variable—number of hours spent composing per month.
[b]Dependent variable—gross income from composing.
[c]Dependent variable—number of compositions completed.
[d]Arithmetic function.
[e]Logarithmic function.
[f]Partial regression coefficient.
[g]t statistic.
[h]1 if male, 0 if female.
[i]1 if black, 0 if not black.
[j]1 if yes, 0 if educational institution.
[k]1 if yes, 0 if no marketing activity.
**Significant at .01.
*Significant at .05.

increase in the wage rate, the number of hours spent composing per month is estimated to increase by .48 of an hour. This variable is not statistically significant. For each $1 per year increase in temporary income, hours per month composing increase by .025; or a $1,000 a year increase in temporary income from composing would bring about an increase of 25 hours per month composing time, or 300 hours per year. This variable is significant at the .01 level. For the dummy variable sex, being male elicits only .14 hours more per month of composing than being female. For each year of age, composing time increases by .44 of an hour; for each additional year of school, it increases by 5.46 hours. Composing time for those who are self-employed is nearly 49 hours per month greater than for those employed at an educational institution.

We see from the table that temporary income and number of years of schooling are the only variables which are significantly associated with hours of composing. As expected, an increase in temporary income from composing exerts a positive influence on hours spent composing. The fact that composers are willing to increase the amount of time they spend composing for $3.33 an hour while foregoing, in part at least, a wage rate of $12.98 for noncomposing work clearly indicates that composers don't compose primarily for money.

It is interesting to note that the number of years of formal schooling is associated positively with the number of hours spent composing but negatively with the number of compositions completed.

The Total Revenue Function

The results here may be interpreted in a way similar to the labor supply function; for example, each additional year of age is associated with an additional $5 of gross income from composing, but not significantly so.

Only four variables were found to have a significant effect on gross income from composing: race, the fact of being self-employed, the number of hours spent composing, and the number of compositions commissioned.

The number of hours spent composing has a small positive effect on gross income from composing. For each additional hour per month spent composing, gross income increases by $35.

Having works commissioned is the only market significant for gross income from composing. Each additional commission added $122 to gross income in 1974.

Of all the types of employment, self-employment is the only one significantly correlated with income from composing, and the dollar amounts involved are larger than for any other variable. Self-employed composers earned $3,098 more gross income from composing than composers employed by an educational institution. One might hypothesize that self-employed composers are likely to have more flexible hours and can, therefore, spend more time composing, if they so choose. But remembering that each additional hour of composing time per month adds only $35 to annual gross income from composing, this explanation is insufficient to account for the large difference in incomes. Rather, it is more probable that the causal arrow runs the other way. Because these composers earn more

from composing, they can afford to work for themselves. Also, the number of composers who are self-employed is small (eighteen), so a few with very high incomes can have a large influence on the averages displayed in the table.

The few black composers who responded received $2,719 more in gross income than their nonblack counterparts. One would have more faith in the validity of these numbers had the sample of black respondents been larger.

The variable age is very close to being significant. This is not surprising: as composers accumulate more compositions over time, income from composing can be expected to rise, even though the amount of $5 per year is discouragingly small.

The following variables were found not to vary significantly with income from composing: number of compositions completed, all styles and mediums of composing, all marketing methods, sex, number of years of school, all types of employment except for being self-employed, and spouse's income. Apparently the academic label put upon a composer's style and the group of instruments for which he or she composes make little difference from the point of view of income. The output of the various methods of marketing does not differ significantly from no marketing effort at all. Finally, unless the composer is self-employed, the type of job held has little influence on income from composing.

The Production Function

Two variables turned out to be significant for the number of compositions completed. Age has a positive effect; a 1 percent increase in age results in a 1 percent increase in compositions. The number of years of formal schooling, on the other hand, has a negative effect—1 percent fewer compositions for each 1 percent increase in schooling. The effect of number of hours spent composing per month is insignificant.

POLICY IMPLICATIONS

The results discussed so far have obvious implications for efficiency in lending support to composers, should this be a desired policy goal. Table 2 shows what it would cost, based on the coefficients computed above and others computed for subgroups of composers, to induce composers to increase their composing time by 25 percent. Subsidizing the wage rate would be by far the most expensive policy tool and applicable to only one subgroup of composers. For all other groups the wage rate is not significant. An increase in permanent income from composing is the second most expensive tool. This would include subsidizing publication, recording, and performances of compositions. Again, only one subgroup could be influenced by this policy. An increase in temporary income is undoubtedly the most efficient of the monetary incentives. It is normally the way patronage is extended—by commissions, prizes, and foundation grants.

Another alternative is to purchase time for the composer. This could be done by purchasing partial release time from the composer's employer. Apparently, even though release time is not unusual in most university departments, it is a rar-

Table 2. *Annual Cost of Increasing Composing Time by 25 Percent Using Different Policy Tools*

| Group or Subgroup | Policy Tool | | | |
|---|---|---|---|---|
| | Wage Rate | Permanent Income | Temporary Income | Release Time |
| All Composers | NS | NS | $315 | $840 (3,818)[a] |
| 19 or More Years of School | NS | NS | 383 | 856 (3,896)[a] |
| Educational Institution | $22,815 | $1,454 | 727 | 800 (4,167)[a] |
| Combination of Jobs | NS | NS | 491 | 854 (3,755)[a] |

[a]This amount indicates the cost of one-quarter release time, not including fringe benefits. The resulting increase in composing time for all composers would be 113 percent if all the release time were spent composing.

NS = not significant.

ity among nonperforming musicians. This option would meet with the approval of many composers. The respondents were asked what would be an acceptable minimum annual income in order for them to spend all of their time composing. While 122 said they would not want to give up their present job, the 325 who liked the idea cited a mean income of $15,700. They also said they would like to spend an average of 84 hours per month composing compared with the 31 they actually spend—an increase of 53 hours. It should be noted that $15,700 is considerably less than the present mean income of $21,800. The difference could be considered a measure of the average psychic income from composing. Purchasing release time for the composer would reap the added benefit of filtering the decision process associated with the present grant systems. Right now this is in the hands of a few tightly knit cliques, some of which are widely rumored to render a favorable decision only in exchange for certain favors. It would introduce a degree of competition among employers for such grants and increase their level of interest in the activities of "their" composers. It would also increase employment opportunities for musicians, since the released composers would require part-time replacements.

A logical extension of this form of patronage, which could increase composing time by even more per dollar spent, is to hire qualified advanced students to take over the chore of manuscript copying and parts preparation. Nearly all the respondents said they would like to hire this part of their job out but could not afford to do so. This would free about half again as much time for the composer at a much reduced cost, since student rates would be paid instead of faculty rates. At the same time, it could provide invaluable experience for budding composers.

Policy implications with respect to income from composing are not quite so encouraging. There are no obvious solutions to the problem of low income from composing. Increasing the number of hours of composing or having another work published, recorded, or commissioned only increases income by a small amount per year. Unless and until there is an increase in the level of demand for contemporary music, the incomes of the majority of composers from their composing activities will continue to remain small.

Notes

1. For the remainder of this section I am heavily indebted to the works of Mincer (1962), Cain (1966), Kosters (1966), Ashenfelter and Heckman (1974), and Keeley (1978).
2. See Chiang, *Fundamental Methods of Mathematical Economics* (1967).
3. The formulation of the rest of this section follows expositions by Keeley (1978) and Cain (1966).
4. I am indebted to Professor Herbert Kiesling for this point.
5. Although we have been able to arrive at a model capable of estimation in equation (8), its limitations are numerous. First, it is restricted to those households with no more than two potential wage earners. Second, the number of variables left out is limited only by one's imagination. In particular, one might consider the composer's taste for composing, manuscript copying, and marketing activities; the prices of manuscript supplies and other items related to composing; and the prices of leisure goods. Third, measures of some of the variables included are theoretically imperfect. For example, the money wage should ideally be adjusted for taxes and expenses of work. Hours of work should be a fixed, equilibrium measure. Fourth, the assumption that the spouse's earnings are not influenced by those of the composer probably does not conform to reality. Finally, the data collected from the composers reflect the interpretation of the questions by nearly 500 different individuals, as well as the varying degrees of care and devotion to accuracy reflected in their answers. Thus, we may have errors in the variables.
6. In the labor supply function we regarded the number of hours spent composing as a function of income from composing. Here we posit income from composing as partially dependent upon the number of hours spent composing. Intuitively, these hypotheses do not appear to be in conflict. The composer may, on the one hand, be thought to be influenced in the amount of time he spends composing by the amount of income he expects to derive from it. At the same time, it seems plausible to expect that the amount of time he spends composing will influence his income by increasing the quantity of compositions available to be marketed, and perhaps their quality. In addition, we may well have a third endogenous variable embedded in the above equation in the number of compositions completed. This could easily be influenced by the number of hours spent composing.

References

Ashenfelter, Orley, and Heckman, James. 1974. The Estimation of Income and Substitution Effects in a Model of Family Labor Supply. *Econometrica* 42 (Jan.): 73–85.

Becker, Gary S. 1965. A Theory of the Allocation of Time. *Economic Journal* 75 (Sept.): 495–517.

Cain, Glen G. 1966. *Married Women in the Labor Force*. Chicago: Univ. of Chicago Press.

Chiang, Alpha G. 1967. *Fundamental Methods of Mathematical Economics*. New York: McGraw-Hill.

Johnston, J. 1972. *Econometric Methods*, 2nd ed. New York: McGraw-Hill.

Keeley, Michael C. 1978. The Economics of Labor Supply: A Critical Review. Palo Alto, Calif.: SRI International.

Kosters, Marvin. 1966. Income and Substitution Effects in a Family Labor Supply Model. P-3339. Santa Monica, Calif.: The Rand Corp.

Mincer, Jacob. 1962. Labor Force Participation of Married Women. In *Aspects of Labor Economics*, H. Gregg Lewis, ed. Universities–National Bureau Conference Series No. 14. Princeton, N.J.: Princeton Univ. Press.

Comment
Clark C. Abt

Dr. Felton's paper is a fascinating and technically competent application of economic analysis to arts-funding policy in general, and to the issue of musical composer labor supply response to financial support in particular. Dr. Felton demonstrates, on the basis of an empirically derived model of composers' revenue generation, that "a relatively modest improvement in the economic reward of composing will result in a relatively large additional investment of time in composing," and of musical composition output. This is substantiated by current survey data.

Dr. Felton finds that "for each $1 per hour increase in the wage rate, the number of hours spent composing per month is estimated to increase by .48 of an hour," but this variable is not statistically significant. More importantly, she finds that "for each $1 per year increase in temporary income, hours per month composing increase by .025; or a $1,000 a year increase in temporary income from composing would bring about an increase of 25 hours per month of composing time, or 300 hours per year. This variance is significant at the .01 level." She also finds that "composers are willing to increase the amount of time they spend composing for $3.33 an hour while foregoing, in part at least, a wage rate of $12.98 for noncomposing work," from which I infer that the average psychic income derived from composing is equal to the difference between these two numbers, or the amount foregone from noncomposing work, or $9.65 per hour.

There are a number of other fascinating findings. For example, "temporary income and number of years of schooling are the only variables which are significantly associated with hours of composing," but years of formal schooling is associated negatively with the number of compositions completed. Does this suggest that schooling beyond some threshold decreases composers' productivity?

Another fascinating finding is that "the number of hours spent composing has a small positive effect on gross income from composing," and "self-employment is the only type of employment significantly correlated with income from composing. . . . Self-employed composers earned $3,098 more gross income from composing than composers employed by an educational institution." There may be a problem of selection bias here. Better composers, or persons more motivated, may not join educational institutions.

Dr. Felton suggests some significant policy implications for more efficient support of composers. She observes that the most expensive and least efficient policy tool for increasing musical composition output would be subsidizing the wage rate of composers. "An increase in permanent income from composing is the second most expensive tool. This would include subsidizing publication, recording, and performances of compositions." Then she states the most significant policy application of her research: "An increase in temporary income is undoubtedly the most efficient of the monetary incentives. It is normally the way patronage is extended—by commissions, prizes, and foundation grants. Another alternative is to purchase time . . . from the composer's employer." Unfortunately, the study is sparse on institutional background, so employment contexts are unexamined for relative cost-effectiveness.

Respondents to Dr. Felton's survey question were asked about "an acceptable minimum annual income" to allow them to use all their time composing. The overwhelming majority of those surveyed (325 out of 447) cited a mean income of $15,700 as the acceptable minimum annual income. Dr. Felton notes that this is "considerably less than the present mean income of $21,800. The difference could be considered a measure of psychic income from composing [$6,100 a year]."

This policy analyst finds Dr. Felton's econometric research and the derived policy implications extremely significant and scientifically persuasive. For those philanthropic and arts-industry decision makers faced with making investments in the arts, and in musical composition in particular, there are some clear policy guidelines that are empirically derived with sound econometric methods.

Dr. Felton's analysis demonstrates that for a modest subsidy of temporary income to composers in the amount of $15,700 a year, it is possible to obtain a large labor supply of full-time composers. This $15,700 public service employment should be compared with a high of $12,000 per person per year in 1973 in CETA jobs. The cost of funding music production is higher, but at the same time it promises to result in an enormously valuable cultural production.

The ultimate issue of the return on public investment in composing remains, however. We still need empirical research on the present market value of the additional musical compositions that Dr. Felton indicates we can obtain economically—before governments can decide whether additional public investment is likely to achieve a positive and competitive return.

Uncertainty and Investment in Human Capital in the Arts*

C. Richard Waits
and
Edward M. McNertney

THIS PAPER IS CONCERNED with uncertainty in the arts. Our focus is on the risk involved in investing one's time, effort, and funds in acquiring the skills necessary to become an artist. Our concern is that greater risk may reduce the flow of human resources toward artistic creation relative to other occupations. If this underallocation exists, then some form of government policy may be necessary to ensure an adequate supply of artists.

The need to study the role of uncertainty in the arts was pointed out in *Understanding the Employment of Actors*: "An important issue to address is the effect of differential degrees of the contractual risk on an actor's willingness to supply labor. How does an actor compensate for increased risk of employment and income?" (Ennis and Bonin 1977, p. 26). Their study did not seek to answer this question; they raised it as an indication of the need for further research in order "to guide policy planning in the arts" (p. 25). Before addressing this issue, one must first determine whether there is increased risk of income in the arts.

MOTIVATION FOR STUDY

In any occupation for which special skills are needed, individuals seeking to enter the profession must engage in a conscious effort to acquire these skills. This entails an act of investment in oneself, that is, foregoing of current consumption in order to acquire an asset which then is used for productive purposes. This is the concept of human capital, originally developed by Becker (1964) and Mincer (1958).

The social involvement in this set of individual choices is relative to two factors: the level of output desired by the society and the intensity of social demands

*We wish to acknowledge the contributions of James L. Mayne, who provided invaluable computer expertise, and Marilyn Forney, who provided invaluable editing and typing expertise.

for particular types of outputs. The first of these factors suggests that society is willing to give up a portion of its present income and to promise a share of future income (perhaps larger than it might otherwise have been) to those who make investments now. In other words, social demands for larger outputs lead to social participation in the individual's cost of acquiring productive assets, including personal skills.

The second factor suggests that society is willing to make social concessions to persons who invest in particular types of assets in order to produce as much of some specific product as the society requires. If conventional market mechanisms generate inescapable risks in individual investments and if these risks vary from one investment to another, then there may be a shortfall in the output of those enterprises in which risk is unusually high. If it can be shown that the risk in a particular set of enterprises will result in less output than is desired, then we may conclude that society will be better off if it elects to compensate for that risk outside conventional market mechanisms.

HYPOTHESIS AND METHODOLOGY

Our hypothesis is that there is greater risk involved in choosing art as a profession than in choosing other occupations requiring a similar skill level. This risk is evidenced by greater variability of earnings. The increased risk in entering the occupation should decrease the number of people choosing to be artists.

The effect of risk on labor supply has two elements: the first is the effect of increased risk on labor force participation of those already possessing the necessary skills, and the second is the effect of increased risk on the occupational choice of individuals who need to acquire the necessary skills to enter the occupation.

The first of these elements concerns the effect on the labor/leisure choice of a change in the disparities between earnings of persons in the occupation. It is assumed that the person possesses the necessary skills and can choose to enter the labor force (or increase the number of working hours) in response to a change in wage rates or a change in the degree of dispersion. A change in wage rates affects the labor/leisure choice through substitution or income. The substitution effect is positive: an increase in wage rates will increase labor supply and decrease demand for leisure, because the opportunity cost of a unit of leisure has increased. The income effect, however, is negative: an increase in income resulting from higher wages will decrease the supply of labor and increase the demand for leisure because of the diminishing marginal utility of income. Thus, the effect of a wage increase on labor supply is ambiguous. At some levels the substitution effect will dominate; at others the income effect will dominate. This is the familiar notion of the backward-bending labor supply curve.

This analysis has been extended to include the effects of uncertainty on the labor supply decision. Block and Heinecke have found that "changes in wage rate dispersion lack unambiguous incentive effects" because of the differing signs of the substitution and income effects (Block and Heinecke 1973, p. 383). Thus, the results are similar to those of the deterministic case.

The effect of increased risk on investment in acquiring skills for a given occupation is to require a higher rate of return to compensate for the greater possibility of loss. Given two projects with the same rate of return, the one with lower risk would be chosen. The same is true of human capital: given two distributions of earnings with the same mean, an individual "would prefer the one with the lower coefficient of variation" (Weiss 1972, p. 1208). Thus, the higher the degree of risk associated with an occupation, the less likely one is to choose that occupation.

The second of the above two effects of risk on labor supply is the one with which we are concerned. The risk arises because the actual earnings an individual will obtain in a given market situation are unknown. The assumption made is that the individual bases his or her expected lifetime earning stream in an occupation on the current earnings of those in the same occupation. The individual may expect to earn an amount equivalent to the mean of the earnings distribution in that occupation. Because of the fact that the actual earnings may differ from the mean, the individual must consider the possibility that his or her earnings will deviate from that mean; that is, the variance of the distribution must also be examined. The individual considers his or her actual position on the earnings distribution as a random phenomenon (Weiss 1972).

The data needed to test our hypothesis consist of earnings distributions by occupation. We have gathered such data for several occupations in which similar skills are required and have calculated the mean, variance, and coefficient of dispersion in each category. Using this information, we can then determine whether there is a significant difference between the variances for the selected occupations and the variance for artists. If the variance is shown to be significantly greater for artists than for other occupations, then our hypothesis will be supported.

DATA ANALYSIS

The data were taken from the *1976 Survey of Income and Education Microdata File*, published by the U.S. Bureau of the Census. This file contains data for the entire United States and for each of nine census divisions. Since we are concerned with the income of artists and since we have assumed that the major concentration of artists is on the East and West Coasts, we have examined the Middle Atlantic and Pacific regions only. The states in these regions are New York, New Jersey, Pennsylvania, Washington, Oregon, California, Alaska, and Hawaii.

The census file contains various types of income by occupation for households surveyed. The income is broken down into various classifications, the most important of which are wage and salary income, self-employed income, earned income, other income, and total income. Since we were interested in earnings by occupation, we have used the earned income data for our analysis. However, because of the possibility that the other income component could be quite large and could subsidize earned income, we have also analyzed total income.

The broad occupational category which contains the relevant data is Professional, Technical, and Kindred Workers. From this category, the following occupations have been chosen: accountants, mechanical engineers, lawyers, chemists,

Table 1. *Mean, Standard Deviation, and Coefficient of Dispersion of Earned Income*

| Occupation | Mean | Standard Deviation | Coefficient of Dispersion | N |
|---|---|---|---|---|
| Accountants | $13,247 | $10,404 | .79 | 476 |
| Artists | 7,022 | 8,399 | 1.20 | 101 |
| Chemists | 16,162 | 8,769 | .54 | 64 |
| Economists | 21,488 | 11,514 | .54 | 58 |
| Lawyers | 23,066 | 15,210 | .66 | 191 |
| Mechanical Engineers | 19,849 | 8,150 | .41 | 99 |

economists, and painters and sculptors. These occupations are all highly skilled and require a conscious act of investment in order to acquire the necessary skills.

The mean, standard deviation, coefficient of dispersion, and number of observations in each occupation for both earned and total income are presented in Tables 1 and 2, respectively. Examination of these tables clearly shows that artistic income exhibits greater variability than does income in the other occupations. For example, the coefficients of dispersion for earned and total income for artists are 1.20 and 1.09, as compared to .79 and .77 for accountants.

The next step in our analysis is to determine whether the variance in artists' incomes is significantly larger than the variance in the other categories. There are two possible tests one might use: the chi-square and/or F-test. However, to use either of these tests, one must assume that the population distribution is normal. Analysis of our data does not support this assumption.

The tests would still be valid if the data could be properly transformed, however. In particular, if the log of the data were normally distributed, then the above significance tests could be used. (See Aitchison and Brown [1963] for a discussion of the log-normal distribution.)

There is ample precedent for assuming that the distribution of income is log-normally distributed (Blinder 1974, pp. 3–8). However, we chose to examine our data instead of making this assumption. One suggestion is to plot lost income against cumulative frequency as a test (Aitchison and Brown 1963; Weiss 1972). If the plot is a straight line, then the data are log-normally distributed. Our data held up rather well under this test. Thus, we concluded that the distribution was approximately log-normal, allowing us to use the chi-square and/or the F-test.

Table 2. *Mean, Standard Deviation, and Coefficient of Dispersion of Total Income*

| Occupation | Mean | Standard Deviation | Coefficient of Dispersion | N |
|---|---|---|---|---|
| Accountants | $14,647 | $11,333 | .77 | 476 |
| Artists | 7,865 | 8,541 | 1.09 | 101 |
| Chemists | 16,723 | 9,180 | .55 | 64 |
| Economists | 23,664 | 13,741 | .58 | 58 |
| Lawyers | 27,131 | 20,338 | .75 | 191 |
| Mechanical Engineers | 19,849 | 8,150 | .41 | 99 |

Tables 3 and 4 present the results of these tests. Examination of these tables reveals that the variance in artists' incomes is significantly greater than the income variance in any of the other occupations. (For obvious reasons zero and negative incomes were removed from the sample before transformation.)

Table 3. *Results of Significance Tests by Occupation, Earned Income*

| Occupation | Natural Log of | | Coefficient of Dispersion | Adjusted Standard Deviation† | χ^2 | F |
|---|---|---|---|---|---|---|
| | Mean | Standard Deviation | | | | |
| Accountants | 9.7519 | .8867 | .0909 | .7370 | 532.267* | 4.086** |
| Artists | 8.1074 | 1.7923 | .2211 | — | — | — |
| Chemists | 9.5704 | .5471 | .0572 | .4637 | 1344.592* | 10.732** |
| Economists | 9.8393 | .6113 | .0621 | .5035 | 1140.422* | 8.596** |
| Lawyers | 9.7425 | 1.1587 | .1189 | .9640 | 311.075* | 2.393** |
| Mechanical Engineers | 9.7170 | .6328 | .0651 | .5278 | 1037.829* | 8.022** |

*Significant at .005 level.

**Significant at .01 level.

†The adjusted standard deviation was calculated by multiplying the coefficient of dispersion of occupations other than artists by the mean of artists' income. The result is what the standard deviation of the occupation would have been had it had the same mean as that of artists. The actual standard deviation of artists was then compared to the calculated standard deviation of each occupation to determine the χ^2 statistic.

Table 4. *Results of Significance Tests by Occupation, Total Income*

| Occupation | Natural Log of | | Coefficient of Dispersion | Adjusted Standard Deviation† | χ^2 | F |
|---|---|---|---|---|---|---|
| | Mean | Standard Deviation | | | | |
| Accountants | 9.3197 | .8918 | .0957 | .7990 | 377.654* | 3.260** |
| Artists | 8.3488 | 1.6101 | .1928 | — | — | — |
| Chemists | 9.6047 | .5409 | .0567 | .4700 | 1091.421* | 8.861** |
| Economists | 9.9293 | .5967 | .0601 | .5018 | 957.474* | 7.281** |
| Lawyers | 9.8652 | 1.1247 | .1140 | .9518 | 266.132* | 2.049** |
| Mechanical Engineers | 9.7986 | .4784 | .0488 | .4074 | 1452.600* | 11.327** |

*Significant at .005 level.

**Significant at .01 level.

†The adjusted standard deviation was calculated by multiplying the coefficient of dispersion of occupations other than artists by the mean of artists' income. The result is what the standard deviation of the occupation would have been had it had the same mean as that of artists. The actual standard deviation of artists was then compared to the calculated standard deviation of each occupation to determine the χ^2 statistic.

These results support our hypothesis that artists' incomes are more variable than are incomes in other occupations requiring a similar skill level. Thus, we can conclude that the decision to invest in becoming an artist is fraught with more risk than the decision to prepare for other occupations.

POLICY IMPLICATIONS

Our analysis has supported the hypothesis that there are real differences in the risks associated with the occupations analyzed. Since the market mechanism is liable to underallocate human resources to artistic occupations, society should consider taking steps to compensate for this greater risk in any of the following three ways.

The first option is to depend on private, voluntary contributions from individuals or businesses. This approach seems most likely to take the form of some nonmarket type of transfer. The subsidy may be a family's direct support, a "retainer" in which the artist is ostensibly on the payroll, or a pseudomarket in which galleries are operated at a loss or works are purchased without respect to current appraisals of artistic merit. The effectiveness of any of these forms of subsidy requires that the pattern of preferences among individuals with sufficient income to provide these contributions be very close to the pattern of preferences in the population at large. The probability that this is so seems to diminish as the scope of the art market becomes smaller.

The second option, public subsidies, offers the possibility, at least, that support will be given to a group of artists whose works will generally conform to the pattern of preferences of the entire electorate. Whether this is realized obviously depends both on the nature of the polity and on the political system used to register popular tastes. Questions regarding criteria for selecting recipients of the stipend are common, and there seems to be a general mistrust of government agencies that carries over into programs of artistic subsidy. The principal disadvantages of this option are, first, that there are no private, nongovernment inputs to the selection of recipients and, second, that it would involve a considerable expense. A lifetime subsidy equal, say, to the difference between mean incomes of artists and of persons in the other occupations in this study would require an endowment of approximately $156,000 for each twenty-three-year-old labor force entrant, which includes no allowance for productivity gains or inflation.

The third option is to offer a subsidy for the acquisition of the skill in the first place. If government were to offer to pay some portion of the cost of an artist's training and development, then an income stream of a given size and certainty would represent a larger rate of return on the individual's personal investment in her or his own productivity. Investment tax credits already are offered for investment in physical assets, and the concept might be applied to investments in human capital as well. Such a policy would permit the selection process to be gov-

erned primarily by members of the artistic community; entrance requirements stipulated by faculties or professional groups could be left intact. Also, a commitment at one point in time to a given individual would not constitute a lifetime contract. If a mistake were made in offering a subsidy to a certain person, society would not be required to continue payments, regardless of the level of creativity accomplished by that person.

CONCLUSIONS

We have found that there is a significant difference between the dispersion of incomes around the mean for artists and that for other professional occupations. From this we conclude that greater risk is involved in choosing a career in the arts than in choosing other careers. This conclusion can be used in building an argument that human resources will be underallocated to this type of enterprise.

Private subsidies may reduce the risk associated with a career choice for a given set of individuals but not necessarily the uncertainty in the consuming public respecting the adequacy or appropriateness of supply. Government income subsidies suffer essentially the same difficulties as private subsidies. A system of tax reductions equal to some portion of the cost of acquiring artistic skills might compensate for, but not reduce, the risks incurred in choosing art as a profession. It has a further advantage of limiting the commitment by society to given individuals and should maintain the connections between the supplier of artwork and the consuming public.

Additional work is needed in order to complete the specification of policy objectives, as well as the policy format. Whether human resources are underallocated requires further study. This may entail the delineation of new techniques for differentiating between individuals in terms of productivity and for measuring consumer preferences. Further research should also be undertaken to investigate the quality of risk aversion among neophyte artists. The data used in this study will be of use in the specification of a "demand price" for artistic human capital.

References

Aitchison, John and Brown, J. A. C. 1963. *The Log-normal Distribution.* Cambridge: Cambridge Univ. Press.

Becker, Gary S. 1964. *Human Capital: A Theoretical and Empirical Analysis with Special Reference to Education.* New York: Columbia Univ. Press.

Blinder, Alan S. 1974. *Toward an Economic Theory of Income Distribution.* Cambridge, Mass.: M.I.T. Press.

Block, M. K. and Heineke, J. M. 1973. The Allocation of Effort Under Uncertainty: The Case of Risk-Adverse Behavior. *Journal of Political Economy* 81 (Mar./Apr.): 376–385.

Ennis, Philip H. and Bonin, John. 1977. *Understanding the Employment of Actors.* National Endowment for the Arts, Research Division Report No. 3.

Metcalf, Charles E. 1972. *An Econometric Model of the Income Distribution*. Chicago: Markham Publishing Co.

U.S. Bureau of the Census. 1976. *1976 Survey of Income and Education Microdata File*.

Weiss, Yoram. 1972. The Risk Element in Occupational and Educational Choices. *Journal of Political Economy* 80 (Nov./Dec.): 1203–1213.

Comment
Louis H. Henry and Carl M. Colonna

While the authors agree that the low-income risk faced by artists is perhaps as old as the profession itself, they set up a different situation, one in which the artist behaves as a hedonistic, cool calculator of pecuniary benefits and costs. They conclude thereby that "there is a significant difference between the dispersion of incomes around the mean for artists and that for other professional occupations . . . [so] greater risk is involved in choosing a career in the arts. . . . " However, the data do not verify this conclusion: the use of the coefficient of variation for this comparison is inappropriate.

Granted, as the authors state, the individual artist makes a career decision based on the expectation of the mean income as his or her future earnings, but also with a certain risk of earning much less or much more. The impact on individual career choice of different mean incomes is calculable. The standard deviation of the distribution becomes the appropriate measure of the random chance that an individual will have the "typical" experience of artists. The variation in mean income among the selected professions has no role in determining the amount of uncertainty faced by potential artists compared to others. Therefore, the coefficient of variation overstates the amount of uncertainty in this data set.

The authors assume that the six occupations are perfect substitutes for a new labor market entrant—that anyone could become an accountant or artist or engineer or lawyer or economist if willing to invest in that form of human capital. But art requires some natural talent; one does not become an artist by simply taking art lessons in the way that one becomes a mathematician after proper training. Only further data can provide the actual rate of return on the monetary investment in artistic training.

Intuitively, we agree with the general view that income risk has a detrimental effect on the arts. Most occupations seem to be operating in less and less competitive markets. The labor market is dominated by unionization, professional associations, licensing laws, and other state protective devices. As Galbraith has observed, we are all trying to gain some control over our income, and this risk reduction phenomenon is a logical extension of the democratic ethos.

Comment
Clark C. Abt

There are a number of theoretical problems with this three-stage model that are not addressed. The independent variable, high variance in artistic incomes, is specified only in terms of cash wage income. There is no shadow pricing of psychic income from exercise of one's talents, freedom from the routine of other kinds of employment, and so forth. Another theoretical problem is the missing variable in the intermediate stage of the causal sequence: income dispersion \longrightarrow greater perceived investment risk \longrightarrow underallocation to the arts. The missing variable in the intermediate causal stage of greater perceived risk is the potential for greater gains balancing it.

While the variance in artists' incomes may be significantly greater than those in the compared occupations (as the authors' aggregate data appear to show), we also know, as indeed the authors state, that "the effect of increased risk on investment in acquiring skills for a given occupation is to require a higher rate of return to compensate for the greater possibility of loss." Indeed, it is my own belief that most people embarking on artistic careers do not do so in the expectation of the very modest average (mean) return on the high-risk investment; rather they make these risky investments in the hope of approaching at least the median and frequently the high end of the possible income spectrum. The most ambitious artists, of course, act as if they have a relatively low or zero time discount rate, since the value of great works of art is timeless or appreciates rather than depreciates with time, yielding potentially much greater discounted present values from very distant returns to the investment.

The authors completely ignore this missing variable of greater potential reward, which to some degree balances the greater risk of investment in an artistic career. I believe a more accurate description of this intervening stage of the model would be the variation in individual preferences for high-risk, high-payoff career strategies versus low-risk, low-payoff career strategies.

Finally, there is a theoretical problem in the hypothecated (and empirically undemonstrated) underallocation of human resources in the arts. The authors do provide some empirical evidence that there are real differences in the risks associated with arts occupations. Then, however, they make a leap in logic by stating, "the market mechanism is liable to underallocate human resources to artistic occupations."

First of all, there is no empirical evidence given to support this hypothesis. Second, theoretically, the greater potential rewards might very well compensate for the greater risks and not result in any "underallocation." Third, exactly what is meant by underallocation? By what criterion is there underallocation? Do the authors mean that the marginal productivity of increased investment in the arts is still increasing when allocation to arts training ceases? If so, what is the nature of the arts production function? Put another way, what is the "correct" amount of investment of human resources in the arts to prevent underallocation?

The policy implications suggested by the authors are based on the assumed likelihood of underallocation. The authors suggest various policies to compensate for the anticipated private underinvestment in the arts with public investments, all on the basis of the alleged private underallocation of human resources, as the result of an allegedly perceived greater risk. Not only are the policy proposals based on empirically unsupported, unconvincing leaps of logic, but the question of the optimal quantity of human resources investment in the arts is never addressed. Thus, no quantitative policy objectives can be based on this analysis for additional public investment in the arts to compensate for the hypothecated and unproven potential private underinvestment.

We have no public policy goals concerning the number of additional artists who should be trained. The authors simply observe that a unit endowment cost of approximately $156,000 is required for a lifetime subsidy compensating the difference between the mean income of artists and persons in selected other occupations. How many such subsidies should be offered until no further underallocation to the arts exists? The analysis does not suggest an answer to this question.

The Employment and Unemployment of Screen Actors in the United States

Muriel G. Cantor

and

Anne K. Peters

O UR INTEREST IN ACTORS and the movie and television industries dates back to the mid-1960s (Cantor 1971, 1972; Peters 1971, 1974). As part of our ongoing research on screen acting, we have interviewed over fifty actors, all members of the Screen Actors' Guild; most have been active in guild affairs, holding positions as president, vice-president, and board member in either New York or Los Angeles. In addition, we interviewed six paid officials of the guild and several "actors" who aspired to join the guild, but at the time of the interviews were ineligible for membership. The majority of the interviews took place in Los Angeles and New York in 1976. Part of the reason we conducted these interviews was that we were puzzled by the phenomenal growth of the guild during the years when movie production in the United States was contracting. As sociologists, we were further puzzled about what seemed to us an oversupply of actors in relation to the demand for their services.[1]

There is general agreement that the movie industry is radically different from what it was in 1939, when the guild was first recognized as the bargaining unit for actors (Ross 1941). There were five major studios then and a few independent movie producers making approximately 400 pictures a year, almost all of them produced in Hollywood. Now, fewer than 150 major movies are being made in the United States and few, if any, are made entirely in Hollywood. Yet as movie production has decreased in the United States, membership in the Screen Actors' Guild has increased. In 1940, one year after the union shop agreement was reached with the Motion Picture Producers' Association, there were 8,505 members of the guild; in 1976 there were approxmately 35,000 members. During the same period, Hollywood became the major production center for television drama. Commercial advertisements made for television became a new source of employment for screen actors. Even so, the work provided by acting in television, although substantial, never made up for the loss of movie production.

Neither can the change in Hollywood explain the growth of the guild. The fact that television commercials are mostly made in New York only helps explain the growth of the New York branch. As the figures show, the supply of actors has always been larger than the demand. In 1945 there were 804 actors under contract to the major studios. That was an all-time high. In 1950 the number of contract players was down to 474; by 1955 there were only 209 and by 1960, 139.

In 1945, when the movie industry was at its height, the guild had 7,732 members in Los Angeles and 541 in New York. By 1960, after the Screen Extras' Guild was formed and guild membership rules changed, 9,996 people belonged to the Los Angeles Guild, and New York membership had gone up to 3,481. The New York branch figures include extras, but the Los Angeles figures do not. Guild membership figures vary from year to year, but after reaching the lowest membership since 1939 in 1953–54, there has been a continuous upswing in membership. In 1978–79 the reported membership was up to 39,000.[2]

THE OPEN UNION AND EMPLOYMENT
AND UNEMPLOYMENT

While others contend that union membership and employment data provide at least a rough indicator of the trends and conditions in the actor labor market (Mathtech 1978), our interviews, data provided by the Screen Actors' Guild, and observations in Hollywood and New York lead us to slightly different conclusions. In fact, union figures provide little reliable information about the supply of actors available, and using the term "labor force" in this connection is misleading, for technically it means (at least in the United States) the number of individuals either employed or actively seeking employment (National Endowment for the Arts 1976). Union membership provides information only on the number of people who belong to the union. The 1970 actor labor force in the United States consisted of 23,430 people (National Endowment for the Arts 1976), including those working in the theater, films, television, and other media (industrial shows, for instance); 33 percent of those people were unemployed. Here unemployment has a technical meaning: those who did not work as actors in their last employment and those who are seeking employment for the first time are counted as part of the labor force but not as actors.

In contrast, Screen Actors' Guild members may or may not be employed. By examining the available data from the guild, one can find out only if and when a particular member worked for a producer who signed a guild contract. The contrast with other craft unions continues. Members of the Screen Actors' Guild who work full-time in a related medium (theater, under an Actors' Equity Association contract, for instance) are not unemployed as actors. Also, many are employed in occupations other than acting and cannot be considered part of the actor labor force. While we can be fairly certain that a member of the guild will not be working for a producer who has not signed a union contract of some kind, there are a number of acting jobs for which no union contract has been signed. For instance, the federal government makes a large number of films yearly but has no agree-

ment with the Screen Actors' Guild. Finally, numerous semiamateur theaters and dinner theaters provide some compensation not covered by union contracts to actors.

If the U.S. Bureau of the Census and Bureau of Labor Statistics consider all people inside or outside the jurisdiction of the various acting unions as actors, the Screen Actors' Guild does not. For guild purposes, only those associated with the Four A's (Associated Actors and Artists of America) meet this definition. Also, the guild counts an actor as employed only when working under the guild's jurisdiction. An actor is not even considered employed when working under the jurisdiction of one of the sister unions associated with the Four A's. The Four A's include, among several unions, the American Federation of Television Artists and the Actors' Equity Association.[3] Many screen actors belong to three or more creative unions. If an actor is working in a theater production, his or her work will usually be under the jurisdiction of the Actors' Equity Association. If an actor is a regular in a serial (soap opera) which is videotaped at a broadcasting studio, then he or she will be under the jurisdiction of the American Federation of Television and Radio Artists. In such cases, the actor is obviously not unemployed. However, when the Screen Actors' Guild reports earnings, those working under other jurisdictions will show no work as guild members and thus are counted as unemployed. Of the total membership, it is unclear how many work at any one time under other union contracts. The total professional employment of any individual actor could be measured only if the unions were willing to consolidate all their pension and welfare records (Ennis and Bonin 1977). The benefits of doing this seem obvious to the outsider, but for reasons beyond our comprehension, the unions are unwilling to do so.

Although it is possible to learn something about the employment of actors from union records, very little can be learned about unemployment. The membership rolls of all the unions show that many pay dues but few work at any one time as actors (Mathtech 1978). This is partially due to the casual nature of the work involved, which will be discussed in the next section. Of all the unions, the Screen Actors' Guild reports the most "unemployment" by their measure. What cannot be discerned from the records of the guild is the number of members who pay dues but no longer consider themselves actors. In the Ruttenberg et al. (1977) survey of members of several performers' unions, 27.5 percent of the respondents said that acting was not their principal occupation. The results of this survey cannot be taken too seriously, because the methods of collecting the data are not specified, and the sample size is not even designated. Although guild officials and officers disagree with us, we believe that as many as half the members who are paying dues have not had a screen role (or any acting role) in a number of years. This could be discerned from union records; but, again, no one has bothered to do so. Belonging to the glamorous Screen Actors' Guild may be of greater psychic benefit than the cost of dues. The costs to maintain membership are low for actors not working under the union's jurisdiction. Such dues-paying members would probably take a part if offered to them but are not actively seeking work as actors.

The guild reports that 85 percent of their membership is unemployed at any one time. This figure is derived from the records of earnings kept by the pension and welfare fund. To repeat: if a member has no earnings as a screen actor, then he or she is considered unemployed. As Table 1 shows, over 75 percent of the membership earned less than $3,500 at screen acting in 1974; only 10.9 percent earned over $10,000, and less than 1 percent earned over $100,000. So much for the myth of high income for screen acting. Also, joining the guild obviously does not insure employment as a screen actor. In fact, the opposite seems to be the case. The Screen Actors' Guild appears to be a union in which most members do not work as screen actors.

Table 1. *Number and Percentage of Guild Members by Earnings Categories, 1974*

| Categories | Number | Percentages |
|---|---|---|
| Under $1,000 | 14,420 | 48.4 |
| $1,000—1,999 | 4,669 | 15.7 |
| $2,000—3,499 | 3,238 | 10.9 |
| $3,500—4,999 | 1,678 | 5.6 |
| $5,000—7,499 | 1,627 | 5.5 |
| $7,500—9,999 | 889 | 3.0 |
| $10,000—14,999 | 1,047 | 3.5 |
| $15,000—24,999 | 1,017 | 3.4 |
| $25,000—34,999 | 412 | 1.4 |
| $35,000—49,999 | 286 | 1.0 |
| $50,000—74,999 | 222 | .7 |
| $75,000—99,999 | 103 | .3 |
| $100,000 and over | 189 | .6 |
| | 29,797 | 100.0 |

The important question here is why the union has experienced such growth in the last twenty years. As others point out, the arts, and possibly acting in particular, are very attractive to many. Yet there is little social or governmental support for the aspiring actor, and there are no professional routes to a career in acting (Peters 1971). Although training seems to make a difference to casting directors, being trained is no guarantee that one will get a part. Moreover, talent is difficult to judge, and beauty and personality seem to count more than talent.

THE STAR SYSTEM: UNEMPLOYMENT AND UNDEREMPLOYMENT

The star system offers an answer. Because of it, all actors have the possibility in their work lives of becoming "stars" and gaining great financial success and acclaim. The star system preserves the large reserve labor force of underemployed and unemployed actors in proportion to the work available. It allows some people upward mobility and provides the television and movie industries with a con-

tinuous supply of mostly young talent ready to try to reach stardom through act-
ing. Even though stars can command enormous salaries and a few experienced
journeyman actors are able to contract for salaries above the minimum standard,
it is advantageous for production companies to have many actors competing for a
few jobs. It is also advantageous for the union. If the pool of actors were small,
the cost to the production company for wages would be much higher. Also, the
union would lose income from dues if there were not a large number of actors
competing for a small number of parts. Therefore, the unions, the actors them-
selves, and of course the producers support the system as it now exists.

But through its commitment to open membership and to letting producers,
directors, and casting directors decide who is qualified for the roles available, the
Screen Actors' Guild helps perpetuate a system in which the majority of its mem-
bers do not work, yet a few of its members have incomes among the highest in the
nation.

Also, the Screen Actors' Guild provides actors with minimal help in skill devel-
opment. The structure of the entertainment business, including television and the
movies, leaves serious actors on their own in developing their skills, their reputa-
tion, and their competitive advantage in seeking jobs.

Thus, we recognize that acting is one of the few occupations which provide a
vehicle for the attainment of personal success and fame. There is the opportunity
for a few to begin with virtually no capital or credentials and become eminently
successful as actors. It is this feature of the occupation which probably helps ex-
plain the striking tenacity of actors in the face of deprivation and compromise.
However, because of this feature, the supply of actors remains large while the
demand remains low.

CONCLUSION: FURTHER STUDY

The discussion has revolved around the difficulties of trying to determine the
size and composition of the screen actor labor force when using union member-
ship rolls as a data base. As others have suggested (Ennis 1977), much could be
discovered if the Screen Actors' Guild were surveyed scientifically. Such a survey
could answer questions about training, work history, professionalism, and per-
sonal and social characteristics. As mentioned above, if all the data from the pen-
sion and welfare funds of the various unions were combined, it would be possible
to find out which individuals work regularly as actors, which have not worked in
several years, and the length of time of individual acting careers. Other questions
which we and others have raised could be answered—such things as whether there
is a floating actor population; whether actors maintain membership, although
they do not consider acting their primary occupation; and whether and how much
youth, beauty, and sexual attractiveness determine a career in acting. This latter
point is especially applicable to female actors.

Although much could be learned from an in-depth study of the Screen Actors'
Guild membership and from the pension and welfare fund data on employment,

only limited information can be gained about unemployment. Possibly through sociometric methods in Los Angeles and New York, nonunion aspiring screen actors could be found and surveyed using an instrument similar to the one suggested for union members. Educational facilities, especially universities and colleges, are also locales where aspiring actors can be found. The studies being suggested are costly and probably will not be implemented. However, without such an effort, the size of the actor labor force will remain a mystery.

Behind the difficulties associated with unemployment of actors lie many problems and conditions. Most important is the condition economists call structural unemployment, which is related to demand. To understand both employment and unemployment of actors, one must understand changes in the structure of acting jobs. As the structure of the entertainment industries changes, so does employment and unemployment for actors. Therefore, simply to consider problems relating to unemployment by finding out who works and at what without a thorough investigation of the movie and television industries, will yield little useful material.

Related to structural unemployment in the arts (especially the popular arts) are cultural conditions. The kinds of drama and other material written and produced vary according to what is considered popular with audiences. Only rarely is this related to problems of employment. For instance, the Women's Committee of the Screen Actors' Guild has known for several years that employment of female actors is proportionately far less than that of male actors. Forty percent of the guild members are women, yet only 400 female members earned over $10,000 in 1977, compared to 3,400 male members of the guild. Also examination of prime-time television programming in the United States shows that three out of four roles are written for males (U.S. Commission on Civil Rights 1977, 1979).

An industrywide study should be conducted to examine not only the business aspects but also the craft aspects. This study would relate the expansion and contraction of work to both the content of dramatic production and the stability and/or contraction of employment opportunities. Who owns and regulates movie and television production in the United States and abroad when American companies are involved? How has this changed since 1940? Has the work (unemployment and employment) of actors changed as ownership, the organization of production, and technology have changed? How do ownership and regulation, coupled with organizational factors, influence or relate to the kinds of dramatic production generated by the American film and television industries and to the kinds of roles available and thus the work of actors? All these questions should be addressed through an industrywide study.

Notes

1. Also, we spent six weeks at the main headquarters of the Screen Actors' Guild in Los Angeles. The guild was helpful in providing most of the data presented here. We are particularly grateful to the controller, Pauline Golden, and C. Brady, office manager of the New York branch, for their cooperation.

2. According to *Variety* (1979), there are now 39,000 members. Of these about 18,000 are in Los Angeles, 12,000 in New York, and the remainder divided among other branches scattered throughout the United States. The New York Guild includes extras. The Hollywood branch does not. Branches of the guild as of October, 1975, are:

Boston
Chicago
Colorado
Detroit
Florida
San Francisco
Philadelphia
Texas
South Dakota
New York
(Plus the Hollywood branch which is not clearly differentiated from the national office).

3. The Four A's is derived from its title, Associated Actors and Artists of America. Affiliates include the American Guild of Musical Artists, the Screen Extras Guild, the Hebrew Actors Union, the Italian Actors Union, the Puerto Rican Association of Actors and Show Technicians, and the American Guild of Variety Artists, as well as the Screen Actors' Guild, Actors' Equity Association, and the American Federation of Television and Radio Artists.

References

Cantor, Muriel. 1971. *The Hollywood TV Producer: His Work and His Audience.* New York: Basic Books.

———. 1972. The Role of the Producer in Choosing Children's Television Content. In *Media Content and Control of Television and Social Behavior*, vol. I, Comstock and Rubenstein, eds. A Technical Report to the Surgeon General's Scientific and Advisory Committee on Television and Social Behavior. Washington, D.C.: U.S. Government Printing Office.

Ennis, Philip. 1977. Some Problems and Perspectives on Assembling a Data Base on Actors' Employment and Unemployment. Paper prepared for "Public Policy and the Arts," a conference on National Endowment for the Arts Policy Research. Baltimore: Dec. 7–9.

Ennis, Philip and Bonin, John. 1977. Understanding the Employment of Actors. Washington, D.C.: National Endowment for the Arts.

Mathtech. 1978. The Conditions and Needs of the Live Professional Theater in America. Phase I report: Data Collection and Analysis. Princeton, N.J.

National Endowment for the Arts. 1976. Employment and Unemployment of Artists, 1970–75. Washington, D.C.

Peters, Anne. 1971. Acting and Aspiring Actresses in Hollywood: A Sociological Analysis. Unpublished Ph.D dissertation. Univ. of California, Los Angeles.

———. 1974. Aspiring Hollywood Actresses: A Sociological Perspective. In *Varieties of Work Experience*, P. Stewart and M. Cantor, eds. Cambridge, Mass.: Schenkman Publishing Co.

Ross, Murray. 1941. *Stars and Strikes: Unionization of Hollywood.* New York: Columbia Univ. Press.

Ruttenberg, Friedman, Kilagallon, Gutchess, and Associates. 1977. Survey of Employ-
ment, Underemployment and Unemployment in the Performing Arts. Prepared for the
Human Resources Development Institute, Inc. in cooperation with the Council of
AFL-CIO Unions for Professional Employees. Dec. 6.

Screen Actor. 1974. Summary of New Contract Provisions for Theatrical and Television
Motion Pictures. Pittsburgh.

Variety. May 23, 1979 (Western edition).

U.S. Commission on Civil Rights. 1977. *Window Dressing on the Sets.* Washington, D.C.:
U.S. Government Printing Office.

_____. 1979. *Window Dressing on the Sets: An Update.* Washington, D.C.: U.S. Gov-
ernment Printing Office.

Comment
Alexander Belinfante

My comments on the paper by Muriel Cantor and Anne Peters are limited be-
cause I largely agree with their analysis and conclusions. I wish only to emphasize
and elaborate a little on the importance of the role of the star system. The "myth
of high income for screen acting" that they refer to is a direct result of the star
system. Since the stars with the high incomes receive most of the attention of the
mass media while the many nonstars with low incomes receive virtually no media
attention, many people are falsely led to believe that acting is a highly paid pro-
fession. This misconception plays an important part in luring many young people
into the profession, yielding the "continuous supply of mostly young talent ready
to try to reach stardom" that the authors refer to. Inevitably, most of those thus
lured into acting soon discover that they cannot support themselves by acting and
are forced to seek other jobs to survive. Apparently, many of these people still
vainly hope to achieve success as actors and maintain their membership in the
Screen Actors' Guild, even though their chances for success are probably mini-
mal. These hopes are probably stimulated by their observation of the often
chance events that make people stars, along with the minimal level of talent pos-
sessed by many of those who achieve stardom. Thus, an aspiring actor may
rightly perceive that he or she has as much talent as some stars and wrongly con-
clude that he or she has as much of a chance of becoming a star.

Finally, I would like to note that this star system and its problems are not
unique to the screen-acting profession. To various degrees it pervades all seg-
ments of the arts and entertainment industries. The mass media play an impor-
tant role in perpetuating the star system by concentrating most of their attention
on the stars.

Comment
John R. Hildebrand

I would suggest adding a broader perspective: that low incomes and unemployment in general are part of the problem, not just unemployment in screen acting per se. Although in my value pattern cultural deprivation in most societies is real and employment in the artistic expressions inadequate, I also suggest that with an alternative dependable source of income people could enjoy participating in artistic expressions during their leisure. The freedom to do some of the more enjoyable things in life exists only after an income has been earned that is adequate to meet basic needs. An expansion of cultural activities for everyone is one of the possible outcomes of economic growth and development under full employment. For example, without growth, development, and employment in our respective areas of the world, participation in this pleasant conference on cultural economics would have been impossible for each of us.

PART FOUR

Cultural and Policy Management
of Arts Institutions

Introduction

WILLIAM HENDON, in *Analyzing an Art Museum* (1979), identifies six potential experiences that museums can provide to visitors: (1) education (2) scholarship, (3) recreation, (4) a moral (spiritual) experience, (5) an aesthetic experience, and (6) satisfaction for status-conscious people. While he had museums in mind, this list is essentially applicable to all (serious) arts institutions. With such a wide range of "satisficing" possibilities, it is understandable that arts institutions seem confused about their role and function. Similarly, national cultural policy often suggests conflicting views on the purpose of arts support. In this section discussions focus on selected cultural policy issues relative to arts institutions and on aspects of their managerial economics.

Erika Wahl-Zieger points out the continuing conflicts for arts institutions between their internal interests and the wider interests of society over such matters as: (1) aesthetic quality versus large attendance, (2) increased access to a wider public, and (3) improved conditions for artists. The role and function of arts institutions, as well as that of government, are still unsettled.

Wahl-Zieger asks which market approach more effectively delivers freedom in artistic expression, a market economy like that in the United States or a mixed economy like that in West Germany? Presuming that arts institutions suffer from a "congenital cost disease," she argues that without public support artistic freedom is interfered with for the sake of consumer freedom. With public support, however, the arts are secured the support needed to pursue their interests "freely," but consumer sovereignty is threatened. She sees the need to solve the public support question in a way that ensures artistic quality and freedom while promoting the wider interests of society mentioned above. The greatest likelihood of this is a convergence of the German and American means of financing the arts.

Erika Wahl-Zieger and David Throsby share an interest (though implicitly opposing points of view) in the role of government in cultural policy formulation and the impact of that role on the opportunities and constraints according to which local arts providers define their function. David Throsby sets forth a theoretical decisional methodology for allocating public support among competing artistic and cultural activities based on objectives formulated by public or private funders. This approach might conflict with Wahl-Zieger's principal concern that artistic freedom be preserved in the presence of public subsidy. Typically, grants are provided indirectly to arts institutions and artists as a deliberate means of guarding against national government interference in the arts world. State and regional arts councils which act as pass-through agents for federal and state monies do not typically deal with arts policy questions. Government grants are tied to projects—rather than operations—but allocation of funds by arts councils are not really based on cultural policy objectives. Throsby takes the view that they ought to be, even though the freedom question is not dealt with.

Frey and Pommerehne, Gapinski, Khakee and Nilsson, and Grist deal with different subjects but share an interest in the managerial economics of arts institutions.

Bruno Frey and Werner Pommerehne examine some basic management policy questions concerning the behavior of art museum directors and their desire to maintain their freedom to act as they deem best. Directors chiefly respond to "performance excellence" within the museum and to prestige and status that might come with the job, as well as to salary, working conditions, and so forth. The constraints on directors are financial budget constraints; restrictive capabilities in exhibiting art; the need to satisfy the "museum community," trustees and donors, and art historians; and a few external sanctions. Generally, directors will not actively seek out popular exhibits; exhibition areas and contents may be poorly marked and thus discourage "new" visitation; and the museum visit is destined to be physically uncomfortable, a further discouragement.

James Gapinski examines the production relationship between attendance at performing arts events and the level of human and capital resources used by arts institutions. For example, are the variations across institutions in the numbers of performers—holding administrative and ancillary support and capital facilities constant—correlated with levels of attendance? Using Ford Foundation data on 164 nonprofit performing arts organizations, Gapinski investigates production processes. He measures output in terms of attendance and inputs in terms of plant and equipment costs and three types of labor: arts, administrators, and ancillary personnel. Five questions emerge:

1. Do support personnel contribute to production?
2. Can support personnel be absorbed without new capital?
3. Does profit maximization hold for these activities?
4. What would happen if public support were reduced?
5. Do production structures differ across art forms?

As described above, arts institutions define their role as provider by selecting from a range of functions; in order to make those choices, they must consider several quantitative aspects which condition the supply of artistic activities and events. For Khakee and Nilsson the question is: can supply constrict demand? To find an answer, they examine data on live theatrical and musical performances in Sweden. Khakee and Nilsson use trends in annual audience figures, attendance-to-seating-capacity ratios, audience profiles, frequency of attendance among Swedish households, and the influence of ticket price to examine demand. They conclude that not all demand is being satisfied—especially in the larger metropolitan areas. What excess capacity exists is produced by a lag in responsiveness to outreach programs on the part of segments of the population not habituated to live performances of music and theater.

Edward Grist discusses some of the financial management issues involved in theatrical program decisions and operations. He draws upon his career experience in Manchester to analyze the financial dealings between theaters and the universities and other support institutions.

An implication underlying all of these papers is that arts institutions are not in the mainstream of national life. They serve limited audiences; they avoid external

controls; they maintain a high interest in freedom in the arts generally and freedom for themselves in particular; and they do not easily function in rational processes, nor do they wish to compete with other public services. Finally, their exclusion from the mainstream of society renders them vulnerable to financial distress of great magnitude. It is unlikely even in the most supportive nations that arts institutions can continue to gain financial support in the needed amounts unless they are more actively committed to entering the political and economic tug-of-war of private and public finance. Their financial plight grows worse instead of better and will continue to do so unless their management becomes more attuned to meeting society's broader need for the arts. Within this context, the need for managerial economics to guide decisions can be clarified.

Reference
Hendon, William. 1979. *Analyzing an Art Museum*. New York: Praeger.

The Performing Arts and the Market: Anglo-American and German Approaches to Theater and Orchestra in Market Economies

~~~

Erika Wahl-Zieger

I N GERMANY and the United States today there is much debate over a complex of noneconomic and political factors or crises confronting theater and orchestra—what has been called "the arts in jeopardy" (Peacock 1969, p. 324). The financial aspects of the crises dominate this investigation and determine the future existence of professional theater and orchestra.[1]

In the countries under discussion here, as well as in other Western countries with market economies, financial crisis is the rule and is characterized by two main symptoms: (1) financial difficulties of individual ensembles due to the insufficiency of income from ticket sales, resulting in dependency on transfer income (subsidies) from either public or quasi-public sources; and (2) the threat of a "decay of the arts," since a sufficient financial return (that is, high enough income through ticket sales) becomes the dominating goal of and criterion for the activities of theaters and orchestras.

The underlying problems are chronic to this subsector of a market system because market forces permanently endanger the subsector, even to the point of a "market failure," which calls for corrective intervention.[2] In Western countries corrective intervention comes through private donations and public transfer payments.

THE NATURE OF THE
UNDERLYING PROBLEMS

The live performing arts subsector of the "services sectors," in the language of the economist, faces a variety of problems, some weighing far heavier on the ensemble than on the single artist or small group and affecting their economic situation more seriously. These special problems include the high initial cost of establishing an ensemble; the sensitivity of ensemble members to wage fluctuations;

the high cost of transportation, resulting in an inability to serve several market segments (places); and the limited capacities of performance halls. Even more basic than these factors are the fundamental qualitative and quantitative dilemmas.

The Qualitative Dilemma

Theaters and orchestras are cultural institutions, as well as enterprises. They simultaneously belong to the field of arts and the field of economics. As such, they are exposed to artistic (that is, noneconomic) and economic forces which mutually influence each other, creating for them what can be referred to as the qualitative dilemma (Wahl-Zieger 1978, p. 16 and especially pp. 136ff.). The problem arises whenever the artistic product is to be sold in the market, since "good" theater or concert performances are not necessarily those which are financially successful.[3] Between artistic demands and economic demands there is an inherent tendency toward conflict. Often, theater ensembles and orchestras are initiated for purely noneconomic reasons, based on the conviction that there is a need for the particular art. Only after being brought into existence—often on a voluntary basis—does the economic problem arise. Economic constraints (the need to cover as much as possible of total cost by ticket sales) start exerting an influence on the artistic element in the choice of author or composer and the choice of play or piece of music; the choice of performer and the style of presentation determine the artistic quality of the performance.

From a conceptual standpoint, the lack of adequate analytical instruments forces the economist to pass over these problems as an analytical area of interest.

The Quantitative Dilemma

The main characteristic of live performances of the type offered by theater and orchestra ensembles is the simultaneous presence of artist and audience. The actual presence of the audience is crucial from the artistic point of view, but it is also of prime economic significance. Related to the proximity of artists and audience and the resulting production technology, we find, as in other subsectors of the services sector, a second fundamental problem: the virtual impossibility of increasing productivity. As revealed by Baumol and Bowen, rising relative costs cannot be compensated by productivity increases, and the live performing arts almost inevitably face growing financial difficulties (Baumol and Bowen 1966, p. 55). This quantitative dilemma is an important research area for economists.

Seen as a problem in market economics, the survival of theaters and orchestras depends on the readiness of private persons or the state to intervene in market allocations. This can only be done by means of transfer payments to the artistic enterprises. There is, however, neither a secure mechanism nor a definite and unequivocal justification for such a correction of the market via transfer payments. In fact, such interferences with the market may be in conflict with the principle of consumer sovereignty. Any violation of this basic principle requires justification and raises questions of political consensus. Justification and political consensus become ever more important as the demand for public transfer payments for theater and orchestra ensembles increases.

TWO SYSTEMS OF MARKET ADJUSTMENT:
THE ANGLO-AMERICAN AND
GERMAN APPROACHES

While in real life virtually every economy is a mixed system containing elements of state intervention and market control, our discussion is facilitated if we abstract from most of the complexities of the institutional pattern of theaters and orchestras and concentrate on certain basic differences in the Anglo-American and German approaches.

The main distinction between the two is in how they solve the "subordination problem," that is, whether or not state interference with private economic activity is admitted (because of certain social or cultural goals). The solution primarily depends on prevailing value judgments in the respective societies.

The Anglo-American approach is guided by the liberal principles of a free market economy and nonintervention. The latter is based on the value judgment that in a free society freedom for the arts should be guaranteed. Prohibition of state involvement in theaters and orchestras, however, is also rooted in another value judgment: the puritan denial of any social value in the pleasure provided by the arts. These two value judgments are the basis of the strict Anglo-American model, and both the United States and Great Britain adhere to this model, though there have been some modifications recently.

In contrast, the German system is characterized by large-scale state intervention resulting in "public" theaters and "public" orchestras, for which the state (federal, regional, or local authority) takes financial responsibility. The sectoral structure thus corresponds more to the model of a mixed economy,[4] where state intervention is not only accepted per se but even appreciated as a necessary market correction in the light of superior, though not very clearly defined, cultural goals. Thus, the state takes over the economic risk of theaters and orchestras and through public transfer payments keeps them in the market.

Historically, the state or local communities gradually assumed the role of patron. Court theaters and orchestras were taken over by local communities when sovereigns lost their power and importance. At the same time, citizens demanded that the state or local authorities back specific theaters and orchestras which had been started privately but which in the long run could not cope financially. The value judgment underlying these changes seemed to be that since the market was in need of some correction it was the duty of the state to secure the existence of theaters and orchestras by subsidizing them, but not to leave them totally free from market forces. The coordinating function of the market is not replaced by central planning (Pütz 1971, p. 27). Public theaters still act as individual enterprises (that is, as microeconomic units) in the market, for example, with respect to labor inputs (artists) and the "selling" of their performances. The degree of dependence on ticket sales is merely reduced by the availability of transfer income from the state. In the absence of any rigid regional planning, the structuring of the subsector of theaters and orchestras in the Federal Republic of Germany largely corresponds to this German model.

In democratic countries with market economies the freedom of the arts is generally postulated as a basic—sometimes even constitutionally entrenched—

right, even though there is often no unanimity about the content of this postulate (Wahl-Zieger 1978, pp. 48ff.). The crucial question now becomes: which of the two systems or approaches better guarantees that precious freedom? To answer this question, two dimensions have to be distinguished: the political and the economic.

The Political Dimension: Open or Covert Political Control

Guarantees against open political control and censorship are essential to both Anglo-American and German approaches. The effectiveness of such guarantees is not determined by whether theaters and orchestras are mainly publicly or privately financed, but only by an effectively functioning political system. "Freedom of the arts" means that the artist is free to pursue his or her work. However, this freedom cannot be understood as being totally unrestrained. Constraints may be imposed where artists consciously use their freedom to fight against the state order or the constitution from which their right of freedom is derived.

It is the political responsibility of a democratic society to guarantee freedom of the arts and to limit direct political censorship by the state or local authorities to a few clearly justifiable cases. In a disguised way, however, covert political control can be exerted upon theaters and orchestras when sponsors try to influence the artists according to the sponsors' own value judgments and political ideas. According to liberal principles, interference of the state via public transfer payments constitutes a specific danger to freedom. As indicated above, this is a basis for the strong rejection of public support for theaters and orchestras in the United States. In the Federal Republic of Germany, where public theaters and orchestras are the rule, these fears about covert control are kept awake, mainly because of traumatic experiences during the Nazi era. Yet what is often forgotten is the fact that in those years the political means to guarantee the freedom of the arts were totally absent.

While the choice of a system of deficit financing may have some influence upon covert political control in a country with an effectively functioning democracy, the German approach does not automatically imply more danger to the freedom of arts, just as the Anglo-American system is not a priori protection against the covert political influence of sponsors. Perhaps the best protection against covert political control is the financial independence of artists; however, today hardly any theater or orchestra of significant size can hire artists without public or private subsidization.

With both approaches patrons, private or public, may influence the arts. In particular, the German system of public financing entails two dangers: (1) politically sensitive self-censure when theaters and orchestras allow their decisions to be influenced by expectations about the political process determining the allocation of tax money; and (2) direct political influence exerted by politicians and bureaucrats in the process of granting and controlling public finances "according to the taxpayers' will."

Such dangers can, however, be controlled and prevented through the resilience of the public, since politicians and bureaucrats are themselves subject to public

control. In fact, public control seems to be an inherent advantage in the German system. In contrast, private patrons who contribute financially cannot be controlled by the public. In sponsoring art they can either grant freedom to the artists, or they can exert political pressure—whichever they like. The hypothesis that private financing of the arts guarantees their freedom is based on an unrealistic model of the competitive system, where many private patrons with varying attitudes compete for artists who are willing to accept sponsorship. However, in reality, the growing demand for transfer payments can hardly be met by private persons. Thus, the potential influence of a few private patrons tends to grow rather than to diminish, since patrons are not competing for artists—artists are competing for patrons. A system which strictly forbids transfer payments excludes state influence—yet at the same time it excludes any social control of indirect political influence by private sponsors. Thus, public financing of theaters and orchestras with social controls against covert influence is no more dangerous for the freedom of the arts than private financing.

This view may be illustrated by two examples relating to the political theater of Bertolt Brecht. In 1961, when the wall was being built in Berlin, in several public theaters of the Federal Republic of Germany Brecht plays were cancelled by local authorities. This led to an open discussion in which the artistic independence of public theater management was successfully defended. W. Hutton gives several examples of private political interference in the United States, with private sponsors dismissing theater managers to prevent certain performances; one such example was the cancellation of a Brecht play which seemed objectionable during the time of the Vietnam War (Hutton 1968, pp. 188ff.).

The Economic Dimension

Not only political interference but also economically motivated control can endanger the freedom of the arts. Two fundamentally different positions can be distinguished, creating two different dangers: (1) violation of the principle of consumer sovereignty when the state "paternalistically" corrects market forces by financing theaters or orchestras (thus keeping them in the market or in existence); and (2) the uncontrolled influence of the market, which exerts a type of "commercial censorship," forbidding a wide range of cultural activities or performances, for example, those which do not yet (fully) correspond to the tastes of the majority of consumers.

For obvious reasons, these positions are incompatible. Whereas the first stresses the freedom of the consumer, the second focuses on the freedom of the artist, at the same time trying to keep more choices open to the consumer. If the existence of the qualitative dilemma mentioned above is accepted, the second position must also be accepted to a certain degree.[5]

Goals Other than Freedom of the Arts

Freedom of the arts is not the only perceivable goal underlying the deliberate structuring of the arts subsector. Economic policy in this sphere cannot possibly be subject to the conventional goals of growth, price stability, or full employ-

ment. In the case of schools, universities, and research institutions, growth may be important in addition to educational goals, but in most other cases economic policy for theaters and orchestras entails primarily noneconomic goals. These goals are seldom unanimously approved of, and they seem less clearly defined and less urgent than conventional economic goals. Both in Europe and in the United States arts policy goals seek to create favorable conditions for making the arts accessible to the public, preserving the cultural heritage of the nation for present and future generations, strengthening cultural organizations, and supporting creativity in the arts. Although private initiative, on which the Anglo-American system mainly relies, is still very important in these countries and needs to be supported, developments in the United States and in Great Britain show that, increasingly, public transfer payments are necessary to pursue these noneconomic goals. It becomes evident that for an optimal system a mix of the characteristics of the two approaches is required.

BRIDGING THE GAP BETWEEN MODEL AND REALITY

The German and Anglo-American approaches reflect fundamental differences in the structuring of cultural policy. In reality a greater variety of structures exists, though we can still discern the typical German and Anglo-American approaches. To clarify the differences between the two systems, we can distinguish three different types of theater and orchestra enterprises in Western market economies in terms of the sources of finance (see Figure 1). In type 1 income from ticket sales at least covers costs and sometimes provides profits. In types 2 and 3 income from ticket sales covers only part of the costs, so that the theater or orchestra requires additional transfer payments in order to survive. There are, however, fundamental differences between types 2 and 3. Transfer payments are from private sponsors in type 2; that is, the existence of the theater or orchestra is

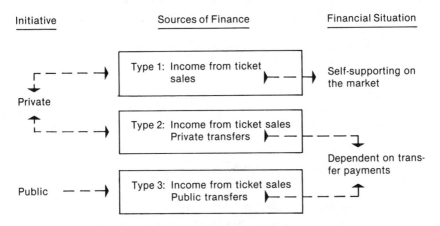

Figure 1. *Types of Theaters and Orchestras*

dependent solely on the private initiative of individuals or organizations. In type 3 the financial gap is filled by public transfer payments. The state (or a local authority) takes over the task of securing the existence of the theater or orchestra.

In everyday life these types overlap. Thus, a fourth type might possibly be introduced, in which the financial gap is closed by a mix of public and private transfers. But usually either public or private transfers dominate, so that we can refer to either type 2 or 3. Similarly, type 1 can be clearly recognized, even though transfer payments are received sporadically and in small amounts.

While the "pure" Anglo-American approach clearly corresponds to the first type and the German to the third, the second type complements both. In reality we find a mix of the three types in every country and a gradual change in the mix over the years. Thus, in the United States and in the United Kingdom, while types 1 and 2 have predominated up to the present, a fundamental change seems at hand with public transfer payments becoming significant in addition to private grants. The system is gradually moving away from type 2, resulting in changes in the internal fiscal structuring of the subsector. In the German-speaking countries (the Federal Republic of Germany and Austria) the third type clearly predominates, with private and self-financing enterprises—once predominant—only of marginal significance.

The difference between the Anglo-American and German approaches can thus be seen as one of degree rather than absolute contradiction. From this it seems possible to draw the following hypothesis: the Anglo-American approach represents an earlier stage of subsectoral structuring, which through time had to be modified, gradually coming closer to the German approach. Developments in the two countries, as well as in other market economies, seem to bear this out:

In Germany private theaters and orchestras, initiated by private individuals in the eighteenth and nineteenth centuries, became public due to severe financial problems.

Developments in the United States since the 1960s and in the United Kingdom since the Second World War indicate a similar trend for the same reasons.

In other Western-style market economies one also finds attempts to use public transfer payments to provide cultural activities of an acceptable quality.

Surely the existing German approach does not represent a final or optimal stage; in fact, it shows the need for modifications and further development.

ADVANTAGES AND DISADVANTAGES
OF THE GERMAN APPROACH

The German system is characterized by a wide network of predominantly public and residential theaters and orchestras, corresponding to type 3 in the above classification. The ensembles are not only concentrated in major cities like Berlin, Hamburg, and Munich, but are also found in smaller towns and communities.

The smallest theaters, the so-called provincial ensembles (*Landesbuhnen*), are itinerant stages; they complement the resident groups and are located in small towns from which they travel to neighboring villages to give performances.

A few statistics illustrate the present pattern in Germany.[6] Currently, about 96 type 3 public orchestras with a permanent ensemble of professional musicians offer a broad repertory of "serious" (mainly symphonic) music and regular concerts or opera performances. Fourteen of them are financed by (public) broadcasting corporations, the others by state and/or local authorities. About 6,500 musicians are employed in these orchestras.

There are 88 type 3 public theaters permanently residing in 76 towns. They employ 24,570 persons on a full-time basis, reaching a public of about 17 million visitors annually.[7] Eight of them are specialized opera houses; 52 offer plays as well as opera and musicals. All are repertory theaters with a permanent ensemble of professional artists. State or local communities are responsible for the financial risk.

About 21 publicly supported festivals are located in 18 centers. Moreover, 33 towns have about 80 private resident theaters (most of them small, en-suite theaters), which reach about 4.5 million visitors annually. About 15 percent of the private resident theaters function without public financial assistance. All of the 15 percent, as well as the others, which receive only small public grants, can be regarded as type 2 enterprises. A few "privately" run theaters regularly receive considerable public funds and can thus be considered type 3. However, in contrast to publicly run theaters, the financial risk associated with the private theaters is not taken over by the state. Many private theaters are also supported financially through "self-subsidization" on the part of the artists, who for the sake of idealism work for less than adequate salaries.

Private grants are rare in Germany. Private theater performances are, furthermore, offered by commercially run, touring, en-suite, type 1 theater groups and by voluntary groups, which might also be classified as type 1. Artists in the latter groups often subsidize their theater work with other part-time or full-time jobs. From an economic point of view, this can be seen as "forced amateurism."

The main advantages of the present system in Germany, which is the result of traditional public support for theaters and orchestras, are (1) regionally widespread provision of performances; (2) continuance of ensemble work with positive effects on the quality of performance, of repertory, and of contact with the audience; and (3) reduced dependence on ticket sales, permitting the financial flexibility required to maintain high artistic standards and encourage exploration of original ideas.

While German cultural policy has had these positive results, the predominant dependence on public support has also dampened private initiative and private sponsorship, giving rise to possible dangers in the future even for the artists concerned.

Public theaters and orchestras are not immune to market forces. This is reflected in growing financial deficits and is rooted in the quantitative dilemma mentioned at the beginning. Public theaters, for instance, covered 40 percent of their costs through ticket sales in 1957, 20 percent in 1972, and only 17.4 percent in

1976. Higher admission prices could not effectively stop this trend. The growing deficit is also reflected in the increasing demand for public transfer payments. Thus, the German system has become more and more expensive. This is reflected in the figures for public transfer payments to German enterprises (see Table 1).

Nearly 60 percent of these monies stem from the budgets of local authorities, which are themselves faced with growing financial problems. In fact, it becomes increasingly difficult to mobilize sufficient public funds for professional theaters and orchestras.

Political debate in Germany over public support for theaters and orchestras is increasing, as is the pressure to come up with convincing justifications for this use of public monies. The result has been a reexamination of the "traditional" role of cultural policy. As mentioned above, state and local authorities had in the past assumed the role of cultural patron without much hesitation, merely taking over theaters and orchestras from the royal houses or from private initiators. The main reasons for doing so were continuity, maintenance, and security; no special conditions were set for the use of public funds.

Currently, some interesting signs of change are emerging. Individual theaters and orchestras are being urged to "rationalize." In many cases, the importance of ticket sales is being reemphasized, and the scope for artistic standards reduced. The long-term effect will inevitably be negative, since financial deficits are still increasing, and it is unlikely that more commercial theaters will be able to justify public support.

Attempts are being made to initiate long-term adjustments to the present system. Some state governments, for instance, have worked out comprehensive regional plans to support the historic growth pattern through a coordinated system of "necessary" theaters and orchestras, on which public funds should be targeted. The optimal location of these theaters and orchestras is being determined by means of mathematical calculations. If implemented, these plans will result in the closing of certain theaters and orchestras and in the merging of others. However, savings effected in this way may be offset by increased administrative costs; also, some of the flexibility and spontaneity of new performing arts groups may be lost. Nevertheless, the need to close certain theaters and orchestras may in the long run become unavoidable.

Table 1. *Public Transfer Payments to German Performing Arts Enterprises**

| Year | Total Transfer Payments (millions) | Rate of Increase |
|------|------------------------------------|------------------|
| 1969 | DM 504 | |
| | | 51% within 3 years |
| 1972 | DM 812 | |
| | | 48% within 4 years |
| 1976 | DM 1,203 | |

*Figures include public transfers to all public theaters and festivals, to nearly all private theaters, and partly to public orchestras.

Presumably, these tendencies will not initiate a fundamental change with respect to the German system. However, it is unfortunate that there are no signs of attempts to implement more selective policies, encourage private sponsorship, or reward artists who try to perform less conventional pieces and plays or attract new audiences.

ADVANTAGES AND DISADVANTAGES OF THE AMERICAN APPROACH

The American system demonstrates an impressive degree of initiative by artists, managers, and sponsors, even though it also illustrates the severe financial problems caused by market forces.

The following effects of market forces are apparent in the U.S. system:

The regional spread of theaters and orchestras has been reduced. For example, Broadway tours have declined; the performing arts are concentrated in New York and other major cities, while smaller cities and towns are undersupplied.

It has become very difficult to maintain the production continuity and permanence of ensembles, especially in the theater sector.

While there is the demand and initiative to establish a less commercial theater "in which artistic standards and the wish to experiment have priority over earnings" (Baumol and Bowen 1966, p. 26), commercial needs tend to take priority, for example, Broadway and off-Broadway.

Notwithstanding repeated attempts to make theaters and orchestras self-supporting, financial deficits and the need for transfer payments are still increasing; in other words, there is a shift away from type 1.

As private sponsors (type 2) cannot adequately cover such deficits, public funding (type 3) is becoming generally accepted and has gradually gained in importance.

Whereas historically market corrections were left to private initiative, remarkable signs of change are evident in the attitude of the state toward cultural policy. Thus, for instance, the policy introduced by the National Endowment for the Arts (NEA) marks a considerable deviation from past practice by actively channeling public monies to theaters and orchestras. However, this cannot be seen as a fundamental change with respect to the Anglo-American approach. It is only a modification, with the rationale of public transfer payments perfectly conforming to the priority of private initiative. NEA does not merely cover deficits, and it never takes over financial risks. Through selective sponsoring and different methods of financing, NEA also tries to activate private sponsorship and to reward as well as support certain artistic activities—mainly those which are inhibited by market forces. This may, in fact, be a more efficient and more effective way of correcting special market failures than the German policy of blanket subsidization. However, it will not and cannot guarantee the "security" of theaters

and orchestras. Furthermore, it will be very interesting to see whether public transfers by NEA, which have increased considerably from 1966 to 1975, will continue to grow in the future.

IN QUEST OF AN OPTIMAL APPROACH

A more nearly optimal approach might be achieved by combining some of the policy elements of the German and the (modified) Anglo-American systems. The sphere of public or institutional theater and orchestra might have to be reduced in Germany and developed and extended in the United States. The financial risk will have to be taken over by the state. Security, continuity of production, stability of ensemble work, and contact with the public should thus be guaranteed. On the other hand, private initiative and acceptance of risk should be encouraged by a more selective policy of subsidization based on the NEA model, so that the private supply—through commercial and noncommercial ensembles—supplements the public supply.

Notes

1. For a more detailed analysis of problems, see Erika Wahl-Zieger, *Theater und Orchester Zwischen Marktkräften und Marktkorrektur* (1978).
2. This question is thoroughly investigated in Wahl-Zieger (1978, pp. 205ff.).
3. This valuation takes place in a complex aesthetic process; there is no absolute measure. See Wahl-Zieger (1978, pp. 140ff.).
4. See Theodor Pütz, *Grundlagen der Theoretischen Wirtschaftspolitik* (1971, p. 23).
5. For a more detailed discussion of these two positions and their consequences, see Wahl-Zieger (1978, p. 52, pp. 136ff., and pp. 205ff.).
6. The data are taken mainly from *Theater-Statistik* and refer to 1972–73, since the situation has not changed very much since then.
7. There are about 60 million inhabitants in the Federal Republic of Germany.

References

Baumol, William J. and Bowen, William G. 1966. *Performing Arts—The Economic Dilemma*. Cambridge, Mass. and New York: M.I.T. Press and Twentieth Century Fund.

Hutton, Winfield. 1968. Das Repertoiretheater Breited Sich Aus, Entwicklungen der Darstellenden Künste in den U.S.A. In *Die Deutsche Buhne* 39 (Oct.): 188ff.

Peacock, Alan T. 1969. Welfare Economics and Public Subsidies to the Arts. In *The Manchester School* XXXVII, no. 4 (Dec.): 323–335.

Pütz, Theodor. 1971. *Grundlagen der Theoretischen Wirtschaftspolitik*. Stuttgart.

Theater-Statistik. 1972–73. Köln: Bühnenverein.

Wahl-Zieger, Erika. 1978. *Theater und Orchester Zwischen Marktkräften und Marktkorrektur*. Göttingen: Vandenhoeck & Ruprecht.

Comment
Alexander Belinfante

Erika Wahl-Zieger's discussion of government subsidy in the United States fails to take note of the subsidies provided by state and local governments, most of which are aimed at reducing the deficits of performing arts organizations but rarely guaranteeing that all of the deficits will be covered.

All levels of government in the United States have also generally provided indirect subsidies to the performing arts that are far in excess of the direct subsidies that Wahl-Zieger discusses. One form that such subsidies take is the provision of performing facilities to artists at no cost or at nominal cost. This is justified along the lines I indicate in my discussion of Austen-Smith's paper. Another form of indirect subsidy is through state universities and other government-funded educational institutions. This is commonly accomplished by means of artist-in-residence programs and subsidies to individual performances. The money often comes largely out of the budgets of the school's music and drama departments, though in many cases the performance subsidies are also financed by student activities fees, which could be thought of as a tax on the student body. However, the largest source of indirect government subsidy for the arts is income tax deductions that are provided to private contributors to the arts. This is the primary incentive for the maintenance of what Wahl-Zieger refers to as type 2 organizations, which depend on private subsidy. In this way, the private contributors control distribution of the funds, while the government indirectly picks up a substantial portion of the tab in the form of forgone taxes.

I would also like to comment on the productivity problem that both Wahl-Zieger and Khakee and Nilsson refer to. The extent of the problem depends on how output is defined; if it is defined as a performance, then the problem exists. However, Gapinski defines performance as an input, and he defines output as a person listening to a performance. Using this definition, productivity can be increased by increasing audience size, which can be achieved by increasing the number of people attending a single performance or by performing the same program for different audiences. In the latter case, the artist's time per listener might be reduced if one counts rehearsal time, since repeated performances presumably require less preparation time per performance.

Multiple-Objective Allocation Procedures in Arts-Funding Decisions*

David Throsby

\mathbf{D}ECISION MAKING is essentially an exercise in constrained optimization. The distinguishing characteristic of multiple-objective decision making is that optimization is required over more than one domain at a given time. In this paper I apply some multiple-objective methods to arts-funding decisions, that is, to questions of grant allocation among competing "artistic" or "cultural" activities subject to an overall budget constraint. The emphasis is on grants, indicating a concern with the deployment of direct financial patronage to the arts from public or private sources. Most of the discussion will relate to public transfers, though the principles are just as applicable to funding by foundations, corporations, or individuals.

In the public sphere in countries such as the United States, Canada, Britain, and Australia, grant allocation decisions are made in several stages. Typically, a central funding agency first determines allocations from a given overall annual budget to boards, programs, or panels concerned with different art forms. These allocations serve as constraints in the distribution of grants by the board committees among competing applicants—companies, projects, and individuals. A further set of allocation decisions by recipients may be required, for example, by performing companies determining the repertoire or program for the forthcoming period. Here the funds from the central agency may be augmented with grants from other public or private donors. At each stage in the distribution it is intuitively obvious that a number of different and often conflicting criteria will be taken into account in reaching a final decision. Hence, the decision-making framework discussed can be seen as applying in principle at all stages of the arts-funding decision sequence.

*This paper is part of a project funded by the Australian Research Grants Committee.

A GENERAL MODEL

We begin by setting up a general model of the arts-funding decision as described. A fixed grant budget has to be allocated among a number of competing activities by a decision maker, whether an individual or a committee. With the latter we assume some mechanism exists for the resolution of intragroup conflicts, so that it is reasonable to refer to a single decision maker whose choices are assumed to be consistent with expressed objectives. A set of constraints on subsidy allocations exists, and more than one objective function in the decision variables has to be optimized. Without loss of generality, we can also assume that the desired direction of optimization is maximization.

The usage of the terms "objective," "criterion," "goal," and "attribute" in the literature tends to vary. The first three are more or less interchanged, though in some contexts the term "goal" is used to denote the desired "target level" of some variable. Also, it is important to distinguish between "objectives," which are general statements of intent, and "attributes," which are specific indicators of the achievement of objectives. For example, an objective of arts policy might be to foster education in music appreciation for the young. One possible indicator of the achievement of this objective might be the number of attendances by schoolchildren at specially arranged musical events in a given time period. One of the objective functions to be maximized might then measure this attribute, that is, the number of such attendances generated by alternative distributions of subsidy.

Formally, the model may be stated as:

(1) $\quad \max U = U[f_1(\underset{\sim}{x}), f_2(\underset{\sim}{x}), \ldots, f_p(\underset{\sim}{x})]$

subject to:

(2) $\quad g_i(\underset{\sim}{x}) \leq 0$

(3) $\quad \sum_{j=1}^{n} x_j \leq b$ and

(4) $\quad \underset{\sim}{x} \geq 0$

where

U is the decision maker's utility function;
$\underset{\sim}{x}$ is the n-vector of subsidy allocations to activities or projects in a given time period;
f_k is the objective function with respect to the k-th objective $(k = 1, \ldots, p)$;
g_i is the i-th constraint on the decision variables $(i = 1, \ldots, m)$; and
b is the budget.

Two broad interpretations of this model are possible. First, if the scalar x_j (the grant allocation to the j-th activity) is fixed and n is relatively small, the problem

is essentially one of project selection. In other words, a finite set of alternatives exists (combinations of one or more discrete projects which satisfy the constraints) from which a single choice must be made. Each project (and hence each feasible project combination) contributes in some way to each of the p objectives, the contribution being measured along some appropriate attribute scale. The objective functions, f_k, in equation (1) can then be interpreted as utility functions over each attribute, and the overall utility function, U, in (1) provides a means of weighted aggregation of utilities derived from each attribute. It is thus possible to attach a specific value of U to each alternative project (or project combination), such that the problem is solved by choosing that alternative with the highest utility index.

Application of this approach is predicated on the assumptions of axiomatic utility theory, enabling derivation of the attribute utility functions by direct questioning of the decision maker. The method also readily incorporates allowance for uncertainty in the generation or valuation of consequences. When uncertainty is present, the utility indexes are dependent on the decision maker's subjective assessment of the appropriate probability distributions over outcomes.

This interpretation of the multicriterion problem is generally referred to as "multiattribute decision analysis" or "multiattribute utility theory" (see MacCrimmon 1973; Keeney and Raiffa 1976). While it may have some relevance to the arts-funding decision at the more devolved levels (for example, the choice between several alternative exhibitions for a gallery, or repertoire choice for a theater company), it seems less generally applicable than the other broad interpretation of the problem. In this second approach at least some x_j are continuously variable and, hence, whether n is small or large, there is in effect an infinite set of alternatives. The problem is thus one of choosing a value of x which maximizes equation (1) subject to the constraints.[1] Formally, of course, this is identical to the multiattribute model, the only difference being the number of alternative prospects under consideration. In practice, however, this difference means that the direct assessment of preferences based on comparisons between discrete alternatives cannot, at least at first glance, be used with this second interpretation, although it may be possible to use it at a subsequent stage in the decision analysis if the number of alternatives can be refined down to a countably small subset of the original array.

Furthermore, while it is possible in principle in the second interpretation for the functions, f_k, to be regarded as individual attribute utility functions, this may not be feasible in practice unless based upon highly simplified utility assumptions. Rather, as we shall see later, the individual objective functions may be seen as attribute "response functions" which are then combined in equation (1) to obtain an expression which may be construed as the decision maker's aggregate utility. This overall interpretation of the model may be referred to simply as "multiple objective decision analysis" (see Hwang and Masud 1979; Roy 1971; and Starr and Zeleny 1977, pp. 5–29). We shall confine our attention to this approach from now on.

SPECIFICATION OF THE MODEL

How might the components of this decision model be specified? First, consider the decision variables, x_j. At the first stage of the funding sequence described, these variables might simply be interpreted as subsidy allocations to various art forms, measured directly in monetary units. Here the assumption of divisibility is clearly tenable. At the next stage, typically involving distribution within a single art form, the decision variables might comprise grant allocations to n final recipients ($x_j \geq 0, j = 1, \ldots n$). By and large, an assumption of continuous divisibility of allocations would again be reasonable over the relevant ranges of output, except in cases where activities are in the nature of all-or-nothing projects or provisions for capital works. In these instances, integer variables may have to be specified.

Second, the constraints are likely to be of several sorts. The major overall constraint will be the budget available for allocation at each stage, as expressed in equation (3). Then there are likely to be maximum and minimum constraints on individual activities which will limit the rate of growth or decline in any activity in the planning period. These constraints simply reflect the fact that sudden large shifts in these sorts of public expenditures are usually neither politically nor administratively feasible; they might not even be economically efficient in light of the short-run costs of resource relocation. Rather, where radical change is indicated unambiguously by the objective functions in the system, such change is likely to be effected by a gradual process of adjustment over time.

Further constraints in equation (2) may be indicated by a wide variety of technical considerations affecting the allocation process. These constraints might also include some objectives when these can be expressed as restrictions on subsidy allocations rather than as functions to be optimized. Note that constraints might be linear or nonlinear equalities, and that these characteristics might influence the choice of solution procedure.

Let us turn next to the specification of objectives. Delineation of the objectives of arts policy has attracted increasing attention in recent years. It has been suggested that the vague charters of public funding bodies, such as the National Endowment for the Arts, the Canada Council, the Arts Council of Great Britain, and the Australia Council, though worthy in intent, provide inadequate guidelines for the precise definition of objectives which is necessary for efficient and equitable grant distribution. For example, King and Blaug (1973, p. 16), in considering the annual reports of the British Arts Council, conclude that "it is not too much to say that in 26 years of official reportage they have failed to produce a single coherent and operational statement of their aims." It is simply insufficient, King and Blaug argue, to advance the subjectivity of artistic judgments as a defense against this criticism. Publicly accountable bodies have a responsibility to make known the criteria by which their expenditures are determined, even if they are working in areas like the arts where there is a strong value element in all decision making.

Reviewing the whole area of arts policy objectives, Throsby and Withers (1979, pp. 203–224) argue that goals should relate to the justifications for government financial assistance to the arts. If these justifications are agreed to be the existence of beneficial externalities (in consumption or production) and/or designation of the arts as a merit good, then a consolidated list of basic objectives for an arts policy may be suggested as follows:

1. To encourage the definition of national identity and to promote constructive national feeling and international understanding.
2. To advance freedom of expression, investigation of human behavior, and critical examination of the state of society.
3. To encourage beneficial application of the arts to other areas of industry and of community life, including recreation and education.
4. To encourage arts activity for its own aesthetic worth, and hence to foster artistic excellence and raise cultural standards.
5. To encourage broader and more equal public participation in arts activity.
6. To encourage artistic appreciation as part of the educational goal to promote informed and intelligent free choice.

It is apparent that translating such objectives into a set of attribute measures suitable for specification as objective functions in our model is no easy task. We may approach the task by first observing a distinction between those attributes relating to the quantity of arts output generated by subsidy and those relating to its quality.

On the quantitative side a number of specific measures of the level of output might be suggested: attendances at arts events, numbers of new works created in various art forms, numbers of people stimulated to engage in creative activity, and so on. The maximization of any or all of these could be included as objective functions in the model. As a simpler alternative, a more general quantity-of-output measure might serve as a summary attribute whose maximization would be consistent in broad terms with quantitative aspects of these objectives. Such a measure might be a "participation index" indicating the aggregate numbers of people attracted to creating or consuming artistic activity in a given time period. If such a measure were used, constraints might need to be placed on decision variables to ensure achievement of satisfactory levels of other participation goals related, for example, to the geographic or socioeconomic distribution of arts activity.

Specification of objective functions relating to the quality of output raises more challenging problems. The incorporation of aesthetic considerations into economic models is an area of research that is beginning to attract the attention of economists.[2] For example, Shanahan (1978) points out that in the demand for music, consumers make market choices which have a strong aesthetic component; if these choices are to be adequately modeled, some measure of aesthetic effects is required. Similarly, in the model of the grant distribution decision process we require not only a set of quality attributes to be specified, but also appropriate measurement scales to be devised for them.

The fact that judgmental issues are raised should not deter attempts to quantify these relationships; even simply dissecting the components of quality decisions can serve to illuminate the way such choices are or should be made. Current research in the area of the performing arts (Throsby and Nielsen 1979) suggests that some agreement may, in fact, be possible as to specific criteria for measuring the quality of arts output. Particular projects or subsidy allocations might be assessed in terms of the extent to which they contribute to these criteria. At a disaggregated level, simple binary scales may be sufficient in the case of some attributes; more detailed cardinal measures may be required for others, reflecting "consensus" judgments as to the contribution of activities to those attributes. Such criteria might, in due course, provide a basis for quantifying individual objective functions in equation (1), or might be able (under certain conditions of the preference orderings of the decision maker) to be aggregated into a single quality index, enabling just one quality-related objective function to be specified.

If this were in fact possible, and if the quantity-of-output side were handled by a single participation index, the arts-funding decision could be simplified to a decision involving only two objective functions. Although such an interpretation of the problem would be highly simplified it might be valuable as a broadly based but manageable first approximation to the arts-funding decision problem.

Once objective functions are chosen and measurement scales determined, the next stage is the specification of their functional form. In other words, what is the exact nature of the relationship between each particular attribute and subsidy allocations across activities? Consider an aggregate-level objective to maximize participation across art forms. It could be suggested that the response to increase participation by grant allocation might first go through a phase of increasing returns at the margin, during which "setting-up" requirements are met and the community learns about the existence of new or expanded activities. Subsequently, a stage of diminishing marginal returns is likely, which will intensify as saturation of interest is approached and the stock of potential talent is exhausted. Just as with short-run production functions in neoclassical economics, which follow a similar pattern, a number of functional forms could be used to describe such a response. In more practical terms, however, the specification of such a relationship over a full range of subsidy allocations is unlikely to be required since, particularly at the aggregate level, decisions will typically be characterized by marginal adjustments to an existing pattern of distribution. Hence, the quantification of objective functions may be confined to small variations in the decision variables, making their specification much simpler. In particular, linear approximations are very likely to be adequate in many cases.

SOLUTION PROCEDURES

Methods of solving the problem posed in equations (1) through (4) may be classified according to the point at which the decision maker is required to articulate the nature of the overall utility function specified in (1). If this is done prior to the analysis, the problem can be solved at once. For instance, if (1) can be assumed to be additively separable and the decision maker can define a set of

weights, w_k, attaching to each objective function (normalized so that $\Sigma w_k = 1$), then the problem becomes:

(5) $\max \sum_{k=1}^{p} w_k f_k(\underline{x})$

subject to equations (2) through (4). If the constraint set and individual objective functions are linear, the problem is solved by linear programming.

If the weights in equation (5) are not known or cannot be specified, they might be assumed to be equal. Alternatively, a solution which comes as close as possible to maximizing all objective functions can be sought. For example, the problem may be written as:

(6) $\min \sum_{k=1}^{p} [f_k(\bar{x}) - f_k(\bar{x})/f_k(\bar{x})]$

subject to equations (2) through (4), where $f_k(\bar{x})$ is the optimal solution to:

(7) $\max f_k(\bar{x})$

subject again to (2) through (4). That is, p separate problems are solved initially by equation (7), followed by a final solution by equation (6), which is again a linear programming problem.[3]

A similar approach requiring prior specification of preferences is goal programming (see, for example, Lee [1972]), which attempts to minimize the deviation of each objective from prespecified desired achievement levels. The problem is:

(8) $\min[\sum_{k=1}^{p} (d_k^- + d_k^+)]$

subject to equations (2) through (4) and:

(9) $f_k(\underline{x}) + d_k^- - d_k^+ = t_k$

where \underline{t} is a vector of target levels and \underline{d}^- and \underline{d}^+ are nonnegative vectors of under- and overattainment, respectively, of these targets such that $d_k^- \cdot d_k^+ = 0$, for all k. In the context of the arts-funding problem, this approach does not appear very promising for two reasons. First, the notion of "targets" for the sorts of objectives we have been discussing is likely to be imprecise. Second, even if targets can be set, there is unlikely to be any penalty attaching to their overattainment, hence the problem reverts simply to the statement in equations (1) through (4).

The prior specification of preferences required by the solution methods discussed so far may be difficult and time-consuming. If it involves complete enumeration of a utility function, it may also be wasteful in the sense that in this process the decision maker is required to express preferences over a range of outcomes, many of which will turn out to be either infeasible with respect to the constraints or, if feasible, dominated by other feasible solutions. Thus, it makes sense to suggest that the multiple-objective decision problem be broken down into two stages. In the first stage an array of "efficient" solutions can be generated with respect to the given set of objective functions and constraints. Here efficient is used in the Paretian sense of a reallocation of subsidies in such a way that in-

creases in one objective can only be achieved at the expense of another.[4] In the second stage the decision maker can choose from among the array of Pareto-optimal solutions according to the expressed or implied trade-off between objectives.

The means of generating the set of efficient solutions depends on the nature of the objective functions and constraints. If the problem is set up as in equation (5), parametric variation of the weights will enable an enumeration of efficient vertexes of the constraint set to be obtained. For example, if $p = 2$, then $\underline{x}w = (1,0)$ solves the problem for maximization of the first objective alone. Variation of $\underline{x}w$ through $(0,1)$ will progressively change the weight from the first to the second objective, and the solutions traced out along the way will all be efficient.

To illustrate, suppose that $k = 1$ refers to arts participation goals and $k = 2$ to quality, and that the two avenues for subsidy allocation in a forthcoming period are traditional and experimental drama, whose allocations above a given minimum base level are to be determined, denoted as x_1 and x_2, respectively. Assume that the capacity of traditional drama to attract audiences at the margin per unit of additional support exceeds that of experimental drama, but that the extra "quality" yielded by the latter per marginal unit of subsidy is judged higher. Hence, we have a composite objective function:

(10) $\max[w_1(\alpha_1 x_1 + \alpha_2 x_2) + w_2(\beta_1 x_1 + \beta_2 x_2)]$

where $\alpha_1 > \alpha_2 > 0$, $\beta_2 > \beta_1 > 0$, and $w_1 + w_2 = 1$, with constraints:

(11) $x_1 + x_2 \leq b$
(12) $0 \leq x_1 \leq y_1$ $(y_1 < b)$
(13) $0 \leq x_2 \leq y_2$ $(y_2 < b)$

where y_1 and y_2 indicate the maximum permitted growth in subsidy allocations to the two activities in the time period considered.

Figure 1 shows the constraint set, and the dotted lines show the slopes of the objective function in equation (10) for extreme values of the weights. The optimum for the participation objective is at A, and for the quality objective the optimum is at B. The segment AB comprises the set of nondominated subsidy allocations. In Figure 2 AB represents the efficient boundary in objective space, that is, the maximized participation rates for given levels of achievement of quality goals, or equivalently maximized quality levels for given participation rates. The solution so far represents what we referred to above as the first stage of the decision analysis. At this point the set of efficient solutions can be presented to the decision maker for contemplation.

If the decision maker's utility function is simply a linear combination of the two separate attributes, a final solution will lie at A or B (saving the coincidence of indifference between A and B and any point between them). If, on the other hand, preferences between quality and quantity of output follow the axioms of standard choice theory, implying a convex utility surface, we might still reach an extreme point solution or perhaps a point such as E in Figure 2, where the dashed curves indicate a possible shape for the implied indifference curves between these

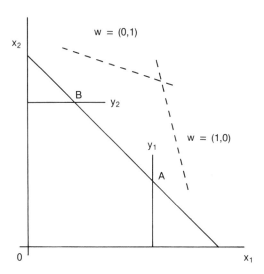

Figure 1. *The Objective Function and Constraints*

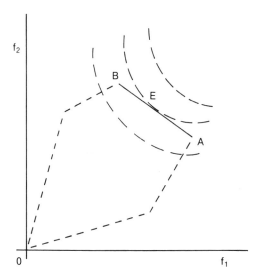

Figure 2. *Maximum Participation Rates for
Levels of Quality Goals*

two attributes. At this point the decision maker's trade-off between objectives (the marginal rate of substitution) equals the marginal rate of transformation between them obtained by shifting subsidy from one use to the other.

For certain problems it may be that the set of efficient solutions is unmanageably large. Various suggestions have been made for reducing the size of the non-

dominated set, such as that proposed by Zeleny (1974), but these suggestions require the participation of the decision maker, for example, in eliminating plainly unpreferred combinations. Such possibilities introduce an intermediate type of solution procedure, lying between the prior and posterior articulation of preferences. It might be referred to as an interactive approach, whereby the decision maker participates during the process of exploring feasible efficient solutions, guiding the decision progressively toward optimality. A number of interactive solution algorithms have been proposed (for example, see Zionts and Wallenius [1976]) which might in principle be contemplated for the arts-funding decision, but the fact that the decision maker is likely to be a group rather than an individual limits their applicability in practical terms.

CONCLUSIONS

It has not been my purpose to put forward a set of practical rules which could be immediately applied to real-world arts-funding decisions. After all, in other areas of public expenditure, such as water resources investment, where multiple-objective procedures have been considered and discussed for over a decade, their routine use in decision making is still less than widespread. Rather, the aim has been, as with any exercise in model building and analysis, to expose the structure of the grant distribution decision process and to investigate relationships between variables. In so doing, some light may be shed on the sorts of information required to make these decision processes more efficient.

Two results are worth stressing. First, for general analytical purposes the arts-funding decision may be simplified to one involving just two objectives, maximization of participation levels and maximization of quality characteristics of arts output. In the first of these objective functions estimation of the relationships between output quantity and support levels should be reasonably straightforward provided adequate data are available, though little empirical research has yet addressed this question. But in the area of quality objectives much more basic theoretical work is required to determine the criteria for judgment, attribute scales, and the "productivity" of financial support directed toward these ends.

Second, the preferred analytical approach is the one that does not require either the complicated definition of utility functions or prior assumptions about the decision maker's preferences. The primary task of decision analysis in this area should be to generate the set of nondominated solutions to the multiobjective problem. Such information provides a useful basis on which a decision maker may work without needing to articulate more than local trade-offs between objectives. Furthermore, this approach lends itself to experimentation with alternative constructs of objective functions, a device which could be particularly useful in enabling sets of efficient solutions to be compared for different interpretations of quality characteristics of arts output.

Finally, as is often pointed out in connection with cost-benefit analysis, it must be remembered that even the most applicable tools of public expenditure analysis are only aids to decision making, and large amounts of intuition, judgment, and

luck are still involved. In the case of arts-funding decisions, multiple-objective procedures will in the end have a role to play, even if all they do is to enable this uncontrolled element to be contained within reasonable limits.

Notes

1. This problem has been referred to as "project design" in contrast to "project selection."
2. See particularly Vaughan (1977), who considers this question in the context of public subsidization.
3. Stronger assumptions about preferences for the size of deviations of actual from optimal with respect to individual objective functions may be introduced by raising the square-bracketed term in equation (6) to the power $q > 0$. The problem will then be one of nonlinear programming for other than $q = 1$.
4. Note that generation of the efficient solution set depends only on the constraints and the individual objective functions and is independent of the decision maker's preferences among objectives.

References

Hwang, C. L. and Masud, A. S. M. 1979. *Multiple Objective Decision Making—Methods and Applications*. Berlin: Springer-Verlag.

Keeney, R. L. and Raiffa, H. 1976. *Decisions with Multiple Objectives: Preferences and Value Tradeoffs*. New York: John Wiley.

King, K. and Blaug, M. 1976. Does the Arts Council Know What It Is Doing? *Encounter* (Sept. 1973): 6–16, reprinted in *The Economics of the Arts,* M. Blaug, ed. Boulder, Col. and London: Westview Press and Martin Robertson, pp. 101–125.

Lee, S. M. 1972. *Goal Programming for Decision Analysis*. Philadelphia: Auerback.

MacCrimmon, K. R. 1973. An Overview of Multiple Objective Decision Making. In *Multiple Criteria Decision Making,* J. L. Cochrane and M. Zeleny, eds. Columbia, S.C.: Univ. of South Carolina Press.

Roy, B. 1971. Problems and Methods with Multiple Objective Functions. *Mathematical Programming* 1, no. 2 (Nov.): 239–266.

Sfeir-Younis, A. and Bromley, D. W. 1977. *Decision Making in Developing Countries: Multiobjective Formulation and Evaluation Methods*. New York: Praeger.

Shanahan, J. L. 1978. The Consumption of Music: Integrating Aesthetics and Economics. *Journal of Cultural Economics* 2, no. 2 (Dec.): 13–26.

Starr, M. K. and Zeleny, M., eds. 1977. *Multiple Criteria Decision Making*. Amsterdam: North Holland.

Taylor, B. W. et al. 1975. Approaches to Multiobjective Planning in Water Resource Projects. *Water Resources Bulletin* II, no. 5 (Oct.): 999–1008.

Throsby, C. D. and Nielsen, E. 1979. *Product Quality Decisions in Nonprofit Performing Arts Firms*. Macquarie Univ., School of Economic and Financial Studies Research Paper Series.

Throsby, C. D. and Withers, G. A. 1979. *The Economics of the Performing Arts*. Melbourne and New York: Edward Arnold and St. Martin's Press.

Vaughan, R. J. 1977. The Use of Subsidies in the Production of Cultural Services. *Journal of Cultural Economics* 1, no. 1 (June): 85–95.

Wallenius, H. et al. 1978. An Approach to Solving Multiple Criteria Macroeconomic Policy Problems and an Application. *Management Science* 24, no. 10 (June): 1021–1030.

Wehrung, D. A. et al. 1978. Interactive Preference Optimization for University Adminis-
tration. *Management Science* 24, no. 6 (Feb.): 599–611.
Zeleny, M. 1974. *Linear Multiobjective Programming.* Berlin: Springer-Verlag.
Zionts, S. and Wallenius, J. 1976. An Interactive Programming Method for Solving the
Multiple Criteria Problem. *Management Science* 22, no. 6 (Feb.): 652–663.

Comment
Clark C. Abt

C. D. Throsby makes a quick pass at applying mathematical optimizing proce-
dures to arts-funding investment decisions. Whatever the particular limitations of
mathematical optimization of multiple-objective allocation, the proposed appli-
cation is effectively blocked by two theoretical problems that remain unsolved.
The first is the relationship between arts output and input support levels or, in
economic terms, the development of a replicable and convincing arts production
function. The author states that "estimation [of this relationship] should be rea-
sonably straightforward provided adequate data are available," but then adds
that "little empirical research has yet addressed this question." I would add that
a substantial amount of data are available, but to my knowledge no one has
solved the theoretical problems of attributing arts output exclusively to certain
levels of input support. No true experiments have been conducted to determine
this relationship, and the natural experiments that might be done are technically
really quasi-experimental designs with irreducible covariance problems.

The second theoretical obstacle to the proposed application of mathematical
optimization methods to multiple-objective allocation in arts-funding decisions is
in the formulation of arts quality objectives in replicably measurable terms.
While I believe that anything that can be described can be measured, in this case
either through sufficiently diligent application of psychometric techniques or sur-
vey research on expert and mass audience preferences, the necessary work has not
been done. Such economic methods as taste preference determination of arts
markets and shadow pricing of arts qualities encounter aggregation problems and
fallacies of composition. Is the quality of a work of art equal to the sum of the
qualities of its components, even if we learn how to identify and measure them?

Until these two major theoretical problems (the quantification of arts quality
objectives and the arts production function) are clarified, I see little utility in con-
sidering this application of mathematical optimizing further. Thus, the quan-
titative research that is needed now is an investigation of these measurement
problems. If they can be successfully resolved, a plentitude of mathematical opti-
mization methods already exists for optimizing arts-funding investment alloca-
tions (for example, linear programming and dynamic programming).

An Economic Analysis
of the Museum

Bruno S. Frey and
Werner W. Pommerehne*

I N RECENT YEARS economics has expanded rapidly into new areas, such as the arts, and a collection of papers on *The Economics of the Arts* is already available (Blaug 1976). The main focus of current cultural economics has been on the performing arts, in particular, theaters and orchestras. The pioneering work in this area was done by Baumol and Bowen (1966), Moore (1968), and Poggi (1968); and the questions asked and conclusions drawn by Baumol and Bowen have recently been reconsidered by Netzer (1978). The economic approach has also been applied to such fascinating areas as classical and Renaissance theater (Baumol 1971; Oates and Baumol 1972), and the performing arts (Austen-Smith 1978a and b and Wahl-Zieger 1978, among others).

Museum research has traditionally been dominated by sociologists, who have mostly conducted large-scale field research on visitor behavior;[1] comparatively little work has been done so far on the economics of the museum. One exception to this is Peacock and Godfrey's (1974) work dealing primarily with the financial situation of the museum, the museum being considered as a firm with a complex objective function and offering an unusual type of product. Earlier, more specialized contributions by Peacock (1969) on the rationale of public support are done in the context of an exchange of views with Robbins (1963, 1971). The discussion between Peacock and Robbins also has dealt with optimal pricing. Contributions by some other authors can be found in *Museum News,* for example, Lee (1972), Montias (1973), O'Hare and Feld (1975), and Bridges (1976); and an article by Gassler and Grace (1980, forthcoming) discusses the museum as a nonprofit insti-

*The authors have had the opportunity to discuss some of the aspects dealt with in this paper with Dr. Felix A. Baumann, director of the Kunsthaus in Zurich. Thanks are due to Kenneth Kahn and Clark Abt for their useful comments, and to Sandra Stuber for editing the paper in English and for other helpful suggestions.

tution. Some of the relevant articles on the economics of the museum are in Blaug's collection (1976) mentioned above.

The present contribution is explicitly based on the economic model of human behavior, applied to both demanders and suppliers (see, for example, Becker 1976; McKenzie and Tullock 1975; and Alchian and Allen 1977), and is intended to complement both the traditional sociological and economic approaches to the study of museums. We have limited ourselves to art museums, but most of the analysis and conclusions apply to other types of museums as well. The paper focuses in particular on the semipublic type of museum most common on the European continent, with the Kunsthaus in Zurich used as an example. The paper deals mainly with the supply aspects of the museum, that is, with the behavior of the museum directorate. The demand for museum services is only considered to the extent that it constitutes an element in the set of restrictions imposed on the directorate's behavior. The concluding section suggests some possibilities for influencing the supply of museum services.

While the museum is an institution in which several actors—the directorate, professional staff (curators and others), guards, craftspeople, and so forth—join together to supply services, the key role of the directorate is our focus.

UTILITY OF AND CONSTRAINTS ON THE MUSEUM DIRECTORATE

The top echelons of the museum derive utility from what has been termed "performance excellence," that is, meeting the high standards established by the profession of museum directors. Such performance excellence in the case of museums is very similar to that motivating hospital doctors (see Lee 1971; Newhouse 1970). Utility is also derived from the prestige and status gained vis-à-vis the reference group, which consists of art lovers (members of the museum club, donors, and trustees); art historians; the international museum community; and, in particular, the directors of other museums. The third element in the museum directorate's utility function consists of agreeable working conditions, income, and job security (the latter is important because of the employment problems associated with this type of education and specialization).

Budget Constraints

Monetary constraints set the limit on expenditures. The main current income sources are public subsidies; private support by the museum membership on a continuous basis; extraordinary subsidies received from specific individuals; income from commercial activities, such as sales of publications, pictures, and posters, and cafeteria or restaurant business; and entrance fees. The main capital income sources (income on the purchase account) are public grants to buy works of art; private donations in money (and in kind if they can then be sold and money realized from them); and income from the sale of objects out of the museum's stock. The most striking feature of the income sources for the Kunsthaus in Zurich from 1973 to 1977 is the unimportance of entrance fees, which provide only

about 10 percent of total income. Income on current accounts amounts to about 90 percent of total income; in other words, the capital (or "purchase") account is relatively unimportant.

The most important income source for the Kunsthaus is government support, which provides 70 percent of the museum's total income; private financial support is relatively unimportant, providing only about 3 percent of total income. This high share of public support seems to be typical for most museums on the European continent. The situation is reversed in the United States: the Museum of Modern Art (MoMA) receives only slightly more than 10 percent of its current and capital income from government sources, but it receives 30 percent through private support. One major reason for this difference in income sources is the tax system, which in Europe offers comparatively little incentive for private giving to the arts, whereas in the United States tax deductions and exemptions offer a strong incentive. With regard to other sources, the Kunsthaus receives only 4 percent of its income from membership dues (the share is again much higher in the U.S.: 10 percent, for example, in the case of MoMA), and only 10 percent from commercial activities (compared to 30 percent for MoMA).

Space Constraints

Most museums are short of exhibition space, often desperately so. This restriction thus seems to be of great importance for the behavior of the museum directorate, and it is accordingly very often mentioned in reports (see, for example, Montias [1973] referring to the MoMA, or Clottu [1975] for Swiss museums). It seems that extending a museum is often practically impossible or only possible at high cost.

Restrictions Imposed by the Museum Community

The museum community is mainly composed of the members of the museum club. In the case of MoMA, for example, there were 38,000 members in 1977–78, which means that one out of every three visits was made by a formal member of the museum family (as of November 1978). Formal members are thus significant not only numerically, they also have a particularly high rate of visitation. These art lovers derive utility from being attached to the museum and visiting it to satisfy their intrinsic interest and from close contact with the museum directorate. They have an interest in keeping the membership exclusive. They are thus less interested in popular exhibitions that may attract large crowds than in the more esoteric and exclusive exhibits.

Another restriction on the directorate's behavior is imposed by the *trustees and donors*. Trustees seem to have considerable influence on museum policy, especially in the case of the privately and commercially run U.S. museums. The donors' influence arises out of the conditions that they may—and often do—attach to their gifts, particularly with respect to the way in which they are to be exhibited, as this can greatly restrict the directorate's freedom to arrange the exhibits as it would like. The utility gained by the donors is that of having their gifts (or works of art purchased with their donations) displayed in the museum with the appropriate credits.

Art historians are another group having a major influence on the directorate's behavior. The utility of this group consists of the professional career and income possibilities that they derive from the museum. These people are not interested in the popularity of exhibits, but rather in their "historic value," which may lead to demands that are very different from those of general visitors. They are interested in specialized exhibitions and specialized stocks because they conduct in-depth research in narrow areas.

Restrictions imposed by *politicians* are, in contrast, quite weak. Politicians mainly derive utility from the museum's existence due to the international prestige connected with it or with particular exhibitions. The politicians' behavior is itself constrained by their need to be reelected. They thus have to espouse a cultural and museum policy that will be viewed favorably by their constituency. They must also consider the desires of the local business community, which may be interested in a certain museum policy because they derive indirect income from the museum's existence. One relevant constraint seems to be to avoid serious scandals with respect to the exhibitions or the museum's administration. Another constraint faced by politicians is budgetary since they have to compare the outlays made for museums with expenditures for other public purposes.

Politicians have little incentive to intervene directly in the business of the museum because of the high information cost this necessitates and the low benefits to be derived from doing so. They do, however, want to make sure that scandals do not occur, and therefore they prefer a conservative museum policy.

The last type of constraint is imposed by legal and administrative restrictions. Most European museums have a special legal status as institutions beneficial to the community, even when they are private, and they are therefore subject to the general principles of the public sector, especially with respect to conditions of employment. Moreover, they are often public institutions (for instance, in Germany about 50 percent are public), which means that employment is narrowly defined according to a bureaucratic rationale, which often conflicts with the desires of the museum directorate.

The museum directorate may also have to take into account a large number of specific regulations. In the United Kingdom, for instance, for a time the museums were not allowed to use money gained from entrance fees to purchase art objects. The directorate is often free to set different prices for different groups of visitors, visiting hours, and so forth, but it is usually not allowed to offer free entrance throughout (though for a while in the United Kingdom museums were not allowed to charge fees). Most European museum directors are in principle free to use the receipts from entrance fees as they wish. They may fear, however, that an increase in entrance income will decrease the support received from public sources, which will in turn force them to resort to tactics that will continue to pull in a larger number of visitors—something they may not wish to do. The situation is different in the United States, where there seems to be a tendency to take income from visitors as an indication of successful operation in the "museum business," which leads to an increased supply of public funds.

No important constraints are imposed by the *general public,* which usually has neither the opportunities nor the incentives to influence museum policy. The

information costs are high and the expected benefits low due to the essentially public good nature of such activity.

Having discussed the main elements in the directorate's utility function and the constraints it faces, we can now formulate hypotheses about the directorate's behavior.

THE BEHAVIOR OF THE
MUSEUM DIRECTORATE

How the museum directorate achieves the goals it sets depends largely on institutional conditions, especially on the nature of the funding. The directorate behaves differently in a private, commercially oriented museum mainly supported by private donors than it does in a semipublic museum that depends essentially on the support provided by the public purse. The latter type of museum prevails on the European continent and will be discussed here.

Attainment of such goals as performance excellence, prestige, and agreeable working conditions is only possible if the directorate has sufficient discretionary leeway to act as it sees fit. One way that the directorate tries to achieve this leeway is by moving from a commercial to a noncommercial framework. A long-term development in this direction can be observed on the European continent and particularly in Germany, where the directorates are getting farther and farther away from monetary evaluations of their activities and exhibits, substituting instead other value standards (Treinen 1973).

Strategies for Obtaining Discretionary Leeway

The directorate prefers to act within a nonprofit framework as much as possible. It is then not forced to try to make a profit. A nonprofit museum has by law and in practice a full deficit guarantee, at least up to a certain amount. Public support is sought and generally received sufficient to cover the costs. Since these costs are determined by bureaucrats, the museum directorate does not have much of an incentive to save or to hold costs down. This deficit guarantee gives the directorate the freedom to pursue policies in its own interests.

In order to have more room for discretionary action, the directorate also tries to isolate the museum as far as possible from market or commercial valuations. Application of specialized noncommercial standards helps to minimize the attacks coming from outside, since it makes it very difficult for ordinary visitors or politicians to propose different policies or question what the directorate does. The competence of both of these groups with respect to museum activities is usually restricted to monetary matters, and thus it is easy to reject their attacks. This strategy amounts to a rejection of the economic view as based on concepts such as substitution, trade-offs, or opportunity costs. It means that the production function connected with the museum's services is actively hidden by the supplier and cannot easily be detected and controlled from the outside.

In line with this policy, valuations of the museum's activity and exhibits are done by "experts." These experts are usually from within the museum world

(there is usually not much exchange between museums and other institutions, such as universities, that could serve as expert reference groups but might have their own ideas about what should be done). Thus, the supplier defines its own standards of service.[2]

This policy of noncommercialization, whose end goal is to increase the museum directorate's discretionary power, has a considerable influence on its behavior in several respects. First, commercial activities will only be carried out by the directorates of semipublic museums on a small scale because they do not suit the nonmarket outlook that such museums cherish. We can thus expect to find few shops, restaurants, and cafeterias. In those museums where these facilities exist, directorates have little interest in making a profit from them.

> In the Kunsthaus in Zurich, one of the most important museums in Switzerland, there is a small cafeteria that is let to an outside contractor, and a shop for posters, prints, slides and postcards that runs a loss. This may be compared to New York's MoMA where publications and retail operations bring in an average profit of $260,000 a year (1973/74-1977/78), and food service since 1976/77 has earned an average profit of over $100,000 a year. (Clottu 1975, p. 207)

Second, according to a bookkeeping practice used in all museums, the objects in the museum's stock are not commercially valued and included among the assets (though their market value may be extremely high, especially in the case of art museums). One reason for this convention is of course the difficulty of estimating the market price when there is such a small number of buying and selling activities. There is thus great uncertainty about the commercial value of most exhibits. In addition, the market value of most pictures would fall drastically if they were actually put up for sale: they would lose their scarcity value as the market became more saturated.

Intervention in the museum's business can be kept at a minimum if the value of the exhibits is determined solely within the museum and by "art-historic" or "artistic" rather than commercial criteria.

Third, the decision to sell objects out of the museum's stock is subject to countervailing influences: on the one hand, selling yields income and thus eases the budget constraint; but on the other hand, the market evaluation that necessarily comes with the selling activity goes against the interests of the museum directorate. Moreover, an increase in income from this source may move private and public sources to give less.

The decision (to sell or not to sell) will depend again on the institutional setting in which the museum directorate acts. It may be hypothesized that when the budget constraint is strict, more objects will be sold. If, on the other hand, the budget constraint is minimal, little selling is expected to take place. Empirical evidence suggests that in the case of museums that have automatic budget deficit guarantees (such as most continental European museums), little or no selling takes place although it is legally allowed. In the case of the Kunsthaus, no selling of art objects has been reported in the last ten years.

Fourth, the ratio of exhibits shown to stocks not shown also depends on the institutional characteristics of the museum. It may be hypothesized that in a private museum the ratio is comparatively high because the opportunity costs of stocks not shown are comparatively high. The directorate thus has an incentive to keep unexhibited stocks small. In public museums, on the other hand, the ratio of exhibits shown to stocks not shown is expected to be lower, as the museum directorate is part of an administrative system in which opportunity costs don't matter.

This proposition cannot be tested directly because there are no statistics available on the market value of stocks, or even on the numbers of exhibits relative to stocks not shown (for indirect evidence, however, see Treinen 1973, p. 348).

Finally, the museum directorate tries to avoid disclosing the prices paid for new objects, so as to ward off discussions about possible alternative uses for the money spent. Also, the conditions attached to donations as a rule are not publicly disclosed in order to avoid controversy.

Another reason for avoiding price disclosure is the asymmetry between buying and selling with respect to the risk involved. When buying an art object the directorate faces little or no risk, because the value of the picture bought is evaluated according to artistic or historic criteria, and thus can always be adjusted to the price paid. Selling is more risky, because the work sold may be sold later on the market at a higher price, suggesting that the museum has charged too little.

Use of Discretionary Leeway

Leeway for discretionary behavior can be used in a variety of ways by the museum directorate. The following examples are drawn from the behavior of semipublic museums.

The museum directorate shows great interest in putting together special exhibits whose success will be directly attributed to the directorate and its staff. Such exhibits gain recognition in the museum world, bringing prestige to the directorate and potential career advancement to the curators. However, the directorate has little interest in passing these exhibits on for several reasons: (1) people must come to the museum that created the exhibit if they want to see it at all; (2) traveling exhibits are usually not accepted for display by first-class museums; and (3) such exhibits may increase the reputation of other museums without a sufficient compensatory increase in the reputation of the creating museum. Moreover, the museum directorate has only a limited interest in hosting traveling exhibits. Even if successful, they may not contribute to the museum's own performance excellence but only please the visitors (whose preferences count for relatively little).

The museum directorate tries to achieve performance excellence through both specialization and—to a somewhat lesser degree—through the completeness of its exhibits.

Specialization means having all the artistically and/or historically important pieces of a particular artist's production in the museum's collection, even if some of the pieces are of low quality. In this they are supported by the interest in specialization of art and other historians. Such achievement in specialization is as a

rule noted only by insiders; however, the overall utility level may be higher if there are several specialized museums in the same city or region, because the visitors can then combine the works of art of painters according to their own taste.

Completeness of exhibits is another way of achieving performance excellence—but one much less likely to be rewarded in the museum world. By having all historic styles represented in the museum, it attains stature when compared to other museums that are too small and unimportant to be able to follow suit.

The museum directorate will also be interested in producing catalogs that have an art-historic value of their own. This gives something of the same prestige as writing a book does for a university-based researcher. These catalogs will be published even if they run a high deficit. Here again, however, the museum directorate's behavior is influenced by the type of institution. Publicly supported continental European museums may run high deficits on publications (including posters). In the Kunsthaus, for example, the average annual deficit on publications was SFr. 54,900 from 1973 to 1977, or more than 20 percent of the turnover from publishing activities. In privately supported museums that are subject to a stricter budget constraint, the directorate cannot afford to run such high deficits and has to make an effort to produce more readable and more popular catalogs.

Discretionary leeway allows the museum directorate to show only limited interest in a large stream of visitors and in the population's preferences in general, because its focus is on the museum world. A high rate of visitation yields only comparatively small rewards for the directorate and its staff. Thus, lacking an incentive, the directorate (particularly the directorate of the semipublic museum) will not search too actively for really popular exhibitions that will have a high visitation rate. High rates of visitation seem to be more the result of chance than intention.

Also, museum exhibits are in general didactically rather poorly presented. Background information sheets are often written in a language that is incomprehensible to those who are not already familiar with the subject. No clear guidance to the collections is offered, and the directorate and staff make no effort to relate the exhibits to what is already known to the average visitor.

Finally, the directorate has no incentive to try to make the museum visit physically pleasant for the average visitor. The entrance is often unattractive and bewildering. Few amenities are offered the museum visitor (comfortable chairs, smokers' corners, cafeterias, and so forth). If any amenities are offered, they are not at a professional level and are in no way comparable to the standards of the exhibits themselves (see Clottu 1975, p. 207).

CONCLUDING REMARKS

The above analysis has been deliberately positive, avoiding normative statements. The next step could be to inquire how museum policy can be influenced on the basis of our knowledge about the behavior of the various actors. The economist can act as an advisor, discussing the possibilities for influencing museum policy.

Museum policy (as well as general economic and social policy) can be influenced on the constitutional level and as it evolves out of the social process on a day-to-day basis (see Frey 1978). The constitutional level is the framework within which museum activities are determined. Here the "rules of the game" (see Buchanan 1977) are set, which the participants have to take (for the time being) as given, and to which they try to adjust optimally in order to maximize their own utility.

There are at least five major areas at the constitutional level in which the problems can be attacked. The economist in his or her capacity as museum advisor can, on the basis of a positive analysis of the museum such as that presented here, suggest the advantages and disadvantages of arrangements dealing with the following problems (for reasons of space only sketched here):

1. The kind of formal participation possibilities available to the overall population. The analysis in this paper has shown that the population has relatively little influence on museum policy, especially under the institutional conditions typical in Europe. The economic advisor thus may suggest alternative arrangements to increase the population's participation and influence. One such possibility is a carefully handled voucher system (see Peacock 1969, Blaug 1977, and the attempts in New York discussed by Bridges 1977).

2. The amount of direct participation by voters via the political process. An institutional arrangement such as referenda on particularly expensive acquisitions of the museum and even on the general budget allows the electorate to make its wishes felt concerning the type of museum and exhibitions they prefer. "In Switzerland, for instance, a popular referendum may be (and has been) held on whether to buy works of art. In 1967 in Basel the voters had to decide whether to buy two additional Picasso paintings amounting to over a million Swiss francs. The outcome was affirmative" (Frey and Kohn 1970).

3. Advice by experts. Established external art experts, such as those in the arts councils at the federal level in the United States and in the United Kingdom, can continue to make it difficult for actual and potential visitors and for the directorate to change museum policy. The institutional establishment of free entry and competition could bring about a more flexible policy. This could be achieved, for example, by introducing a rule limiting the length of period during which an expert can serve (see Peacock 1978).

4. Conditions of donations. As noted above, donors have considerable influence on museum policy through their power to prescribe the way in which the donated art exhibits may be shown. It can be argued that under present institutional conditions donors have too much influence, that they can impose their will on the museum to a disproportionate extent, because the greater part of costs incurred in connection with donations (up to 80 percent) is in fact indirectly paid by the taxpayer (tax deductions, maintenance, new building space necessitated, and so forth). Few museums, how-

ever, can presently afford to reject donations (of sufficient quality) because of the strings attached, in view of the intensive competition among museums for donations. In this situation the museum advisor may suggest new rules of the game that would reduce the donors' ability to influence museum policy.

5. Private or public institution. The analysis has shown that the property rights structure has a considerable impact on the museum. The choice of legal form is closely connected with the structure of the financing and the importance of donations. It also influences the directorate's behavior concerning the ratio between exhibits shown and stocks kept in the basement. The economist would point out the relative advantages and disadvantages connected with private and public museums and the merits of combining the two forms of property rights.[3]

It should be noted that in all these areas (as well as in others) the advisor can only inform the actors about the implications of the various institutional arrangements at the constitutional level.

If the economic advisor wants to influence museum policy as it evolves on a day-to-day basis, the most important task is to mobilize the population and visitors. He or she can, for instance, inform them of the opportunities they have to make their preferences known by "voice" (protest) or as voters through the democratic political process. The advisor can also help the museum directorate reach its own goals, for example, by suggesting how the directorate should act in order to gain the most prestige within the museum community. The suggestions made by the economic advisor with the view of influencing museum policy in a given direction will only have a chance to succeed if the actual behavioral basis of museum policy, concerning both demand and supply, is taken into account. This paper tries to take some preliminary steps in providing such a basis.

Notes

1. See, for example, Zetterberg (1962, pp. 137–138), Graña (1971, pp. 95–111), Thurn (1973, pp. 39–43), Eisenbeis (1972), Treinen (1973), Dumazedier and Ripert (1966), and Bourdieu (1969), who gives a long list of further works. The book edited by Bott (1970) contains contributions concerning museum work from other scientific disciplines, such as law, archeology, and zoology. A survey of relevant studies in German-speaking countries is given in Klein (1978); for French-speaking countries, see Bourdieu and Darbel (1966) and Érard (1969). A comparative study of visitors' behavior in selected European museums is given by Bourdieu (1969).
2. The directorate is supported in this policy of noncommercial valuation standards by art historians, for whose research art museums and their services are of considerable importance. They are especially in need of efficient cataloguing services.
3. In evaluating a museum's overall policy, care should be taken not to restrict one's attention to questions of cost effectiveness. One should not lose the overall perspective, in particular that there may be many other—and much larger—sections of the economy where it would be more sensible to discuss efficiency gains (for example, in defense or space policy).

References

Alchian, Armen A. and Allen, William R. 1977. *Exchange and Production: Competition, Coordination and Control*. Belmont, Calif.: Wadsworth.

Austen-Smith, David. 1978a. *Skilled Consumption and Political Economy of the Performing Arts*. Unpublished Ph.D. dissertation, Univ. of Cambridge.

———. 1978b. Taste Change, Learning and Subsidy in the Demand for the Arts. (mimeographed) Univ. of York.

Baumol, William J. 1971. Economics of the Athenian Drama: Its Relevance for the Arts in a Small City Today. *Quarterly Journal of Economics* 85 (Aug.): 365–376.

Baumol, William J. and Bowen, William G. 1966. *Performing Arts—The Economic Dilemma*. Cambridge, Mass. and New York: M.I.T. Press and Twentieth Century Fund.

Becker, Gary S. 1976. *The Economic Approach to Human Behavior*. Chicago: Univ. of Chicago Press.

Blaug, Mark, ed. 1976. *The Economics of the Arts*. Boulder, Col. and London: Westview Press and Martin Robertson.

———. 1977. Rationalizing Social Expenditure—The Arts. In *Public Expenditure*, Michael Posner, ed. London, New York, and Melbourne: Cambridge Univ. Press, pp. 205–219.

Bott, Gerhard, ed. 1970. *Das Museum der Zukunft*. Cologne: Du Mont Schauenberg.

Bourdieu, Pierre. 1969. *L'amour de l'art. Les musées d'art européens et leur public*. Paris: Editions de Minuit.

Bourdieu, Pierre and Darbel, Alain. 1966. *L'amour de l'art. Les musées et leur public*. Paris: Editions de Minuit.

Bridges, Gary. 1976. Cultural Vouchers. *Museum News* 54 (Mar./Apr.): 21–26.

———. 1977. Citizen Choice in Public Services: Voucher Systems. In *Alternatives for Delivering Public Services,* E. S. Savas, ed. Boulder, Col.: Westview Press, pp. 51–109.

Buchanan, James M. 1977. *Freedom in Constitutional Contract. Perspectives of a Political Economist*. College Station, Texas: Texas A&M Univ. Press.

Clottu, Gaston (under the direction of). 1975. *Beitraege fuer eine Kulturpolitik in der Schweiz*. Berne: Eidgenoessische Drucksachen- und Materialzentrale.

Dumazedier, Joffre and Ripert, Aline. 1966. *Loisir et culture*. Paris: du Seuil.

Eisenbeis, Manfred. 1972. Elements for a Sociology of Museums. *Museum* 24 (Apr.): 110–119.

Érard, Maurice (under the direction of). 1969. *Le musée et son public*. Univ. of Neuchâtel, Institute of Sociology and Political Science.

Frey, Bruno S. 1978. *Modern Political Economy*. London: Martin Robertson.

Frey, René L. and Kohn, Leopold. 1970. An Economic Interpretation of Voting Behavior on Public Finance Issues. *Kyklos* 23 (Fasc. 4): 792–805.

Gassler, Robert S. and Grace, Robin. 1980 (forthcoming). The Economic Functions of Nonprofit Enterprise: The Case of Art Museums. *Journal of Cultural Economics* 4, no. 1 (June).

Graña, César. 1971. *Fact and Symbol. Essays in the Sociology of Art and Literature*. New York: Oxford Univ. Press.

Klein, Hans-Joachim. 1978. *Barrieren des Zugangs zu oeffentlichen kulturellen Einrichtungen*. Univ. of Karlsruhe, Institute of Sociology.

Lee, Maw L. 1971. A Conspicuous Production Theory of Hospital Behavior. *Southern Economic Journal* 38 (July): 48–58.

Lee, Sherman. 1972. The Art Museum as Wilderness Area. *Museum News* 51 (Sept./Oct.): 11–12.

McKenzie, Richard and Tullock, Gordon. 1975. *The New World of Economics*. Homewood, Ill.: Irwin.

Montias, J. Michael. 1973. Are Museums Betraying the Public's Trust? *Museum News* 51 (May/June): 25–31.

Moore, Thomas. 1968. *The Economics of the American Theater.* Durham, N.C.: Duke Univ. Press.

Netzer, Dick. 1978. *The Subsidized Muse.* London: Cambridge Univ. Press.

Newhouse, Joseph P. 1970. Toward a Theory of Nonprofit Institutions: An Economic Model of a Hospital. *American Economic Review* 60 (Dec.): 64–74.

Oates, Mary I. and Baumol, William J. 1972. On the Economics of the Theatre in Renaissance London. *Swedish Journal of Economics* 74 (Nov.): 136–160.

O'Hare, Michael and Feld, Alan L. 1975. Is Museum Speculation in Art Immoral, Illegal and Insufficiently Fattening? *Museum News* 53 (May/June): 24–26, 52.

Peacock, Alan T. 1969. Welfare Economics and Public Subsidies to the Arts. *Manchester School* XXXVII, no. 4 (Dec.): 323–335.

_____ . 1978. Preserving the Past: An International Economic Dilemma. In *Nur Oekonomie ist keine Oekonomie,* Pio Caroni, Bernard Dafflon, and Georges Enderle, eds. Berne: Haupt, pp. 305–312.

Peacock, Alan T. and Godfrey, Christine. 1974. The Economics of Museums and Galleries. *Lloyds Bank Review* 111 (Jan.): 17–28.

Poggi, Jack. 1968. *Theater in America. The Impact of Economic Forces 1870–1967.* Ithaca, N.Y.: Cornell Univ. Press.

Robbins, Lionel C. 1963. Art and the State. In *Politics and Economics: Papers in Political Economy,* Lionel C. Robbins, ed. London: Macmillan, pp. 53–72.

_____ . 1971. Unsettled Questions in the Political Economy of the Arts. *Three Banks Review* 91 (Sept.): 3–19.

Treinen, Heiner. 1973. Ansaetze zu einer Soziologie des Museumswesens. In *Soziologie,* Guenter Albrecht, Hansjuergen Daheim, and Fritz Sack, eds. Opladen: Westdeutscher Verlag, pp. 336–353.

Thurn, Hans P. 1973. *Soziologie der Kunst.* Stuttgart: Kohlhammer.

Wahl-Zieger, Erika. 1978. *Theater und Orchestra zwischen Marktkraeften und Marktkorrektur.* Goettingen: Vandenhoeck & Ruprecht.

Zetterberg, Hans L. 1962. *Social Theory and Social Practice.* New York: Bedminster Press.

Comment
Kenneth Kahn

Frey and Pommerehne point most decisively to a major question facing communities supporting arts facilities: who decides what the public needs and gets? By turning a spotlight on the museum directorate, they make what I think is a gentlemanly but also a slightly damning case against those directly in charge of supplying museum services.

It appears, at least in the case of European and, in particular, Swiss museums, that directorates can almost entirely dispense with consideration of the general

public in programming; that is not to say that European museums fail to provide high-quality exhibitions and catalogs, but rather that the exhibitions are conceived for elite audiences with specialized tastes and concerns. These are exhibitions which attract the attention of a powerful and significant international art community but usually will not have much popular appeal for local residents. In the apparent absence of any local criticism, museum directorates perpetuate their elitist ways, to the applause of trustees and donors, museum members, politicians, art historians, other museum directors, and sophisticated foreign visitors.

As sophisticated museum goers, the authors, I gather, may themselves be enchanted with such exhibitions, but as concerned citizens and economists, they gently suggest that given the very high level of public subsidy for European museums, there ought to be more attention paid to the needs and comforts of the general public.

European museums appear to be short on exhibitions with popular appeal; educational programs and materials; and amenities such as cafeterias, bathrooms, and lounge areas. So by design they forbid easy access to the general public, that is, people with less than a university education; with more than three children under ten years of age; and with nervous and nasty habits like snacking, excreting, and smoking.

I do not think the authors' suggestions for influencing the economic and social policies of museums will soon be acted on by museum officials; the authors' "economic advisor" would not be welcomed with open arms by museum directors. I suggest that only an informed public can effect changes in museum policy; progressive politicians who feel their constituents are not being adequately served by museums may well be advised to review this paper.

American museums and their directorates have slowly but steadily evolved in the direction of service to a wider public. They have wisely maintained "performance excellence" and at the same time have shrewdly attracted further public subsidy to accommodate the educational needs of expanded audiences and provide amenities for them. In addition, they have in many cases adopted very profitable publishing and sales activities to underwrite expanded programs and new facilities (to say nothing of helping to pay alarming utility bills).

The authors provide a sound analysis of what makes museums run and present reasonable approaches for their expanded public utility. I personally would not be quite so demanding and critical of museum directorates; they are often criticized as creatures interested in power who prefer ornamentation to experimentation. As the authors suggest, museum directors have much in common with fine hospital doctors who alone are helpless to practice or implement preventive medicine and public health programs.

A Layperson's Guide to Production Structures of Nonprofit Performing Arts

James H. Gapinski[*]

THE PRODUCTION FUNCTION AND
QUESTIONS, QUESTIONS

Master chef C. Ampbell, carefully following the company's prize recipe, adds mushrooms to the chicken broth, which has been slowly heating in a kettle. Otto Moubile, chief mechanic of the firm, reaches for a socket wrench to tighten the new spark plugs of a 1976 Buick. Dr. Ann A. Sprin, sitting in her office studying laboratory reports, advises her nurse about the proper medication for a patient. These examples have a common denominator: they provide glimpses of productive activity. Workers combine with tools, materials, and buildings to produce a good or service—be it soup, automobile repair, or health care. The performing arts might be viewed similarly. They combine artists, administrators, and ushers with props, amplifiers, and auditoria to produce a service: cultural experiences for the audience.

A good or service does not result from purely chance happenings; rather it eventuates from both the systematic ordering of events and the proper balance of contributing elements. Given this regimentation, it seems likely that there should exist some formula to summarize the relationship between the quantities produced and the quantities of all ingredients needed for that production. Such a formula does exist; it is called a production function.

Production functions have been applied to a wide spectrum of manufacturing industries ranging from food to apparel and from glass to primary metals. Recently they found their way into the health industry to address the production of

*This paper reviews in nontechnical terms the results of a study conducted under a contract from the office of the Special Assistant for Cultural Resources, U.S. Department of Commerce. I sincerely thank Special Assistant Louise W. Wiener for her cooperation and support. I also thank Richard C. Sheldon and Rita K. Roosevelt for providing key data from the Ford Foundation and Kathleen Touchstone for her diligent help throughout the entire project. Responsibility for all views and errors herein is mine alone.

261

physicians' and dentists' services (Reinhardt 1972; Scheffler and Kushman 1977). Their excursion into the arts generally and the performing arts specifically has been less extensive; more accurately, it has awaited a beginning. This circumstance is unfortunate because the knowledge to be gained would supply answers to a list of basic, important questions. For the nonprofit performing arts that list would include these questions:

Do support personnel such as ushers and cashiers contribute appreciably to productive activity? Reason suggests that their contribution should rank below that of artists, but it remains silent about whether their role is substantial or negligible.

Can support personnel be absorbed by the arts without the need of additional capital—buildings and equipment? An affirmative response would lead to a corollary question: how easily can they be absorbed?

Are input levels for the nonprofit performing arts determined according to the rules of profit maximization? A distinctive feature of nonprofit arts organizations is their heavy reliance on patronage to meet expenses. Such organizations therefore may be less responsive to market forces in their input decisions than firms striving to maximize profit would be. An example of the latter might be commercial performing arts.

Are production structures identical across art forms? Is the relationship between inputs and output the same for, say, theater and opera, or does it differ?

These and other questions can be addressed with the aid of production functions. The answers obtained should prove useful not only to the arts community but also to policymakers at all tiers of government. Specifically, they bear on the jobs programs created under the Comprehensive Employment and Training Act and administered by the U.S. Department of Labor, as well as on the Local Public Works Program of the U.S. Department of Commerce's Economic Development Administration. They also relate to the funding activities of the National Endowment for the Arts and to the awards made by its satellites at the state and local levels. They even have implications for programs like President Carter's proposed New Partnership, a coordinated assault on central-city decay utilizing community cultural projects as part of the arsenal.

THE TYPICAL ARTS ORGANIZATION

Data of any quality on the arts are generally scarce. There is, however, one fortuitous exception. Recently the Ford Foundation surveyed 164 nonprofit performing arts organizations having annual budgets in excess of $100,000. The inquiry covered nine fiscal years, 1966–1974, and focused on five art forms: theater, opera, symphony, ballet, and modern dance. Theater was represented by thirty-six organizations, opera by twenty-nine, symphony by seventy-nine, ballet

by twelve, and modern dance by eight. With this data set, mysteries of the production structures can be probed. However, insufficient data on modern dance necessitates its removal from consideration.[1]

The investigation begins with a look at the output and input levels of a typical organization. Output is defined as cultural experiences (ce) and is measured by the sum of ticketed attendance and attendance at contracted fee performances, those for which a fee is set in advance regardless of actual audience size. Alternative output measures were contemplated, notably, the number of productions and the number of performances. These, however, are broadly indivisible entities (fractional productions or performances are uncommon), and given the divisible nature of the input variables, they were deemed inferior. Furthermore, of the three output measures, the first most closely reflects the intimate role of consumers in the productive process, a hallmark of service industries.

Labor consists of three separate groups. One, called artists, includes performing and guest artists, directors, conductors, and technicians. Administrators and supervisors form a second group appropriately dubbed administrators. Stagehands, clericals, promoters, and ushers form a third—ancillaries or support workers. All labor variables are expressed in man-hours. The capital variable represents "plant and equipment." It encompasses the cost of using facilities that are either rented or owned. It also entails the cost of sound and lighting equipment, musical instruments, scores, scripts, and wardrobe. Capital is expressed in dollars adjusted for inflation.

Table 1 presents a profile of the typical or average organization for each art form. The least output occurs for opera, yet opera employs the greatest amount of each labor type. Ballet registers the most output and matches that with the greatest capital input. Dissimilarities which persist across art forms are clearly manifested by the input ratios. For instance, the ratio of artists to administrators

Table 1. *Output and Input Levels for the Typical Nonprofit Arts Organization**

| | Theater | Opera | Symphony | Ballet |
| ---------------------------- | -------- | -------- | -------- | -------- |
| Output (ce) | 112,411 | 87,655 | 139,984 | 154,256 |
| Artists (mh) | 59,507 | 166,160 | 151,051 | 158,857 |
| Administrators (mh) | 15,944 | 18,490 | 13,201 | 14,276 |
| Ancillaries (mh) | 35,207 | 85,480 | 15,012 | 51,655 |
| Capital ($) | 139,287 | 187,046 | 63,133 | 255,961 |
| Artists/Administrators | 3.73 | 8.99 | 11.44 | 11.13 |
| Artists/Ancillaries | 1.69 | 1.94 | 10.06 | 3.08 |
| Administrators/Ancillaries | .45 | .22 | .88 | .28 |
| Capital/Artists | 2.34 | 1.13 | .42 | 1.61 |
| Capital/Administrators | 8.74 | 10.12 | 4.78 | 17.93 |
| Capital/Ancillaries | 3.96 | 2.19 | 4.21 | 4.96 |
| Overall Capital-Labor Ratio | 1.26 | .69 | .35 | 1.14 |

*Entries are, or are based on, the mean values for all organizations in each art form.

ranges from 3.73 for theater to 11.44 for symphony. Analogously, the capital-administrators ratio varies from 4.78 to 17.93 for symphony and ballet, respectively. These profiles suggest basic structural differences across art forms.

A CLOSE-UP OF PRODUCTION STRUCTURES

The averages presented in Table 1 convey information about the production structures. In a sense, however, they conceal more than they reveal; they say nothing about production structures away from the mean *point*. Surely more can be said! True, but to do so a somewhat more advanced examination device, known as regression analysis, must be pressed into service. For present purposes, it is sufficient merely to recognize that regression analysis fits a *line* through the data for an art form. That line includes the averages reported in Table 1.

Implementing regression analysis requires an enlightened guess about the shape of that line. Is it straight? Does it have a bend? Is the bend upward or downward? In making this guess it seems tactful to opt for flexibility. That is, the guess itself should impose as few restrictions on the line as possible to enable the twists and turns implicit in the data to dictate its final shape. If, for instance, one guessed a straight line, the data would have no choice but to report back a straight line.

In the present case, guessmanship advised adopting a production function termed transcendental, which allows a host of possible relations between inputs and output and among inputs.[2] After the data were purged of statistical impurities, regression analysis of the function uncovered those relationships. Table 2 summarizes the findings for the typical organization in each art form. There, adjuvants represent the combination of administrators and ancillaries. Statistical analysis indicated that both labor types had identical effects on output and thereby dictated their consolidation.[3]

A marginal product gives the change in output due to a unit change in an input when all other input levels are held constant. This concept provides one measure of an input's contribution to production. For instance, in theater the marginal product of capital is .21, meaning that if the capital input were increased by $1, output would increase by .21 cultural experiences, provided that all other input quantities remained unchanged. Similarly, the marginal product for adjuvants in theater is .65, signifying that incrementing adjuvants by 1 man-hour would raise output by .65 cultural experiences. Notice the negative sign for adjuvants in ballet. Increasing adjuvants by a man-hour decreases output by .28 experiences!

Why would an arts organization hire adjuvants who appear to be counterproductive? Two explanations apply. First, the organizations in question are not driven by the motive of maximizing profit. No company inclined toward a profit maximum would bear the extra wage cost associated with an additional worker if that worker actually reduced the firm's output and, hence, its revenue. Costs would rise while revenue fell, and profit would shrink. A nonprofit organization, however, might behave this way because patronage serves to cover the discrepancy between earned income and costs, the so-called income gap. Second, the

Table 2. *Selective Production Characteristics of the Typical Nonprofit Arts Organization*

| | Theater | Opera | Symphony | Ballet |
|---|---|---|---|---|
| **Marginal Product** | | | | |
| Artists | .5943 | .2909 | .0870 | .5899 |
| Capital | .2051 | .0849 | .0347 | .1136 |
| Adjuvants | .6483 | .1489 | .2053 | − .2768 |
| **Marginal Product Change*** | | | | |
| Artists | − .0840 | − .0085 | − .0035 | − .0481 |
| Capital | − .0170 | − .0059 | − .0059 | − .0039 |
| Adjuvants | .0092 | .0023 | .0072 | .0464 |
| **Marginal Product Correlative** | | | | |
| Artists | .5623 | .3958 | .0608 | .6899 |
| Capital | .7196 | .4224 | .0890 | .4918 |
| Adjuvants | .6133 | .2026 | .1435 | − .3237 |
| **Output Elasticity** | | | | |
| Artists | .3490 | .5719 | .5619 | .8529 |
| Capital | .2820 | .1878 | .0936 | .2646 |
| Adjuvants | .3273 | .1831 | .2478 | − .1661 |
| Absorption Index | 1.1225 | 1.3308 | 1.1189 | 1.7114 |

*These entries are size-adjusted. To obtain the actual values, divide each by 10,000.

negative marginal product may indicate that adjuvants have not yet been employed in sufficiently large numbers to generate positiveness; further increases in their quantity might force the marginal product to become positive. As argued anon, this is the case for ballet. In fact, adjuvants' marginal product would turn positive if their input level were doubled.

Each unit of an input has its own marginal product. The first man-hour of, say, artists might produce 10 cultural experiences. Adding a second man-hour might yield another 6, and a third might yield still another 1. The marginal products of the first, second, and third units are therefore 10, 6, and 1, respectively. In this exercise the marginal product declines as the input increases, and according to the entries in Table 2 for the marginal product change, that is precisely what happens for artists and capital across all art forms. By contrast, adjuvants evidence an increasing marginal product: the marginal product increases as their quantity increases.

These behavior patterns pertinent to the marginal products enable a comparison between employment levels for nonprofit arts organizations and those for theoretical profit maximizers. A profit maximizer tries to equate the value of an input's marginal product to that input's price. This point can be easily demonstrated. Suppose that each cultural experience can be sold for $2 while each artist man-hour costs $5. For the example sketched above, the first artist man-hour costs $5, but it leads to a $20 revenue (since 10 cultural experiences are produced

and sold). The organization receives more in revenue than it pays in costs, and consequently profit increases by $15. The second man-hour also costs $5, but it returns $12, increasing profit by another $7. Now comes the third man-hour. It too costs $5, but it returns only $2. Employing that third man-hour decreases profit by $3. A profit-maximizing organization would, therefore, employ only two man-hours of artists. The same is true of capital and adjuvants.

Do nonprofit arts organizations dance to this tune? Apparently not. Table 2 presents the marginal product correlative, which is simply the ratio of the marginal product value to the input price. A profit maximizer would boast correlatives of unity, whereas those reported for nonprofit arts organizations all lie far below that mark. Artists and capital evidence declining marginal products, implying that a decrease in these inputs would raise their correlatives to unity. Hence, these two inputs are used excessively based on a profit-maximizing standard. Symphony, with the lowest ratios for those inputs, shows the greatest departure from profit-maximizing behavior. Adjuvants too have correlatives below unity. But because their marginal product increases, their quantity must increase for the correlative to rise. Adjuvants are employed deficiently, based on the profit-maximizing rule. Commercial performing arts probably provide at least a crude approximation to theoretical profit maximizers; consequently, these conclusions deduced by comparing nonprofit organizations with a hypothetical profit-making firm might also apply when the commercial arts serve as the norm.

A second measure of an input's contribution to the production process is its output elasticity. This measure has strong kinship with the marginal product, but it expresses the input and output changes in percent terms. It is more convenient than the marginal product for comparing the contributions of alternative inputs to the production process. Why? The marginal product carries dimensions of both output and input. For instance, the marginal product of artists is denominated in cultural experiences per man-hour, capital's marginal product in cultural experiences per dollar. An image of confusing apples and oranges comes to mind. The output elasticity, by focusing on percents, restricts attention only to apples (actually, to numbers without any dimension). As already described, the marginal product relates a change to a change. When comparisons are made across inputs, however, equal changes represent different magnitudes relative to the base levels, those from which the changes are made, if the bases differ. An example will help. Two individuals each donate $1,000 to charity. One has an income of $10,000; the other, $5,000. The sacrifice of the second individual is consequently twice that of the first, 20 percent instead of 10 percent. Output elasticities address equivalent relatives.

Stated precisely, an output elasticity gives the percent change in output due to a 1 percent change in an input, all other inputs held constant. The data in Table 2 exemplify this. For ballet a 1 percent increase in capital alone increases output by .26 percent, while a 1 percent increase in adjuvants decreases output by .17 percent.

The output elasticities are quite telling. For each art form artists show the greatest elasticity. That result is hardly surprising, since any art form is the art-

ist's personal vehicle of expression. Art and the artist are synonymous. What is surprising, however, is the strong showing for adjuvants. For theater and symphony their elasticity finishes second, ahead of the elasticity of capital. And for opera it just misses second place. Adjuvants thus appear to be important contributors in cultural production structures. The likely explanation for this finding is that adjuvants serve to inform a potential audience of cultural events and to assure that those events are experienced in a relaxed environment, where artistry can be fully appreciated.

Table 2 also presents an absorption index for the adjuvant input. This index measures the ease with which an arts organization might alter its existing input mix to accommodate additional quantities of adjuvants.[4] A zero value means that the mix cannot be altered at all: no additional adjuvants can be employed on existing capital. In this case additional hires would require new capital acquisitions. Absorption indices reported for manufacturing industries exhibit considerable volatility although values near unity stand among the most frequent. Nonprofit performing arts apparently rival their manufacturing cousins in absorption ability.

Table 2 reveals numerous dissimilarities in structural properties across the arts, lending credence to the impression conveyed by Table 1 that production structures differ by art form. Statistical tests of that hypothesis provided further corroboration.[5]

QUESTIONS ANSWERED, TENTATIVELY

Answers to the questions posed at the outset have been offered throughout the discussion; for the sake of clarity and convenience, however, they are collected here.

Do support personnel contribute appreciably to the productive activity of nonprofit performing arts? They do. Output elasticities for adjuvants, listed in Table 2, show that this labor group contributes roughly at least as much to output as does capital. The exception to this pattern is ballet, where the elasticity for adjuvants is negative. That sign, however, may intimate a deficiency in the use of adjuvants. Since their marginal product rises steadily, increases in adjuvant levels would eventually make the marginal product and elasticity positive. This would occur if the input level were doubled. Perhaps it should be repeated that the adjuvant variable combines administrators and supervisors with ushers and box office help. These occupations span a wide range of skills, and consequently the amalgamation issue was subjected to statistical test, which dictated that the consolidation be performed. Equivalently phrased, administrators and ancillaries display identical effects on output.

Can support personnel be absorbed by the arts without the need of additional capital? Yes. The absorption index in Table 2 lies above zero, meaning that additional employment of support workers need not await new construction of capital. Furthermore, regarding the corollary question, support personnel seem to be

absorbable in the four arts about as easily as labor can be absorbed in manufacturing. In short, support personnel apparently do not face any special difficulties in this respect.

Are input levels for the nonprofit performing arts determined by the rule of profit maximization? No. A true profit maximizer would adjust input levels until the marginal product correlatives assumed a value of unity. As Table 2 shows, all correlatives lie below that value. Since artists and capital evidence declining marginal products, a decrease in these inputs would raise their correlatives to unity. Consequently, these two inputs are used excessively, according to the profit-maximizing criterion. For adjuvants, whose marginal product increases, would augmented quantities raise the correlative to unity? Adjuvants are used deficiently based on the maximizing rule. These findings might apply at least approximately to comparisons between nonprofit and commercial performing arts.

Finally, are production structures identical across art forms? No. Table 1 shows sizable disparities in output and input levels and in input ratios across the arts. Table 2 shows similar results for other characteristics of the production structures. These results, coupled with statistical test of the hypothesis, suggest a negative response.

LOOKING AHEAD

This initial inquiry into cultural production structures provides tentative answers which, if confirmed by additional study, have important policy implications. But it also raises new questions for future research. Production structures of small organizations, those with budgets below the $100,000 threshold, might be explored and compared with the budgets of large entities. Organizations under the threshold would tend to have a semiprofessional or an amateur orientation, and consequently their structures might be radically different. Commercial performing arts might also be examined to determine if they have unique structural characteristics. Perhaps they *do* behave like profit maximizers. And what about the nonperforming arts?

A production function, when stood on its head and combined with rules governing company operations, generates an employment function, which indicates the responsiveness of employment to economic stimuli. The production functions discussed here could be used to tackle the unemployment problem in the arts, which, in view of figures released by the National Endowment for the Arts (1976) is enormous.

Countless issues remain, and researchers are eager to begin work. A principal obstacle to further investigation, however, is the absence of meaningful data files. The Ford data have nobly served several major studies, and most of their information has already been extracted. Gathering new, comprehensive data will require surveys, undertakings which can quickly swell in their dimensions. So can the requisite funding levels. In this respect the National Endowment for the Arts stands as a crucial beacon of light. Perhaps others might join in penetrating the

darkness. With so little understood about economic aspects of the arts, even modest funding levels would greatly expand the frontier of knowledge. Undoubtedly, there would be many beneficiaries.

Notes

1. The Ford tape used in this analysis is an updated version of the data file described in Ford (1974, pp. 27–35). Following its acquisition the tape was further augmented to meet specific needs of the study.
2. A transcendental production function does not impose a fixed factor proportion; instead, it allows the same output quantity to be forthcoming from the combination of, say, 7 capital units and 3 artist units or from 5 capital units and 4 artist units, administrator and ancillary quantities being held constant. This substitution possibility causes no conceptual problem since output is defined as cultural experiences enjoyed by the audience. As a practical matter, factor substitution would be accomplished by staging different productions, each with different input requirements.

 The basic form of the transcendental production function chosen reads:

$$Q = \Omega(\pi_i X_i^{\alpha i}) \exp \{\xi t + \sum_i \beta_i X_i + \sum_j (\gamma_j Z_j + \alpha_j Z_j^2)\},$$

 where Q denotes output quantity, X_i and Z_j denote input quantities, and t, representing time, allows for technological change. Ω, α_i, ξ, β_i, γ_j, and δ_j are parameters. Analytics for alternative versions of the transcendental function appear in Halter et al. (1957), Reinhardt (1972), and Scheffler and Kushman (1977).
3. Ordinary least squares was applied to the moving-panel data for each art form separately, with dummy variables inserted to capture peculiarities associated with individual organizations. Such a practice has been shown to generate results analogous to the error-components estimation procedure.

 According to conventional tests, preliminary data transformation yielded a file which escaped autocorrelation and heteroscedasticity.
4. Another name for this absorption index is the direct partial elasticity of substitution between capital and adjuvants. Formally, it indicates the extent to which adjuvants can be substituted for capital at a given level of output when the quantities of all other inputs, in this case artists, remain unchanged.
5. A complete covariance analysis based on regressions of the transcendental function *sans* organization dummies soundly rejected the hypotheses of intercept, slope, and overall homogeneity for the four art forms.

References

Ford Foundation. 1974. *The Finances of the Performing Arts.* vol. I. New York.

Halter, A. N., Carter, H. O., and Hocking, J. G. 1957. A Note on the Transcendental Production Function. *Journal of Farm Economics* 39 (Nov.): 966–974.

National Endowment for the Arts. 1976. *Employment and Unemployment of Artists: 1970–1975.* Research Division Report No. 1 (Apr.).

Reinhardt, U. 1972. A Production Function for Physician Services. *Review of Economics and Statistics* 54 (Feb.): 55–66.

Scheffler, Richard M. and Kushman, John E. (1977). A Production Function for Dental Services: Estimation and Economic Implications. *Southern Economic Journal* 44 (July): 25–35.

Comment
John R. Hildebrand

In regard to Professor Gapinski's paper on production functions for the performing arts, I would like to raise a question concerning the stability of estimated elasticities or marginal productivities. I once ran thirty-seven whole-farm, Cobb-Douglas-type production functions covering a three-year period for farms in two Kansas areas. With thirty-seven production functions, the estimated marginal value productivities of the various inputs were so erratic as to defy rationalization. Consequently, I wonder if additional production functions of the Gapinski type would yield similar unexplainable irregularities and, therefore, be of doubtful practical use without substantial improvements. When we choose only one form, we foreclose other possibilities and, more seriously, we force an outcome without even knowing what that outcome is going to be.

Comment
Bevars D. Mabry

Professor Gapinski's presentation, while dealing with a highly technical economic topic, provides a discussion that a noneconomist can understand. Hence, Gapinski cannot be accused of contributing to the bewilderment of those noneconomists who express concern over the relevancy and comprehensibility of economic analysis. Moreover, the input-output structure of firms operating in the performing arts market is a neglected area of inquiry, and Professor Gapinski is to be congratulated for his seminal effort. On the other hand, the discussion is not all that satisfying to economists who are interested in the technicalities that have been omitted. For example, the actual production functions derived, the level of significance of the parameters, and measures of closeness of fit might well have been included in an appendix. Inclusion of these functions might also have obviated some of the questions that follow in this comment.

Professor Gapinski must have pondered hard and long, as have I, over the appropriate output measure of a performing art. Is it a performance, a cultural environment, a season of performances, a training school for performers? Output is probably a set of joint products, including (1) the corps of musicians or other artists available in a community for theater, opera, and ballet performances; (2) a set of community teachers in the performing arts; (3) a model for aspiring musicians, dancers, singers, or actors; (4) a producer of schools to train young people in style and grace, and so forth.

But attendance figures are not an appropriate measure of output. Attendance is a *demand* concept. Given the set of box-office prices, the work or works performed, and the constraint of size of the theater, attendance reflects the demand for that performance or set of performances. A performance, utilizing a given set of inputs, can be played before either a large or small audience, constrained only by the size of the theater. If demand is sufficient and the theater capacity is too small, performances are often repeated. On the other hand, the production function is a technological concept independent of actual demand. Obviously, if output is inappropriately measured, then the relevancy and accuracy of such characteristics as marginal product, its correlatives, and elasticities are questionable.

I am concerned about the relevancy and interpretations given here to the marginal product correlatives. Only if a production function is of the nature of homogeneity to degree one, which this production function probably is not, and only if the market structure approaches that of perfect competition, which the performing arts market does not, will equating the value of the marginal product to the price of the input be useful as a test for profit maximization. Moreover, if artists sell their services in an imperfect market, their wages also will deviate from either their marginal value or marginal revenue product (whichever applies). One may also question whether a finding that a nonprofit organization does not hire inputs in the same manner as a profit-oriented organization is even useful. Of more importance, perhaps, is specifying the objective function of the administrators of a performing arts company, which may not even include a profit goal.

I am sure that Professor Gapinski is aware of these points, and undoubtedly data limitations contributed significantly to them. As a first step in deriving production functions, his paper is to be commended. Let us hope that better data and future refinements will produce more useful results, and that the important questions which Professor Gapinski raises may soon be answered more definitively.

Is the Supply of Cultural Events an Indicator of Their Demand? Music and Theater in Sweden

Abdul Khakee
and
Göran Nilsson

OUR AIM in this paper is to examine the extent to which the supply of performing arts determines their demand in Sweden. In doing so, we assume that the supply of performing arts is almost entirely determined by public support. However, because of limited data about performances and audiences, we have limited our discussion to two categories of performing arts: live performances of theater and music.

THE SUPPLY OF MUSIC AND THEATER

An important feature of music performances is that the supply comes from numerous and varied sources of professional and semiprofessional performance groups. For example, the central government's Institute for National Concerts (henceforth referred to as the National Concerts) occupies a prominent place within the country and collaborates with the government-financed regional orchestras. Ten locally or regionally active music institutions are run by county councils or municipal authorities. There are about 260 professional independent music groups. Amateur activities are also of great importance. The number of amateur choral singers is about 250,000.

Aside from the two national stages in Stockholm—The Opera and the Royal Dramatic Theatre—the productions of the Swedish National Theatre Center (the National Theatre) cover the whole country and are of great significance to audiences outside the capital (see Figure 1). Spread throughout Sweden are sixteen central-government-subsidized city and regional theaters operated by municipalities or county councils. The central government provides subsidies according to the same principles as the corresponding music institutions. Professionally active independent theater groups number seventy, just over forty of which receive government subsidies, although the sums involved are generally regarded as insufficient.

Figure 1. *Location of Permanent and Noninstitutionalized Theater and Music Groups 1977–78*

THE EXTENT OF PUBLIC SUPPORT

The majority of music and theater activities in Sweden receive public subsidy—both the amount and the nature of subsidy vary depending on whether the activity is performed by a permanent institution or a noninstitutionalized group. Public subsidy to permanent music and theater institutions consists of central government subsidies and grants from county councils and municipal authorities.

These subsidies represent the overwhelming share of the institutions' incomes: more than 90 percent of the income for music institutions and more than 80 percent for theaters (see Table 1).

Subsidies are disbursed annually via the national budget and are dictated by short-term changes in national and international development. In periods when public expenditure increases faster than public income and when the central government is compelled to borrow money both at home and abroad, as has been the case for the past few years, the central government makes major cuts in the public sector. Public services, which occupy politically less "important status" than other budget items, are affected most—in other words, music, theater, and other cultural activities.

While municipalities provide the largest share of public support for cultural activities, the long-run outlook for municipal support is not bright. Most Swedish municipalities are beset with exactly the same kind of financial pressures which affect the performing arts. Municipal services operate under productivity handicaps similar to those which cause costs in the arts to soar. At the same time, the municipalities are severely constrained in raising taxes. The municipal tax in Sweden is a proportional tax on income applying to both natural persons and corporations registered in the municipalities: "The municipal tax level has increased throughout the 1960s and the beginning of the 1970s. This has created a strong public concern, partly because the municipal proportional tax reduces the impact of the society's egalitarian income distribution policies and partly because there are inherent restrictions to raising municipal income in this fashion" (Khakee 1979, p. 70).

Nor is the situation bright for noninstitutionalized music and theater groups, which provide the largest part of the supply of music and theater activities in Sweden. The activities of these groups are often organized as extramural educational activities and as such receive a certain amount of public subsidy. The provision of subsidies to extramural education is the main reason the noninstitutionalized music and theater activities exist. Most of the persons engaged in these groups have very few opportunities to become full-time artists and depend upon other occupations to provide them with regular income.

Table 1. *Income for Permanent Music and Theater Institutions, 1975–76*

| | Percent of Total Income | |
| --- | --- | --- |
| Source of Income | Music Institutions | Theater Institutions |
| Box Office Incomes | 3 | 6 |
| Public Subsidies | 94 | 82 |
| Other Incomes (including broadcasting and recording) | 3 | 12 |
| Total | 100 | 100 |

Table 2. *Income for Noninstitutionalized Music
and Theater Groups, 1975–76*

| Source of Income | Percent of Total Income | |
| --- | --- | --- |
| | Music Groups | Theater Groups |
| Box Office Incomes | 57 | 25 |
| Public Subsidies | 26 | 72 |
| Other Incomes (including broadcasting and recording) | 17 | 3 |
| Total | 100 | 100 |

As to sources of income for noninstitutionalized music and theater groups, public subsidies play an important role for independent theater groups while their importance for corresponding music groups is relatively small (Table 2). This is explained by the fact that many of the music groups provide performances in folk music and Afro-American music which enjoy a considerable amount of popularity, especially among young people.

Even in the case of noninstitutionalized music and theater groups, public subsidies play an important part. Many such groups have ceased to exist because they failed to receive public money. For instance, Gislaved Orchestra, a well-established and well-known nonprofit music association, covered half of its costs with the help of public subsidies. In 1976–77 the orchestra failed to receive these subsidies and had to decide either to reduce its activities drastically or to increase its box office income. The orchestra did not opt for the latter course and was forced to fold.

Dependence on public subsidy has a paralyzing effect on the activity of many of these noninstitutionalized groups; moreover, they are dependent on the income they receive by selling their services to local, county, and central authorities. If these authorities fail to buy the services in a reasonable amount, the groups face severe financial crisis. In a period when the public sector is beset with financial pressure, the proportion of public money spent on performing arts has been considerably reduced. At the same time, the cost of performance increases at an accelerating rate. The result is a reduction in supply.

TRENDS IN OVERALL COST OF PERFORMANCE

Music and theater, like many other cultural activities and some public services, are beset with financial pressure because earnings fall short of costs. The gap between expenditures and earned income has been referred to as "the income gap," and evidence from many countries shows that it is not only here to stay but expected to widen steadily with the passage of time (Baumol and Bowen 1966, pp. 147, 161).

Costs in the live performing arts can be roughly divided into two broad categories: costs of artistic personnel and production expenses—the latter include stage expenses, hall rental, and other operating costs. Wages for artistic personnel account for the largest portion of the total costs, from 66 to 85 percent of the total costs for permanent music institutions in Sweden; the corresponding figure for theater institutions is between 80 and 85 percent. International wage surveys show that earnings in the performing arts lag behind wages in the rest of the economy. This is not true for artists employed in the permanent arts institutions in Sweden. But artists working on a free-lance basis have considerably lower incomes. Labor costs in noninstitutionalized music groups account for about 55 percent of the total costs; the corresponding figure for theater groups is about 65 percent. Stage and other operating costs have also increased.

Table 3 shows the increase in costs per performance for local and regional music and theater institutions and for the National Concerts and the National Theatre. The cost per performance for regional and local music institutions has increased by about 61 percent between 1970–71 and 1975–76 but only by 18 percent for the National Concerts. For regional and local theaters the corresponding figure is 95 percent; for the National Theatre, about 50 percent. The reason for the low rise in cost for the National Concerts and the National Theatre is that most of their performances are played in several municipalities. Here is a case where the economies of scale have, indeed, some impact on cost increases! We do not have data for the two national stages in Stockholm but figures from the previous decade show that the cost per performance in the Royal Dramatic Theatre rose from 6,000 Skr in 1960 to nearly 24,000 in 1969. This is on the order of two to three times the rise in the general Swedish price level.

In order to corroborate trends in the overall cost of live performances, we collected some data on the trends in expenditure for music and theater institutions between 1960 and 1976. The data show that the average annual percentage increase in the total cost for music institutions is 3.4 percent from 1960 to 1976; the corresponding figure for theater institutions is 18.3 percent.

Table 3. *Cost per Performance from 1970 to 1976 (Skr)*

| | 1970–71 | 1971–72 | 1972–73 | 1973–74 | 1974–75 | 1975–76 |
|--------------------------|---------|---------|---------|---------|---------|---------|
| Music | | | | | | |
| Local Orchestras | 10,000 | NA | 12,700 | NA | 15,300 | NA |
| Regional Orchestras | 24,800 | 24,000 | 25,100 | 40,700 | 42,700 | 40,000 |
| National Concerts | 2,800 | 2,400 | 3,000 | 2,700 | 3,100 | 3,300 |
| Theater | | | | | | |
| Regional and Local | | | | | | |
| Theaters | 14,200 | 18,700 | 17,400 | 19,300 | 23,600 | 27,610 |
| National Theater | NA | 3,600 | 3,500 | 4,000 | 4,700 | 5,300 |

Source: *Kulturstatistik* (1977, pp. 21–41). Data on local orchestras are taken from *Mål, medel, musik* (1978, pp. 18–19). The cost per performance is calculated on the basis of total cost for music and theater institutions.

Our brief survey of the trends in overall cost clearly demonstrates that the survival of both institutionalized and noninstitutionalized music and theater activities is to a large extent dependent on public subsidies. There is little room for labor-saving innovations since the end product is the labor of the performer. While the cost of performances increases, the possibility of increasing box office income is limited, since factors affecting demand and the principles of ticket pricing are somewhat special for the performing arts.

DEMAND FOR MUSIC AND THEATER: ATTENDANCE

Data on attendance in relation to capacity provide a direct measure of the balance between supply and demand in live performances. Unfortunately, detailed statistics on the audience for the performing arts are unavailable, but we have succeeded in collecting data on attendance in relation to capacity for national and regional music and theater institutions, as well as on the growth in audience size for music and theater performances from 1960 to 1975, and on attendance in relation to capacity in different regions.

Table 4 shows that unused capacity is somewhat larger than we had expected. In interpreting figures of this kind, it is important to recognize that no industry can easily achieve full use of capacity and that to do so often requires decisions which would be unacceptable on other grounds. In the case of music and theater, it might be necessary, for example, to eliminate the least popular performances.

Table 5 shows that the average annual percentage increase for music performances is 15 percent; the corresponding figure for theater performances is 7 percent, a growth not in keeping with the fact that the number of performances has increased and people have more leisure time than previously.

These figures should not be interpreted as reflecting a decline in interest in music and theater in Sweden, for they hide several trends in uneven growth in audiences. In the last few years, public authorities have taken various measures to make performances available in sparsely populated areas and for various disadvantaged groups. We can illustrate the consequence of these measures with the

Table 4. *Attendance as Percent of Capacity by Art Form 1977-78*

| | Average |
| --- | --- |
| Music | |
| The Opera (Stockholm) | 86 |
| Nörrkoping Orchestra* | 78 |
| Theater | |
| The Royal Dramatic Theatre (Stockholm) | 86 |
| Borås City Theatre* | 76 |

*A regional/local arts institution.

Table 5. *Attendance at Music and Theater Performances Between 1960 and 1975 (in thousands)*

| | 1960–61 | 1965–66 | 1968–69 | 1970–71 | 1974–75 |
|---------|---------|---------|---------|---------|---------|
| Music | 491 | 540 | 592 | 600 | 711 |
| Theater | 2,145 | 2,240 | 2,609 | 3,111 | 3,190 |

help of attendance data for the National Theatre in 1976–77. In urban centers attendance as a percent of capacity was 68.8 percent; in rural areas the National Theatre played to only 48 percent of hall capacity. On the other hand, the old, established city and regional orchestras and theaters have increased their audiences throughout the postwar period (see Table 6). The figures must be interpreted cautiously, since the data for "other cities and towns" show large intercity differences. However, the demand for music and theater is clearly greater in metropolitan areas and large urban localities. As we mentioned earlier, the National Concerts and the National Theatre are of great significance for areas which do not have permanent music and theater institutions. These two national institutions have played a major role in revitalizing interest in live performances. But they give only sporadic performances, and in some cases their performances have not met demand, since the National Concerts and the National Theatre have high transportation and other costs in connection with their tours.

Profile of the Swedish Audience

Surveys of audiences at music and theater institutions show that audiences are made up of certain categories of people. Compared to the total population, members of audiences have a higher educational level and higher incomes, and they belong more frequently to the professional classes. The data in Table 7 summarize the social affiliations of the Swedish audience. For purposes of statistical surveys, the population is usually divided into three social groups corresponding roughly to upper, middle, and lower classes. Although the figures are from 1965–66, it is unlikely that any significant change has occurred since then in the

Table 6. *Attendance as Percent of Capacity in Different Regions, 1977–78*

| Type of Region | Music | Theater |
|----------------|-------|---------|
| Stockholm Metropolitan Area | 67 | 82 |
| Göteborg and Malmö Metropolitan Area | 62 | 72 |
| Other Cities and Towns | 59 | 67 |
| Urban Localities in Southern Sweden | 54 | 75 |
| Urban Localities in Northern Sweden | 69 | 53 |
| Sparsely Populated Areas in Northern Sweden | 53 | 55 |
| National Average | 59 | 71 |

Table 7. *Proportion of the Population from Each Social Group Which Attended At Least One Theater Performance, 1965-66*

| | Male | Female |
|---|---|---|
| Music | | |
| Upper Social Group | 49% | 48% |
| Middle Social Group | 25 | 24 |
| Lower Social Group | 12 | 9 |
| Students | 51 | 50 |
| Theater | | |
| Upper Social Group | 84 | 75 |
| Middle Social Group | 56 | 69 |
| Lower Social Group | 36 | 38 |
| Students | 53 | 69 |

Source: Swedner (1967, pp. 181-182). Swedner's figures are for the Stockholm Metropolitan Area for 1965-66. We believe that they are representative of the whole country.

composition of the audience. According to the same survey, only a small portion of the population regularly attends live performances. Nearly half of the population never goes to the theater, and nearly half of the theater visits are made by 10 percent of the surveyed population. Attendance at concerts is made up of an even narrower segment of the Swedish population, about 3 percent.

The existence of a causal relationship between social affiliation and arts performance attendance is an important issue because it is associated with the case for government support. Since attendance at a performance contributes to the welfare of the individual, one might conclude that because the audience is drawn from an extremely narrow segment of the population, performing arts organizations need not receive greater public support than they do now. Nothing can be further from the truth!

Audience surveys show that the audience profile depends on the type of performance. For classical music, opera, and serious theater, the audience shows the above-mentioned distribution. On the other hand, for light opera, jazz, and revue, the audience is more heterogeneous and is drawn more evenly from all three social groups.

As a result of the new cultural policy, various attempts have been made to increase the participation of disadvantaged groups. For instance, the National Concerts have started an extensive program of musical performances for schoolchildren and young people. During 1977-78, they presented 6,918 performances for these groups. The National Theatre presented 2,458 performances for these groups in the same year. The independent groups have accounted for the largest number of performances for various disadvantaged groups. Unfortunately, we do not have any data on their activities. The noninstitutionalized groups extend their activities to many different types of audiences—children, young

people, pensioners, trade union clubs, political associations, and other groups —and thereby contribute heavily to the cultural enrichment of a large part of the population.

Ticket Pricing

A thesis of this study is that public subsidies play a crucial role in determining the supply of and, therefore, the demand for music and theater performances. We have also discussed the income gap which is a permanent feature of the performing arts. A relevant issue in this context is to what extent box office incomes can reduce operating deficits.

Except for the regional and local orchestras, ticket prices have not increased faster than the consumer price index. Moreover, the crucial question is not the relationship between ticket price and the consumer price index, it is the relationship between ticket price and the cost of the performance.

Table 8 shows the changes in ticket prices in relation to the consumer price index from 1960 to 1978 for some music and theater institutions.

Table 8. *Changes in Ticket Prices and in the Consumer Price Index, 1960 to 1978*

| Organization | Ticket Prices in Skr | | | Average Annual Percentage Change | |
| | 1960 | 1970 | 1978 | Ticket | Consumer Price Index* |
| --- | --- | --- | --- | --- | --- |
| The Opera (Stockholm) | 13.0 | 16.0 | 20.0 | 2.9 | |
| Regional/Local Theaters | 10.5 | 11.5 | 15.0 | 2.3 | 5.8 |
| Regional/Local Orchestras | 4.0 | 8.0 | 14.0 | 13.9 | |

*Base year 1949.

If we study the expenditures and the income per performance for music and theater institutions, we find that the income gap is so great that no measures aimed at increasing ticket prices will ease the financial pressure. Moreover, it is easy to visualize what might happen if the organizations tried to eliminate the gap by increasing ticket prices. The nation's music and theater activities would be reduced to a vestigial state. The data for the income gap for the two national stages in Stockholm and the two regional music and theater institutions illustrate the financial pressure faced by each category of organizations, a pressure which cannot be eased by raising box office incomes (see Table 9).

Besides the inherent restrictions in raising ticket prices, we must remember that there are other factors which also prevent increases in ticket prices. First, performing organizations are generally dedicated groups which are convinced of the value of their product to the society. It is natural that they should seek to distribute their services as widely as possible. Second, performing arts do not occupy

Table 9. *Expenditure and Income for Music and Theater Institutions, 1977-78 (thousands of Skr)*

| Organization | Expenditure | Income | Income Gap |
|---|---|---|---|
| Stockholm Philharmonic Orchestra | 22,058 | 5,047 | 17,011 |
| Hälsingborg Symphony Orchestra | 5,964 | 404 | 5,560 |
| The Royal Dramatic Theatre | 48,572 | 5,317 | 43,225 |
| Norrbotten Theatre | 6,071 | 536 | 5,535 |

the same place in the ticket purchaser's hierarchy of necessities as food, shelter, clothing, medical care, and education. If performances become very expensive, most people will try to get along without them. Furthermore, low-price substitutes, such as television entertainment and movies, hold ticket prices for live performances down. In addition, a Swedish survey of a representative sample of the population revealed five major obstacles to attendance at live performances: (1) fatigue after a hard day's work, (2) difficulties in getting baby-sitters, (3) ticket prices, (4) timing of performances, and (5) difficulties in purchasing tickets (Swedner 1967, pp. 134–135).

A similar survey carried out in the district of Mölndal, outside Göteborg, showed that 42 percent of the interviewed gave "lack of time" as the main obstacle in attending live performances. Whether such a high figure is a symptom of most people's stressful lives or whether it is just an easy excuse was not discussed in the survey (Lundberg and Rhöse 1973, p. 88).

Nevertheless, these and other surveys conducted elsewhere in Scandinavia show that many factors other than the price of the ticket hinder attendance at live performances. It might be that those persons who feel that ticket costs are an inhibiting factor are not accustomed to attending live performances. We must not, however, forget that the cost of the ticket is only one part of "the price" of an evening at a live performance. According to Baumol and Bowen, the nonticket costs, which include transportation costs, baby-sitter charges, and a meal or drink at a restaurant, account for 46 percent of the total cost of attending a performance (Baumol and Bowen 1966, pp. 261–264).

RELATIONSHIP BETWEEN SUPPLY AND DEMAND FOR MUSIC AND THEATER

Our discussion indicates a strong relationship between the supply of and demand for live music and theater performances. Looking at the demand side, we find that the number of empty seats was limited and that unused capacity has been the result of recent attempts by public authorities to make music and theater performances available to newer types of audiences which have not as yet developed the habit of attending live performances. In fact, the growth in attendance

implies that a considerable amount of demand is not satisfied. Demand is only apparently low. There are various types of obstacles to attendance, which is determined by human resources in the form of disposable time, level of knowledge, level of health, purchasing power, and so forth. Attendance can be constrained by internal and external factors. Supply is one factor, but we have also pointed out others. Difficulties in purchasing tickets and actions to get the National Theatre to increase tour performances show that the supply is not forthcoming. This, in turn, acts as a constraint on the demand for live performances. While the data on attendance in relation to capacity provide useful information on the current balance between supply and demand, naive tinkering with statistical data often leads to spurious relationships.

Our analysis shows that the demand for music and theater is great in metropolitan areas where there are permanent institutions with music and theater traditions. In the sparsely populated areas which lack permanent institutions and where the habit of attending performances is not well developed, the demand is small. We can characterize the demand for live performances as supply-oriented: to increase the attendance, increase the opportunities for cultural participation.

References

Baumol, W. J., and Bowen, W. G. 1966. *Performing Arts—The Economic Dilemma*, Cambridge, Mass. and New York: M.I.T. Press and Twentieth Century Fund.

Galbraith, J. K., 1973. *Economics and the Public Purpose*. London: Andre Deutsch.

Khakee, A. 1979. *Planning in a Mixed Economy. The Case of Sweden*. Stockholm: Swedish Council for Building Research.

Kulturarbetarnas inkomster (Cultural Workers' Wages). 1971. Stockholm: Government Printers.

Kulturstatistik 1970–1975 (Cultural Statistics 1970–1975). 1977. Stockholm: Government Printers.

Lundberg, V. and Rhöse, A. 1973. Fritid i Mölndal 1972; En undersökning av fritidssektorn i Mölndals kommunblock (Recreation in Mölndal 1972; A Survey of the Recreation Sector in Mölndal Municipality). Institute of Human Geography, Univ. of Göteborg.

Mål, medel, musik (Goals, Means, and Music). 1978. Nyköping: The Association of Swedish Orchestras.

Musgrave, R. A. 1959. *The Theory of Public Finance*. New York: McGraw-Hill.

Ny kulturpolitik (New Cultural Policy). 1972. Swedish Public Commission Report. Stockholm: Government Printers.

Scitovsky, T. 1966. *The Joyless Economy. An Inquiry into Human Satisfaction and Consumer Dissatisfaction*. London: Oxford Univ. Press.

Siffror om kultur (Data on Culture). 1973. Stockholm: The National Council for Cultural Affairs.

Swedner, H. 1967. Teatervanor och musikvanor i Stor-Stockholm (Theater and Music Habits in Metropolitan Stockholm). Stockholm: Stockholm's City Council.

Swedner, H. and Yogüe, P. 1969. Teaterpublikundersökningar (Survey of Public Theater). Dept. of Sociology, Univ. of Lund.

Verksamhetsberättelse 1977–78 för Norrköpings orkesterförening (Statement of Accounts for Norrköping Orchestra for 1977–78). 1979. Linköping: Stencil.

Verksamhetsberättelse 1977–78 för Hälsingborgs stadsteater (Statement of Accounts for Hälsingborg City Theatre for 1977–78). 1979. Hälsingborg: Stencil.

Comment
Alexander Belinfante

I have no comments on the discussion by Abdul Khakee and Göran Nilsson of the supply of cultural events in Sweden. But I do wish to comment on their discussion of demand and ticket pricing. They fail to consider explicitly the price elasticity of demand for tickets. Some of their statements seem to imply that demand might be elastic, while other statements seem to imply that demand is inelastic. I gather that they believe the latter is the case at present. It is important to know which is the case, because for a given performance almost all costs are fixed (that is, not related to the number of tickets sold for that performance), and thus the deficit (and required subsidy) will be minimized at the point where total revenues from ticket sales are maximized, which will occur when the demand elasticity is unitary. (It is quite possible that there is no price that will enable the deficit to be eliminated.) If the demand is elastic, the price should be lowered, whereas if demand is inelastic, the price should be raised to increase revenues. While it is probably not safe to assume that the demand curve is linear, it probably is true that demand is usually elastic for very high prices and inelastic for very low prices.

On the other hand, if the goal is to maximize the audience size rather than to minimize the deficit, then ticket prices should be lowered to the point where the capacity of the hall is reached. (For some unpopular performances this might require a zero or negative price.) But pursuit of this alternative goal could result in unacceptably large deficits. In any case, it should be clear that the goal to minimize the deficit is generally not compatible with the goal to maximize the audience size.

It should also be noted that there are many things other than price which affect demand, so that it could be possible to stimulate demand by other means than lowering ticket prices. Some of these factors are identified by Khakee and Nilsson as obstacles to attending performances. The obstacles they cite could be reduced or removed by (1) scheduling more performances on weekends instead of week-days and/or at more convenient hours, (2) providing child-care facilities for the children of those who wish to attend the performances, and (3) improving the means of distributing tickets. Other things that might help include (4) increasing the amount of publicity and advertising for performances, (5) providing information to the public that would increase their interest in and appreciation of performances, and (6) taking care in scheduling to avoid major conflicts with other forms of entertainment that would appeal to the same audience.

In considering the relationship between supply and demand, the kind of information that Khakee and Nilsson present could be useful. For example, it appears that in northern Sweden the demand for music is relatively greater and the demand for theater is relatively smaller than in other parts of the country. This could be taken as an indication that there should be an increase in the relative supply of music in northern Sweden and/or efforts should be made to increase the relative demand for theater there. (The opposite is true for other parts of the country.) A more uniform balance of supply and demand could thus be achieved, bringing about a more efficient allocation of cultural resources.

Sources of Funding in the Performing Arts and Their Attendant Management Problems

Edward Grist

SUBSIDY IS THE KEY to financing the arts in Great Britain. Without it, the performing arts would have suffered a lingering death. National finance for the arts is channeled through the Arts Council of Great Britain; however, there is no direct government control over its allocation. There is a private sector, comprising the West End, some seaside theaters, and touring companies, but most of the performing arts, including the theater, survive through subsidy.

THE UNIVERSITY THEATRE AND THE CONTACT THEATRE COMPANY

It is against this general premise that we must set the University Theatre in Manchester and the Contact Theatre Company. Universities have played a role in the construction of theaters throughout the country, for example, the Nuffield Theatre in Southampton, the University Theatre in Newcastle, and the Northcott Theatre in Exeter. Each has its own financing arrangements, and each is run on different lines with differing artistic policies.

The University Theatre in Manchester was built in 1965 by the University of Manchester with money from the University Grants Committee to provide a venue for staff and student productions. It has always provided a home for a resident professional company.

Replacing the Century Theatre Company, which moved to new quarters in 1972, the Contact Theatre Company was founded in the same year. Geoffrey Rowe, its present administrator, states that at the time there was a need for "... a kind of 'Manchester Young Vic'—a theatre which sets its cap at young people in particular for its audience, but was still open to all" (Contact Theatre Company 1978). Not only does Contact work in the theater building, but it also takes shows to schools and the community in general, does short tours, and runs youth workshops.

Both institutions are separate financial and legal entities, the University Theatre being funded to a certain deficit by the university authorities. (The proportion of income from different sources is shown in Table 1.) Contact, on the other hand, receives a combination of grants from the Arts Council, local authorities, and the university. There is also box office income, as well as a new source, urban aid (see Table 1).

The University Theatre's finances are run through the bursar's office, although day-to-day expenditure is directly under the theater's control through an ordering system; invoices are paid and income received through the bursar's office, which produces a quarterly computer printout of the theater's accounts. A more unusual aspect is that, by arrangement with the university, Contact Theatre's finances are channeled through this office as well.

MANAGERIAL PROBLEMS

In terms of actual organization size, both the University Theatre and Contact Theatre Company are quite small. For instance, the staff of the theater building,

Table 1. *Percentage Proportion of Income from Various Sources*

| | University Theatre (1977–78) |
|---|---|
| Self-Generated Income | |
| Box Office | 39.43 |
| Refreshments | 15.46 |
| Rental | 13.38 |
| Program Sales | 1.95 |
| Telephones | 0.21 |
| Subtotal | 70.43 |
| Grant Aid | |
| University of Manchester | 29.56 |
| Total | 99.99 |

| | Contact Theatre Company (1979–80) |
|---|---|
| Self-Generated Income | |
| Box Office | 26.84 |
| Miscellaneous | 1.71 |
| Subtotal | 28.56 |
| Grant Aid* | |
| Arts Council of Great Britain | 39.54 |
| Greater Manchester Council | 21.25 |
| City of Manchester | 9.74 |
| University of Manchester | 0.59 |
| Cheshire County Council | 0.32 |
| Subtotal | 71.44 |
| Total | 100.00 |

*Excluded are special grants from Urban Aid and from the Gulbenkian Foundation.

which contains about 300 seats, includes nine people. The average size of the company is thirty. In British theater terms, this would make a small-to-medium-size operation with minimal managerial problems.

With the University Theatre, the bulk of the income is self-generated and only a little under 30 percent comes from Manchester University. Thus, the main management problem is to ensure that the income generated is sufficient to cover budgeted expenditure, a third of which goes for salaries and wages and two-fifths for payments to companies of their box office receipts, less deduction for rental and other charges by the theater.

Unlike those theater managements able to choose bookings for their buildings, the theater has no control over its artistic intake. There is the potential for a run of bad plays artistically affecting the building's reputation and its income. But this situation is controlled from other directions. First, the administrator of Contact Theatre is also the general manager of the University Theatre. So he readily appreciates that the artistic desires of Contact have to be tempered with the box office needs of the theater and, ultimately, of Contact itself. Second, since the amateurs play for only a short time in the theater, and close links are maintained with these groups, the potential for disaster is minimized. Third, there is a financial safeguard, however small the box office, in the form of a minimal rental charge that must be paid. The university itself has very little say over the way the money is spent, although there are board meetings to keep abreast of the general situation. The main concern of the university is that the prescribed deficit is adhered to and that profit margins on catering are maintained. It is up to the general manager to achieve these objectives in whatever way he chooses.

Being part of the university poses certain managerial problems, for example, the slowness of the bursar's office in paying invoices and the even slower production of the quarterly computer printout. The former is of vital importance to the cash flow position of small suppliers; with the big suppliers, the breweries particularly, it could mean the cessation of further deliveries. However, remedial action can be taken by marking the invoices "urgent" and ensuring a continuous flow of payments to regular suppliers. Delay in the printout, which is completely out of the theater's control, makes it very difficult to balance the theater's books with the printout.

Contact's sources of income are more diverse, so its managerial problems are more complex. Perhaps its major managerial problem is that it is compelled to budget in the blind, as it is impossible to have a firm figure from the Arts Council or from local authorities for the new fiscal year until very late in the preceding fiscal year.

In practice, the assumption is made that both the Arts Council and local authorities will fund the same as before, plus a percentage of inflation, so that the company's activities will at least be maintained at the same level. Other things being equal, this is a fairly safe assumption to make for a well-established company such as Contact, although the generally higher rate of inflation associated with the arts can threaten this funding.

Not knowing the precise level of the award means that planning, certainly for the initial stages of the season, has to be short-term and tentative. This is further

complicated by the level of box office income required, balanced against the fact that it is a young people's theater and, therefore, its audience has a limited income. Since the theater sponsors new writers, some shows may be financial disasters, whatever the artistic merit, and allowance has to be made for this. Planning also has to take into account the fact that every January the main wage increases are backdated to this month. The application process for the Arts Council and local authorities is roughly the same. A first estimate is sent in from which the grant-giving body intimates a figure it is likely to give. Final estimates are then sent in and become the basis for the final grant amount.

The need for theater in Manchester, particularly young people's theater, is never really called into question by the Arts Council now that Contact is an established company. But local authorities always require justification of money expended on Contact. For example, the Greater Manchester Regional Council's grant is dependent on Contact taking its tours outside the City of Manchester. Every year data must be provided on audience breakdown for schools and programming. However, once the grant is established, none of the funding bodies exercise direct control over the ways in which the company handles its expenditures. Arm's-length control is the order of the day.

There are two methods by which this control may be exercised. First, the grants are not paid in one lump sum. The Arts Council pays in quarterly intervals and the local authorities, biannually. The Arts Council makes payment against returns made by the company on its previous quarter's financial figures on which may be assessed the financial well-being of the company. If things appear not to be going well, the next installment may be withheld until an assessor has discussed the problem with the company.

A very useful facet of working within the university system is that if Contact does incur greater expenditure than expected or a grant check is late, the university temporarily finances Contact. This means that Contact, like the University Theatre, never has to pay any bank or interest charges on an overdraft.

The second method of control is the guarantee-against-loss system of the Arts Council. It was initially designed by the Treasury to allow for the eventuality of a company doing so well financially that it did not really need its full grant. In that event, the guarantee does not have to be paid. Since this very rarely happens, most theaters plan to take up their guarantee in order to justify their need for a full grant. So it has really turned into a management tool of the Arts Council, whereby once the council has received the final account of the company, incorporating the guarantee, and overall expenditure and income have been as planned, the balance is paid.

Since all the funding bodies operate on an arm's-length principle, the administrator can to some extent control the company's budget. However, room for maneuver is limited because wage costs, which form the greater part of the budget, are relatively fixed. It is on the production side—the number of productions, the length of run, the scale of the production—that the administrator can exercise the most control and discretion.

Aside from council funding, government job creation schemes and urban renewal programs have been sources of finance for many theaters. Contact has

received monies from the Job Creation Programme. More recently it has obtained approval for grant aid through the Urban Aid Programmes.

On the private side, it has obtained funds from the Gulbenkian Foundation to contact, hire, and run a much-needed touring van for the company. Apart from this, there is very little private sponsorship despite many approaches. A recent example is Barclay's Bank paying for the production of a theater program for a school show in return for advertising. The Regional Arts Association in the form of North West Arts plays a small role in the life of the two organizations. For Contact, its main function is to provide a guarantee against loss for incoming fringe and community companies when they visit Contact's Studio Theatre. For the University Theatre, it acts as a ticket agency and as an outlet for publicity material.

Overall, the managerial problems of both organizations are a function of their size. Since all the funding bodies delegate control to the management of these institutions, the situation really depends on the quality of personnel, their relations with each other, and the bigger institution to which they are attached—the university. It is only at the fiscal year's beginning and end that the above-mentioned problems are likely to arise, because it is then that decisions have to be made, often in the light of imperfect knowledge.

MANAGERIAL PROBLEMS: A MICROCOSM OF GENERAL ARTS MANAGEMENT

Whatever the source of funding and as indicated above, the managerial problems of both organizations are a function more of size than of funding origins. This will apply to most arts organizations, certainly those which receive the bulk of their funding from the Arts Council, where the arm's-length principle is strictly adhered to. There is always the danger of political intervention at the local authority level, though this problem looms larger for community theater companies than for repertory theaters. The Regional Arts Association has been known to take a direct interest in community theater companies through sudden closure or short notice of grant cuts. And in some repertory theaters boards of management sometimes take a more detailed interest in the running of a theater than has been thought acceptable by either the artistic director or the administrator.

In general, though, there are two main areas of concern exogenous to all theaters in Great Britain, including Contact. The first is the earlier notification of grant awards. This is not the Arts Council's fault, since it often does not know the actual figure available from the Treasury until later in the old fiscal year. Indeed, in 1976 the Treasury figure was not announced until early April. There was also a proposal that the Treasury would make commitments to the Arts Council on a three-year basis, thereby allowing the council to do the same to its clients; however, there is little sign that such a system is likely to be introduced. The high inflation rate experienced by the arts would now invalidate such commitments very rapidly, so that, if such a plan were readopted, commitments

would need to be linked to the retail price index or perhaps to a special performing arts price index to maintain real value.

The second problem, which has been touched on in the context of Contact, is the guarantee-against-loss system. This system of subsidy, if not used wisely, may seem neither to reward financial virtue now nor, unless some drastic error is made, to penalize financial vice. If Contact Theatre or the University Theatre succeeds by good budgetary control and/or good artistic policy in coming under budget, it is unable to carry the balance of monies unspent to the next fiscal year. A company like Contact could not claim its guarantee.

The options to a theater company are twofold. It can either spend in a rush near the end of the fiscal year on items not desperately needed or lose funds forever with the chance that grant aid may be cut the following year. As Stephen Langley has pointed out in the American context, it is the taxpayer who suffers under the system (Langley 1974, p. 200).

Too often, under the present system, there is a tendency for theaters to overstate their needs in order to obtain what they actually need. If there is a surplus, it should not automatically be presumed by funding bodies that because money was not needed in one year, it will not be urgently needed in the next. A theater should have the opportunity to put the money on deposit until really needed.

It is interesting to note that the proposed National Heritage Fund, which replaces the Land Fund, is to be financed in this way. According to the Victorian Society ". . . the Fund . . . will get an annual grant. . . . This will not be subject to the usual rules in that it will not have to be spent in that year and can be accumulated and invested by the Trustees" (Hobhouse 1976, p. 2). It should also be noted that the Arts Council itself has to return any unspent allocation to the Treasury. So an overhaul is needed right to the top.

Perhaps as a concluding thought we ought to bear in mind the idea of Richard Condon, general manager of the Theatre Royal in Norwich, who feels that subsidy ought to be linked to success, not failure; that is, it should be used as a kind of substitute for profit, thereby creating an approximation to commercial planning (Diggle 1976, p. 4). I doubt if this kind of thinking is applicable to the majority of theaters. Like Contact and the University Theatre, they suffer from Baumol's disease and follow artistic policies which are not geared to commercial needs for very good reasons.

References

Contact Theatre. 1978. *50 Not Out*. Introduction by Geoffrey Rowe. Manchester: Contact Theatre Company.

Diggle, Keith. 1976. *Marketing the Arts*. Centre for the Arts and Related Studies. London: The City Univ.

Hobhouse, Hermione. 1976. *Victorian Society Newsletter,* no. 6 (Spring).

Langley, Stephen. 1974. *Theatre Management in America*. Drama Book Specialists/Publishers.

Comment
James F. Richardson

Edward Grist's paper provides a useful overview of the sources of funding and some of the managerial problems of university-related theater in Britain. Using Manchester as his case study, he shows that the university affiliation gives a theater financial support in a variety of ways. At the same time, the slowness of the bursar's office in paying bills and supplying computer printouts hampers the theater's management. An additional difficulty, widespread in public agencies or publicly supported bodies, is that the organization rarely knows how much money it will have for the forthcoming year until late in the present one. These findings are unexceptional, except to bursars and Treasury officials, who could quickly produce a list of their problems longer than those of Grist's theater managers.

To my mind, the paper raises additional questions, to some extent beyond the boundaries of Grist's topic but pertinent to the overall subject. Manchester's University Theatre is home for both university theater groups and a resident professional company, Contact. We are not told what the differences are in repertory, audience, and ticket sales between University Theatre and Contact; nor do we get much sense of how Contact's fare differs from other professional theater offerings in the city. The author indicates that Contact seeks to attract a youthful audience; "youth" is not defined, and I would like to know whether the company tries to reach children, adolescents, or young adults. Does Contact as a subsidized group offer plays that a strictly commercial company, if there is any such thing in Manchester, could not risk?

At one point the author argues that a repertory company such as Contact is less likely than a community theater to be the victim of punitive action by local authorities, who are not always as scrupulous about observing the arms-length principle as is the Arts Council. At another we are informed that Contact runs some risks at the box office because it presents plays by new authors. On the face of it, it seems probable that new plays would be more likely to upset local sensibilities than would revivals or standard repertory. Also, I do not have a clear sense of the differences between a repertory company and a community theater.

In the recent past, groups such as University Theatre and Contact have received some additional funds in subsidy to maintain programs in the face of inflation. As John Caff and the daily headlines inform us, this pattern will not continue in the immediate future, and theater managers may soon yearn for the good old days when their major financial problems were slow-paying bursars, tardy computer printouts, and bureaucrats who made acceptable decisions later than one would wish.

PART FIVE

The Arts and Urban/Regional Development

Introduction

T HE HYPOTHESIS that the arts, as cultural resources, contribute to various aspects of economic growth and development and the quality of life is central to all papers in this section. By cultural resources, we mean: cultural amenities that result directly or as externalities from art, artistic values, and artistic events; the economic impact of the arts industry; and cultural processes for achieving human development. These properties are derivative from the explicit objectives of artists and arts institutions. While considerable interest has been expressed in the idea of the arts as cultural resources and the role that they play in societal development, written works are scarce and tend to be advocacy position statements.

The predominant research has focused on the economic impacts on the community of local nonprofit arts institutions. At least forty case studies, mostly done by arts councils in the United States, have been completed. Typically, the primary form of export for the local arts industry is measured by the extent to which tourists visit or attend local arts institutions and events. Of course, there are other ways to export local arts "products": visual artists have tangible pieces of art which can be exhibited for sale and/or commissioned by clients in other cities, and some local performing artists go on tour. Even though the local arts industry can literally take its products to distant consumers, the industry's ability to generate and support tourist trade locally is emphasized in these studies.

Despite the popularity of this policy research tool with arts administrators, several features of the way it has been applied remain defective. Most studies try to equate arts expenditures with export demand and multiplier effects with cause and effect. Typically, the economic impact studies are not content with the multiplier effects for arts spending; they also calculate a ripple effect, or what Cwi calls an induced effect. To local arts spending is added the complementary expenditures made by arts *consumers*—expenditures for taxi fares, restaurants, parking, hotels, and so forth—and this total is subject to the multiplier effect. Even if this kind of multiplier effect is limited only to scientific analysis of tourists' demand for local arts, an almost unanswerable question of cause and effect is implied: is the local arts industry generating even part of the tourism, or is it, like parking service, merely responding to it?

When discussing regional and national demand for durable goods, it is understood that the local economy can benefit directly only if there are local manufacturing firms which have the capacity to produce the demanded goods and market them outside of the region. It is clear what the local economy must do to meet the demand of the distant consumers. This is less clear for any service industry that must attract the customer to the locality in order to export its output. Even nonresident students attending a local university may have made that choice considering other features of the local area. With tourism, it is almost totally vague. Arts institutions and activities will be only one of many attributes and amenities that rather inexplicably define the "product" demanded by travelers and vacationers.

Other questions are (1) why do culture consumers choose to travel to exercise their demand, and (2) to what extent can an expanded local arts industry induce net new levels of cultural tourism at the regional or national level, rather than increasing the community's share of a constant market?

In contrast to this narrow discussion of economic impact, James Shanahan and David Cwi attempt to clarify some of the policy-related issues by placing in perspective the claims about the developmental properties of the arts and separating the arguments over what the arts can and cannot do as cultural resources.

Shanahan uses the broadest brush in developing definitions of cultural resources, breaking development into economic, physical, and human components. To provide some perspective on these claims he raises four questions:

What are the ways in which the arts can be development tools for achieving balanced urban and regional growth and development objectives?

What facets of overall growth and development are most responsive to the arts development role and what are the implied development objectives?

How and at what points in this dynamic process do the arts assume their developmental role, over what time horizon?

Cwi identifies two interpretations of the importance of the potential local economic effects of community-based arts institutions: one views the local arts sector in terms of its relative potential to bring net new income dollars into the regional economy; the other views the local arts sector in terms of its potential to redistribute fiscal and economic activity back into the central city and its neighborhoods. It is in this latter context that local policymakers may consider investing in the arts: to induce investment and location decisions on the part of households and firms that favor the central city.

Roger Vaughan and Harry Kelejian with William Lawrence attempt to model and measure the economic impact of artistic events, but in quite different ways. Vaughan estimates the economic impact of the annual Edinburgh International Festival, using the rather standard export base theory. Kelejian and Lawrence, in contrast, attempt to model leisure consumption as one sector of an econometric model for the New York City economy. Again, the intent is to measure the potential export demand for cultural institutions.

Mary and Bevars Mabry, using Thailand as a case in point, attempt to isolate the potential for the arts to facilitate economic development while keeping cultural shock to the human condition to a minimum. The Mabrys suggest that the arts can enhance human potential and that, if the artistic development itself reflects the value of creativity and innovation, a cultural climate for change may result. Stated another way, while art can provide the symbolism for linking the new with the past, strongly held values must be preserved or economic change is not possible. These points and the Thailand case history tie nicely into Abbing's concerns over the derived goods from artistic innovations.

The Arts and Urban Development

James L. Shanahan

O VER THE LAST DECADE the U.S. government has instituted significant direct support of the arts. As the debate over justification for public support of the arts moved into full swing, the proponents of art subsidy turned the policy debate 180 degrees. The question of what the economy can do for the arts has been reversed to what the arts can do for the economy.

This new role for the arts has been presented only in fragments and argued largely by advocates of the arts, not social scientists; however, since most of the arguments relate to the social sciences, there is a need to look at the social science context of the claims:

Arguments for the arts as industry:
1. The arts are a part of the local economic base, providing jobs and income to local residents.
2. The arts industry involves minimal use of exhaustible resources.
3. The arts industry will be an integral economic part of the service economy in the postindustrial era.
4. The arts industry is the single most significant source of amenities that clearly favors the central city economy as a location.

Arguments for the arts as cultural amenities:
5. In reshaping and rebuilding the physical environment in our urban centers, we must take care to apply artistic skills for an aesthetically pleasing and integrated physical fabric. These efforts will enhance and expand the economic objectives.
6. The availability of artistic and cultural activities and cultural amenities can be a decisive factor in both industrial and population relocation and retention of a rich human resource mix.

295

Arguments for the arts in education and development:

7. Arts appreciation encourages consumption patterns that are less wasteful of exhaustible resources and do less harm to the environment than other types of consumption.
8. The arts can provide the ethnic and cultural glue for neighborhood identity and cohesion—an intangible element of neighborhood revitalization.
9. The arts can fulfill the human need for relatedness—dependence on others for nurturance, support, and identity—which is important to the emotional well-being and mental health of city residents.
10. Many of our unemployed and underemployed can be retrained utilizing the arts and artistic skill development.
11. Neighborhood economies can be strengthened utilizing arts and artists.

In examining the relationship of the arts to urban development, we may minimize some problems of definition if we consider urban development to have three components: (1) economic, emphasizing the importance of the industry mix for a vital local economy; (2) physical development, encompassing the importance of the physical environment as the skeleton of the urban fabric; and (3) human development, emphasizing the importance of meeting the total set of human needs. Obviously, any strategy for setting development objectives requires an integration of these three aspects.

ECONOMIC DEVELOPMENT

In the short term local economic growth is largely dependent on the local industry mix—particularly as it is made up of new manufacturing and services with income-elastic product demand and any other fast-growing industry with a regional or national base of operations. Also, as we have entered the postindustrial (manufacturing) era in the United States additional development criteria have emerged: environmental safety and energy efficiency, if not conservation. Claims 1, 2, and 7 view the arts as a local industry capable of promoting qualitative development in both production and consumption.

Over the longer term, however, the viability of any urban economy is dependent upon its capacity to invent and/or innovate or otherwise acquire new export bases. But what must we accomplish now and what kinds of processes should we set in motion if the transition to a service economy is to be made? In this context, claims 3 and 6 would apply: the arts industry is an integral part of a future service economy, and a broad set of cultural amenities may act as a magnet for attracting and retaining future generations of people and jobs.

PHYSICAL DEVELOPMENT

Physical environment provides a considerable amount of place value for society. On the one hand, the aesthetic design of the physical environment may be an important social amenity in the quality of life. Hence, claim 5 says that the arts

can apply skill and use cultural tastes in the design of a pleasant physical environment. Ed Bacon, for example, refers to the arts as the "paradigm for urban planning."

The present physical environment also provides cultural ties with both the past and the future, a cultural inheritance for immediate future generations with some parts even preserved for the more distant future. Hence, the youth of American cities, when compared to cities like Edinburgh, and the acutely American "disposable city" development process reduces the historical significance of American cities.

The physical environment is the skeletal framework for the economy. Development of physical resources over time must be compatible with changing social and economic activity. The arts industry, as an integral part of a developing service economy (claim 3), may contribute to important economic returns—at least in portions of the local economy—even though the arts industry may not be directly responsible for generating these benefits.

HUMAN DEVELOPMENT

The idea of quality of life includes the full range of human needs, not merely economic gains. Indeed, many needs can be satisfied outside the economic market.

Much work has been done to identify measurable dimensions of social, economic, and cultural factors for the purpose of monitoring "improvement" in the urban quality of life. Social indicators, for example, can measure increased schooling or decreased infant mortality which, by definition, are assumed to indicate increased well-being of the population. Such achievements are positive, and as individuals we feel positive about them. However, unless we experience them personally, we have no effective need or means to place a real value on them, and our lives in the city may be largely unrelated and unresponsive to many of the elements of social indicators.

Claims 7 and 9 suggest that the arts and their appreciation have an aesthetic potential which permeates all human experience; that is, for some people the arts can provide the aesthetic thread from which the quality of life's fabric is woven. This provides the context for the claim that the arts can be directly related to emotional well-being and mental health.

Not surprisingly, then, the development of human potential has become linked to the arts in education. The arts can be an educational tool if aesthetic values and artistic methods enhance the building of production skills while developing consumption skills. In other words, the arts may be an integral part of developing human potential for production and consumption.

There is an important link here with the economic development objective of achieving an urban life-style that is not wasteful of exhaustible resources or environmentally unsafe. Meeting any of these needs outside of the marketplace is problematic, however, since the urban area functions best as a market center—for production and for meeting final demand by residents for consumption

and investment. Urban institutions work very well to satisfy the economic needs of the cities within the limits of their individual control over resources, but they work very poorly at meeting noneconomic needs. Tibor Scitovsky presents cogent evidence of the institutional and cultural bias in American society against meeting human needs for social comfort and stimulation outside of the marketplace (Scitovsky 1976, especially chapter 11). The net result is that Americans—when compared to citizens of other Western countries—satisfy their need for status, self-fulfillment, recreation, and so forth with the aid of many durable goods that may be bought for other reasons. Window shopping, driving for pleasure, and gauging status in terms of durable goods collections are examples.

If the arts are used as an educational tool, individuals in the future may choose less materialistic consumption patterns and life-styles as a result of taste development influenced through the educational process.

In addition to the foregoing claims, arguments as to the role of the arts in urban development are deeply embedded in the question of public support of the arts. Providing these claims have validity, public support of the arts and cultural amenities might be viewed not as subsidies but as investments for (re)building America's urban areas. Any affirmation of these claims will undoubtedly become grounds for providing some form of public support to the arts. It is vital, then, that any affirmation also provide a basis for allocating support among the arts.

RECENT HISTORY OF
U.S. PUBLIC SUPPORT OF THE ARTS

Prior to passage of the National Endowment for the Arts Act in 1965, the direct channeling of public dollars and actions in support of the arts was virtually nonexistent. Even though the U.S. government inadvertently and indirectly provided a great deal of support, this support was in the form of special tax exemptions, nonprofit tax status, and tax deductions for private contributions. Dick Netzer estimates that over 400 million 1974 U.S. tax dollars were foregone by all levels of government because government either rebated a portion of the private donations at tax time or, in effect, matched the nonprofit organizations' resources by exempting them from income and excise taxes (Netzer 1978).

Direct federal support to the arts essentially began with the National Endowment for the Arts, the "chosen instrument" for such support. Since 1965 the federal purse has been opened for rapid, but now slowing, increases in annual support. Direct federal spending on the arts had increased to $151 million in 1975, nearly a tenfold increase over that decade, but these monies are still comparatively small. For example, the entire annual National Endowment budget would only build a three- to four-mile section of interstate highway in certain sections of the United States.

Some would argue that even the current level of support is not yet as secure as, or in parity with, support for many other functions, such as health services. But support for the arts has to be justified on grounds of effectiveness and the equity of the results the arts make possible. Even in the absence of our knowledge of

these results, there have been many claims in recent years that the arts should be given *special* consideration in any public policy that is aimed at urban revitalization, balanced growth, and development. Some advocates believe that the arts are essential to development in both attracting and keeping the young and better educated in our cities and tapping the human productive potential of the hard-core unemployed. It is clear that the Departments of Commerce and Housing and Urban Development have not formulated measurable developmental objectives for the arts. Yet, if the Economic Development Act, Community Development Block Grants, and Comprehensive Employment Training Act monies are to be invested in the arts, criteria should exist for distinguishing between arts projects with real development potential and those with little or no potential.

EVALUATING THE CLAIMS

The term "the arts" is used ubiquitously in making these claims; the arts are loosely identified as: (1) an industry in which institutions and organizations are functioning as businesses interrelated with other local businesses; (2) broad-based to rather specific cultural amenities; or (3) cultural education, tools, and processes.

Some of the claims that the arts contribute to revitalizing urban centers have been better thought out than others. Some of the implied development resources are intangible and not empirically verifiable. In some cases, just how the tool can be increased or changed, let alone utilized, is unknown.

What is clear is that the potential for the arts to be any one of these three developmental tools is almost entirely removed from the usual objective of artists and arts organizations—the achievement of artistic excellence. The single exception is the profit motive of the commercial portion of the arts industry.

Overall, the main linkage question is whether program objectives designed to achieve artistic excellence can also be made to contribute indirectly to economic growth and development and an improved quality of life. Of course, the converse also applies: if these derivative objectives are emphasized, how can the achievement of artistic excellence be left uncompromised? There are no clear-cut answers to these questions at this time, just as there is limited and uneven verification of the development potential of the arts.

EVALUATING THE ROLE OF THE ARTS IN
ECONOMIC GROWTH AND DEVELOPMENT

The arts industry is said to be capable of direct and immediate contributions to the local economic base—to the level of and trend in economic performance and the quality of life for individuals. Can the arts, as an industry like any other industry, be a part of the growth sector capable of producing net additional spendable income and jobs at the local level? If so, what part of the metropolitan region is most affected?

The arts industry can contribute directly to the local economic base in two ways: first, by exporting a major part of its output, bringing net new income dollars into the economy; and, second, by relying on local firms and factors of production for its endeavors, thus keeping the local arts industry income dollars within the area. That is, economic growth can occur because of increased demand for the exporting of locally produced arts or by reduced reliance on economies in other regions for local industry's requirements for fixed capital, current supplies, and new materials, or for its financing or labor resources. In economic jargon, we need to measure the balance-of-payments position of the local economy relative to the rest of the "world" as a result of the presence of the local arts industry.

These short-run direct economic impacts have been researched extensively, although empirically little is known about how the arts compare to other service industries in terms of contributing to import substitution. Studies of the economic impact of the arts continue to ignore the import needs of the local arts industry and balance-of-payment issues, despite the existence of a conceptually sound model developed by Cwi and Lyall that has been circulated widely by the National Endowment for the Arts (Cwi and Lyall 1977).

But what happens in the longer run? What determines the potential of an urban economy to sustain its growth and development as new industries and populations are born and old ones disappear? What happens as established industries have the opportunity to relocate or reallocate their industry activity? How can the arts, viewed as the set of development tools discussed earlier, influence these choices? This is the subject matter of the growth and development as a dynamic process, with all sectors of the economy interactive.

As stated above, and paraphrasing Wilbur Thompson, a noted American urban economist, the local economy must have the capacity to innovate or otherwise acquire new export bases. Thompson argues that:

> The economic base of the larger metropolitan area is . . . the creativity of its universities and research parks, the sophistication of its engineering firms and financial institutions, the persuasiveness of its public relations and advertising agencies, the flexibility of its transportation network and utility systems, and all the other dimensions of infrastructure that facilitate the quick and orderly transfer from old dying bases to new growing ones. (Thompson 1968, p. 53)

There is also the implication that these factors have the capability to hold or attract new generations of the population. And because of decentralization of the work place and suburbanization of the population, it is important to include in the analysis the peculiar economic problems of the urban center.

Cultural Industry and the Future of the Central City
Downtown areas and many neighborhoods within the core of older urban centers have already experienced varying degrees of decline, both in the subarea economy and in the quality of life for residents. Job decentralization, racial

and income segregation among neighborhoods, some public housing projects, highways, and so forth have wrecked the stability and cohesion of many neighborhoods.

Harvey Perloff argues that as we move into the postindustrial era, the economic future of the urban center, whether or not it is depressed, is dependent on urban competition for certain service industries: company headquarters and the knowledge/technology services industry; recreation and tourism; arts and cultural services; health, learning, and other personal services. New manufacturing, retail and wholesale trade, and even the traditional FIRE services (finance, insurance, and real estate) are locating at centers of activity throughout the metropolitan area.

As stated in claim 4, the arts industry—arts institutions and performing arts centers in particular—have a clear preference for central city over suburban/exurban locations. Perloff states:

> For many of the arts activities, such as symphony, opera, major theatre, dance, and the like, a central location is an advantage. For visual arts and crafts, the highly unique nature of the individual products recreate many of the "market place" needs which originally contributed to the evolution of urban areas. (Perloff et al. 1979)

Reinforcing inner-city locational preferences for the revitalization of downtown commerce, rather than trying to hold the decentralizing service employment, may be one of the more compelling reasons for investing in the arts for their economic potential. Most of the arts industry, however, operates at a deficit, or would if not for the direct and indirect public support noted earlier. Careful analysis of the direct industry effects is needed.

Perloff argues that the development of this strong service economy for the urban center will not evolve on its own, as Thompson suggests. A new form of research and development is needed to provide the organizational capacity and skill development necessary to encourage these industries.

1. Many of them, as now organized—the arts and cultural activities, recreation, and preservation and rehabilitation activities, for example—are likely to require large amounts of public financial support and sponsorship if they are to expand substantially.
2. Many of them, as now organized, call for a relatively high level of skills.
3. Many of them provide a high proportion of part-time jobs and relatively low wages and salaries.
4. Most of them, to achieve much greater economic importance and service-industry status (i.e., a highly organized, sustained, exchange and employment-provision system), would need provision of substantial social overhead—for example, improved transportation, appropriate facilities, various public supports, helpful legal arrangements, and improvements in residential quality. (Perloff 1978, p. 118)

Cultural Amenities as a Magnet for Jobs and People

Theories of urbanization evolved with the underlying premise that people follow jobs. Urban areas evolved and grew because of the economic advantages of concentrated production, with firms and plants placed at an optimal distance from either sources of materials or final demand and with firms from various industries clustering for mutual economic advantage. Shifts of industry and population from one urban area to another have always been viewed as an interactive dynamic process—a chicken-and-egg dilemma:

> Population growth and employment growth interact. The growth of industry cannot be sustained in an area without a readily available local supply of labor, and a local market to purchase the final product. At the same time, population growth cannot be sustained without an expansion in local economic activity. (Vaughan 1979)

Do Jobs Follow People?

Urban analysts and policymakers are beginning to realize that the regional shifts in industry are as much a response to population shifts as vice versa, that is, that jobs follow people (Academy for Contemporary Problems 1977).

Roger Vaughan has had the most to say about this:

> Movements in population may have been the single most important factor in explaining differences in economic growth among regions and the suburbanization of employment. Although some households have moved to seek jobs, there is mounting evidence that companies have followed population rather than vice versa. (Vaughan 1977, p. 79)

Population growth means unmet consumer demand and a growing labor supply, to which local service industries have responded.

But the idea that jobs follow people is simplistic. Workers pursue jobs, but jobs follow the markets that people create. In the immediate time period, persons looking for employment must consider the current distribution of jobs as given. So college graduates, as well as displaced manufacturing workers, must consider their short-term job options in light of what is available in their own communities, as well as in other communities. However, even in the short run there are other kinds of influences on the choice of employment—matters that gauge the urban area as a place to live. People, particularly the younger and well-trained job seekers, are beginning to restrict their search to certain regions of the country or even to a particular city size. "In the main . . . the sunbelt and the suburbs have developed rapidly because people want to live there" (Kasoff 1977).

The formation of new and dissolution of old enterprises are influenced by economic conditions, business climate, and public policy. For example, new business may be quite sensitive to the local entrepreneurial mix or the availability of new venture financial capital. Even so, in choosing a new location or reassessing current location, entrepreneurs and executives can make the choice from among

alternative areas based on attributes of a place to live as well as of a place to do business.

So the importance of residential choice in analyzing both business and population shifts is magnified to the extent that jobs follow people (markets and labor). Lest we miss the point, population shifts are prompted by the search for a better quality of life that does not follow from, and might even be in contradiction to, economic conditions. Going one step further, industries—the service industry and innovative manufacturing in particular—are following the markets created by these regional or city/suburban shifts.

One way to view the importance of the arts for attracting population to large urban centers is in terms of the cultural diversity that results. As Perloff states, "The arts serve to enhance one of the built-in advantages of the city, that of *urbanity*. The arts serve to increase the element of *excitement* and *variety* which is the key to urbanity. Government and the private sector need to recognize the role of artists as dynamic city builders" (Perloff et al. 1979). But the use of cultural amenities to attract in-migration of the mobile population requires a great deal more study than it has received.

Are households attracted to urban areas that offer a comfortable climate, pleasant physical surroundings, and cultural and recreational amenities? Despite our argument that population shifts are occurring for reasons other than direct economic benefits, research on the importance of all amenities—let alone the cultural amenities—in explaining interurban migration and residential choice is incredibly thin. Studies have addressed only climate and pollution and have concluded that net migration is to warmer climates and away from polluted areas.

At least two sets of amenities are recognized by urban residents. The first includes the physical conditions of neighborhoods, such as general appearance of housing stock and cleanliness of streets, as well as the broader problems of traffic congestion, crime, and noise and air pollution. The importance of this set of amenities in determining the quality of life is recognized by residents at all levels of income. The second set of urban amenities, which includes cultural and recreational activities, seems to be of greater importance to upper- and middle-income than to lower-income residents (Kunde and Kasoff 1978).

Attraction of Businesses and Executives:
Some Empirical Evidence

A thorough analysis of the Baltimore region, based on data collected during unstructured interviews, revealed the following:

1. There was universal agreement among respondents that the arts by themselves are not a *determining* factor in industrial location decisions.
2. There are many quality-of-life factors perhaps more important than quality artistic and cultural amenities.
3. Quality-of-life issues appear to be more important to firms that employ highly trained, salaried, and mobile personnel.

4. The presence of varied and high-quality arts appears to be used as an important indicator of the general level of a community's civility and culture. The presence of these amenities is used to suggest that a community is progressive, resourceful, concerned about itself, and energetic.

5. Cultural and recreational opportunities are generally viewed as one area of concern, with firms interested in the total mix of educational and recreational opportunities available to an employee and his or her family.

6. Quality of life and life-style issues are very much matters of personal preference. While few want to live in a place with no cultural ambience, this does not mean that executives who are interested in artistic and cultural amenities require them to be "world class" or to be located in the home community. (Cwi and Lyall 1977, pp. 21–24)

Retention of Business and Executives:
Some Empirical Evidence

A more recent broad-based study of business locational factors in ten major SMSAs has been conducted by the Joint Economic Committee in Congress (1979). When asked to identify characteristics of the city that influenced their decision to expand or stay at a present location, businessmen listed quality-of-life issues as six of the seven most important criteria, of a total of twenty-six. Cultural attractions were ranked seventh among the criteria. Crime, quality of schools, and attitude of the city toward business are some of the more important factors. The study concludes that "improving the quality of life in cities where it is poor, and maintaining it where it is good, can have an important impact on decisions of firms to relocate, alter the size of their work force and reduce or expand their operations" (Joint Economic Committee 1979, p. 2).

As enlightening as these findings are in providing some vitally needed empirical discussion of the context in which cultural amenities influence locational choices, the interview technique is only one side of a balanced social science study of behavior.

References

Academy for Contemporary Problems. 1977. *Simulating the Economy of the Great Lakes States*. Report prepared for the Economic Development Administration, U.S. Dept. of Commerce.

Cwi, David and Lyall, Katherine. 1977. *Economic Impacts of Arts and Cultural Institutions: A Model Assessment and Case Study in Baltimore*. New York: Publishing Center for Cultural Resources.

Joint Economic Committee, U.S. Congress. 1979. *Central City Businesses—Plans and Problems*. Washington, D.C.: U.S. Government Printing Office.

Kasoff, Mark. 1977. The Urban Impact of Federal Policy. *Nation's Cities* (Nov.), Supplement.

Kunde, James E. and Kasoff, Mark. 1978. Public Opinion and Public Policy. *Nation's Cities* (Nov.), Supplement.

Netzer, Dick. 1978. *The Subsidized Muse*. London: Cambridge Univ. Press.

Perloff, Harvey. 1978. Central City in the Post-Industrial Era. In *The Mature Metropolis,* Charles Levin, ed. Lexington, Mass.: Lexington Books.

Perloff, Harvey et al. 1979. *The Arts in the Economic Life of the City.* New York: American Council for the Arts.

Scitovsky, Tibor. 1976. *The Joyless Economy.* Oxford: Oxford Univ. Press.

Thompson, Wilbur R. 1968. Internal and External Factors in the Development of Urban Economies. In *Issues in Urban Economics,* Perloff and Wingo, eds. Baltimore: Johns Hopkins Univ. Press.

Vaughan, Roger. 1977. *The Urban Impact of Federal Policies: Economic Development,* vol. 2. Santa Monica, Calif.: The Rand Corp.

_____. 1979. *The Urban Impact of Federal Policies: Population and Residential Location,* vol. 4. Santa Monica, Calif.: The Rand Corp.

Comment
J. Mark Davidson Schuster

Professor Shanahan has provided a very useful summary of the important issues related to the arts and urban development. But I am much more pessimistic than he about the ability of arts advocates to develop a set of studies to justify further expenditures in the realm of the arts on the basis of economic development.

Although research in the arts and economic development is in a very early state, I think it useful to consider carefully what policy decisions might be affected by further knowledge about the arts and economic development. I'm afraid the research may be leading to a situation where no particular policy will be applicable, either because the implied policies are perverse (in conflict with other well-developed and widely accepted public policies), or simply because of the unique nature of the arts as a nonprofit sector.

Are we interested primarily in economic development and secondarily in fostering the arts? In making the claim that fostering the arts will foster economic development, we must address a very important issue, which we have thus far neglected in our discussions: the question of opportunity cost. If we are to justify arts funding on the basis of economic development, then we must be prepared to make comparisons. What would have happened if we hadn't invested resources in the arts but had invested them in some other sector? Since the arts are usually a relatively unimportant local industry, generating little export income, if the arts are to compete against other economic sectors for public economic development funds, they will have a very difficult battle because of the obvious strengths of alternative investments.

A second aspect of opportunity cost and, again, one not sufficiently emphasized, is the question of *where* we foster the arts, or, from another perspective, where do we draw the boundary around our analysis of economic development and the arts? Analysis aimed at a particular city has a very different boundary from analysis at the state, regional, or national level. I see little reason why jurisdictions should be put in the position of competing with one another for artistic activities on the basis of economic development. If we finance artistic activities in one location out of a finite budget, we are not financing them in other locations. The public policy debate should thus address the question of how we decide where *not* to subsidize, as well as how we decide *where* to subsidize. It is at this point that the goal of geographical distribution will come in conflict with the goal of economic development.

One further question needs to be asked if we are going to use the arts in order to foster economic development: what policies are available to a local government agency wishing to foster the arts? For example, many (American) states use significant property tax forgiveness as an incentive to attract industry. But this tool is usually not available for cultural policy: property tax exemption is already widely available to artistic institutions, as long as they meet a very basic criterion—nonprofit status.

The question of opportunity cost arises here again. If we could offer tax exemption to, say, a profit-making art institution, should we do so? Consider Lincoln Center: in New York it is commonly agreed that the large property tax exemption was well worth the foregone revenues because of the economic development and increased tax base which the center generated nearby. But if Lincoln Center had never been built and the taxable development had not occurred in that area, would it have occurred elsewhere in the city? The difficulty of answering such a question cannot be ignored in making a logical, tight argument for fostering the arts to foster economic development.

Another policy tool that governments have used to provide incentives for economic development is income tax deductions and other special income tax provisions. Once again, this tool is not available for most arts institutions because of their nonprofit status. They do not have to file income tax statements and are not liable to income tax; therefore, exemption from income tax would offer no incentive for those institutions to move or grow. Dick Netzer has argued that public policy might well include increased support of profit-making institutions. And if we begin to rely more on economic development arguments, we might well find ourselves seeking more subsidies for profit-making arts institutions and fewer for nonprofit institutions. Again, the policies available may be thought of as perverse, in that they contravene commonly accepted public policy for the arts in the United States. To pursue them would require redefinition of the goal of cultural policy.

Another way to foster economic development through the arts is through manpower development, as suggested by Clark Abt. This is an area in which we have little experience, although it is quite feasible for the government to become in-

volved. Suffice it to say that in this area a policy instrument *is* available for the purpose of fostering economic development via the arts.

Finally, there is the whole area of direct subsidy. It remains to be seen whether governments are willing to increase their direct subsidies to arts or other non-profit institutions on the basis of economic development arguments.

Comment
V. N. Krishnan

James Shanahan has raised some interesting questions about the contribution of arts to urban growth and development. Considering the formidable problems in quantifying payoffs to community welfare or in working out the income and employment effects of promoting the arts, his contribution is highly commendable.

We must first define the "art" before assessing its impact on growth and development and deciding whether to view public support of the arts as a subsidy or an investment. A closely related issue is whether the arts generate income or merely respond to external stimuli, such as parking services—an enlightening distinction made by the author.

Any attempt at definition—and the author has rightly stressed its importance—is bound to encounter a host of problems concerning the establishment of boundaries for the various dimensions of the arts themselves. In a very general sense, art means different things to different individuals. Responses range from an ecstatic and almost wild enthusiasm on the part of some people to total apathy on the part of others, making it difficult to formulate a stable art consumption function. Actually we need something like a stable marginal propensity of art consumption. Meaningful application of the multiplier analysis and forecasting efforts require at least some approximate values here. We cannot even use an equilibrium approach or some combination of the comparative static and dynamic approaches. Thus, the problem of definition must be resolved before we can approach questions concerning the arts and development.

Models of the Role of the Arts in Economic Development

David Cwi

SUPPORT for the arts by cities across the United States has evolved historically out of a sense that the arts are a "good thing" for a community to have and important to the quality of life. Typically, cities came to support museums and the performing arts as much by chance as by design. In many cases, individuals have left endowments, collections, or facilities in the city's care, and the city has simply responded to this civic generosity rather than planned for arts development.

As we enter the 1980s, communities are under increasing pressure to provide necessary services and support meritorious activities, such as the arts, that have historically been funded by the private (nonprofit) sector. At the same time, policymakers are aware of the increased necessity to plan for multiple objectives. Activities and programs that were once viewed in complete isolation now must be understood in terms of the contribution they can make to a community's broader objectives, including economic development and community revitalization.

Arts advocates have welcomed this perspective. Believing the arts to be desirable in and of themselves, advocates also claim that arts activities and institutions can contribute to community revitalization, retaining and attracting business, expanding the local tax base, increasing the number and improving the quality of jobs, and increasing the number of tourists and other consumers.[1] These claims can be understood and evaluated from two perspectives, which are reviewed below. To facilitate this review, it is useful first to describe briefly U.S. research on the economic impact of the arts.

U.S. RESEARCH TO DATE

Studies devoted in whole or in part to assessing the economic effects of one or more cultural activities have been conducted in at least twenty-eight U.S. cities and seventeen states. In almost all cases, these studies were sponsored by local or

state arts councils and conducted as part of the political process. In a typical
study:

The scope of services of a group of activities viewed as clients of the arts
council is described. Consequently, the group is usually limited to not-
for-profit fine-arts-oriented activities. Information about services in-
cludes days open to the public; number of productions, performances, or
exhibits; and so forth.

Attendance data are cited, perhaps in conjunction with national surveys
citing favorable public opinion toward the arts.

Information is provided on the work force, payrolls, and other expenditures
of the examined institutions.

Claims are made regarding spending by audiences, in addition to admission
payments.[2]

A multiplier, typically in the range of 2.5, is applied to the total of institu-
tional expenditures and audience spending to estimate total local busi-
ness volume.

Some attempt is made to characterize taxes generated.

Conclusions are drawn as to the importance of more funding for the arts,
and additional facts are given about their fiscal plight. The latter may in-
clude brief explanations of the labor-intensive nature of arts activities,
market failure in the provision of arts, and so forth.

It was in this context that Katherine Lyall and I received a grant from the
National Endowment for the Arts to develop an economic impact model and user
manual together with a case study showing an application of the model. This pilot
study resulted in *Economic Impacts of Arts and Cultural Institutions: A Model
Assessment and Case Study in Baltimore.*[3] The study improved on previous re-
search designs in several respects which are detailed in the report.

The Baltimore project and our subsequent research have sought to improve
past research designs in order to gather sufficient data to begin an assessment of
the various economic development claims made for the arts. Our current activi-
ties include an expansion of the Baltimore pilot effort to include research on some
forty cultural institutions of all types in six additional U.S. cities: Columbus, St.
Louis, Springfield (Illinois), Salt Lake City, Minneapolis-St. Paul, and San
Antonio. Research will result in important data sets on local and nonresident
audiences, staff households, and institutional operating and financial characteris-
tics. These data will make it possible to begin a serious evaluation of the role of
the arts in urban economic development.

MODELING THE IMPACT OF THE ARTS:
DIRECT, INDIRECT, AND INDUCED EFFECTS

To evaluate the role of the arts, we have focused on the direct, indirect, and in-
duced effects of arts activities. Direct effects are expenditures made by arts insti-
tutions and their staff households in transactions with local vendors. Indirect

effects are the multiplier effects identified through interindustry analysis; that is, the indirect local production requirements associated with direct sales to arts institutions and consequent spending with local vendors, who in turn meet some portion of their needs locally. Interindustry analysis treats the relationship between direct and indirect effects as if it were causal, in the sense that expenditures by arts institutions and their staffs are viewed as responsible for (increased) activity in the specific sectors of the local economy from which they (and their suppliers) purchase goods and services.

Induced effects are the most difficult to understand and model, requiring an examination of consumption, as well as production, behaviors. Once an effect has been induced, we can trace its impact in direct and indirect terms. For example, the most frequently cited induced effect of the arts is audience spending for items other than admission to the arts activity—bar, hotel, restaurant, and so forth. (Attendance at the arts event is itself, in a sense, an induced effect, since suburban residents and tourists can sometimes be viewed as "induced" to come back to the city for the sole purpose of attending an arts activity.)

Our research suggests that the induced effects claimed by arts advocates may be the most important. To the extent that they are manifest as audience spending, these expenditures have been treated by advocates as a direct effect of particular interest to the regional economist. (They are often the single most important institution-related economic activity and account for the bulk of indirect or multiplier effects.) To the extent that they are manifest as changes in behavior by households and firms, these induced effects are of particular interest to the (city-based) economic development administrator.

Induced effects are not part of the production requirements of the arts industry; for example, dining at a restaurant before or after a show is not required for the show itself to go on. To say that spending is induced is simply to assert that attending, say, the theater somehow prompts the individual to spend over and above the admission expenditure. This implies that attendance at an arts event is somehow responsible for other (spending) behaviors. We explore below the importance of the induced effects claimed for the arts together with the inherent difficulties in identifying and modeling them.

TWO VIEWS ON THE IMPORTANCE OF
THE IMPACT OF THE ARTS

Economists and practitioners seeking to evaluate the significance of research on the economic effects of the arts may adopt differing points of view addressable from within the framework of direct, indirect, and induced effects. Economic development practitioners, particularly those in central cities, are concerned with a broad range of objectives involving both fiscal and economic growth. They may be particularly concerned with redirecting regional growth and investment back into the city and its neighborhoods, attempting not only to increase city-based economic activity and markets but also to induce households and firms to invest in the city. The practitioners' goals are aimed at city revitaliza-

tion in the sense of increasing tax bases, as well as retaining and increasing city-based economic activity. Economists interested in regional growth might focus exclusively on the broad goal of regional economic development expressed in terms of increases in personal income and jobs. These two points of view may prompt differing judgments of the potential importance of the arts.

THE EXPORT BASE MODEL

Economists focusing on regional economic growth would examine the direct and indirect effects of the arts from within the context of export base theory. The export base model suggests that an activity is important to regional economic growth if it brings in new dollars through export sales (or keeps dollars in the community by restricting imports of goods, services, and labor). An industry may not be a direct "export earner," but it can be indirectly important if it supports local industries that are (important) export earners. From this point of view, industries that simply service the needs of local residents are not important, especially if residents are willing to substitute a locally available activity for one not available locally rather than rely on imports, for example, attend a local movie theater rather than travel to another city for an arts activity not available locally.

In a speech before a conference on arts and economic development, Dick Netzer typified this point of view when he asserted, "speaking as an economist . . . I disagree . . . sharply with the empirical proposition that the arts are or can be a significant factor in urban economic development, except in extraordinary and unusual circumstances" (Netzer 1978). He arrived at this assessment by focusing on the traditional issues:

> To ascertain the economic role of a given industry, the first question the urban economist asks is: is the industry an "export" industry—one that sells all or a large share of its output to non-residents? . . . Second, if the industry is mainly a local service industry, does it have important effects on the area's export industries? Would its absence (or shrinkage) have negative, albeit indirect, effects on the export sector? (Netzer 1978)

By ignoring the export base issue and concentrating solely on multiplier effects, earlier studies have almost completely ignored the questions raised by the regional economist. Our six-city study suggests that arts institutions in the majority of U.S. cities sell the bulk of their output to local residents; that direct and indirect effects are relatively modest in the context of total local business activity, but not necessarily insignificant; that the arts are many industries, not one; and that audience spending, whether by visitors or residents, usually is the single largest institution-related economic effect. (With regard to export sales—sales made to visitors to the community—there have been doubts, which we will explore, about attributing these in all cases to the presence of the institution.)

Finally, the arts, as defined by advocates, do not appear to provide services that are required by local export earners in manufacturing their products or con-

ducting their day-to-day business.[4] In addition, the evidence is equivocal that they are indirectly important in the sense that they alone may help to influence decisions by export earners or executive households to move into the community, or decisions by local firms and households to stay and invest.

While our research suggests that the direct and indirect multiplier effects of arts activities are relatively modest in the context of total local business activity, their direct, indirect, and induced effects are perhaps more significant than those of other leisure services supported by government, perhaps even significant enough to warrant increased public concern for public funding of the arts. This, in fact, is the arts advocates' argument, and our comments are not intended to pass judgment on its worth.

INDUCING DESIRABLE BEHAVIOR BY HOUSEHOLDS AND FIRMS

From the point of view of the economic development practitioner, the principal value of the arts may stem less from their direct and indirect effects, in terms of dollar flows through arts institutions and related suppliers of goods and services, than from their more subtle induced effects. These effects may be particularly important to central cities because they involve city revitalization and the redirection and stimulation of (regional) growth and investment that may be driven by factors unrelated to the arts. This notion of city revitalization focuses on city tax bases, as well as city economic growth. The goal of revitalization may be expressed as a set of objectives concerning specific places within the city, such as neighborhoods and downtown (central business district), physical and commercial revitalization, and regional economic growth.

This point of view necessitates an appreciation of the challenges confronting American cities. Many cities are losing population (as have their Standard Metropolitan Statistical areas (SMSAs). Between 1960 and 1970 the central cities of some 130 SMSAs lost population. At the same time, the number of persons in these cities requiring extensive social services has increased significantly. Middle-class residents have left the city to live in the suburbs—while still working in the central city. Growth in manufacturing jobs has occurred in the suburbs, if it has occurred at all.

The city that has experienced these trends typically has a lower per-capita tax base and higher per-capita demands for expenditures on social services. The central retail district has deteriorated as retailers have followed the middle class and invested in the suburbs, and the growth of suburban commercial centers is seen as a threat to the white-collar workers remaining in the central city. Neighborhoods are in decline, and the city has the appearance of being dreary, crime-ridden, and dirty. At the state level, it is perceived as a drain on tax revenues without redeeming virtues. Moreover, the city is at an increasing political disadvantage to the suburbs, inasmuch as the latter contain more voters, if not population. At the same time, the city has become more fiscally dependent on tax revenues or services provided by the state and federal governments.

Thus, the city needs revitalization. Industrial development may be limited in that the city may be unable to compete with the locational advantages of the suburbs (and there may be little available city land). The city-based development practitioners want middle-class taxpayers to return to city neighborhoods or, at least, not to leave when they marry and start a home. They believe that city homes are undervalued and that a city life-style is valuable and competitive with life in the suburbs. Finally, they want to encourage and reward merchants who remain downtown.

Revitalization objectives may be expressed not simply in terms of the retention and attraction of firms and households but also in terms of attitudinal dimensions that are thought to induce behavior relevant to revitalization. Objectives may include the following:

changing the city's image;
retaining the downtown retail trade that remains;
encouraging development of the city as a tourist and regional center;
creating markets for new business;
encouraging new private investment;
channeling commercial development and private investment from suburban to city locations;
developing community pride and spirit so that people have a stake in preserving the area's health and vitality; and
enhancing the city's tourist and industrial or (business) development programs, such as they are, and improving the success of the larger downtown development projects (for example, convention centers) that are important export earners.

In short, decision makers might be drawn to invest in the arts if they believed that arts activities affect the investment and location decisions of households and firms. For example, arts advocates seem to suggest that many persons view the availability of artistic activities as an indicator of a community's sophistication, wealth, human resources, and willingness to invest in itself and take risks. While they might not need the arts directly, firms and households may use the arts as an indicator of the availability in the community of resources they do need to be successful. Thus, arts activities may be useful in projecting a community image to persons who have a preconceived image or none at all; thus, they contribute to the success of revitalization efforts.

Some case studies suggest that the presence of arts activities and facilities can help draw people to redeveloped (downtown) areas. In this case, the arts play a direct role in changing the image of the city. Suburban and city residents who begin to participate in arts events may see the city in a new light. Taken together with city efforts to upgrade other services and amenities, this new image may help instill the belief that the city is in control of its fiscal, economic, and assorted other plights. The decision to locate in the city will thus be viewed more as a desirable investment than as a risk.

Additionally, arts activities can help ensure the success of various downtown or neighborhood businesses by regularly bringing thousands of suburban residents back into the city. These individuals and the businesses they support play a role in creating an exciting urban environment and in transforming the downtown area from a commercial center to an evening and weekend entertainment center. In sufficient concentration or on an adequate scale, the arts can help support restaurants and other businesses. They can facilitate the success of tourist, convention center, and other entertainment strategies by helping to create an attractive and exciting urban environment—a fact that cities like Baltimore have capitalized on by redeveloping their downtown areas to include multiuse structures housing theaters, plazas, galleries, and so forth.

Thus, in helping to draw people to redeveloped downtown or other areas, the presence of cultural facilities may be a favorable if not a consequential factor in inducing development. Furthermore, there is some indication that individuals who attend some arts activities represent households that the city would like to attract and retain—those most interested in amenities, least deterred by such disadvantages as poor public schools, and most attracted by the prospect of living within a short commuting distance of the central business district.

In addition, the arts could be politically useful to cities if they help create a climate in which people have a stake in preserving the area's economic health and vitality. This may occur at two levels. First, as cities battle politically for a greater share of tax dollars from state and national levels of government, they will want to be perceived as both commercial and cultural centers that must be supported at all costs. Second, persons who contribute to arts organizations, serve on the board of directors, and volunteer in other capacities may be drawn into the life of the city even if they live elsewhere. Since the health of the city affects the health of the institutions, they may become interested in the city's vitality.

Finally, assistance to the arts and support of other amenities is at least one way that cities themselves can contribute to an environment helping local export earners. The managerial, highly educated, professional class is the most mobile group of workers, since these individuals compete in a national labor market. The presence of the arts and the broader effects to which they contribute may help to create an urban environment attractive to these individuals and even offer some compensation for urban disadvantages.

MODELING INDUCED EFFECTS

Having made the advocate's case for the importance of the induced effects often attributed to the arts, we should point out that good research documenting and modeling these effects is scarce. In fact, the range of effects of the arts on households and firms is far from clear, as are the ways in which the effects may vary.

However, three types of induced effects are claimed for the arts. The first involves spending and other behaviors by users of the arts at the time of such use. The second is an image effect as certain behaviors or attitudes continue indepen-

dent of arts attendance. The third is the attitudinal effect on nonattenders, leading to relevant behaviors on their part.

Other claims seem to suggest that the mere presence of the arts makes the city an attractive place to live or to locate a business in, even for those who do not have an interest in the arts. Even the most straightforward claims of this sort seem problematic upon inspection.

Critics point out that the only audience effects traceable directly to the institution are audience payments for admission. If audience members happen also to go to a bar or restaurant, it's not clear how this is tied to the operation of the arts institution. Even had they not gone to the arts event, they might have gone to the restaurant. Sometimes they happen to do both. In fact, for all we know they might not have gone to the arts event had there not been a restaurant in the vicinity. Similarly, visitors from outside the metropolitan area may decide to attend an arts event only after arriving in the city. It seems appropriate to count their expenditures in the community as an impact of the arts only if the presence of the arts is a determining factor in their decision to visit, an issue we have explored in our research. In other words, it is sometimes difficult to determine when the arts lead development and when they follow.

In the context of available research, the importance of the arts for economic development is a bit like Pascal's wager. Pascal argued that belief in God costs little, is meritorious in itself, and guarantees access to the kingdom of heaven should it and God exist. Similarly, the arts in America cost taxpayers very little and may bring economic development rewards.

Thus, research on the economic role of the arts should be approached with extreme caution in the absence of clear-cut policies of support of the arts for their own sake. The arts may be useful in meeting objectives that will result in increased employment, income, and tax bases. The broader questions of the commercial and nonprofit arts, leisure, quality of life, and economic development concern the demands that ought to be created by public sector support for various art and leisure activities, as well as the institutional forms through which activities should be expressed and the ways that facilities and programs should be integrated. It may or may not be damaging to arts policy to support (and define) the arts in ways that help meet particular economic development objectives.

Notes

1. As used in the context of economic impact studies, "the arts" refer to activities such as museum exhibits and the various performing arts, as well as to outdoor exhibitions and festivals. Parks and libraries are considered cultural facilities but not the arts. Historic preservation and adaptive use have not been included. The extant studies reflect the focus of the sponsoring organizations in that they largely ignore individual artists and craftpersons. Studies do not explore the employment and other effects possible through improvements in the marketplace for the skills and output of individual artists. The role of such strategies is not addressed in this paper but can be explored from within the general framework provided.

2. In general, studies have been technically deficient in numerous matters relative to the measurement of audience expenditures. Several issues are discussed in the text. Others are reviewed by David Cwi and Katherine Lyall in *Economic Impacts of Arts and Cultural Institutions: A Model Assessment and Case Study in Baltimore* (1977, pp. 83–84). The approach we have devised utilizes expenditures per party, controlling for party size. Technical papers are forthcoming.

3. Cwi and Lyall (1977). It is anticipated that selected data from Cwi and Lyall's six-city study will also be published by the National Endowment for the Arts. In addition, the author is currently preparing a monograph for Public Technology Inc., under contract from the U.S. Economic Development Administration, on the role of the arts in urban economic development. This monograph summarizes and interprets available research and will be released by the Economic Development Administration. Additional working papers will be available from the Center for Metropolitan Planning and Research of The Johns Hopkins University. Research on the implications of "economic impact" data for regional cost sharing of arts and cultural institutions by the several units of government that comprise a metropolitan area can be found in David Cwi, "Regional Cost-Sharing of Arts and Cultural Institutions" (1979).

4. Advertising, packaging, architecture, and other aspects of design may involve (commercial) artists trained in various ways. But the output of museums and the (nonprofit) performing arts does not appear to be directly used by most businesses.

References

Cwi, David. 1979. Regional Cost-Sharing of Arts and Cultural Institutions. *Northeast Regional Science Review* 8.

Cwi, David and Lyall, Katherine. 1977. *Economic Impacts of Arts and Cultural Institutions: A Model Assessment and Case Study in Baltimore.* New York: Publishing Center for Cultural Resources.

Netzer, Dick. 1978. Address given at a national conference on the role of the arts in urban economic development, sponsored by the Minneapolis Arts Commission, October 4–7.

Comment
Virginia Lee Owen

David Cwi has provided a succinct summary of the rationales, issues, and problems connected with economic impact studies of arts institutions. Such studies are applications of economic base analyses or measures of the induced effects arts institutions may have on households and firms. Professor Cwi has detailed the assumptions underlying these applications and warned of potential problems in their use.

As complete as the Cwi survey is, however, it still lacks the global perspective required to answer those who criticize government subsidy of arts institutions. Only if alternative public development programs are compared in effectiveness to arts subsidies can the case be made. Cwi discussed the enhanced central city of

Baltimore which has resulted from redevelopment centered around a number of arts institutions. The economic impact of these institutions has been detailed. What is not known, however, is whether the economic impact of other subsidized institutions would have been greater. Detroit has also seen a redevelopment of the central city, in this case, a multistory office/shops/theaters complex (Grove 1979). Unlike symphony and ballet, offices, shops, and movie theaters are profit making and self-sustaining. They will not be a continual drain on public coffers and thus may be more appealing than arts alternatives. Furthermore, they provide an immediate increase in the tax base and are unaffected by the problems of nonprofit institutions or government-owned facilities. It is not clear that the Lippizaner Riding School in Vienna is less economically beneficial than the opera. If arts institutions can be shown to have larger economic impacts than these other alternatives, they can still be justified. Such economic impacts may result from increased purchases by those outside the region (economic base) or from greater inducements for consumers to spend and firms to invest in the central city. There is little evidence on this issue.

Even if we ignore the nonart alternatives in these impact studies, the actual analyses are still too restrictive. The numerous impact studies which have been conducted have focused on a narrow definition of the arts. Cwi notes that this results from the interests of those funding such studies—usually arts councils concerned with public arts institutions. If other arts activities were included, the economic impact might be larger. However, the returns from private arts activities might be greater than those from public arts institutions, thereby endangering public subsidies. Jazz concerts and even films may attract larger audiences and contribute significantly to local economies. The Ford Foundation reports that audiences at these kinds of events represent broader segments of the population, so that equity as well as economic benefit can be cited in their behalf.

Arts advocates have long urged arts subsidies. The economic impact studies have provided fodder for those of us in search of a rigorous theoretic defense. Such studies are a necessary but not sufficient part of that defense.

References

The Ford Foundation. 1974. *The Finances of the Performing Arts,* vol II. New York.

Grove, Noel. 1979. The Two Worlds of Michigan. *National Geographic* 149 (June): 802–843.

Comment
J. Mark Davidson Schuster

On the whole, I think that the interest in the relationship between economic development and the arts is best summarized as a basic interest in fostering the arts. Cwi states that there have been some forty studies in twenty-eight cities of seventeen states on the economic impact of arts institutions, and perhaps it is this thread that best explains why all those studies were conducted. But even Cwi, in his own commendable earlier analysis of this topic, is very cautious about discussing the policy implications of such studies. When all of his caveats are added up, it becomes clear that studies of the economic impacts of the arts don't serve a very large public policy purpose; and one realizes that most such studies have been done simply to advocate or justify a larger subsidy, with economic development serving only as the rationale of the moment. But the emphasis on fostering the arts does suggest a very interesting area of research on economic development: how might economic development be used as a tool to foster the arts? Although this use of economic development vis-à-vis the arts has not been addressed in any of the papers in this volume, a strong case can be made that this is exactly what has happened in such cities as Atlanta, where economic revitalization has been accompanied by a major revitalization of the arts.

In many respects, the debate over government financing for the arts in the United States has been resolved at least de facto; the government is heavily subsidizing the arts, particularly when indirect sources of aid are included in the count. Further justification for fostering the arts is really icing on the cake. This is particularly interesting in light of Cwi's conclusions in another paper that the rationales for public support of the arts are all based ultimately on a "merit good" argument, an argument which he points out is primarily political and not economic. By pursuing the economic argument beyond necessity or beyond the data, I fear that we do the arts a disservice. Society *has* decided to support the arts, and policy research should be concentrated on how we can do a better job of providing that support.

Does a Festival Pay?

David Roger Vaughan

R EFERENCE TO NEWSPAPERS and journals at certain times of the year reveals that the City of Edinburgh stages one of the most comprehensive and best known of the world's festivals of art. However, an examination of Edinburgh newspapers at any time of the year reveals that the attitude of the residents of Edinburgh toward the festival is, to say the least, mixed. Some residents praise it for directly or indirectly increasing trade and thus providing extra income, employment, better shopping facilities, and a wider range of entertainment. Other residents complain that the festival is the cause of social, cultural, and environmental problems and is a wasteful use of the local taxpayers' money.

Thus, in the past, without sound information, the debate over the festival has been highly subjective, colored by emotion and prejudice. Those who oppose the festival point out that there is no firm evidence on the benefits provided. Proponents, however, claim that even though ticket prices have not always covered the full costs of the festival, thus necessitating subsidies, the wider benefits, such as the customers attracted to hotels, restaurants, and shops, make it worthwhile.

In 1976 the Scottish Tourist Board and the Lothian Regional Council commissioned a study of the economic benefits to the local community from the presence of the Edinburgh Festival. The findings were presented in October 1977 in a report entitled "The Economic Impact of the Edinburgh Festival, 1976" (Vaughan 1977a). This paper describes the analysis and findings contained in that report and expands on those findings in order to illustrate how the results could be used to shape one aspect of the future impact of the festivals—the development of the visitor market—in ways which would increase the economic benefit to the local community of festival visitors.

THE EDINBURGH FESTIVAL

The Edinburgh Festival is not one but four autonomous annual festivals taking place simultaneously during August and September. The attraction ranges from the commercial mass appeal of the Military Tattoo to the subsidized Inter-

national Festival and from the popular and diverse International Festival Fringe to the smaller International Film Festival.

The Edinburgh International Festival was established in 1947 with the aim of bringing to the city the best examples of artistic and creative expression in the world. During the 1976 International Festival there were 136 performances of opera, music, dance, theater, and poetry spread over three weeks. Over the years the International Festival has received substantial support in the form of grants, because the revenue from ticket sales has not covered the cost of ambitious programs of high quality.

The International Festival Fringe is unique in that both amateur and professional people present their own shows at their own risk and expense. The Festival Fringe consists of autonomous groups coordinated, but not screened, by the Festival Fringe Society. The Fringe has grown since its inception in 1947 to a total of 182 groups in 1976 giving 2,928 performances over three weeks (although some shows started and some finished outside this three-week period).

The International Film Festival is one of the senior world film festivals (only the Cannes and Venice Festivals are older), having been established in 1947. However, it differs from all others in the level of public participation—a level substantially in excess of any other film festival; in 1976 150 feature films were presented over a two-week period. The Film Festival is financed through ticket sales and grants.

The Edinburgh Military Tattoo originated in the military drill displays taking place in Princes Street Gardens in the years after the Second World War. It became a formal event in 1950. In 1976 there were twenty-seven performances of the Tattoo which consisted of military bands and service displays from Britain and the rest of the world spread over three weeks. It is self-financing from ticket sales, although it does benefit from its military connection.

THE STUDY DATA BASE AND METHOD

The data base used and the analysis conducted for the report were, of necessity, complex and extensive. The data were derived from interviews conducted with 660 groups of visitors to Edinburgh, of whom 346 gave details of their expenditure over the previous three days; an audience survey of 16,842 people at 107 festival performances; and information from the accounts of 123 businesses, including the two local authorities and the four festivals. Substantial use was made of the 1973 *Scottish Tourism and Recreation Study* (Tourism and Recreation Research Unit, University of Edinburgh 1975a), the 1976 International Passenger Survey (Department of Industry 1977), the British Home Tourism Survey (Scottish Tourist Board 1977), and the 1975 Family Expenditure Survey (HMSO 1976).

The data base and the subsequent analysis were complex because the overall impact of the festivals results from more than a single sector of the local economy operating in isolation. Not only is expenditure on the festivals involved, but also expenditure in hotels, guest houses, shops, restaurants, and so forth, and the sub-

sequent expenditure on products supplied by local manufacturers and whole-salers.

The data were combined in an ad hoc Keynesian multiplier analysis measuring the income benefits which the local community (residents of Edinburgh) was able to derive from festival-related expenditure directly or from the additional income generated at each round of exchange as part or all of the original expenditure circulated locally. The extent of the benefit was governed by the leakages arising from the payment of income to, or the purchases of goods and services from, individuals, organizations, and governments based outside the locality.

DEFINITION OF TOTAL INCOME GENERATION

An elegant formulation of multiplier analysis in connection with tourism was presented in "The Economic Impact of Tourism: A Case Study of Greater Tayside" (Tourism and Recreation Research Unit 1975b) as follows:

$$(1) \quad Gr = \sum_{j=1}^{J} \sum_{i=1}^{I} N_j \, Q_j \, K_{ji} \, Y_i \, \frac{1}{1 - L \sum_{i=1}^{I} x_i \, z_i \, y_i}$$

where Gr is the income generated locally after tax,

N_j is the number of nights spent in the area by j types of tourist,

Q_j is the total daily expenditure of j types of tourist,

K_{ji} is the proportion of £1 expenditure by tourists in different business types,

Y_i is the income generation per £1 of business turnover,

L is the average propensity of local residents to consume,

X_i is the distribution of local resident expenditure among businesses, and

Z_i is the proportion of X_i expenditure which is local.

N_j, Q_j, and K_{ji} represent the multiplicand, and the remainder of the equation represents the subsequent multiplier process. The impact created by the multiplier process is dependent on the expenditure, its distribution, and on the term Y_i.

DEFINITION OF THE INCOME COEFFICIENT OF BUSINESS

Equation (2) indicates the pattern of expenditure of different types of businesses:

$$(2) \quad Y_a = \frac{W(1 - h - t_w) + P(1 - t_p) + F(1 - t_w) + \sum_{i=1}^{I} S_{ai} \, Y_i}{D}$$

where Y_a is the income generation coefficient of a business,

W is the gross wages and salaries to residents of the city,

h is the deduction rate on wages and salaries (national insurance, and so forth),

t_w is the tax rate on wages and salaries,

P is the profit retained by residents,

t_p is the tax rate on profit,

F is the rent paid to residents,

S_{ai} is the cost payment to i-th type of business,

Y_i is the income generation coefficient of i-th type of business, and

D is turnover.

There are four components of multiplier analysis, three forming the multiplier and one the multiplicand. The three components of the multiplier, using the festivals as the example, are:

1. direct income (wages, rent, and profit paid locally, net of tax, by the festivals);
2. indirect income (wages, rent, and profit paid locally, net of tax, which can be attributed to spending on the festivals but which arise from the purchase of supplies by the festivals from, for example, local retailers);
3. induced income (wages, rent, and profit paid locally, net of tax, which arise from the spending by local residents, for example, festival staff, of income earned from the festivals).

The final component is the multiplicand or injection of money into the city—the level of impact being ultimately determined by how the multiplicand is expressed and what is or is not included in it. The multiplicand can take three forms: the initial injection of capital for construction, the recurring expenditure of visitors, or the investment induced by, for example, the presence of the festivals and the consistent inflow of money. The form the multiplicand takes in a study is governed by the policy context. The policy issues for the festival study related to tourism; therefore, the recurring injection of visitor expenditure was used in the analysis.

However, even after the type of injection was defined as recurrent expenditure, a problem still existed. In analyzing the benefits of the festival there were three possible measures of the multiplicand: the expenditure of visitors who would not have come had the festivals not existed, the expenditure of visitors who knew about the festivals before coming, and the expenditure of visitors who attended the festivals while in Edinburgh—each measure being based on expenditure within Edinburgh. In the festival study the last (usage) definition of the multiplicand was adopted.

It may be asked, however, why the first measure was not applied, that is, defining the impact as that resulting from the expenditure by visitors for whom the festivals were the prime reason for visiting Edinburgh. The festivals could be one of a number of things which in combination motivated visitors to come to the area, and no research system exists for completely unraveling the nature and strengths of the various influences on consumer decisions. Use of the first mea-

sure would require that consumers express their attitudes toward these influences. A similar reason ruled out identifying the impact of individual festivals, since most visitors attended performances at more than one of the festivals.

Finally, it is necessary to emphasize that the local income multiplier formulation adopted was of the unorthodox type in which the multiplier value is taken as the ratio of the direct, indirect, and induced income to the initial expenditure. Thus, the income multiplier formulation used presents income to local residents as a fraction of turnover, a coefficient of 0.35 indicating that 35p of local income resulted from an initial £ of expenditure. Care must be taken not to confuse this type of formulation with that adopted in an orthodox multiplier analysis, in which the multiplier value is the ratio of the direct, indirect, and induced income to the direct income. In this alternative presentation the multiplier is expressed as an increment to local income rather than as a fraction of initial expenditure, a value of 1.35 indicating that an additional 35p of local income is added to the original £ of the direct local income, the £ being only a part of the original injection (expenditure).

RESULTS OF THE ANALYSIS

The form of analysis allowed for the incremental buildup and presentation of results. The first of the incremental stages was an estimation of total expenditure on each of the festivals by visitors to Edinburgh. This estimate was based on the income from festival productions, as documented in accounts, apportioned on the basis of the audience survey. The second incremental stage was an estimate of city income coefficients for each of the festivals.[1] These were based on an examination of the accounts of each of the festivals, accounts of local businesses, and so forth. In the final incremental stage the two previous stages were combined in order to reveal the impact on local income (see Table 1).

As stated earlier, to put the economic benefit of the festivals into true perspective, it was also necessary to measure the impact of visitor spending outside the festivals. This impact was built up through a similar incremental approach, al-

Table 1. *Total Expenditure of, and Local Income Generated by, Visitors Attending Performances During the 1976 Festivals*

| The Festival | Visitor Expenditure (£000s) | City Income Coefficient (per £) | | | | Total Local Income (£000s) |
|---|---|---|---|---|---|---|
| | | Direct | Indirect | Induced | Total | |
| International Festival | 226 | 0.05 | 0.05 | 0.02 | 0.12 | 27 |
| Fringe Festival | 65 | 0.23 | 0.02 | 0.04 | 0.30 | 20 |
| Military Tattoo | 293 | 0.08 | 0.04 | 0.02 | 0.14 | 41 |
| Film Festival | 5 | 0.28 | 0.09 | 0.07 | 0.44 | 2 |

though of necessity certain parts of the stages were more complex. The first stage was to estimate the average daily expenditure of visitors to Edinburgh who attended a festival event. The expenditure was divided among the different types of businesses in which visitors spent money (see Table 2). The second stage was to develop an income multiplier for each type of tourist. Such multiplier values were based on the distribution of expenditure as presented in Table 2 and on the propensity of different types of business to generate local income. The income multiplier values are presented and as before the third stage required combining expenditure and local income coefficients in order to reveal the size of the impact of visitor expenditure on local income (see Tables 3 and 4).

In addition to the recurrent expenditures which have been identified (see Tables 2, 3, and 4), there are others, as shown in Table 5, which include day visitor expenditure in city businesses, excluding the festivals; performer expenditure; and film conference visitor expenditure.[2]

Table 2. *Average Daily Expenditure Pattern of Staying Festival Visitors (£)*

| Type of Tourist by Area of Home Residence | Accommo- dations | Retail | Souvenir | Cafe/Pub | Transpor- tation | Other | Total |
|---|---|---|---|---|---|---|---|
| Scotland | 2.53 | 0.33 | 0.21 | 1.21 | 0.25 | 0.02 | 4.55 |
| Rest of U.K. | 2.09 | 0.94 | 0.27 | 1.33 | 0.42 | 0.08 | 5.15 |
| W. Europe | 2.92 | 1.01 | 0.91 | 1.71 | 0.17 | 0.17 | 6.90 |
| N. America | 5.85 | 1.30 | 1.27 | 2.21 | 1.50 | 0.06 | 12.19 |
| Elsewhere | 3.60 | 2.33 | 1.58 | 1.90 | 0.39 | 0.44 | 10.23 |
| Weighted Average | 3.08 | 1.19 | 0.73 | 1.62 | 0.54 | 0.13 | 7.32 |

Table 3. *Average Daily Expenditure and Local Income Generation in the City of Edinburgh by Staying Festival Visitors (£)*

| Type of Tourist by Area of Home Residence | Average Daily Expenditure | Local Income Multiplier Value (per £1) | Local Income Created per Visitor Day |
|---|---|---|---|
| Scotland | 4.55 | 0.32 | 1.45 |
| Rest of U.K. | 5.15 | 0.28 | 1.44 |
| W. Europe | 6.90 | 0.29 | 1.99 |
| N. America | 12.19 | 0.29 | 3.49 |
| Elsewhere | 10.23 | 0.29 | 2.93 |
| Weighted Average | 7.32 | 0.29 | 2.09 |

Table 4. *Number of Bed-Nights Spent by Festival Visitors Accommodated in Edinburgh, Total Expenditure, and Total Local Income*

| Type of Tourist by Area of Home Residence | Number of Bed-Nights in City of Edinburgh (000s) | Total Expenditure (£000s) | Total Local Income (£000s) |
|---|---|---|---|
| Scotland | 9 | 42 | 13 |
| Rest of U.K. | 167 | 859 | 241 |
| W. Europe | 60 | 415 | 120 |
| N. America | 57 | 696 | 199 |
| Elsewhere | 48 | 488 | 140 |
| Total | 341 | 2,500 | 713 |

Table 5. *Other Recurrent Expenditures and Local Income Generated (£000s)*

| Source of Recurrent Expenditure | Amount of Expenditure | Local Income Created |
|---|---|---|
| Day Visitors (excluding festivals) | 213 | 49 |
| Visiting Performers | 197 | 61 |
| Film Conference Visitors | 9 | 3 |

OTHER CONSIDERATIONS

There are other important aspects of the impact of the festivals which have not been detailed so far; for example, trade created by the festivals at other times of the year; grant aid to the festivals from outside the Lothian Region, which amounted to £237,400 in 1976 and, with multiplier analysis applied to it, created £32,500 of local income; the free advertising of Edinburgh implicit in coverage nationally and internationally in editorial features throughout the year—about 70,000 column centimeters in 1976 for the International Festival alone. Perhaps the most important of the other considerations relates to attendance by local residents at festival performances, which has both economic and social implications.

In terms of economic analysis, the festival study implicitly identified the possible cost resulting from a high proportion of local residents in the audiences and the reduction in the size of the multiplicand. In 1976 local residents spent £253,000 on tickets. If this expenditure had been by visitors to the city and the region, a further £45,000 of local income could definitely have been added to the overall income.

However, such a statement on the impact of this reduction in the size of the multiplicand can only be tentative and should be treated with caution because it assumes that visitors to the city would have purchased the tickets had residents not done so. As the initial expenditure on tickets was made by local residents, the

actual benefit may have been smaller depending on whether the expenditure was "extra" or on whether it was diverted from other uses. These other uses, of course, would also have created income. The difference between the two levels of income creation is the actual gain or loss attributable to residents purchasing tickets.

For local social benefits the study highlighted the scale of attendance by local residents at the festivals. The survey gave little support to the idea that local residents neither wanted nor could afford to attend the festivals. In 1976 residents of the Lothian Region occupied 50 percent of the 168,000 seats filled at the Fringe Festival, 54 percent of the 18,000 seats occupied at the Film Festival, and 15 percent of the 251,000 seats filled at the Military Tattoo.

The main criticism on lack of local participation is normally reserved for the International Festival, which has been described as "a costly jamboree, staged for the benefit of an elitist group of well-heeled connoisseurs, mostly from abroad" and also as having "failed to reach the people of the city that cradled it." In fact, it was estimated that of the 120,000 seats at the 1976 International Festival, 36 percent were taken up by residents of the city and the Lothian Region, who attended all types of performances.

THE SUCCESS OF THE FESTIVALS

As evidenced by the opening paragraphs, a festival is open to judgments, not all of which are sympathetic to subsidizing an artistic event at times of economic stringency. The problem is that, while the worth of a festival needs proof if it is not to go by default, there is no absolute measure, in the sense of a scale or a set of values, of what constitutes effectiveness or success. Whether a festival is a success depends on how its role is defined, because the role determines such things as target audience composition, pricing policies, and management policies concerning content and form. If the role is to bring in money by attracting tourists, it is senseless to attack the festival as the "domain" of tourists; if the role is to provide performances of high quality at "low" (relative) prices so that local people are encouraged to attend, it is senseless to attack the need for subsidies (always assuming, of course, that theaters provide merit goods which, while reflecting private preferences, are too important to be left to market forces).

A researcher cannot say if a festival is good or bad, but it should be possible to provide some arbitrary measure of economic success, recognizing, of course, that this may be misleading if economic cost-effectiveness is not part of the role of the festivals.

Based on the survey conducted in 1976, a quasi balance sheet for the festivals can be constructed. The direct cost to residents of the Lothian Region of staging the four festivals was £206,000, the amount allocated in the form of grants. These grants or, more correctly, the festivals they gave rise to attracted into the city of Edinburgh £3.7 million of visitor expenditure and grant aid from national bodies. This total was made up of £600,000 in ticket sales to visitors, £2.9 million spent in shops by various types of visitors, and £237,000 in grant aid from national bodies.

The £3.7 million total, which formed the multiplicand in the analysis, resulted in £960,000 of local city income.

But how do we judge such bald figures? Bearing in mind that income, as identified by multiplier analysis, may not necessarily have been distributed equally throughout the local community, the £206,000 of grant aid derived from the rates has produced slightly less than £1 million, which is a good rate of return. Alternatively, the £206,000 has resulted in 19 percent of both the expenditure and local income generated by all holiday visitors to Edinburgh during 1976 (Vaughan 1977b), and there is no telling how many others were attracted to the "Festival City" because of the reputation and image established by the festivals.

A GUIDE FOR FUTURE MANAGERIAL DECISIONS

The development of tourism based on the festivals essentially depends on managerial decisions. In making these decisions it is essential that visitors are seen not as a single group but as contrasting groups providing different levels of benefit and resulting in different costs. Visitors staying in serviced accommodations, for example, spend more on average than those staying in unserviced accommodations, but the demand for caravans and campsites may greatly outnumber that for hotels and guest houses. Thus, it is important to take into account both numbers and types of visitors in order to assess the different markets and then to try to influence their distribution through the stock of accommodations, the location of facilities, resource management, publicity, and licensing controls.

Multiplier analysis does give simplistic guidance on the way the visitor market should be developed. In Table 6 the results of two alternative strategies for development are presented. The first attempts to maximize local income produced from a set amount of grant aid. The second is aimed at maximizing the local income produced while keeping visitor numbers to a minimum. As the figures in Table 6 indicate, the two strategies involve different target markets and different results in terms of income and visitor numbers. Three factors are at work—visitor numbers, visitor expenditure, and local value added—and for this reason the results should be interpreted with care.

Implementation of policies based on this analysis should be undertaken with even greater care, because the number of visitors is largely outside the direct control of the planner. Numbers can be influenced by controlling the stock of accommodations or by manipulating the festivals (if potential visitors favor one festival), but this need not necessarily bring about a transfer of resources controlled by private hands or of visitors. Thus, the analysis cannot answer the question of what kind of development, but it can be used to assess the implications of intended policies and to identify the most profitable.

The 1976 study results, for example, suggest that:

1. Visitors who also attend the festivals tend to spend more than ordinary holiday visitors, even excluding festival expenditure—£7.32 compared with £6.86.

Table 6. *Two Strategies for Development*

| Type of Accommodation | Capacity | Maximum Number of People per Night | Average Daily Expenditure (£) | Local Income Multiplier Value | Daily Impact at 100% Occupany (£) |
|---|---|---|---|---|---|
| *Maximizing Income from a Set Amount of Grant Aid (£200,000)* | | | | | |
| Hotel | 25 double rooms | 50 | 15.60 | 0.30 | 234 |
| Guest house | 25 guest houses 8 people per establishment | 200 | 10.14 | 0.32 | 649 |
| Caravan site | 5 caravan sites 50 caravan stands 4 people per caravan | 1,000 | 1.81 | 0.24 | 283 |
| *Keeping Visitors to a Minimum (1,000)* | | | | | |
| Hotel | 20 hotels 50 people per hotel | 1,000 | 15.60 | 0.30 | 4,680 |
| Guest house | 125 guest houses 8 people per establishment | 1,000 | 10.14 | 0.32 | 3,245 |
| Caravan site | 5 caravan sites 200 people per site | 1,000 | 1.81 | 0.24 | 434 |

2. When classified by type of accommodation used, hotel residents make the biggest impact in relation to their numbers—18 percent of bed-nights accounting for 39 percent of expenditure and 41 percent of local income.
3. When classified by place of residence, visitors from North America make the biggest impact in relation to their numbers—17 percent of bed-nights accounting for 28 percent of expenditure and of income.

An interesting feature of the 1976 study results was that the pattern of bed-nights for festival visitors was different from the pattern for holiday visitors, with a substantial increase in the number of festival nights accounted for by bed and breakfast in private houses—from 11 percent of the total to 29 percent. Investigation of the reasons for and implications of this increase would be well worth further research.

MAGNET ATTRACTIONS

As is evidenced by the research study and the contents of this paper, the festivals are magnet attractions which, although perhaps in need of some financial support, generate larger economic benefits. The festivals act as a magnet not only directly but indirectly as image-building events which receive substantial coverage in the national and international media throughout the year.

However, merely having a magnet attraction is not sufficient if the objective is to use it for greater benefit and here the use of a technique such as multiplier analysis may hide the wood among the trees. Two of the most important findings which are often forgotten are that actual expenditure is as important for policy formulation as is income generated and, related to this, direct income generated makes up approximately 70 percent of all income generated.

Therefore, the more opportunities people have to spend their money the better. Policies aimed at providing these opportunities (for example, policies related to store and restaurant hours of business) may be far more cost-effective than policies designed to manipulate the actual market. Also, the festival attracts people but it does not occupy the whole of their time. Perhaps consideration should be given to the development of subsidiary events elsewhere within the Lothian Region in order to spread the benefits.

CONCLUSION

What, then, are the lessons, if any, which can be learned from this analysis in a situation where the festival does not receive an automatic endorsement and has to earn the support of the local population, if not the local authority?

The central lesson which emerges is that, quite apart from any intrinsic value of the festivals in terms of artistic merit, they are tangible, major economic assets which produce a measurable financial return. The limited grant aid to the festivals is a sensible investment producing measurable returns, largely—although not wholly—based on expenditure outside the festivals in shops, hotels, and restaurants. The results of the 1976 study are now history; they are useful as a basis for moving the debate over the festivals away from the defensive, problem-solving, sterile arguments of the past toward a more positive assessment of the opportunities the festivals offer to improve both the economic and social well-being of residents of the region. A large part of this task must consist of promoting understanding: how do the authorities establish "an acceptable face of the festivals"? As has been pointed out for tourism in general, "local receptiveness . . . has rarely been considered by those planning and developing . . . and yet it is of crucial importance" (Brougham and Butler 1977).

A festival is a conglomerate industry, but an uncoordinated conglomerate. It is a weird mix of bureaucracy and individualism, of Art Council, of local councils answerable to taxpayers, of big hotel groups, of transportation operators, of retailers, and of local individuals. It is also a conglomerate product, a package of entertainment, accommodation, access, and advertising. Its constituent parts are

managed by both the public and private sectors, and achieving concensus so that the whole is greater than the parts is the major task for the future. The issue which surmounts all others is how to shape the future pattern of the festivals and to weld together the interests of all those concerned. It is important to make positive use of the festivals not as individual activities, but as a group of often contrasting activities, each with a market and with social, economic, and environmental benefits and costs to the local community.

If a local authority is to take selective action to stimulate or guide certain aspects of festival activity, it must have a clear understanding of the present situation and, in particular, the economics and the conditions of demand and supply. Without removing the festivals altogether, the local authority can simply encourage, discourage, or guide nonlocal visitors. The degree of influence that public authorities can exercise over the scale and pattern of visitation is limited. The direct action of the local authority will be far outweighed by market forces related to the economy. Thus, there is a need for understanding and realism in both development aspirations and management measures.

The festivals provide the cream on top of what has been an otherwise buoyant tourism market and an added support for facilities which are primarily for local use. The extra revenue derived from the festivals is making businesses and facilities more profitable and more economical; without the festivals they would be smaller in scale. When the first of the festivals, the International Festival, was inaugurated, the following statement was made:

> If the festival succeeds Edinburgh will score an artistic triumph and will have a major industry, a new and exciting source of income. At a time when we need as never before to attract visitors and foreign capital it would be as senseless to disguise this aspect of the festival as it is childish to attack it.[3]

Given current economic trends, the festival may reassert its position of prominance, which probably was never lost but became obscured by the general success of Edinburgh in the holiday visitor market.

Notes

1. The coefficients for the Fringe Festival are a weighted average based on a division of Fringe into groups located in Edinburgh (24), groups located in the rest of Scotland (21), and groups located elsewhere (112).
2. Other recurrent expenditure was estimated from interviews. Day visitors were included in the main visitor survey. Visiting performer expenditure estimates were based on less detailed interviews with members of Fringe groups (39), people attending the Film Festival Conferences (20), and managers of visiting companies to the International Festival (4).
3. H. Wood (1947), quoted in Bruce (1975).

References

Brougham, J. E. and Butler, R. W. 1977. The Social and Cultural Impact of Tourism: A Case Study of Sleat, Isle of Skye. Edinburgh: Scottish Tourist Board.

Bruce, G. 1975. *Festival in the North: The Story of the Edinburgh Festival.* London: Robert Hale and Co.

Calder, J. 1977. *Sunday Mail.* September 18.

Department of Trade and Industry. 1976. International Passenger Survey 1976.

HMSO. 1976. Family Expenditure Survey 1976. London.

Tourism and Recreation Research Unit. 1975a. STARS Series No. 1: Survey Description. Edinburgh: Univ. of Edinburgh.

———. 1975b. The Economic Impact of Tourism: A Case Study of Greater Tayside. Edinburgh: Univ. of Edinburgh.

Scottish Tourist Board. 1977. British Home Tourism Survey, 1976.

Vaughan, D. R. 1977a. The Economic Impact of the Edinburgh Festival, 1976. Edinburgh: Scottish Tourist Board.

———. 1977b. The Economic Impact of Tourism in Edinburgh and the Lothian Region, 1976. Edinburgh: Scottish Tourist Board.

Comment
Virginia Lee Owen

This study of the Edinburgh Festival is a straightforward application of regional multiplier analysis. It is based on previous Edinburgh-area studies and a survey of visitors to the 1976 Edinburgh Festival. Vaughan concludes that the rate of return to local residents on their initial festival subsidy is about 500 percent. Furthermore, approximately one-fifth of all expenditure and local income generated by visitors to Edinburgh comes from this festival. This payoff includes external public grants attracted by the festival, which represent a gain to the local residents but not to society as a whole, since such subsidies are funded through general revenues.

An arts festival is a special case in studies of the economic impact of the arts. Its duration is limited and it is usually aimed specifically at attracting visitors from beyond the local region.[1] The more "successful" the festival, the more likely that visitors will come from great distances, thereby necessitating ancillary expenditures for food and rooms as well as increasing the likelihood of souvenir purchases. This avoids one of the problems of impact studies in which ancillary expenditures by suburban visitors to urban arts institutions cannot be directly attributed to arts attendance.[2] This "lumping" of visitors in a short time span may create other problems, however, which need to be addressed if an overall assessment of festival success is to be made.

Could it be that a festival alters the timing of visits to the festival city rather than the number of visitors? Some of the Vaughan data would seem to deny this: the free advertising of Edinburgh through festival reviews, the image of Edinburgh as a cultural center projected through the festival, the festival's con-

tribution to the ambience of the city even in nonfestival periods. All of these factors would tend to increase the number of visitors to Edinburgh in general and at festival time specifically. On the other hand, it is possible and even likely that some potential tourists postpone their visits until festival time. By focusing on the festival period only, this study can never assess the possibility of such timing patterns.

The influx of a large number of visitors in a short time period will tax facilities. This creates negative externalities in the form of traffic congestion, crowded sidewalks, noise, and litter. Most of these externalities necessitate either additional local public expenditure for additional police, garbage, and other services or private absorption of these costs. No wonder the local residents complain about the social, cultural, and environmental problems of the festival. No attempt to correct for these externalities was made in the Vaughan study.

The "feast or famine" nature of tourism in a festival city will also create pressure to build facilities for this maximum influx, with resources underutilized much of the rest of the year. Such building will expand the local economy during construction and such expansion could be attributed to the festival. This effect is excluded from Vaughan's analysis by his choice of the recurrent expenditure form of the multiplicand. Notwithstanding this positive effect, one could question the efficiency of this use of resources. If tourism could be maintained in volume but spread over a longer period by redirecting festival subsidies to other arts programs, less capital investment would be required for arts facilities and private ancillary service facilities. The ability to sustain a cultural atmosphere sufficient to maintain a stable tourist trade may not be possible for all cities. New York and London needn't host a festival to attract tourists. They have a variety of cultural events. Smaller cities may need to host a festival in order to mount a sufficient array of simultaneous cultural events to attract those same tourists.

Does a festival pay? Vaughan says yes for Edinburgh. The 500 percent return on festival subsidies suggests that he is correct even if his figures are adjusted for timing of tourism, negative externalities, and underutilized resources. But a festival may not pay for all cities. Very large centers and very small cities might not profit from them. Research into appropriate city size for successful festivals should prove fruitful.

Notes

1. A prime example is the concluding quotation in the Vaughan paper.
2. Vaughan's figure for local resident attendance at the Edinburgh Festival is surprisingly high. A comparison with other festivals, such as those in Salzburg and Bayreuth, would be interesting.

Estimating the Demand for Broadway Theater: A Preliminary Inquiry*

Harry H. Kelejian and William J. Lawrence

THIS PAPER represents a preliminary exploration into a segment of the cultural and arts sector of the New York City economy. A more encompassing study contemplated by the authors involves an investigation into the full cultural and arts "industry" in New York. That study will embody the performing and nonperforming arts, as well as museums, galleries, and tourist attractions. The objective is to view economic activity within the industry as it is affected by and as it affects the health and vitality of New York City. The analytical process to test this interdependency is now feasible, thanks to the development of the New York Regional Econometric Model. A forecasting as well as structural investigation of the industry is planned.

In the present paper we concentrate only on the Broadway theater because of both our desire to test the feasibility of the full study and the encouraging assistance we received in obtaining advice and data concerning the Broadway theater from several individuals familiar with that theater district in New York.

GENERAL STATEMENT OF THE PROBLEM

Whatever their value to us in nonmonetary terms, arts and cultural activities make up only a minute fraction of America's (or any other country's) gross national product. However, when we take a regional rather than a national approach to economic output, this is no longer the case. There are many regions, all metropolitan areas to be sure, where arts and cultural activities make a significant economic contribution to the local product. Los Angeles, with its film and

*We are grateful for the assistance of L. Bertorelli, G. Rossi, and M. Prensky during various stages of preparing this paper. Financial assistance was provided by the Pace University Graduate School of Business.

recording industries, immediately comes to mind. And, of course, New York—the cultural center of America and perhaps even the world, with over 1,500 arts and cultural institutions—serves over 65 million people per year. In 1971 the Mayor's Cultural Policy Committee found that artistic and cultural activity in New York City generated over $3 billion annually; by 1976 the figure was at least $5 billion. This was 6 percent of New York City's gross annual product of $82.6 billion for 1976.

Arts and cultural activities contribute significantly to the city's economy in many ways. Direct employment generated about $136 million in salaries and 34,000 paid jobs in 1975–76.[1] Indirect employment is generated in restaurants, taxicab companies, and so forth. Tourism, often cited as New York City's second largest industry, is also stimulated. Although much of the artistic and cultural sector is tax-exempt, the industry contributes approximately $10 million annually in tax receipts to the city. It attracts and retains businesses and serves as an important factor in strengthening and stabilizing real estate development. Finally, arts and cultural activities make up a significant percentage of New York City's export base with plays and art exhibits, for example, traveling around the country and the world.

Of course, most artistic and cultural activity is not self-supporting, and New York City contributes over $50 million a year to the arts, with other governmental sources contributing close to an equal amount. Analyzing these expenditures in purely economic terms is complicated because of the profound and complex relationships between artistic and cultural activities and New York City's economy. Exploring the nature and direction of these relationships is one goal of the project which we describe in this paper.

To help uncover these relationships, we shall integrate the arts and cultural sectors into the New York Regional Model discussed below. Our method is first to compile a data base of characteristics such as employment, wages, production costs, revenues, and growth factors for the arts and cultural industries. Then the arts data and model can be linked with the regional model, so that effects of changes in such factors as employment, output, population, retail sales, public expenditures, and tax policies on the arts and cultural sector can be simulated under any number of economic assumptions and scenarios.

It must be noted that there are some fairly serious problems in modeling the arts and cultural sector of the city's economy. The first of these problems is data collection. There are over 1,500 arts and cultural institutions in New York City, representing an enormous variety in terms of size, complexity, accounting procedures (or lack thereof), fiscal year, and so forth. Previous studies indicate that the data are not very well organized. A second problem is the division of the arts and cultural institutions into profit and not-for-profit categories. The two differ considerably with respect to both goals and operating procedures. For example, the Broadway theater is a for-profit, tax-paying enterprise, while the off-off-Broadway theater is largely nonprofit and experimental, similar to the Edinburgh Fringe. A way must be found to integrate the two categories. A third problem is that because theater revenues depend greatly on the quality and longevity of

shows produced in a particular season, revenues fluctuate greatly from one season to another.

This "quality" aspect of performance is extremely important and should be included in a unified analysis of theater revenues.[2] Such an analysis would also include national and local economic factors, such as growth, employment, personal income, retail sales, and so forth. Among other things, an integrated analysis should be of value in estimating tax receipts which are directly and indirectly related to the arts and cultural sector of the city. Such an analysis might also indicate whether or not certain subsectors of the arts and cultural sector can be viewed as predictors of changes in the city's or region's economy. As an illustration, perhaps changes in theater revenues signal similar changes in the city's economy. This type of integrated analysis should be greatly facilitated by the existence of the New York Regional Econometric Model.

As discussed above, in order to come to grips with these problems and to test our methodology on a smaller scale, it is our intention to begin with a case study of one particular unit of the arts and cultural sector: the Broadway theater. This important component of New York City's arts and cultural industry generated gross revenues from ticket sales of $125 million in the 1978–79 season, 95 percent of which was represented by theater owners and producers in the city of New York. In addition, it is estimated that theatergoers spent at least an equal amount during the season on transportation, hotels, dining, parking, taxis, and so forth. Direct tax payments to New York City from the theater alone were at least $12.5 million during this period. Moreover, shows which left New York to go "on the road" generated direct revenues of over $140 million. The combined Broadway and road total gross of $265 million represents approximately 5 percent of New York's total arts and cultural sector revenues.

THE NEW YORK REGIONAL ECONOMETRIC MODEL

Critical to the implementation of a cultural and arts industry model for New York City is the New York Regional Econometric Model (NYREM). NYREM is a fairly detailed planning model of the entire New York metropolitan SMSA. New York City is separately broken out, as are the surrounding suburban areas. NYREM provides biannual forecasts on twenty-two two-digit industries within the region. Annual employment and output are projected for a ten-year period. Personal income and retail sales are also provided for the city and each of the four subregions of NYREM. Income can be generated by place of work or by place of residence, enabling an analysis of the more than 600,000 workers who commute to New York City each day. Employment can be estimated by age, race, and sex for each industry. NYREM has a fairly extensive public sector satellite model that at present exists only for the city of New York. NYREM is linked to the national economy through the Wharton Econometric Forecasting Associates Annual and Industry Model.

A MODEL OF THE BROADWAY
THEATER INDUSTRY

In this section we outline a model of the general interrelationships characterizing the Broadway theater industry. Although preliminary and as yet untested, the model is described here to suggest that it may be feasible and useful as a policy instrument from both the city's and the theater industry's point of view. Also, such a model may be a stepping stone to a more general model of the arts and cultural sector of the city's economy.

As one might expect, our model of the Broadway theater industry involves characteristics of both the New York City environment and the tourists who visit the city. Our analysis also includes a discussion of related crime and tax problems and their effects on the size of the New York City population. This is important because the size of the population is one of the major determinants of the demand for theater tickets, and the health of the theater industry, in turn, is one of the major determinants of the general health and vitality of the city.

We begin our discussion by outlining each of the equations of the model; at this stage in the analysis our specifications are meant to be suggestive rather than exact. After specifying the equations, we will illustrate the interrelationships involved.

The Demand for Tickets Equation

Let Q_t be the demand for New York City Broadway theater tickets at time t. Then we will explain Q_t in terms of the number of potential customers; their incomes; prices; the crime rate; and a vector of variables meant to capture the effects of tastes, performance quality, and relevant institutional changes which may take place over time. More specifically, our broadly specified demand function is:

$$(1) \quad Q_t = F_1(\overset{(+)}{POPNYC_t}, \overset{(+)}{YNYC_t/PINYC_t}, \overset{(+)}{TOUR_t}, \overset{(+)}{YTOUR_t/PI_t}$$

$$\overset{(-)}{P_t/PINYC_t}, \overset{(-)}{CRIME_t}, X_{1t})$$

where　　　$POPNYC_t$　is the relevant population of the New York City area at time t;

$YNYC_t$　is the per-capita money income corresponding to $POPNYC_t$ at time t;

$PINYC_t$　is a relevant index of consumer prices in New York City at time t;

$TOUR_t$　is the number of tourists who visit New York City at time t;

$YTOUR_t$　is the per-capita money income of tourists who visit New York City at time t;

PI_t　is a general cost-of-living index for the country as a whole at time t;

P_t is the average price of a Broadway theater ticket at time t;

$CRIME_t$ is a relevant crime rate or vector of such rates which may affect the demand for theater tickets at time t; and

X_{1t} is a vector of variables representing the effects of tastes, performance quality, and institutional changes over time.

The partial effect that each of these variables may have on the dependent variable should be evident. However, for the convenience of the reader, we have indicated the expected partial effect of each variable by a plus or minus sign immediately above that variable. The partial effect of X_{1t} is not indicated because this vector represents a number of factors. This notation is used throughout the paper.

From equation (1), we see that the number of potential customers for theater tickets is represented by the relevant population of the New York City area and by the number of tourists who visit the city. These population variables are entered separately because their propensities for theater tickets are undoubtedly different. The relevant population of the New York City area may include several subgroups, two of which are the number of people who work and live in the city, and the number of people who work in the city but live elsewhere. Results suggest that the propensity for theater tickets of these two subgroups of the relevant New York City population may be quite different. Further details concerning the demand equation in (1) are given below in terms of its empirical specification.

The Tourist Equation

We basically assume that the number of tourists who visit New York City during a certain period of time, $TOUR_t$, is related to a relevant crime rate in the city; prices in the city relative to prices elsewhere; and the potential number of such tourists, their income, and other variables. More specifically, we assume:

$$(2) \quad TOUR_t = F_2 \overset{(-)}{(CRIME_t,} \overset{(-)}{PINYC_t/PI_t,} \overset{(+)}{(POPUS_t - POPNYC_t),}$$

$$\overset{(+)}{YUS_t/PI_t,} X_{2t})$$

where, in addition to the variables previously defined,

$POPUS_t$ is the size of the relevant population of potential New York City tourists in the country as a whole at time t,

YUS_t is the per-capita money income corresponding to the $POPUS_t$ variable at time t, and

X_{2t} is a vector of variables representing the influence of other factors.

The Crime Equation

A reasonably complete specification of a crime index or crime rate equation is beyond the scope of this pilot study. In this section we will simply take note of two factors which may have an influence on crime rates in general. Again, our purpose is to be suggestive.

The first factor is a category of policy variables. These are variables which the city has control over and which, in turn, have an effect on crime rates. Some may be viewed as typical "crime-fighting" variables, such as the number of policemen and street lighting schemes. For purposes which will become evident below, we will simply represent the level at time t of all such crime-related variables over which the city has control by the symbol CON_t.

The second factor we will consider in partially explaining crime rates is the average income of residents of the city. This variable is considered as a measure of general economic opportunities in the city; as such, its effect on crime rates should be negative. Unlike the control variables above, the level of this variable is by and large determined by the private sector of the city economy, so the city government would not have *direct* control over it.[3] The city government would, however, have indirect control, since its policies generally have an effect on the city economy.

Our equation explaining the theater-relevant crime rate variable, $CRIME_t$, is thus broadly defined as:

$$(3) \quad CRIME_t = F_3(\overset{(-)}{CON_t}, \overset{(-)}{YNYC_t/PINYC_t}, X_{3t})$$

where X_{3t} is a vector of variables representing other relevant factors. We have indicated a negative partial effect corresponding to CON_t. Our purpose in doing this is only to indicate that CON_t represents a vector of variables, each of which can be viewed as having a negative effect on the crime rate variable, $CRIME_t$.

Aggregate City Income Equations

If the aggregate income of a city is viewed as the sum of the income generated in its various sectors, then the aggregate city income will in part be related to the income generated by the theater sector. This relationship will be both direct, in the sense that the theater sector is one of the sectors of the city, and indirect, in the sense that income generated by the theater sector has spillover effects on some of the other sectors of the city.

Let $YTNYC_t$ denote the money income directly generated by the theater sector in New York City at time t. For purposes of illustration, we specify the aggregate city income equation as:

$$(4) \quad AYNYC_t = YTNYC_t + X_{4t}$$

where $AYNYC_t$ is aggregate city money income, namely, $YNYC_t * POPNYC_t$, and X_{4t} is that portion of total city income which is directly generated not by the theater industry but by the other sectors.

A more complete study would be required in order to specify the income spillover effects of $YTNYC_t$ on X_{4t}. At this point, we simply note that these spillover effects should be positive, so, ceteris paribus, the aggregate city income variable, $AYNYC_t$ should be positively related to the other income variable, $YTNYC_t$.

The Theater Sector Income Equation

Let Q_t be the number of theater tickets sold at time t. We express the income directly generated in the theater sector as a function of the value of the tickets sold, namely, Q_t*P_t. Thus:

$$(5) \quad YTNYC_t = \overset{(+)}{F_4(Q_t*P_t)}$$

The basic assumption in equation (5) is that variables other than Q_t*P_t which have an effect on the income variable $YTNYC_t$ have a reasonably high correlation with Q_t*P_t, and so need not be considered separately.

The Tax Equation

The city of New York finances at least part of its expenditures via taxation. In this section we describe two factors which help determine the city's average tax burden. The first is the aggregate income level of the city, $AYNYC_t$. Ceteris paribus, the higher this variable, the lower need be the tax burden (for example, the tax rate) imposed on the residents of the city, say, TAX_t.[4] The second factor is the level of expenditures, as described by the crime control variables, CON_t. Ceteris paribus, the higher such expenditures, the higher the tax burden must be. Thus, perhaps thinking of TAX_t as an average tax rate imposed on the city's residents, our tax equation is:

$$(6) \quad TAX_t = F_5(\overset{(-)}{AYNYC_t}, \overset{(+)}{CON_t}, X_{6t})$$

where X_{6t} represents other relevant factors.

Equation (6) corresponds to an average tax burden of the city's residents. A more detailed and disaggregated examination of the city's tax burden requires a more complete analysis.

The City Population Equation

Residential location decisions are determined by a multitude of factors. Again, we abstract from this multitude of factors only those factors which have a direct bearing on the variables of the model. We therefore assume that the number of people residing in the city as of time t is determined by its previous magnitude at time $t-1$, the city's tax burden, its crime rate, and its general level of income. The income variable is considered a proxy for economic opportunities associated with the city. The equation therefore is:

$$(7) \quad \frac{POPNYC_t}{POPNYCt-1} = F_6(\overset{(-)}{TAX_t}, \overset{(-)}{CRIME_t}, \overset{(+)}{YNYC_t/PINYC_t}, X_{7t})$$

ILLUSTRATIONS OF THE
MODEL'S INTERRELATIONSHIPS

The model presented above is an interrelated model. Therefore, a formal discussion concerning its properties should focus upon the characteristics of its solution—its reduced form. This requires the model to be specified in more detail and, if the equations are nonlinear, to be empirically specified as well, so that a numerical solution can be obtained.

In this section we will attempt, instead, to gain some insight into the model and its potential in terms of a few illustrations. As one example, consider the possible effects on the variables of the model of an increase in city expenditure on items related to crime fighting, that is, an increase in CON_t. One would expect that the level of crime in some manner will be somewhat reduced. This is supported by equation (3). One would also expect that the financing of such an increased level of crime-fighting expenditures will also lead to budgetary difficulties which will probably result in a higher tax burden on the city's residents. This is suggested by equation (6). However, such an analysis would clearly be incomplete. Equations (1) and (2) suggest that a reduced level of crime would also lead to an increased sale of theater tickets and an increased number of tourists who visit the city. This would benefit not only the theater industry directly but the city in general, as measured by its general level of income. These effects are described by equations (4) and (5). However, if the income level of the city were to increase, the tax burden that the city's residents face relative to their income could decrease. This is described by equation (6). A reduced tax burden, in turn, along with a reduced crime rate and higher income level might then be expected in the long run to lead to an increase in the city's population, since the city would then be a more attractive place to be. This is described by equation (7). The continuing dynamics of the city's economy should now be evident. It should also be evident that short-sighted responses to some of the improvement policies the city might consider (such as crime prevention and financial aid to the theater industry) leave much to be desired.

As another example, suppose it is predicted that the general level of per-capita income in the nation as a whole will decrease by a certain amount. In terms of our equations, one would first be concerned with the possible reduction in the number of tourists who visit the city of New York. This possible reduction could be estimated in terms of equation (2). The resulting estimated reduction in the number of theater tickets sold could then be obtained in terms of equation (1). This reduction would affect not only the theater industry but the general well-being of the city as a whole due to the spillover effects. The effects are described in reference to equation (4).

In response to such predicted financial difficulties, the theater industry might take steps either to stimulate the demand for its product or to prepare itself (for example, by cutting back on its offerings) for the projected hard times ahead. The theater industry could stimulate demand for its product by lowering ticket prices or by not increasing ticket prices as the prices of other goods and services increase. Another way to stimulate demand would be to increase advertising. The

possible benefits of efforts of this sort could be estimated in terms of an empirical form for equation (1). Similarly, the importance of the spillover effects of a possible protracted cutback of theater industry offerings on the general economy of the city could be estimated in terms of equations relating the components of X_{4t} in equation (4) to the theater industry income variable, *YTNYC*. The results of such an analysis might suggest the appropriate levels of financial aid to the theater industry, as well as other policies.

A SUGGESTED EMPIRICAL FORM OF THE DEMAND FOR BROADWAY THEATER TICKETS

In this section we specify a reasonably complete regression model for the demand for Broadway theater tickets, that is, a possible empirical form of equation (1). Such specifications for the remaining equations of the model will have to await further analysis.

The first four variables listed in the equation below have components which were considered in equation (1). The remaining four variables were not explicitly considered in that equation; instead, they were subsummed in the catchall variable X_{1t}. These additional variables relate to the average quality (or acceptability) of the Broadway shows offered in a given year, advertising expenditures undertaken to stimulate the demand for Broadway theater tickets, the proportion of Broadway shows produced which are musicals, and a time trend variable to account for the many factors which are not explicitly considered.

More explicitly, our regression model is:

$$(8) \quad Q_t = a_0 + a_1\left(\frac{POPNYC_t + YNYC_t}{PINYC_t}\right) + a_2\left(\frac{TOUR_t * YUS_t}{CPI_t}\right)$$

$$+ a_3\left(\frac{P_t}{PINYC_1}\right) + a_4\left(CRIME_t\right)$$

$$+ a_5 \, Quality_t + a_6 \, Critic_c + a_7\left(\frac{ADVERTISE_t}{PINYC_t}\right)$$

$$+ a_8 \, Musicals_t + a_9 Trend_t + U_t$$

where $\quad Q_t \quad$ is the total number of Broadway tickets sold.

$\dfrac{POPNYC_t * YNYC_t}{PINYC_t}$ is the total disposable money income received in year t by the citizens of New York City, divided by a corresponding consumer price index for all items for the New York SMSA. This variable accounts for both the number of potential customers, and their financial position.

$$\frac{TOUR_t * YUS_t}{CPI_t}$$

is constructed by taking $TOUR_t$ as the hotel occupancy rate, YUS_t as disposable money income, and CPI_t as the consumer price index in the nation as a whole during the t-th year. If the number of hotel rooms and the number of occupants per room are relatively constant over the sample period, the variable should be proportional to the total real income of the tourists who visit the city. Under these conditions, this variable should account for both the number of tourists who visit the city and their mean income.

$$\frac{P_t}{PINYC_t}$$

is the average price of a Broadway theater ticket divided by the consumer price index corresponding to New York City during the t-th year. The average price of a Broadway theater ticket can be estimated as the ratio of total box office revenues to the number of tickets sold.

$CRIME_t$

is a morals crime rate in the immediate area surrounding the theater district. In a future study we may also consider (if the data are available) a crime rate variable related to city transportation, as well as a total city crime per-capita variable.

$Quality_t$

is the number of different shows in year t offered by Broadway theaters. The idea behind this variable is that unsuccessful shows have short runs; consequently, a year in which many different shows are offered is a year in which the average quality, or at least acceptability, of the offered shows would be low.

$Critic_t$

is a variable indicating the average evaluation given to the plays performed in a given year. The higher the value of this variable, the more positive the evaluation of the plays by the critics. The purpose of this variable, which is described below, is to capture the possible influence critics may have on the demand for theater tickets.

| | |
|---|---|
| *ADVERTISE$_t$*
PINYC$_t$ | is advertisement expenditures undertaken by Broadway theaters, divided by the consumer price index corresponding to New York City. |
| *Musicals$_t$* | is the proportion of all Broadway shows offered that are musical in year *t*. The basic assumption underlying the variable is that, ceteris paribus, musicals are more popular, hence ticket sales should be higher if more musicals are offered. |
| *Trends$_t$* | is a time trend variable. (*Trend$_1$* = 1, *Trend$_2$* = 2, etc.) The purpose of this variable is to account for the many factors with separate effects that cannot be measured because they are too numerous or because of data shortcomings. A few examples are the increased use of credit cards, improved transportation facilities, different forms of advertising, and earlier performances in order to reduce or avoid problems associated with crime. |
| *U$_t$* | is a disturbance term which is assumed to satisfy all of the standard assumptions. |

Our expectations concerning the parameter of equation (8) are:

$$(9) \quad a_1 > 0, \ a_2 > 0, \ a_3 < 0, \ a_4 < 0, \ a_5 < 0, \ a_6 > 0, \ a_7 > 0, \ a_8 > 0$$

We do not have prior expectations concerning a_7. We also remind the reader that a_5 is expected to be negative because *high* values of our quality variable, Quality$_t$, correspond to *short runs* for the offered shows, and this corresponds to *low* performance quality—in brief, *high* values of Quality$_t$ indicate *low*-quality performing.

The Estimated Power of the Critics[5]

As a side point of interest, we note that over the years the critics have evaluated each play as it was introduced. In a sense their evaluations can be viewed as forecasts of the success or failure of the various shows considered. A test of the forecasting ability of the critics, *or their ability to influence popular demand*, is therefore called for. Specifically, we suggest evaluating critiques for every Broadway play that was offered from 1960 to 1978. Each evaluation will be given a weight from 1 to 5, with 1 corresponding to a prediction of "total failure" for the play being evaluated, and 5 corresponding to an unequivocal prediction of success. The critic ratings for each play can then be averaged. For example, if half of

the critics predicted total failure for a particular play, and the other half predicted unequivocal success, the average critic rating for that play would be 3. The actual success of each play can then be measured in terms of its actual length of stay on Broadway, measured in terms of months.

Let $CRITIC_i$ be the average critic rating for the i-th play, and RUN_i the number of months the i-th play was performed on Broadway. Then, as a first approximation, the "power" or "foresight" of the critics can be tested in terms of the regression model:

$$(10) \quad RUN_i = b_0 + b_1 (CRITIC_i) + E_i$$

where E_i is an error term. If the critics have been unsuccessful in their evaluation, b_1 should equal zero. If they have been successful, b_1 should be positive. If their predictions have been perverse, b_1 should be negative. Assuming the critics have not been perverse in their evaluations, the hypothesis of interest concerning the critics would be: $H_0 : b_1 = 0$, against the alternative $H_1 : b_1 \neq 0$.

The variable $Critic_t$ described above is the weighted average of the critic ratings, $Critic_i$, for each play offered during the t-th year. The weight given to each play is the number of months during the year that the play was offered.

PRELIMINARY EMPIRICAL RESULTS

Unfortunately, because of severe time constraints, we have not been able to implement our complete model empirically. Indeed, we have not even been able to implement the regression model for the demand for Broadway theater tickets which was specified earlier. What we have been able to do is construct annual calendar-year data for the period 1960–1978 on the ticket demand variable, Q_t; on the tourist variable $(TOUR_t * YUS_t)/CPI_t$, which we now abbreviate as $TOURIST$; on personal income of the city's residents, $PYNYC$; on personal income of noncity residents who earn their income within the five boroughs, $PYSUBURB$; on a crime variable which measures the total number of crimes reported throughout the city; and on the average price of theater tickets, $P_t/PINYC_t$, which we now denote as $PRICE$. Note that the income data we were able to construct relate to *personal* income rather than to disposable income; the disposable income variable is preferable because it accounts for personal income taxes, whereas the personal income variable does not.

As noted above, the ticket price variable we are using is constructed as the ratio of total box office revenues to the number of tickets sold. As such, it relates to a general average price of all tickets sold. Therefore, it obviously does not account for differential pricing or changes in the price breakdown among and within active theaters. We plan to account for such considerations in constructing one or more ticket price variables in a more complete future study.

Although our data are less than perfect and are incomplete, we tried to get a feel for some of the relationships that may be involved by estimating a few regression models. The results of these estimations can, and perhaps should, be viewed as exercises in data description.

As stated above, the crime variable used is a gross measure of total crimes reported throughout the city. It is not clear how compatible this variable is with the dependent variable. Potential theatergoers may be more sensitive to the hazards that prevail only within the theater district. Total crimes reported may not be indicative of the crime-related deterrent perceived by theatergoers. Armed robbery, arrests, publicized crimes, or nighttime crimes may prove to be more informative. The crime variable in the regressions reported in Table 1 shows a persistently perverse (positive) relationship to the dependent variable. Its equally persistent (apparent) statistical significance suggests that the variables omitted from the regression analysis (because of data constraints at this time) may be imparting a substantial bias to the estimates reported in the table. Clearly, a more complete study is required in order to understand fully the interrelationships involved.

The tourist variable appears to be positively and strongly related to the dependent variable. This is as it should be: as both tourism (measured by the occupancy rate in New York City hotels) and the real per-capita income of tourists increase, there should be a positive and significant impact on the number of tickets sold. The city's personal income variable, *PYNYC,* also appears to be positively and strongly related to the ticket demand variable. This is also as one would expect. On the other hand, Table 1 shows that the income variable relating to the city's suburban residents has a negative relationship to the ticket demand variable, Q_t. This result is consistent with results obtained by Moore (1968). Moore found that the income elasticity of theatergoers was "surprisingly" inelastic. Moore did not

Table 1. *The Demand for Broadway Theater Tickets*
Dependent Variable: Total Tickets Sold for Performances at Broadway Theaters

| | (1) | (2) | (3) | (4) |
|---|---|---|---|---|
| CONSTANT | 9.93 | 13.09 | 4.71 | 27.27 |
| | (4.09) | (3.00) | (1.09) | (4.60) |
| TOURIST | 2.38 | 3.38 | 2.41 | 6.24 |
| | (4.45) | (3.74) | (2.04) | (4.93) |
| PYNYC | 8.64 | 5.68 | 11.94 | −9.62 |
| | (6.23) | (1.56) | (2.99) | (4.32) |
| PYSUBURB | −4.99 | 4.23 | −5.65 | — |
| | (11.96) | (4.40) | (4.93) | |
| PRICE | −2.91 | −4.28 | .602 | −8.95 |
| | (1.18) | (1.45) | (.182) | (1.61) |
| CRIME | .315 | .435 | — | .827 |
| | (3.65) | (2.68) | | (3.20) |
| TREND | — | −.167 | .262 | −.918 |
| | | (.87) | (1.77) | (5.41) |
| R^2 | .98 | .98 | .96 | .92 |
| DW | 1.96 | 1.93 | 2.35 | 2.52 |
| N | 12.00 | 12.00 | 12.00 | 12.00 |

differentiate empirically between markets in terms of their place of residence; however, he was very careful to point out that the low elasticity "may lie in the fact that theatergoing in New York requires considerable time—about two and a half hours inside the theater and for the average commuter to Manhattan about 140 minutes round trip" (Moore 1968, p. 175). Moore acknowledged the fact that theatergoing is most likely a luxury good and that high-income people probably place a higher premium on their time than do low-income people.[6] We observe a substantial positive association between theater ticket demand and the income of the city's residents, and a strong negative association between ticket demand and the income of the city's suburbs. This seems more reasonable than an overall weak association between ticket demand and the income of people who live in or near the city. Nonresidents who earn their income in New York City but live outside of the five boroughs most likely have an attachment to the city but use their higher incomes to take advantage of alternate sources of entertainment in the local suburbs where they reside. A major policy investigation should be launched to attract this economically profitable and responsive market back to the urban center.

Notes

1. Cultural Assistance Center (1978). Total employment was 56,070, comprising 22,000 volunteers.
2. There are ways of evaluating length of run, advertising effort, published critiques, and so forth which may lead to a measure of quality as perceived by theatergoers. We are exploring several such procedures.
3. The city government would have direct control over that portion of city income for which it is directly responsible.
4. Alternatively, we can think of the average tax burden of the city's residents as the ratio of total tax collections to total city income. Then, clearly, the higher the income variable, the lower the tax burden, if tax collections are constant.
5. We are grateful to George Wachtel of The New York League of Theater Owners and Producers for his work on this concept.
6. Moore (1968, p. 175). Steve Globerman concludes that for the theater, income and substitution effects related to the opportunity cost of time and theater attendance are "somewhat ambiguous to derive" (1978).

References

Baumol, William J. and Bowen, William G. 1966. *Performing Arts—The Economic Dilemma.* Cambridge, Mass. and New York: M.I.T. Press and Twentieth Century Fund.

Cultural Assistance Center. 1978. The Financial Condition of New York City Arts Organizations. Study No. A033–C. New York.

The Ford Foundation. 1974. *Finances of the Performing Arts.* New York.

Globerman, Steven. 1978. Price Awareness in the Performing Arts. *Journal of Cultural Economics* 2, no. 2 (Dec.): 27–42.

New York League of Theater Owners and Producers. 1978. *The Impact of the Broadway Theater on the Economy of New York City.* New York.

Moore, Thomas G. 1968. *The Economics of the American Theater.* Durham, N.C.: Duke Univ. Press.

Comment
James L. Shanahan

The research undertaken by Kelejian and Lawrence marks the first full-blown probe into the local arts industry of an urban area. The authors recognize the importance of examining the full range of artistic activities and services available within the city—from museums and galleries to Broadway theater—and that the arts sector influences and is influenced by other sectors within the city economy.

The focal point of their preliminary empirical results for Broadway theater only is the belief that at least part of the local arts provision, as a consumer-oriented industry, contributes net economic gain to the New York City economy. Early in their paper the authors follow the tradition of economic impact discussions concerning the arts as described in the introduction to this section on the arts and urban development. Any causative conclusions and policy recommendations drawn by the authors in future expansion of this work that is grounded in export base logic are subject to the criticisms mentioned in the introduction.

Because of the preliminary nature of the work reported here, my comments will focus on the implied limitations of such economic modeling, rather than specific criticisms of their modeling and testing. As best this reader can tell, the model is intended to provide a measure of the export potential of the arts sector. As with all discussions of economic impacts of the arts, no assessment is made of the import-substitution potential that can result from growth in the local arts industry.

The magnitude of the income effect that can result from the sale of local arts products to consumers living in distant places is dependent on the portion of the industry's sales dollars that remains within the local economy to be respent. To the extent that purchases of fixed capital and raw materials and such are from firms outside the local area, and to the extent that income payments (wages, rent, interest, and in some cases profit) accrue to nonresidents, the potential for local income and employment multiplier effects is diminished. The urban economy typically is fairly open. A firm in retail trade produces a vastly larger sales volume than any arts organization, but only a small part of those final sales dollars flow as income to local residents, mostly in the form of wages. The proportion of the arts income dollar that remains within the local economy will vary significantly among arts activities and with size of city as the following examples indicate:

Cities with major art museums. The largest portion of current budgets for major museums will go for new collections; this means spending the money on art objects, most of which will be imported from other places. Also, major museums provide few jobs for local residents, relative to their budget, and generally provide income for nonresidents as a result of their spending patterns.

Supplying quality performing arts. In all but the largest of cities live theater may be provided by touring companies. It may well be the case that on the average only very large urban areas like New York can retain a large portion of their arts industry income dollars.

Jobs for local workers. Much of the arts industry may be labor-intensive. Unless those jobs are held by local residents, and unless purchases are made from local firms, which in turn employ local residents, the potential for increased jobs locally as a result of increased demand for local arts activities may be more illusionary than true. Both of the preceding examples cast doubt on the potential of significant local employment.

Empirically, little is known about how the arts compare to other service industries as far as contributing to import substitution. Studies of the economic impact of the arts almost totally ignore the import needs of the local arts industry. This is a major failing of the empirical work because new growth for the local economy can result from either increased exports or reduced imports.

The work by Kelejian and Lawrence holds considerable promise for investigating many of the industry linkages in a major city where much of the arts sector undoubtedly is a part of the faster growing service sector.

The Role of the Arts in Developing Countries: Thailand, A Case Study

Mary Connelly Mabry
and
Bevars D. Mabry

B Y ITS NATURE, economic development is a process of change by which be-havior patterns and activities are altered to permit and assist an expansion of resources, output, and wealth. A society is prone to development if its culture accommodates change at a pace sufficient to sustain the augmentation of resources.[1] To the extent that a people identify with the traditional culture, its values, institutions, and morality, they may be unable to appreciate and reluctant to adopt the rationale of new forms of social organizations required by the new technology. This resistance affects the rapidity with which a society is capable of adapting to the demands of a new technology, and this capacity to adapt may be as important to economic development as the acquisitions of capital and the supporting infrastructure.[2] Unless strongly held traditional values can be preserved, so that cultural identity is not lost, a society may not become "modernized." Cultural identity can be preserved if symbolisms are developed that link the new with the past. It is here that the arts function as an agent in economic development.

Development literature has recognized cultural barriers, but it has not incorporated these barriers into a formal model, nor has it dealt uniquely with the role of the arts as an element influencing the size of the barriers. Conceptually, the contribution of the arts could be measured if their influence on the barriers could be specified. To the extent that resources are devoted to the arts and the arts impede or enhance cultural receptivity to development, then economic growth along a time path will be accelerated or retarded. Given the cost of "investment" in the arts, an internal rate of return can be calculated from the differential rate of growth over the time path.

The maturity of the arts can influence development in a number of ways. Negatively, consumption to satisfy aesthetic values can divert resources from more productive uses and thereby lessen the growth rate. Wealth can be accumulated in art forms rather than in capital goods and perpetuate a climate hostile to

growth and change. Yet the arts can also enhance productivity. The demand for art as a form for giving homage, showing respect, and paying tribute may stimulate productivity. If, for example, art encourages and promotes creativity, it may facilitate the acquisition and development of technology, a search for the solution of problems, and it may lead to the development of entrepreneurship. If an appreciation for creativity is encouraged, if the exploration of new ideas and themes is permitted, the arts may provide a climate for change. Indeed, art, expressed in product and architectural designs, may stimulate the demand for goods by translating traditional tastes into modern ones and hence making the latter more acceptable.

THE ROLE OF ART IN THE
DEVELOPMENT OF THAILAND

Traditional art in Thailand, as in much of Asia, is basically hieratic, mixing religious and mythological themes. Artists were anonymous in the oriental and medieval tradition, and their efforts were literally dedicated to superior workmanship, not to their own creative, original expression.[3]

Thailand's ethnic identity began with the Sukhothai Kingdom (thirteenth to fourteenth centuries) and remained relatively static throughout the succeeding Ayuddhya and Bangkok Kingdoms. Belief systems, religious dogmas, and technology were essentially fixed, and not until the nineteenth century, when slavery and corvée were abolished, did Thai social structure undergo change. Indeed, even though changes accelerated after World War II, 80 percent of the population are still peasant rice farmers utilizing traditional farming techniques and 90 percent are Theravada Buddhists, whose adherence to their faith is well documented. Therefore, there were few inducements to evolve new art forms. Emphasis was placed upon exact, imitative reproductions of received forms, not creativity, originality, or individual expression.

Attributable in part to this underdeveloped sense of artistic pride, demand for artists and their products was weak (Feroci 1954, p. 284). This lack of appreciation for the aesthetic quality in art extended not only to new forms of expression but also to existing art objects. Buddhist dogma holds that in the "making of merit," one's store of merit, and hence one's status in future reincarnations, is determined by the net value of all one's good and bad deeds. Good deeds, or moral behavior, involve among other things creating new tributes to the Buddha, such as the construction of a new temple or the addition of a new image. Much more merit is earned through additions than through the preservation of existing objects. Together with the fact that religious objects were considered essentially utilitarian in nature, this perception contributed to a lack of concern with preserving art objects.[4] Also, the costs of preservation were high because of the impermanence of the materials used in a tropical climate. Wood rots; stone crumbles; frescoes fade from heat, sunlight, and mildew. Hence, making new objects was not much more costly than preserving old ones, and with the added merit

they conveyed, more marginal utility per outlay resulted from allocations of resources to the new. The consequence of this lack of preservation has been a depleted store of ancient art treasures.

Production, then, of religious artifacts became primarily a function of their rate of real depreciation. In the Bangkok period, beginning in the first half of the eighteenth century, tile began to replace wood as roofing material, and the longevity of temples and their contents was extended. The corveé obligation also acted as a disincentive to the highly skilled craftsman. Such workmanship was likely to be "rewarded" by compulsory service in a noble's court. The artisan found himself uprooted and separated from home, family, and friends (Ingram 1971, pp. 58–63). The quality of life and the real income of the farmer were greater than those of the artisan. Hence, artisanship became a low-status occupation among ethnic Thais, and the quality of workmanship reflected this status. Indeed, kings and nobility seeking craftsmanship in the nineteenth century were compelled to import alien Chinese, who supplied the level of desired skills and who eventually, with their superior skills, replaced Thai artisans (Skinner 1957, pp. 8–117).

THE RENAISSANCE OF CLASSICAL ART

The European imperialist push into Indochina in the last century profoundly affected the course of development of Thailand and its perception of art. Thailand emerged in the middle of the nineteenth century as a neutral buffer state between the British in the east and the French in the west. In part, it achieved détente with Britain in the Bowring Treaty of 1852 because it was able to display a stable culture that appeared to be civilized, perhaps not in the modern sense but in an exotic, aesthetic sense. However, the succeeding kings of Thailand realized that to maintain independence the country would have to display to the outside world a capacity for modernization. In addition, the kings recognized that the kingdom would have to be strengthened internally by developing among the people a clearer sense of national identity, by abolishing the divisive institutions of corvée and slavery, by assimilating the aliens, and by weakening the power of vassal lords. Nation building involved strengthening the identification of the populace with their common roots in the Buddhist church, their cultural heritage, and the inextricable role of the crown in the continuity of both of these traditions. The traditional art of Thailand symbolized the common heritage of the people and thus emerged as a recognized instrument in the development of a Thai identity.

As the society focused upon these distinctive elements of Thai culture, intrinsically the elements became more highly valued. Indeed, tradition has tended to be strengthened as a unifying force among the Thai in direct proportion to any increased external threat to national autonomy. Yet the need to modernize the economy in order to acquire the resources sufficient to defend Thai autonomy

from such external threats generates pressures for change within the society. External threats, then, give rise to pressures both for and against change within Thai society.

The renaissance of traditional Thai art in the twentieth century has in part emanated from foreign threats and occupation. The post-world-war period witnessed a major expansion in the collection, preservation, and reemergence of her classical art. Museums were established throughout the country to collect, preserve, and promote interest in Thai arts and crafts. Silpakorn University of Fine Arts was established to preserve and foster classical architecture, sculpture, music, drama, and the dance, and to develop Thai archaeology. Performances by university artists are frequently given in the ornate National Auditorium, an architectural gem in the Thai tradition that adjoins the university. Hence, both the supply of artists and the demand for art have been concurrently promoted. The ruins of ancient capitals and cultural centers have been archaeologically explored and restored. Universal, compulsory education has been introduced, and Thai children imbued with a sense of national identity through instruction in Thai history, religion, and art. Thus, the Thai art market has expanded.

Thailand has sought to develop her economy from both internal and external sources of capital. Foreign capital has flowed into Thailand in huge amounts because of the stability of Thai culture and commitment to private enterprise. This stability has aided the process of modernization. Modernization, by exposing Thailand to the rest of the world, has stimulated interest in the most visible form of her culture, that is, her art. Along with this influx of capital has come an army of foreign technocrats, and Bangkok has become a major stop on international air routes. During the Vietnam War thousands of American soldiers and their families were stationed in Thailand, and thousands of soldiers on leave visited Bangkok annually. Tourism in Thailand has become a major industry and a major earner of foreign exchange. Between 1961 and 1975 the annual number of visitors to Thailand increased more than tenfold to almost 1,200,000, and annual tourist expenditures increased over sixteenfold to 4.1 billion baht (20 baht equal U.S. $1.00).

Tourism has literally resurrected Thai crafts. Villages near Chiengmai, each specializing in different crafts—woodcarvings, lacquerware, parasols, pottery, tribal jewelry—produce for the tourist trade and are stops on sight-seeing tours. The design and making of fine jewelry, using Thai gems, has become a major industry, and tourists supplement the domestic market. Art dealers and a large, resident, international population frequent antique and artifact stores and have enlarged the market for teak and rattan furniture, celedon ceramics, and bronze cutlery. Graduates of Silpakorn University of Fine Arts are employed in numerous restaurants as performers of classical dance and music. Tourists visit the sites of the ancient cities of Sukothai, Ayuddhya, and Pimai, and in suburban Bangkok a precise, reduced-to-scale replica of Thailand's most historic structures can be viewed at the "Ancient City." Charcoal rubbings from carved stone friezes of temples provide tourists with inexpensive replicas of mural art. Silk

decorated with traditional designs is also available. Thus, Thailand markets her ancient culture well.

Modernization through the development of the road, educational, and utility infrastructure has brought ethnic Thais into greater contact with their cultural heritage. Merchandisers in the mass market use traditional symbols to make their products acceptable. Expanding incomes have increased the demand for artifacts. New structures are being designed, built, furnished, and decorated to house the burgeoning factories, the growing number of shops and stores, and multinational corporate staffs.

Institutions of higher education, including schools of fine arts, have increased their enrollments, and Thai government scholarships have financed the education of thousands of art students in advanced Western countries, particularly the United States. By the end of the Third Five Year Plan in 1976, enrollments in the performing arts had increased to 600 from 400 in 1972, and enrollments in other art programs had increased to 2,000 from 1,500 in 1972. A design development program was established in 1969 to improve the standards in product design for both the domestic and export markets (Sponaugle 1972, pp. 15–18, 28, 29). The program not only trains commercial artists in production design but also solves the design problems of local industry, incorporating the solutions into the actual products that are marketed. A large number of the designs utilize traditional Thai patterns. One type of commercial art that has received international recognition is the gigantic billboard poster. Painted by anonymous Thai artists, the posters advertise current films and utilize a compositional style not unlike those in temple mural art.

> The posters' immense scale and clarity of presentation resemble what is known in the West as Pop Art. Both American Pop Artists and Thai poster artists display violence, folk heroes, calendar girls, and other popular themes. While [Thai poster art] shares scale, impact, and directness with American pop art, its aesthetic approach is eclectic, derived partly from its own culture and borrowed in part from the West.[5]

Poster artists are trained on the job, are fine craftsmen, and usually are employed by the cinema showing the advertised film.

The dimensions of the art sector in the Thai economy can be revealed by the number of professional artists and artisans in the labor force. This information for 1970 is presented in Table 1. Professional artists comprised about 10 percent of the 280,000 professional workers in the country, and artists in traditional crafts represented about 13 percent of the 1.1 million craftsmen and production workers. Males predominated among professional artists; females comprised the larger proportion of artisans. Although 45 percent of professional artists were employed in Bangkok-Thonburi, only 19 percent of the artisans worked there. About 7 percent of the population of 3.4 million people lived in Bangkok-Thonburi, and about 30 percent of the population was engaged in nonagricultural employment.

Table 1. *Artists and Selected Artisans in Thailand, 1970*

| | Whole Kingdom | | | Bangkok-Thonburi | |
|---|---|---|---|---|---|
| Professional Artists | Total | Male | Female | Total | Percent of Kingdom |
| Architects and Engineers | 2,774 | 2,415 | 359 | 1,693 | 61.03 |
| Sculptors, Painters, Related Artists | 8,884 | 7,762 | 1,212 | 3,998 | 45.00 |
| Authors, Journalists, Writers | 1,839 | 1,524 | 315 | 1,426 | 77.54 |
| Actors, Musicians, Performing Artists | 15,559 | 10,600 | 4,959 | 5,999 | 38.56 |
| Total | 29,056 | 22,211 | 6,845 | 13,116 | 45.14 |
| Artisans | | | | | |
| Spinners, Weavers, Knitters, Dyers, etc. | 55,955 | 10,825 | 45,130 | 16,194 | 28.94 |
| Jewelers, Goldsmiths, Silversmiths | 15,146 | 11,306 | | 7,360 | 48.59 |
| Glass Formers, Potters, Clay Workers | 29,615 | 15,652 | 13,963 | 3,128 | 10.56 |
| Basketry Weavers | 43,062 | 15,857 | 27,205 | 1,112 | 2.58 |
| Total | 143,778 | 53,640 | 90,138 | 27,794 | 19.33 |

Source: National Statistical Office (1973).

CONCLUSIONS

The arts in Thailand mirror the contradictions inherent in a society which values the traditions of the past but desires the fruits which accompany growth and change. Because the Thai elite, who are the usual patrons of the arts, do not yet understand the art of the modern world, contemporary Thai artists, many of whom have received their training in Western schools, find an infertile ground for their newly developed talents. Thus, Thai artists are faced with the problem of developing a modern Thai art that preserves the aesthetic values of the past yet acknowledges the themes and demands of the modern world. This contradiction is seen in the contemporary architecture of Bangkok. Buildings in the mode of classical Thai architecture required abundant space to accommodate the massive roofline, yet such space is normally unavailable in crowded Bangkok. The design

of modern buildings tends to reflect this major constraint (Devakul and Jumsai 1973, p. 19). Yet there are a number of modern buildings of great beauty which combine features of classical architecture with modern functional needs. The National Museum, the National Auditorium, and the Siam Intercontinental Hotel are cases in point. On the other hand, the Indra Regent Hotel combines the exterior beauty of the international school of architecture with the classical aesthetic qualities of its interior decor.

Artist colonies, such as the Mekpayab Art Centre, have sprung up in urban centers, often under the patronage of a royal princess. Modern art exhibits are opened by foreign ambassadors and are attended by increasing numbers of educated Thai and members of the international community. Hence, Thailand is being exposed to modern art and architecture. An indigenous film industry produces movies with epic story lines in which violent fighting, blood, lust, and stereotypical idealism are portrayed. The blend of the modern with the themes of the past has been commercially successful—as cinemas showing Thai features are consistently sold out. As of 1976 Thailand had no symphony orchestra, and the better military bands play Western music, at best badly. But this is because Thai musicians have not been well trained in Western instruments. No conservatory of music exists, and why should it? Only the international community has much appreciation for Western music, and it is too small to support a continuing orchestra. Yet folk music, which blends Thai, Chinese, and American ballads in melodies that are not dissonant to either the oriental or Western ear, has an immensely popular following.

Thailand is modernizing, but at a pace which accommodates her own needs. Reactions against the trend occasionally erupt. Leaders who are too materialistic and insufficiently Buddhist are overthrown, often after a prelude of subtle, indirect criticism through allegorical plays and skits. Anti-American and anti-Japanese feelings sometimes emerge when the rampant commercialism of the two foreign countries encroaches upon Thai identity and moral values and threatens Thai autonomy. Western progress, Western ideas, and Western art have been acceptable only when made compatible with Thai values. It is in this area that art can mediate the modernization of Thailand by developing recognizable symbols that link the beauty of the past with the beauty of the present.

Notes

1. To modernize and to develop a culture requires an initiation, adaptation, and management of change. See Daniel Lerner, *The Passing of Traditional Society: Modernizing the Middle East* (1958), and Everett Hagen, "How Economic Growth Begins: A Theory of Social Change" (1963, pp. 20–34).

2. Charles A. Murray attempts to answer an analogous question: "Why is it so much easier to get things done in one village than in another just down the road? . . . Why do villages react so differently to the problems of modernization and what is the nature of the differences?" Among other things, he notes "the underlying quality of life as being strategically important." *A Behavioral Study of Rural Modernization: Social and Economic Change in Thai Villages* (1977, p. viii).

3. "During long periods in human history, [art] was [created] by men who did not claim to be artists creating in beauty and who had no awareness that they were at the service of the beautiful, that masterworks in beauty were produced. . . . [The Indian, Chinese, and medieval artisans] considered themselves craftsmen, and they consciously sought only to do a good work." Jacques Maritain, *Creative Intuition in Art and Poetry* (1953, pp. 175–176).

4. After all, since craftsmen were obligated to reproduce the objects exactly, one Buddha or temple was as good as another, and new ones were better because all engaged in their production could earn more merit.

5. Ahlemeyer (1972, p. 8). Edward Voeller, writing in 1975 in the *Christian Science Monitor,* noted that twenty of these giant posters were exhibited in 1974 at the Museum of Modern Art in Paris and at the Cannes Film Festival.

References

Ahlemeyer, Marilyn. 1972. Movie Billboards. *Sawaddi* (Mar.–Apr.): 8.

Devakul, M. L. and Jumsai, Sumet. 1973. Directions in Thai Architecture. *Sawaddi* (Sept.–Oct.): 19.

Feroci, C. 1954. Traditional Thai Painting. *Siam Society Fiftieth Commemorative Edition,* vol. II. Bangkok: Siam Society, pp. 280–300.

Hagen, Everett. 1963. How Economic Growth Begins: A Theory of Social Change. *Journal of Social Issues* 19: 20–34.

Ingram, James C. 1971. *Economic Change in Thailand, 1850–1970.* Palo Alto, Calif.: Stanford Univ. Press.

Lerner, Daniel. 1958. *The Passing of Traditional Society: Modernizing the Middle East.* New York: The Free Press.

Maritain, Jacques. 1953. *Creative Intuition in Art and Poetry.* New York: Pantheon Books.

Murray, Charles A. 1977. *A Behavioral Study of Rural Modernization: Social and Economic Change in Thai Villages.* New York: Praeger.

National Statistical Office. 1973. *Population and Housing Census, 1970.*

Skinner, G. W. 1957. *Chinese Society in Thailand.* Ithaca, N.Y.: Cornell Univ. Press.

Sponaugle, Judith B. 1972. The Design Development Program. *Sawaddi* (Mar.–Apr.): 15–18, 28–29.

Comment
Verna Hildebrand

As people interested in cultural economics, we have the objective of probing the linkages between economics and cultural expressions—all the "products" of art, literature, music, dance, drama, and cultural sites, both contemporary and historical. Through these individual and collective cultural expressions people of

each generation express themselves, find enjoyment, and gain a sense of the history of humanity. Economics links with cultural expressions as individuals and societies make decisions about allocating resources after assessing both the private and social costs and benefits resulting in a broad sense from various cultural expressions.

Values are concepts of the desirable, implicit in all cultural expressions and in a consumer's decision to purchase a work of art or attend a performance. Value assumptions are also involved in economic analysis. The value a society places on cultural expressions can be measured to some extent by the commitment of resources to cultural expressions by individuals and groups.

A human ecologist like myself customarily takes a holistic view, seeing the world as one large ecological system with dynamic interactions among three environments: (1) the natural environment, (2) the human-constructed environment, and (3) the human behavioral environment. The human behavioral environment includes the creators and the consumers of creative works. The human-constructed environment is exemplified in the economic, educational, religious, and political institutions which support artists and inspire their creations. The Mabry paper shows how political and economic life are tied to artistic expression. In one way or another the natural environment contributes resources for artistic works and for the support of artists and consumers of art. Also, in the case of Thailand, as reported by the Mabrys, the natural environment with its high humidity causes serious deterioration problems with certain art treasures.

The Mabrys' report on art in Thailand explains how artists' works are being incorporated into development plans, thus indicating a linkage between the political-economic institutions and creative expression. Political and creative freedom are closely related, as some Soviet artists clearly state today. In some ancient societies enjoying the arts was the privilege of royalty. Artists were conscripted to produce beautiful works which the artists and the common people were never privileged to enjoy. The Chinese often note this fact when they show visitors their historical museums and shrines. The Mabry paper mentions a similar attitude toward art in traditional Thailand.

The Western economic model and its related cognitive model widely used in education today appear to place a higher value on correct or convergent answers than on creative or divergent reasoning. This is exemplified by the fact that coaches and physics teachers are paid more than are music and art teachers, and when the funds are tight, art and music programs are cancelled or offered on a voluntary basis, thereby reducing both the prestige of the programs and the numbers of participating students. If we accept the argument posed by Mary and Bevars Mabry that artists can make an important contribution to economic development, then cutting back on creative arts programs is short-sighted, even in the narrow sense of economic development.

Art educators contend that creative expression developed in one medium is transferable to other media. Thus, new solutions to technical and social problems could be stimulated by individuals enjoying experiences in creative expression. It seems there are ample problems calling for creative solutions today. If such solu-

tions are deemed desirable, serious consideration should be given to increasing our efforts to support creative expression in all countries on the planet earth we share as a home.

In conclusion, both cultural economics and human ecology value a holistic perspective. Production and consumption of creative expressions by the people of the human behavioral environment merit the support of the institutions of the human-constructed environment.

Afterword

A Postscript to the Edinburgh Conference on Cultural Economics

≈≈≈≈≈≈≈≈≈≈≈≈≈≈≈≈≈≈≈≈≈

Mark Blaug

OR ONE WHO HAS PERHAPS been in this game—cultural economics, or, as I
prefer to call it, the economics of the arts—a little longer than most of you,
this conference has proved to be a heartening experience. Frankly, I expected thin
pickings, even though the young *Journal of Cultural Economics* has so far pro-
duced five issues, all of them filled with interesting and worthwhile contributions.
I suppose that I was reacting to my own experience when preparing an anthology
of readings in the economics of the arts a few years ago. Like most cultural econ-
omists, I was stimulated by Baumol and Bowen's book, *Performing Arts—The
Economic Dilemma* (1966), and started to do some research in the area around
1970. I soon realized that, although there was a great interest in the economics of
the visual and performing arts, few economists other than Baumol and Bowen
had done much work on the subject. There was Alan Peacock, of course, and
Lionel Robbins and Thomas Moore and Steven Globerman, but there are few
others. Indeed, I had some difficulty in justifying a book of readings in the eco-
nomics of the arts and drew attention to a whole series of questions, not to men-
tion vast areas of artistic activities, that had so far been almost entirely neglected
by economists (*The Economics of the Arts* 1976).

I would have less difficulty today in putting together an ensemble of excellent
papers in the economics of the arts, particularly if I could raid some of the papers
presented in this conference. Nevertheless, we are still waiting for a modern eco-
nomic study of the film industry, for a definitive economic study of television,
and, most surprising of all, for the first account of the economics of the pop
music industry. It is almost as if the more commercialized the artistic endeavor,
the less—not the more—inclined are economists to study the phenomenon. In
short, there is little fear of future unemployment among cultural economists.

A great deal of work is now going on in cultural economics and the next few
years should see some notable additions to the literature. I hope I may be for-

given, however, if I underline once again some of the still neglected questions. Sonia Gold notes how little is really known about the price and income elasticity of demand for artistic performances, but even if we had that knowledge, it would tell us little about what might be called the "performance elasticity of demand" for something like orchestral concerts, that is, the response of the public not to variations in seat prices or their levels of income, but to the items to be performed in a particular concert. There is reason to believe that performance elasticity greatly exceeds the price and income elasticity of demand for concerts.

Roger Vaughan describes the effort to quantify the spillover effects of the Edinburgh Festival on transportation, hotels, and restaurants in Edinburgh—this too is a generally acknowledged but little studied dimension of the demand for cultural events. James Shanahan, Harry Kelejian and William Lawrence, and David Cwi address this range of questions.

In Britain, the issue of foreign exchange costs and earnings of the arts has been endlessly debated in the press without so much as a single systematic investigation. The interfiscal complications of public support schemes for the arts and the trade-off between public and private patronage are explored by Bruce Seaman and Steven Globerman, but the curious unwillingness of private benefactors outside the United States to support the arts, despite the existence of favorable tax privileges for arts donations, so far has not attracted the attention of economists.

Perhaps most troubling of all is the way we as a profession continue to be fascinated by the question of whether it is possible to provide a rationale for public support of the arts on the standard grounds of Pareto optimality and the like. When this sort of question, which is addressed by David Austen-Smith and Hans Abbing, among others, arises with respect to education or health or social insurance, what is designed to be a rationale for public subsidies is frequently invoked illegitimately to justify public ownership of schools, hospitals, pension plans, and so forth. That confusion fortunately does not arise in the arts. Nevertheless, it is difficult to see (or, rather, it is all too easy to see) why economists insist on analyzing the arguments for public subsidies of the arts in what is, after all, the narrow framework of standard welfare economics. Surely, the school of public choice and the works of Downs and Niskanen on the economics of bureaucracy have taught us by now that there is a vast difference between a positive description of what governments actually do and a normative prescription of what they should do. I believe that we have thrashed the normative horse to death—and even here it must be said that there is more to the rationale for government action than the self-denying ordinance of Pareto and that it is time to turn to the problem of monitoring the achievements or failures of governments in pursuing certain avowed policies in the arts. I once combed through the annual financial reports of the British Arts Council in an effort to discover what they were trying to do. I assumed that they knew what they were doing and were able to write it down. I now realize that this approach took far too much for granted. I wish that I could have been an invisible presence at the meetings of the Arts Council to observe, describe, and eventually understand the nature of their deliberations.

I think that economists have something valuable to say about the art of suboptimal decision making (see David Throsby's paper), but even here I am not as

confident as I once was. We tend to think that any government department or quasi-governmental body must be maximizing a multivariable objective function subject to definite and known constraints, whereas it is much more likely that it is "satisficing" in the light of provisional targets and adjusting both the ends of policy and the means to achieve these ends as they "muddle through." This sort of "bounded rationality," as Herbert Simon calls it, is too little understood to give us grounds for complacency. Papers such as those by James Gapinski and Bruno Frey and Werner Pommerehne seem to me to be moving in the right direction of reexamining the operations of nonprofit arts enterprises.

I do think that we should approach the whole question of governments subsidizing the arts in a more humble frame of mind than hitherto, seeking to learn rather than to teach or, at any rate, first to learn so as later to teach. Of course, we can go on insisting that *they* should play the rules of *our* game because that is the only game we want to play. But if we do so, we can hardly turn around to complain about how little impact we are making in the corridors of power. If we want to influence governments, we must get our hands dirty and abandon the vain pretence that economics is plentifully furnished with general principles that can be readily applied in an armchair fashion to an area like the arts.

Toward an Ideology of
Cultural Policy Research:
Concluding Observations

David Cwi

A LL SOCIAL NEEDS can be approached from either an objective or subjective point of view. For example, poverty can be defined in terms of politically or socially established income and other standards or explored from the point of view of persons experiencing the specified conditions. With respect to public subsidy of the arts, I have called attention in the past to the "ambiguity of the merit good argument," which equivocates over whether elements of the arts system are meritorious in themselves or whether merit attaches to aesthetic experiences (Cwi 1979). This fundamental distinction affects the design and interpretation of cultural research in various ways.

It may be useful to recall Mill's distinction between the quality and quantity of pleasure. He argued that two pleasures could be qualitatively distinguished and weighed only by persons capable of experiencing both. It was presented as an empirical claim that persons capable of experiencing both would make the same choices.

To the extent that public subsidy is justified, there may be a presumption that the arts activities receiving subsidy include those that the general public would desire to have supported had they the ability to experience them. If they have no felt need for the (subsidized) arts, this is treated as a lack of consumer skill. In short, there is an objective function to taste that reflects real differences in arts activities.

Many researchers are clearly concerned that in art as in other policy areas need has been defined by articulate and influential groups expressing what they genuinely feel to be in the best interests of the nation but in fact expressing little more than their own personal biases. This thrusts on the researcher the uncomfortable question of how arts need is to be defined and measured. Further questions include not only "needed" arts activities but the frequency and mode of contact for audience-based programs (for example, live versus electronically reproduced). Since many arts researchers are themselves incapable of deriving genuine satisfaction from art, they may only be able to approach this issue from a narrow aca-

demic or meta-policy sciences standpoint. They may be able to discuss the nature of the problem but not the implications of alternative policies for human welfare.

These issues arise again with respect to research on the social and market organization of art. Current subsidy practices implicitly sanction a variety of organizational (nonprofit) forms for which there is market failure. Unlike the more commercial forms, the nonprofit arts are largely controlled by artists or at least directed with artistic and not commercial goals primarily in mind. Little work has been done on other organizational forms or practices perhaps more attuned to the needs of both artists and the public. And no one has seriously examined how we would know if we had an oversupply of arts activities as opposed to market failure for certain arts organizations.

These issues are compounded by a lack of high-quality time series data on arts production and consumption, a deficiency of serious and unprejudiced examinations of the culture-consuming public and their desires, and conflicting *Weltanschauungs* regarding the role of the state in the provision of art. English-speaking researchers tend to see the arts as simply another special interest group, some elements of which are failing in the market place and which now seek public dollars. Europeans view the provision of cultural services as an essential state function and find it difficult to understand how others seem willing to rely as much as possible on the marketplace.

Most researchers are unfamiliar with the policies and function of the local and national bodies through which public dollars are channeled to the arts. In the United States, for example, arts agencies are very much like private foundations, giving (matching) grants based on merit if not need. They have a mission, not specific objectives, and only the most general sort of plan. In fact, it is not clear that they can seriously plan since they were never intended to take responsibility for assuring levels of service or the availability of particular programs. In general, they were established to do good works and stimulate the supply of "good" art. The approaches taken by many researchers are simply irrelevant to the decision agenda of these agencies, identifying problems they cannot solve and solutions they cannot implement.

Finally, it is important to place cultural policy research in the broader context of work and leisure. Through public policy we can create a variety of needs and demands. There is a bias in favor of arts-centered activity, perhaps because the creative act is viewed as good and meaningful while other actions involved in production and consumption are seen as inherently less satisfying. (Thus, the creation of art is good in itself, independent of demand in the marketplace.) If this is the researcher's or advocate's attitude, it is inherently condescending and may have no basis in the experiences of many persons, including artists, who are creative but may derive little satisfaction or happiness from it. Life's meaning is the ultimate cultural issue. It requires an orientation that goes beyond a focus on the production and dissemination of preferred art forms and the recognition that creative acts may not be inherently meaningful.

Reference

Cwi, David. 1979. Merit Good and Market Failure Arguments for Subsidy of the Arts. *Journal of Behavioral Economics* 8, no. 2 (Summer).

An Observation on
Art and Economics

∽ᴑ∿ᴑ∿ᴑ∿ᴑ∿ᴑ∿ᴑ∿ᴑ∿ᴑ∿ᴑ∿ᴑ∿ᴑᴦ

William S. Hendon

I F THE CASUAL READER picks up this volume, he is Abt to wonder when faced with economics and art, "economics and Art who?" Others might be scandalized. A bartender might opine that mixing art and economics is like mixing aged malt whiskey with Kool-Aid. A chef might just as well serve his Ballottine of Peacock Regence on a shingle as serve art on economics. A cabbie might rather drive his Austen-Smith into a Wahl than put art and economics together. An alchemist using economics on art might think he was turning Gold into lead. A maker of clichés might think he was making a molehill out of a Montias, or a sow's ear out of a silk purse, or jingle that "Ehrlich to bed, Ehrlich to rise," or "the left hand never knows what the Shanahan is doing" or "the world comes to him who only stands and Waits." Indeed, the mixing of art and economics is strange and may well debase the art without improving the economics. Like oil and water resources, the mix is surprising.

But it is being done. Economics is looking at art through its own marginally tinted glasses à la Throsby, and art is beginning to look back with a jaundiced (but elegantly presented) eye. In universities around the world, typists in economics departments are learning to spell the names of operatic tenors in the Richardson manner. Research assistants are taking a Khakee attitude in their expanding Globerman view. Economics students are being Bowened by Baumol and falling into income Gapinskis. Deans are having Malthusian nightmares with research requests to support economics faculties who desire to spent time in art galleries in exotic cities. Researchers are seeking the fatted Caff as their Owen in order to make their own festivals pay. Computer center directors are faced with increasing dabs and smears from the Ford arts and economics data. Spouses of economists, when Abbing up the time of separation, may raise McCain and wonder if marriage is a market for lemons. Economists' children are building arts policy models but are unable to Cwi them through. Their pet horses are Can-

toring about unemployment and trying to get to the Grist of the matter. Research is going on. Theses are being developed and tested and economists in ever increasing numbers are turning their efforts to the arts under the generic name of cultural economist.

Yet the artist asks, "What is a cultural economist? Indeed, what is a Troub, a Blaug, a Pommerehne, or a Seaman? Is it not generally suspected that the highest level of culture achieved by the cultural economist grows on the leftover beef stew in his refrigerator?" Have economists so tired of messing up the world's economies that they now use their modest and infirm tools on defenseless cultural institutions, the arts? After all, as one museum director has contemptuously put it, "What could an economist possibly know about art?" Yet in universities arts management programs grow; composers consider their labor supply functions; in arts institutions audience surveys proliferate; in arts publications economic policy questions are raised; in corporations patrons are examining their motives; in legislatures elected officials ponder the value to society of the sound of dirt hitting the floor as recorded in performance arts classes. The arts become a matter of common interest and public policy develops.

And as public interest and policy develop, so do the interests of economists. Learning as we go, we cultural economists tread lightly on the boards; we move quietly in the galleries; we digest a bit of art history; and we sharpen our knowledge about the arts and their value to the individual, the society, and the economy. It is an expanding activity and one which is just beginning on a broad scale. Its future lies in our sensitivity to the arts and our respect for the discipline of economics, as well as in our sense of humor about our work as we combine individual pleasure with professional activity.

Appendix:
Abstracts of Other
Conference Papers

The Economic Functions of Nonprofit Enterprise: The Case of Art Museums*

Robert Scott Gassler
and Robin Grace

I T IS NOT SURPRISING that economic theory has had so little to say about non-profit organizations, specifically, the two major types of nonprofit enterprise, charities and bureaus. A charity can be thought of as an enterprise which, inter alia, derives income from one set of individuals essentially by asking for it, and which provides goods and services (sometimes just income) to another set of individuals who essentially ask for it. A bureau can be defined as a subdivision of a firm, a government, a charity, or another type of organization. It usually derives its income at least partly as a result of budgeting by the parent enterprise. What is needed is an economic theory of charities and bureaus which takes into account the realization that different kinds of enterprises are set up for different purposes and that, therefore, the standards applied to one type might not be identical to those applied to another.

How should we design a theory of nonprofit enterprise? Since a theory of organizations must be related to notions about individuals' behavior, it would probably be necessary to begin with a discussion of altruism and conflict. From there it would work up to the organizational and institutional levels and, finally, the relation of nonprofit enterprise to the whole society.

A very tricky problem in economics is the transition from individual preferences to group choice. For charities and bureaus, it would be possible to assume an entrepreneur or manager who sets policy for the whole enterprise. The charity manager's preferences would have to include a social welfare component—perhaps just the output of the charity—and such items as own labor (entrepreneurial) supply. The constraints would have to include a different kind of relation among outputs, inputs, revenue, and cost (except for the presence of a produc-

*Published in full in the *Journal of Cultural Economics* 4, no. 1 (June).

tion function). The bureau manager's preferences might be similarly conceived, with constraints set by the parent organization.

We can make a threefold distinction among market, government, and sociocultural institutions. Theories can be and have been developed about each institution in isolation. A needed important study, however, is that of institutional failures and interinstitutional interactions, which are closely related. This leads to the problem of determining, in the case of failure found in one institution, which of the other two is better suited to correct it.

The serious study of the economics of charities and bureaus has begun, after a long period of neglect, to emerge piecemeal from several sources. It is time now to begin work on a theoretical basis for the economics of nonprofit enterprise as rich and versatile as the theory of the firm.

The Oriental Ideal in Art
and the Art of Economic Man
in the Orient*

Tetsunori Koizumi

THE PURPOSE of this paper is to examine the role of art as an exemplification of humanistic ideals. Such an examination is useful for economists in that man's economic behavior is influenced by his humanistic ideas, which, in turn, are molded by the artistic, religious, and other cultural factors of society.

The paper begins with a general discussion of how art, defined as a symbolic expression of the image of beauty, can serve as an exemplifier of humanistic ideals. Special consideration is given to the interaction between the artist and the society in generating a specific style of art in a specific place at a specific time. The four representative ideals of humanity in art, noted by Herbert Read in his classic, *The Meaning of Art,* are used to illustrate the discussion. These are the primitive ideal, the Greco-Roman ideal, the Byzantine ideal, and the Oriental ideal. The four archetypal images of man are inferred in relation to the psycho-physiological implications of the works of art which exhibit these ideals.

The paper then turns to an economic application with a discussion of how economic man in the Orient reflects in his economic behavior that he is committed to the realization of his humanistic ideal, of how he strives to attain the union between the logic of economic rationality and the good of human unity in the context of the theory of a cost-minimizing producer. The paper concludes by pointing out the linear mode of thinking which prevails in economics today, reflecting the left hemisphere's mode of perception, a mode which has dominated the evolution of the Western mind. Other brands of cultural economics should be developed to analyze the behavior of other economic men whose minds have been molded by other cultural values.

*Published in full in the *Journal of Cultural Economics* 3, no. 2:75–88.

Economic Education:
The Indianapolis
Children's Museum Approach*

Marianne Talafuse

THE IDEA OF TEACHING economic concepts in a museum setting is new, and the Children's Museum in Indianapolis, as far as it is known, is the first in the country to plan an exhibit with the express purpose of teaching basic economic concepts. This study reports on the development of a pilot economic exhibit by the Children's Museum and the Indiana Council for Economic Education. The report includes a discussion of the development of a plan for the pilot exhibit after an examination of other museums' approaches, selection of computerized fantasy games as a medium, observations and compilations of data from the first twelve days of the exhibit, and a summary of the project.

The pilot economic exhibit is described in terms of the software, hardware, design of the exhibit area, and reactions of museum visitors. Three computerized games that could be used to teach economic concepts, "Sell Robots," "Star Trader," and "Kingdom," were written or modified from existing computer games. The APPLE II microcomputer was chosen as the hardware for the project. The work station, or "The Decision Shop," was designed to reinforce economic concepts central to the exhibit. To evaluate the learning taking place, five sets of data are stored on computer disk: name of the visitor, age of the visitor, game selected, question on game selected, and question related to visitor's experience.

Early observations on the exhibit show that reaction to the exhibit is favorable, that older visitors are much more hesitant to interact with the exhibit than are younger visitors, and that more eleven-, twelve-, and thirteen-year-olds are using the exhibit than the museum population would suggest. From these facts, the author concludes that the exhibit is reaching the segment of the population it was designed for.

*Published in full in the *Journal of Cultural Economics* 3, no. 2:41–56.

After rigorous evaluation, the Children's Museum and the Indiana Council for Economic Education will determine the direction of the pilot project. Even if children and adults do not learn economics through this exhibit, the project will continue to serve the museum as an innovative exhibit designed to pique children's interest in their economic world. However, if evaluation shows that visitors learn they must make choices and every choice they make has consequences, the project will serve as a base for further economic education in museum settings.

Contributors

Hans Abbing is an economist (and sculptor) who specializes in welfare economics. After a university career he worked for the Dutch Ministry of Culture and since 1976 has been a free-lance consultant to the Ministry. He is the author of *Economics and Art.*

Clark C. Abt is founder and President of Abt Associates Inc. and a founder and past President of the Council for Applied Social Research. He is the author of *The Social Audit for Management* and *The Evaluation of Social Programs* and editor of *Problems in American Social Policy Research.*

David E. Ault holds a B.S. in social sciences from Illinois State University and a Ph.D. in economics from the University of Illinois. He is Associate Dean for Graduate Programs, School of Business, and Professor of Economics at Southern Illinois University—Edwardsville. His articles have appeared in several economics journals.

David Austen-Smith holds a B.S. (University of Bristol, England) and a Ph.D. (University of Cambridge, England). A lecturer in economics at the University of York, England, Dr. Austen-Smith specializes in the economics of the arts, philosophy in economics, welfare economics, and positive and normative public choice theory.

Alexander Belinfante holds a B.A. in economics from Purdue University and a Ph.D. in economics from the University of California at Berkeley. He is currently employed as an industry economist for the Common Carrier Bureau, U.S. Federal Communications Commission.

Mark Blaug holds an M.A. and a Ph.D. in economics from Columbia University. He has worked as a statistician for the U.S. Department of Labor and is now Professor of the Economics of Education at the University of London's Institute of Education. He has published several books, including *Economics of the Arts.*

John T. Caff studied mathematics and economics at Oxford University and Harvard University. He served in the British diplomatic service from 1960 to 1975 and is currently Assistant Secretary of the Social Service Division of the British Treasury, with responsibility for public expenditures on health and the arts.

Muriel G. Cantor is Professor of Sociology at American University, author of *The Hollywood TV Producer: His Work and His Audience,* and coeditor of *Varieties of Work Experience.* She is presently engaged in research on acting as an occupation and on sex and sexual violence against women in fiction.

Gregory B. Christainsen is a graduate student in economics at the University of Wisconsin—Madison. His areas of specialization are comparative economic systems, labor economics, and environmental economics. He has served as a consultant for the Organisation for Economic Co-operation and Development and for the Office of Technology Assessment of the U.S. Congress.

Carl M. Colonna is Assistant Professor of Economics at Christopher Newport College in Virginia and Southern Regional Director of the Association for Cultural Economics. He has presented and published several papers on economics.

Stroud Cornock, a graduate of Kingston School of Art and the Royal College of Art, lectures at Leicester Polytechnic, England. He has exhibited as an artist, and his publications are listed in *Contemporary Authors.* His most recent research has been a systems study of the art world.

377

David Cwi received his Ph.D. from The Johns Hopkins University and is affiliated with its Center for Metropolitan Planning and Research. Recent publications include a study of the economic effects of arts activities on six U.S. cities and a monograph on ways that the arts can be used to promote the economic development process.

Cyril Ehrlich is Professor of Economic and Social History at Queen's University, Belfast. He has published widely on the economic and social history of music, including a book on the piano and a contribution to *Grove's Dictionary*. He is currently engaged in research on the history of the music profession.

Marianne V. Felton was educated at Guilford College (B.A. in French) and Indiana University (B.A. in music, M.A. and Ph.D. in economics). She has held research positions with the American Bankers' Association and with the State Department in Seoul, Korea. She is presently Assistant Professor of Economics at Indiana University Southeast.

Anthony Field has worked in theaters in Liverpool, Farnham, and the Isle of Wight, and was chief accountant for a group of companies controlling West-End theaters and cinemas. Since 1957 he has served as Finance Director of the Arts Council of Great Britain. He has been particularly interested in the training of arts administrators.

Bruno S. Frey holds a Ph.D. in economics and occupies a chair in economics at the University of Zurich in Switzerland. The author of several publications, he has focused much of his research on nonmarket economics, especially political processes.

James H. Gapinski, Professor of Economics at Florida State University, received his Ph.D. from the State University of New York at Buffalo in 1971. A former Brookings Economic Policy Fellow, Dr. Gapinski holds a Phi Beta Kappa key and serves as a member of the *Southern Economic Journal* editorial board. He is writing a graduate text in macroeconomics for McGraw-Hill.

Robert Scott Gassler is Assistant Professor of Economics at Guilford College. He has an A.B. from Oberlin College, an M.S. (library service) from Columbia, and an M.A. (economics) from the University of Washington (Seattle), and is finishing his Ph.D. at Colorado with Kenneth Boulding. His dissertation topic is the economics of nonprofit enterprise.

Steven Globerman, who holds a Ph.D. in economics from New York University, is an associate professor at York University (Toronto). Among his publications on cultural economics are a monograph for the Ontario Arts Council and articles in the *Journal of Cultural Economics, the Southern Economic Journal,* and *Canadian Public Policy.*

Sonia S. Gold is Professor of Economics at John Carroll University. Formerly she taught at Carnegie-Mellon University and Chatham College, and was a fellow of the Radcliffe Institute and Scholar-in-Residence at Radcliffe College. She has served as an economist in various U.S. government agencies and has published articles in several professional journals.

Robin Grace, a graduate of Prescott College in Arizona (B.A., Anthropology), has imported traditional sculpture from upper Volta, West Africa and has worked in arts administration at the Children's Museum, Denver, Colorado, and the Nancy Spanier Dance Theatre. She is presently a marketing consultant.

Edward Grist has a degree in economics and economic history from Sheffield University (England). He is House Manager of the University Theatre in Manchester, England, and Treasurer of the Independent Theatre Council, which manages community theater companies in Britain. Earlier he cofounded his own company, South Yorkshire Theatre Workshop, in Sheffield.

William S. Hendon is Professor of Economics and Urban Studies at the University of Akron and editor of the *Journal of Cultural Economics*. He has conducted research in urban economics and public finance, with emphasis on cost-benefit analysis of public programs in parks and recreation. His publications include *Economics of Urban Social Planning, Analyzing an Art Museum,* and *Evaluation of Urban Parks and Recreation.*

Louis H. Henry holds a Ph.D. in economics from the University of Notre Dame. An Associate Professor of Economics at Old Dominion University in Virginia, he specializes in urban economics, the economics of medical care, and social economics.

John R. Hildebrand is Professor of Social Science at Michigan State University and is affiliated with its Latin American Studies Center. He has held consulting and research assignments in Latin America and is the author of *Economic Development: A Latin American Emphasis* and numerous articles.

Verna Hildebrand is Professor of Family and Child Sciences at Michigan State University and the author of *Introduction to Early Childhood Education, A Laboratory Workbook for Introduction to Early Childhood Education, Guiding Young Children,* and *Parenting and Teaching Young Children* (forthcoming).

Robert Hutchison was Senior Research and Information Officer at the Arts Council of Great Britain from 1973 to 1978. He is the author of *Three Arts Centres* and the editor of *A Directory of Arts Centres.*

Kenneth Kahn, a native New Yorker and a painter, has served as Executive Director of the Maryland State Arts Council for the past four years. Kahn was formerly Director of the Kirkland Art Center in Clinton, New York, Director of the Queens Museum in Flushing, New York, and a researcher and editor for Reader's Digest Books.

Harry H. Kelejian received his Ph.D. from the University of Wisconsin—Madison. He has served on the faculty of Princeton University, New York University, and the University of Maryland. His major publications are in theoretical and applied econometrics.

Adrian P. Kendry holds a B.S. and an M.S. in economics from Queen Mary College. He is a Senior Lecturer in Economics at Bristol Polytechnic and was Visiting Lecturer in Economics at Illinois State University in 1978–79. His publications concern the methodology of economic science and the statistical uncertainty of macroeconomic policy.

Abdul Khakee is Senior Lecturer in Economics at the University of Umeå (Sweden) and has taught at the University of Delaware. He has conducted research in development planning, urban economics, cultural economics, and local government, and is the author of *Development and Planning in Tanzania* and *Planning in a Mixed Economy: The Case of Sweden.*

Tetsunori Koizumi holds a B.A. from Hitotsubashi University and a Ph.D. from Brown University. He has taught at Nagoya University and Otemon Gakuin University, and is currently Associate Professor of Economics and East Asian Studies at Ohio State University. His research interest is in culture and the patterns of individual behavior.

V. N. Krishnan is Professor of Economics at Bowling Green State University. Previously he taught at the University of Madras and conducted research at the Indian Institute of Management for the Indian Planning Commission. He is coauthor of a text on modern governments and is interested in economic development, labor economics, and microeconomic theory.

Berend J. Langenberg studied economics at the University of Amsterdam and worked as a scientific researcher at the Dutch Ministry for Cultural Affairs, Recreation, and Social Welfare. He is Director of the Association of Dutch Theatre Companies, a service and employers' organization of all subsidized theater companies in Holland.

William J. Lawrence holds a Ph.D. in economics from New York University. He is Associate Professor of Economics at Pace University Graduate School of Business and Director of the New York Regional Econometric Model at Wharton EFA. He is currently conducting an empirical analysis of the cultural and arts industries in New York City.

Dorothy Lee holds a Ph.D. in sociology from the University of Iowa. She is Associate Professor and Chairperson of the Department of Sociology, Anthropology, and Social Work at Illinois State University. Dr. Lee has published articles in several professional journals and is coauthor of *Minority Status: The Position of Women.*

Bevars D. Mabry is Professor of Economics and Chairperson of the Economics Department at Bowling Green State University. He was a visiting Rockefeller Foundation professor at Thammasat University in Thailand and has written extensively on the Thai economy. He is the author of several books and articles on labor economics and economic development.

Mary Connelly Mabry chairs the Division of Art Education at Bowling Green State University. She has also taught at Chulalongkorn University (Thailand) and at the Toledo Museum of Art. She has published several articles on oriental fiber crafts, and her paintings and weavings have been exhibited in Italy, in Thailand, throughout Southeast Asia, and in the United States.

Alice J. MacDonald received a B.A. in history and an M.A. in English from the University of Akron. She is an instructor in the Department of English at the University of Akron.

Roger A. McCain holds a B.S. in mathematics and a Ph.D. in economics from Louisiana State University. He is Associate Professor of Economics at Temple University and the author of *Markets, Decisions, and Organizations* (forthcoming).

Edward M. McNertney is Assistant Professor of Economics at Texas Christian University. He received his B.A. in mathematics from Bloomsburg (Pennsylvania) State College, his M.A. in economics from Bowling Green State University, and his Ph.D. in economics from the University of Massachusetts.

J. M. Montias received his B.A. and Ph.D. from Columbia University. He is Professor of Economics at Yale University and the author of *Central Planning in Poland, Economic Development in Communist Romania,* and *The Structure of Economic Systems.* He edits the *Journal of Comparative Economics.*

Göran Nilsson is a Research Fellow in Economic Geography at the University of Umeå (Sweden) who specializes in cultural and recreational planning. He has researched the spatial aspects of cultural activities, municipal and regional planning, and the development of cultural and recreational activities in Sweden.

Michael O'Hare holds degrees in engineering and architecture from Harvard University. He is Director of Policy and Management Analysis in the Massachusetts Executive Office of Environmental Affairs and was previously Associate Professor of Urban Studies and Planning at the Massachusetts Institute of Technology. He has studied public policy for the arts under Twentieth Century Fund sponsorship.

Philip James Owen received his Ph.D. from the University of Illinois in communication with an emphasis on cybernetics and psycholinguistics. He founded and now heads Phil Owen Associates of San Francisco, a business consulting firm specializing in organizational communication and management training.

Virginia Lee Owen holds a Ph.D. in international economics from the University of Illinois. She is Associate Professor and Chairperson of the Department of Economics at Illinois State University. She has coauthored two textbooks and several articles on international finance and cultural economics.

Alan Peacock is the Principal of the University College at Buckingham (England) and is also Professor of Economics there. He is the joint author (with Ron Weir) of *The Composer in the Marketplace* (1975) and was Chairman of the Arts Council Enquiry into Orchestral Resources in Great Britain (1970).

Anne K. Peters is Associate Professor of Sociology and coordinator of the Labor Studies Program at California State University, Dominquez Hills. She has conducted research on the mass media, performers' unions, and the work life and social history of actresses. She is currently writing on pornography from a feminist sociological perspective.

Werner W. Pommerehne holds a Ph.D. in economics from the University of Konstanz (Federal Republic of Germany). He is a Lecturer in Economics at the University of Zurich in Switzerland and has conducted research on political institutions and processes, fiscal redistribution, and cultural economics.

James F. Richardson holds a B.A. from Iona College and a Ph.D. from New York University. He is Professor of History and Urban Studies at the University of Akron and the author of *The New York Police: Colonial Times to 1901* and *Urban Police in the United States*.

F. F. Ridley is Professor and Head of the Department of Politics at the University of Liverpool. His publications include *Public Administration in France, Revolutionary Syndicalism in France, The Study of Government, Specialists and Generalists* (editor), *Studies in Politics* (editor), and *Government and Administration in Western Europe* (editor). He also edits *Parliamentary Affairs*.

J. Mark Davidson Schuster is an assistant professor in the Department of Urban Studies and Planning at M.I.T. His Ph.D. dissertation, "Income Taxes and the Arts: Tax Expenditures as Cultural Policy," was part of the Twentieth Century Fund's Project on Indirect Aid to the Arts. In 1979, under the United States–France Exchange of Scientists, he was affiliated with the French Ministry of Culture.

Bruce A. Seaman holds an M.A. and a Ph.D. in economics from the University of Chicago. He is Assistant Professor of Economics and member of the Urban Life Faculty at Georgia State University, and is Staff Economist for the Atlanta office of the Federal Trade Commission. His research interests include public sector economics, antitrust economics, and economics methodology.

James L. Shanahan is Associate Professor of Urban Studies at the University of Akron and associate editor of the *Journal of Cultural Economics*. His research and writing have emphasized urban development and urban policy issues. Currently, he is organizing the Cultural and Leisure Studies Program at Akron's Center for Urban Studies.

Ina Stegen holds a Ph.D. from the University of Vienna. She founded and directs Salzburg College, which offers a foreign studies program for American students. She conducts research on modern art and the theater and is the author of several publications, including "Das schonste Atelier der Welt."

Marianne Talafuse holds a Ph.D. in the college teaching of economics and is Associate Director of the Indiana Council for Economic Education. She specializes in economic education, teaching teachers and other community leaders economic theory and decision-making processes in accordance with learning theory.

David Throsby holds degrees from the University of Sydney (Australia) and the London School of Economics. He is Professor of Economics at Macquarie University in Sydney and coauthor of *The Economics of the Performing Arts*.

Roger M. Troub is Professor of Economics at Texas Tech University. His research and publications focus on developmental change within and among societies, an area of

inquiry which encompasses the dynamic interdependencies among economic, political, and sociocultural societal subsystems.

David Roger Vaughan is a Research Associate at the Tourism and Recreation Research Unit, University of Edinburgh. He has analyzed the economic impact and marketing of tourism and the financing of recreational facilities. Currently he is studying the interaction between the conservation-recreation objectives for the National Parks of England and Wales and the economic and social well-being of communities within these areas.

Erika Wahl-Zieger studied economics at the Universities of York (England) and Munich and received her Ph.D. in cultural economics from the University of Munich. She is employed at the Bavarian Ministry of Economics and is the author of *Theaters and Orchestras Between Market Forces and Market Correction* and several papers.

C. Richard Waits holds an M.A. and a Ph.D. from the University of Texas at Austin and is Professor and Chairperson of the Department of Economics at Texas Christian University. He has also taught at the University of Texas at El Paso, Northwestern State College of Louisiana, and San Antonio College. His articles have appeared in the *Journal of Cultural Economics*.

Index